NOSTALGIC JOURNEYS

ZEITREISEN
L'ÂGE D'OR DU VOYAGE

Stefan Bitterle

teNeues

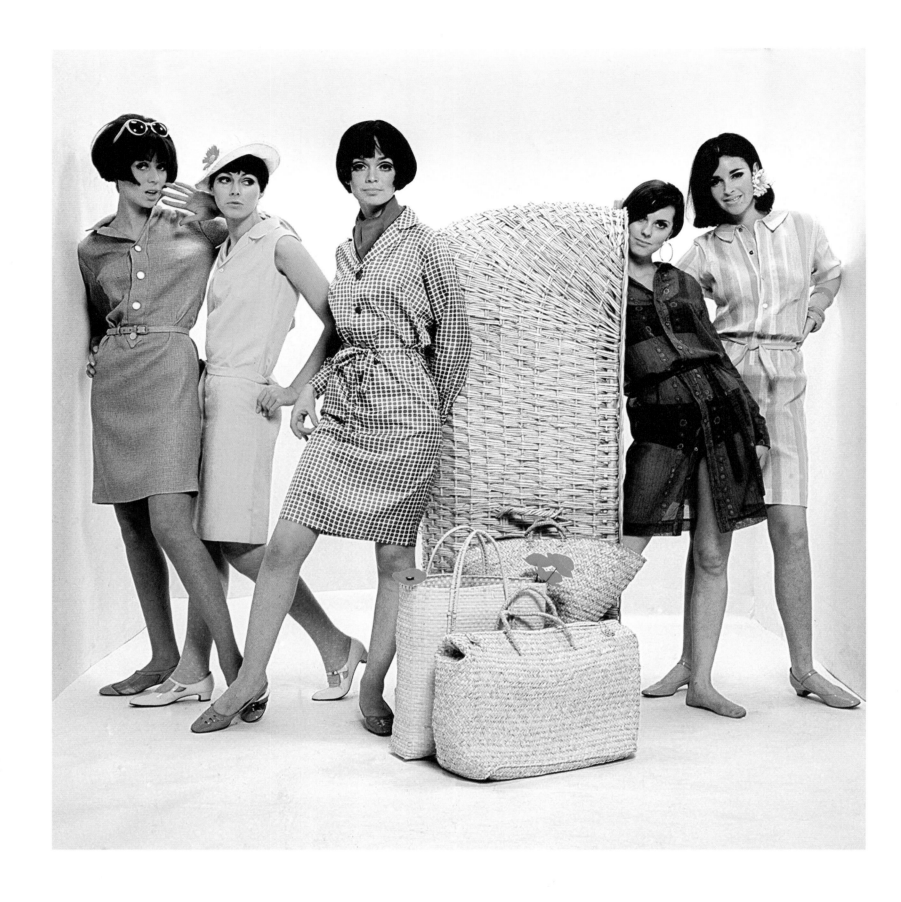

CONTENTS

INHALT

SOMMAIRE

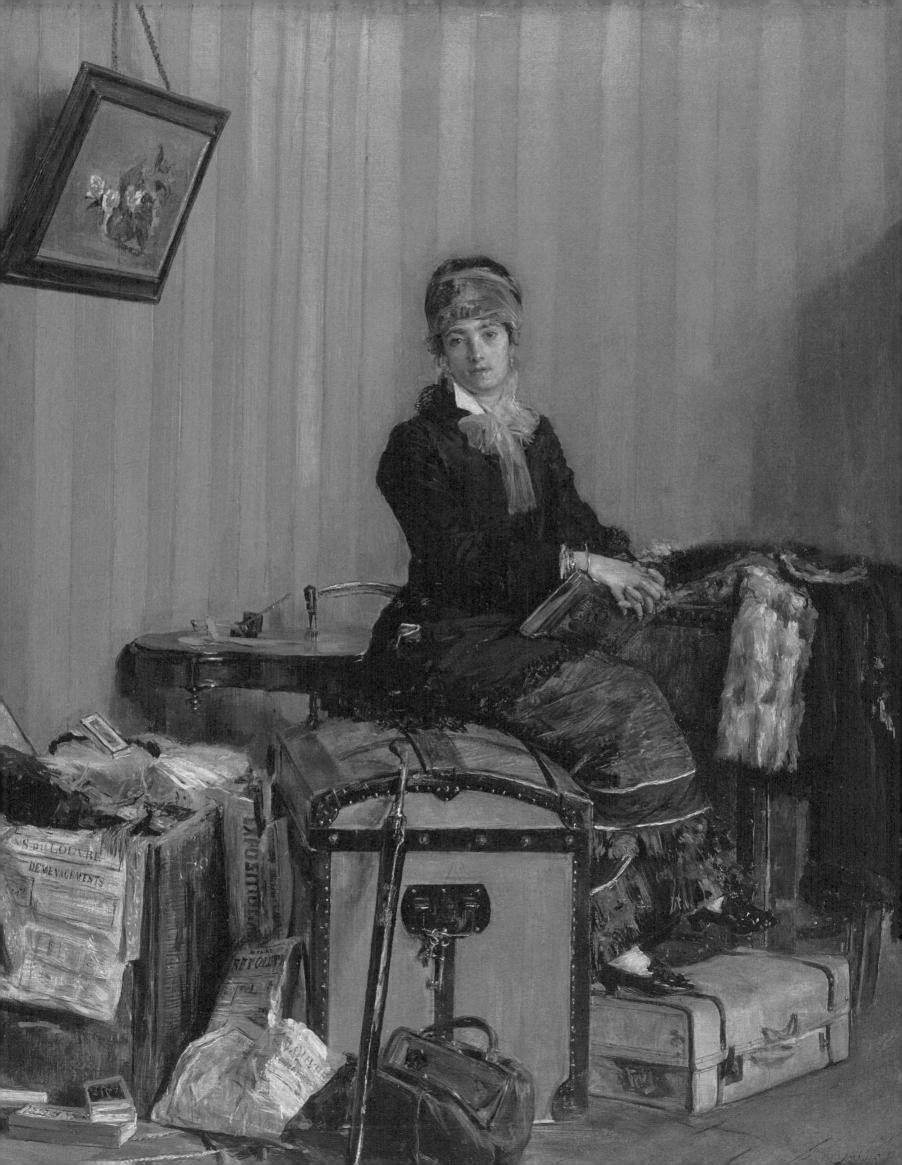

1

INTRODUCTION

EINLEITUNG
INTRODUCTION

FROM THE GRAND TOUR TO TOURISM

Curiosity has always inspired individuals to look beyond their own horizons. The first travelers were adventurers, explorers, and merchants. The concept of traveling solely for pleasure, which would eventually be called "tourism," began about two hundred years ago. But it was a long way from the vacations we now know today.

For a long time, travelers either sought adventure or had a specific mission. Some hoped to discover unknown lands or find routes to get there—either at their own expense or on behalf of a ruler. Sometimes they wanted to tap into new markets for a business or a kingdom, while at other times they embarked on military raids. Others went on pilgrimages to holy places—either alone or in the company of other likeminded individuals. The sites of some of these strenuous journeys included Santiago de Compostela in Spain, Lourdes in southern France, Rome, and a shrine to the Virgin Mary in Częstochowa, Poland. As a holy city for all three Abrahamic religions, Jerusalem has always been a pilgrimage destination, just as Mecca is for Muslims and Varanasi for Hindus.

When did this kind of travel evolve into tourism's precursor? Since the Renaissance, young aristocrats undertook educational trips of Europe known as the Grand Tour. They typically traveled through central Europe, stopping mainly in Italy and Spain before continuing to the Holy Land. Although the journey was both informative and entertaining, it was also uncomfortable and strenuous.

Over the course of the eighteenth century, forty thousand young people journeyed to Italy in an effort to acquire what the British author Laurence Sterne described as, "an urbanity and confidence of behavior, and fit the mind more easily for conversation and discourse—to take us out of the company of our aunts and grandmothers and from the track of nursery mistakes."

Various literary figures were known for their travels, including Michel de Montaigne, Lord Byron, and Johann Wolfgang von Goethe, who toured the Italian peninsula from September 1786 until May 1788. As the Minister of the State at Weimar, he was able to travel in great luxury in a custom-built carriage accompanied by as many as five servants while staying at only the best hotels. Goethe later recorded his many impressions in his *Italian Journey*. The main purpose of travel was no longer to conquer the unknown—but to enjoy it.

Only in the modern age did travel transform into an actual pastime, and starting in the early nineteenth century, the necessary conditions were also in place: new means of transportation, comfortable accommodations, and improved communications. At first only relatively few people with a great deal of time (and plenty of money) were able to benefit from these developments.

As with so many trends, the impetus for organized tourism came from the United Kingdom. Thomas Cook was born on November 22, 1808, in Melbourne, England. As a village evangelist and committed member of the temperance movement, Cook coordinated the first rail excursion in history in July 1841. For a price of one shilling for a round trip, 570 temperance supporters traveled by third-class open railway carriages from Leicester in central England to Loughborough, located eight miles away. The fare included a ham sandwich and a cup of tea. These travelers' goal was to abstain from gin and enjoy the fresh air!

Starting in 1836, Cook's compatriot John Murray began publishing a series of travel guides called *Red Books*, which described the attractions of the Netherlands, Belgium, and the Rhineland. Karl Baedeker, a book-seller from Koblenz, Germany, followed suit, catering to "Rhine romanticism," which had been enticing artists to the legendary river since the late eighteenth century. In 1827, he founded a publishing company for travel guides. The revised second edition of *A Rhine Journey from Mainz to Cologne*, published in 1835, was the first red *Baedeker* guide which quickly became synonymous with guidebooks in the nineteenth and twentieth centuries. Karl Baedeker was a visionary—and, quite literally, a bean counter. As the story goes, Baedeker supposedly used a pocket full of beans as a memory aid to count the tower steps at the Milan Cathedral.

Cook, Murray, and Baedeker laid the foundations for modern mass tourism by promoting organized travel. Cook primarily accomplished this as a tour operator: following his first trip, he established a travel agency in 1845, and began offering excursions within the United Kingdom. These were followed by tours to increasingly distant destinations—he arranged his first trip to the Continent in 1855. After Cook discovered North America as a travel destination in 1866, it didn't take long before he set his sights on Egypt. He personally guided his company's first trip there, prompted by the Suez Canal's opening. In 1872, Thomas Cook offered the first world tour, which lasted nearly eight months.

Apart from the culturally significant sites that have always attracted travelers, spas and seaside resorts became popular destinations in the early nineteenth century. With their springs and healing treatments, European spas drew upon a long tradition extending as far back as Roman times. Seaside resorts where relaxation-seekers actually bathed in the ocean did not come into vogue until the late eighteenth century.

Traveling to the unpredictable ocean was once just as inconceivable as voluntarily climbing mountains. With the romantic enthusiasm for nature inspired by Jean-Jacques Rousseau, however, even the seemingly impassable Alps became less threatening, and transformed into a popular destination for travelers in

search of unspoiled nature that was also conveniently accessible by railway. In the 1860s, mountain climbers—the majority of whom were British, such as Edward Whymper—conquered more than fifty Alpine peaks, including the Matterhorn in Switzerland, and they did so simply out of the desire to climb them.

A new form of guest accommodations came into being: Grand Hotels, sophisticated and comfortable establishments equipped with the latest technology and every conceivable luxury, from the room furnishings to hotel cafés and restaurants, which offered exquisite cuisine. There, hotel guests could not only enjoy excellent food, but could also see and been seen, which explains why some stayed for weeks or even months at a time rather than just a few days. What's more, these hotels

boat shortened the arduous journey from Europe to the New World from the five weeks required by ships under sail to a mere two weeks. Compared to the sedate speed of uncomfortable horse-drawn carriages, which generally traveled at little more than four miles per hour, travel speeds by rail increased significantly. Soon enough, there was an urge to set new records. Published in 1873, just one year after Thomas Cook's first package tour of the world, Jules Verne's novel *Around the World in Eighty Days* tells the story of an eccentric British gentleman named Phileas Fogg who is so fanatical about punctuality that he accepts a wager to travel around the world in less than three months—which he manages to win at the last minute.

In the late nineteenth century, telegraphs

Ships evolved from steam-supported sailing ships with Spartan amenities into imposing ocean liners of unprecedented dimensions and undreamt-of luxury: at the end of the nineteenth century, these swimming palaces reached lengths of nearly 660 feet and achieved speeds of over twenty knots (close to twenty-five miles per hour).

In the twentieth century, railways and steamships soon gave rise to two overpowering rivals that once again revolutionized travel: automobiles and airplanes. When Ford's Model T rolled off the assembly line in 1914 as the first reasonably priced automobile, it launched an era of mass motorization. Travelers no longer had to rely only on railway routes; instead, they could set out on their own to explore the USA's vast distances via an increasingly dense network of highways. This paved the way for numerous new travel destinations, ranging from national parks to amusement parks.

The commercial conquest of the skies began at the same time as mass motorization. The Junkers F 13, developed by Hugo Junkers in 1919, boasted six seats and became the world's first airliner entirely manufactured from metal. The F 13 heralded the triumph of passenger airplanes, which brought continents even closer together and caused the last white spots on the world map to disappear forever.

> **❝ ONE DOES NOT TRAVEL IN ORDER TO ARRIVE SOMEWHERE, BUT SIMPLY FOR THE SAKE OF TRAVEL ITSELF. ❞**
> —*JOHANN WOLFGANG VON GOETHE*, CONVERSATIONS, *1788*

offered amenities that some visitors did not even have in their own homes.

With steam engines as the driving force, vehicles on water and land could operate largely independently of the weather, and were able to reach previously unimagined speeds. In 1807, the *Clermont*, invented by the American engineer Robert Fulton, made its first trip up the Hudson River from New York to Albany; it took two days to travel 150 miles. In 1825, the steam locomotive *Locomotion*, the brainchild of the British engineer George Stephenson, pulled a train from Shildon in northeastern England to Stockton, located twenty-five miles away. The train reached a maximum speed of fifteen miles per hour.

Before long, steamboat and railway connections existed worldwide. Traveling by steam-

and improvements in postal service greatly accelerated the transmission of messages and the delivery of shipments, bringing distant countries closer together.

The European railway network grew rapidly. In addition to carts and carriages, the means of transportation came to include trains—some of which were sumptuously furnished. Depending on their budget, travelers could choose from open or closed upholstered carriages as well as dining cars and sleepers. Those with a particularly high opinion of themselves could arrange to have their own Pullman car attached to the train. Luxury trains, such as the *Orient Express*, which connected Paris to Constantinople starting in 1883, were the exclusive domain of a very lucky few.

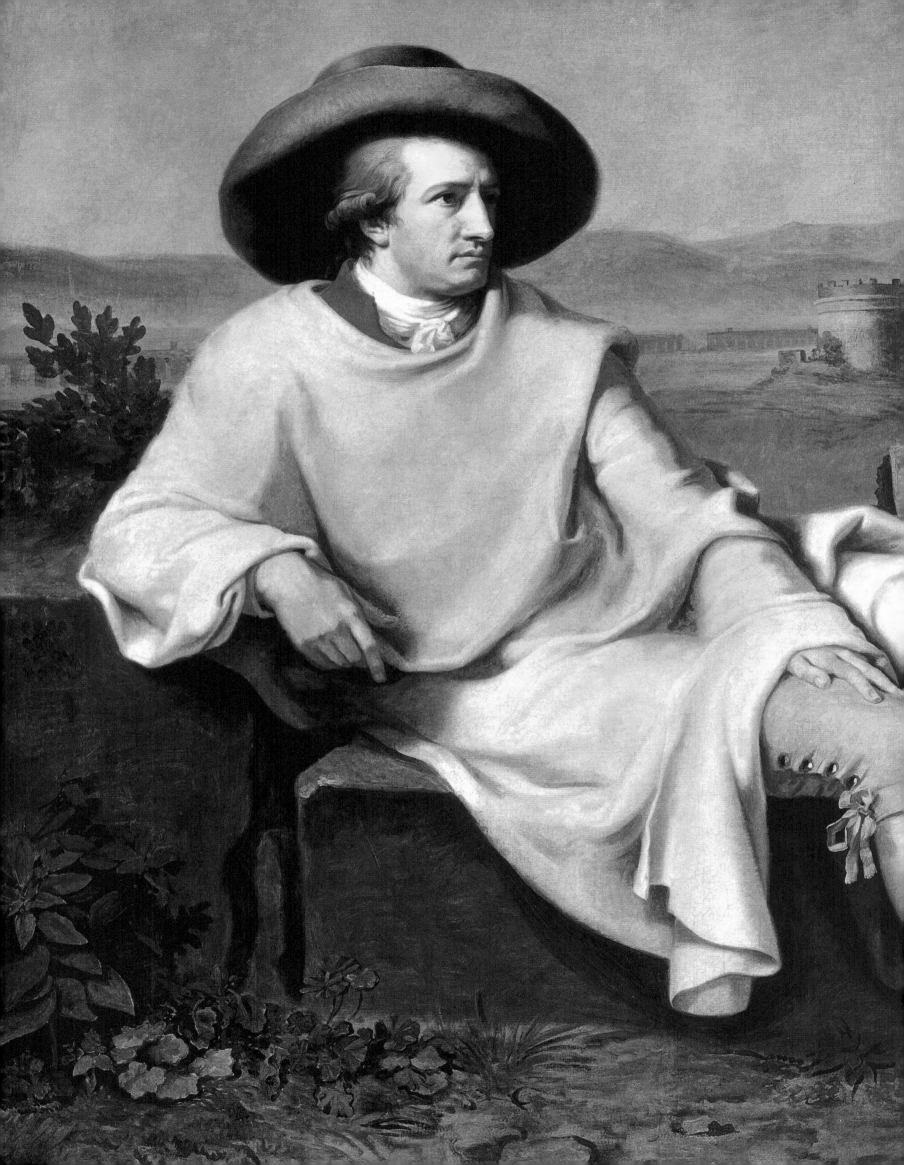

VON DER GRAND TOUR ZUM TOURISMUS

Schon immer hat Neugierde Menschen dazu bewegt, einen Blick über den eigenen Tellerrand zu werfen. Die ersten Reisenden waren Abenteurer, Entdecker oder Kaufleute. Das Reisen zum reinen Zeitvertreib kam erst vor etwa 200 Jahren auf. Gleichzeitig entstand auch der Begriff „Tourismus". Bis zu den Urlaubsreisen, wie wir sie heute kennen, war es ein weiter Weg.

Lange Zeit suchte jemand, der unterwegs war, entweder Abenteuer oder hatte eine Mission. Zum Beispiel die, dass er unbekannte Länder oder Wege dorthin entdecken wollte – auf eigene Rechnung oder im Auftrag einer Herrschaft. Es konnte auch sein, dass er neue Waren- oder Absatzmärkte erschließen wollte – für eine Gesellschaft oder ein Königreich. Oder er brach zu Raubzügen auf. Nicht umsonst ist der mittelhochdeutsche Begriff „reise" gleichbedeutend mit „Kriegsfahrt". Andere Reisende pilgerten an einen heiligen Ort – allein oder mit Gleichgesinnten. Zu den Zielen solcher strapaziöser Wallfahrten gehörten das spanische Santiago de Compostela, Lourdes im Süden Frankreichs, Rom und der polnische Marienwallfahrtsort Tschenstochau. Jerusalem als heilige Stadt aller drei abrahamitischen Religionen war schon immer ein Pilgerort, genau wie Mekka für Muslime oder Varanasi für Hindus.

Wann aber begann nun das, was als Vorläufer des Tourismus gelten kann? Seit der Renaissance unternahmen junge Adelige gern eine „Grand Tour" oder „Kavalierstour" genannte Bildungsreise. Sie führte typischerweise durch Mitteleuropa mit Schwerpunkt Italien und Spanien bis ins Heilige Land, diente neben der Bildung zwar auch dem Amüsement, war aber unbequem und anstrengend.

Im 18. Jahrhundert machten sich immerhin 40 000 junge Menschen auf den Weg nach Italien, um während der Reise mit den Worten des britischen Schriftstellers Laurence Sterne „Weltgewandtheit und Sicherheit im Benehmen" zu erwerben und „den Geist zur Geschmeidigkeit" zu erziehen. Außerdem, so Sterne, würden sie damit „endlich der Gesellschaft unserer Tanten und Großmütter entwöhnt".

Die Literatur kennt berühmte Einzelreisende wie Michel de Montaigne, Lord Byron oder Johann Wolfgang von Goethe, der von September 1786 bis Mai 1788 die Apenninen-Halbinsel bereiste. Als Minister tat er das in großem Luxus: in einer eigens gebauten Kutsche, mit bis zu fünf Dienern und Übernachtungen nur in den besten Hotels. Seine vielfältigen Eindrücke hat Goethe später in seiner *Italienischen Reise* niedergeschrieben. Es ging nun nicht mehr darum, die Fremde zu erobern. Es ging darum, sie zu genießen.

Erst mit der Moderne wurde das Reisen zum bloßen Zeitvertreib, und ab dem frühen 19. Jahrhundert gab es auch die notwendigen Voraussetzungen dafür: neue Verkehrsmittel, komfortable Unterkünfte und ein verbessertes Nachrichtenwesen. Nutznießer waren aber zunächst wenige Menschen mit viel Zeit – und viel Geld.

Wie so viele Trends kam der Impuls für den organisierten Tourismus aus dem Vereinigten Königreich. Im englischen Melbourne wurde am 22. November 1808 Thomas Cook geboren. Der Wanderprediger und überzeugte Alkoholgegner Cook organisierte im Juli 1841 die erste Pauschalreise der Geschichte. Zum Preis von einem Schilling pro Person fuhren 570 Abstinenzler mit der Eisenbahn in der offenen dritten Klasse vom mittelenglischen Leicester ins 13 Kilometer entfernte Loughborough und zurück. Im Preis enthalten waren ein Schinkenbrot und eine Tasse Tee. Eigentliches Ziel dieser Reisenden: Weg vom Gin, hin zur frischen Luft!

Cooks Landsmann John Murray veröffentlichte ab 1836 seine *Red Books* genannten Reiseführer über die Sehenswürdigkeiten der Niederlande, Belgiens und des Rheinlands. Der Koblenzer Buchhändler Karl Baedeker tat es ihm gleich und bediente die Rheinromantik, die bereits seit dem späten 18. Jahrhundert viele Künstler an den sagenumwobenen Strom lockte. 1827 gründete er einen Verlag für Reisehandbücher; 1835 erschien mit der überarbeiteten 2. Auflage der *Rheinreise von Mainz bis Cöln* der erste rote *Baedeker*, der zum Synonym für Reiseführer im 19. und 20. Jahrhundert wurde. Karl Baedeker war ein Visionär – und buchstäblich ein Erbsenzähler. Mit der Hülsenfrucht als Merkhilfe in der Tasche soll er die Turmstufen des Mailänder Doms gezählt haben.

Cook, Murray und Baedeker haben den Grundstein für den modernen Massentourismus gelegt, indem sie sich für das Reisen in organisierter Form verwendet haben. Cook tat dies vor allem als Reiseveranstalter. Nach seiner ersten Tour gründete er 1845 ein Reisebüro und bot in schneller Folge Exkursionen zu immer weiter entfernten Zielen an, zunächst innerhalb des Vereinigten Königreichs, eine Reise auf das europäische Festland organisierte er erstmals 1855. Nachdem Cook 1866 Nordamerika als Reiseziel entdeckt hatte, war es nur noch ein kleiner Schritt bis zu einer Ägyptenreise, die er selbst leitete. Anlass dazu war die Eröffnung des Suezkanals 1869. Die erste Weltreise, die fast acht Monate dauerte, hatte Thomas Cook 1872 im Angebot.

Neben den kulturell bedeutenden Orten, die Reisende seit jeher anzogen, wurden Anfang des 19. Jahrhunderts Kur- und Seebäder bevorzugte Reiseziele. Die europäischen Kurorte mit ihren Quellen und heilenden Anwendungen blickten teilweise auf eine lange Tradition bis zur Römerzeit zurück. Seebäder, in denen die Erholungsuchenden sich tatsächlich ins Meer begaben und badeten, kamen erst seit dem Ende des 18. Jahrhunderts in Mode.

Aus Vergnügen an die unberechenbare See zu fahren, war ehedem ebenso undenkbar, wie freiwillig Berge zu erklimmen. Mit der romantischen Naturbegeisterung in Anlehnung an Jean-Jacques Rousseau verloren jedoch selbst die unwegsamen Alpen ihren Schrecken und wurden zum Sehnsuchtsort von Reisenden auf der Suche nach unverfälschter Natur, die bequemerweise bald mit der Eisenbahn zu erreichen war. In den 1860er-Jahren bezwangen Gipfelstürmer, die meisten von ihnen Briten wie Edward Whymper, über 50 Alpengipfel, darunter auch das Schweizer Matterhorn – einfach nur, um sie bestiegen zu haben.

Mit dem Grandhotel entstand eine neue Form der Gästeunterkunft: mondäne Häuser, komfortabel, mit der neuesten Technik und allem erdenklichen Luxus versehen, von der Ausstattung der Räume bis zu hauseigenen

brauchte das Boot zwei Tage. 1825 zog die Dampflokomotive *Locomotion* des englischen Ingenieurs George Stephenson den ersten dampfgetriebenen Eisenbahnzug vom nordostenglischen Shildon ins 40 Kilometer entfernte Stockton. Die Höchstgeschwindigkeit des Zugs betrug 24 Kilometer pro Stunde.

Bald gab es weltweit Dampfschifffahrts- und Schienenverbindungen. Die Fahrt mit dem Dampfer verkürzte die beschwerliche Reise von Europa in die Neue Welt von etwa fünf Wochen, die ein Segelschiff brauchte, auf zwei Wochen. Gegenüber dem gemächlichen Tempo der unbequemen Pferdekutschen, die häufig nur wenig mehr als 7 Kilometer pro Stunde zurücklegten, vervielfachte sich das Reisetempo mit der Eisenbahn. Die Jagd nach Rekorden begann. Jules Vernes Roman *In 80 Tagen um die Welt* erzählt 1873, ein Jahr nach der ersten Pauschalweltreise Thomas Cooks,

besonders auf sich hielt, ließ einen eigenen Salonwagen an den Zug anhängen. Luxuszüge wie der *Orient-Express*, der ab 1883 Paris mit Konstantinopel verband, blieben gänzlich einer glücklichen Minderheit vorbehalten.

Die Schiffe wandelten sich von dampfunterstützten Seglern mit spartanischer Ausstattung zu imposanten Ozeanlinern mit nie gekannten Dimensionen und ungeahntem Luxus: Solche schwimmenden Paläste erreichten Ende des 19. Jahrhunderts Längen von nahezu 200 Metern und erzielten Geschwindigkeiten von über 20 Knoten, annähernd 40 Kilometern pro Stunde.

Eisenbahnen und Dampfschiffen erwuchsen im 20. Jahrhundert zwei bald übermächtige Konkurrenten, die das Reisen abermals revolutionieren sollten. Mit Fords Model T, das 1914 als erstes erschwingliches Automobil vom Fließband rollte, begann die Massenmotorisierung. Die Reisenden mussten sich nun nicht mehr an Schienenwege halten, sondern konnten über ein feinmaschiges Netz aus Highways in die amerikanischen Weiten vordringen, was eine Vielzahl neuer Reiseziele, von Nationalparks bis Vergnügungsparks, hervorbrachte.

Parallel dazu begann die kommerzielle Eroberung der Lüfte. Die sechssitzige Junkers F 13, 1919 von Hugo Junkers entwickelt, war der erste vollständig aus Metall gefertigte Airliner. Die F 13 läutete den Siegeszug der Passagierflugzeuge ein, durch den die Kontinente noch näher zusammenrückten und die letzten weißen Flecken auf der Weltkarte verschwanden.

> ❞ *MAN REIST JA NICHT, UM ANZUKOMMEN, SONDERN UM ZU REISEN.* ❝
>
> *JOHANN WOLFGANG VON GOETHE*, GESPRÄCHE, *1788*

Cafés und Restaurants mit exquisiter Küche, in denen die Hotelgäste nicht nur hervorragend speisten, sondern sich auch bewusst zeigten, um etwas zu sehen und gesehen zu werden. So erklärt es sich, dass manche Gäste sich nicht nur für wenige Tage, sondern gleich für Wochen oder gar Monate einquartierten. Im Hotel konnten sie Annehmlichkeiten genießen, die vielleicht nicht einmal das eigene Zuhause bot.

Mit der Dampfmaschine als bewegende Kraft konnten Fahrzeuge zu Wasser und zu Lande weitgehend unabhängig vom Wetter betrieben werden und erreichten vormals ungeahnte Geschwindigkeiten. 1807 fuhr die *Clermont* des amerikanischen Ingenieurs Robert Fulton erstmals von New York den Hudson River hinauf nach Albany. Für die 240 Kilometer

von einem britischen Exzentriker: Der Held des Romans, Phileas Fogg, hat einen fanatischen Hang zur Pünktlichkeit, der ihn zu der Wette verleitet, in weniger als einem Vierteljahr die Erde zu umrunden; diese Wette gewinnt er in der letzten Minute.

Im späten 19. Jahrhundert erlaubten die Telegrafie und das immer besser ausgebaute Postwesen auch eine schnelle Übermittlung von Nachrichten und Sendungen. So wurden weit entfernte Länder enger zusammengeschlossen.

Das europäische Eisenbahnnetz wuchs schnell. Zu den Kutschen und Fuhrwerken kamen teils opulent ausgestattete Züge als Verkehrsmittel, in denen – je nach Geldbeutel – offene oder geschlossene, gepolsterte Waggons und Speise- oder Schlafwagen bereitstanden. Wer

ITALIAN JOURNEY
Previous pages: *Goethe in the Roman Campagna*, painting by Johann Heinrich Wilhelm Tischbein, 1787.

ITALIENISCHE REISE
Seite 8/9: *Goethe in der römischen Campagna*, Gemälde von Johann Heinrich Wilhelm Tischbein, 1787

VOYAGE EN ITALIE
Pages 8-9 : *Goethe dans la campagne romaine*, tableau de Johann Heinrich Wilhelm Tischbein, 1787

DU « GRAND TOUR » AU TOURISME ORGANISÉ

Depuis toujours, la curiosité incite l'homme à aller voir au-delà de ses horizons. Les premiers voyageurs sont des aventuriers, des explorateurs ou des marchands. Le voyage de loisir, lui, remonte à deux siècles seulement. C'est à cette époque-là qu'apparaît le terme de tourisme, mais le temps des vacances exotiques telles que nous les pratiquons aujourd'hui est encore bien loin.

Longtemps, le voyageur reste un homme en quête d'aventure ou investi d'une mission – explorer de nouvelles contrées ou défricher de nouveaux itinéraires, pour son propre compte ou celui d'un souverain. Parfois, il part à la découverte de nouveaux marchés ou de nouveaux débouchés, au profit d'une compagnie de commerce ou d'un royaume. Ou bien c'est pour en piller les richesses qu'il s'aventure en pays lointain.

D'autres encore vont en pèlerinage dans un lieu sacré – seul ou à plusieurs fidèles. Leurs longues marches mènent à Saint-Jacques-de-Compostelle, en Espagne, à Lourdes ou encore à Rome ou en Pologne, au sanctuaire de la Vierge noire de Czestochowa. Jérusalem, ville sainte des trois religions du Livre, a toujours attiré les pèlerins, tout comme La Mecque est une destination incontournable pour les musulmans, ou Bénarès pour les hindous.

À quand remonte ce qui peut être considéré comme les prémices du tourisme moderne ? Dès la Renaissance, l'aristocratie aime à former ses jeunes gens en leur faisant entreprendre un long voyage. Ce « grand tour » ou « tour du chevalier » les mène le plus souvent en Terre sainte, en passant par l'Europe continentale, avec une prédilection pour l'Italie et l'Espagne. Un voyage culturel, mais aussi de divertissement qui, toutefois, reste éprouvant, car sans confort aucun.

Au XVIIIe siècle, 40 000 jeunes gens se rendent ainsi en Italie pour, loin du cocon familial, acquérir « aisance et assurance » et développer leur « agilité spirituelle », selon les mots de l'écrivain anglais Laurence Sterne. En outre, ajoute-t-il, ils reviennent « enfin sevrés de la compagnie des tantes et grands-mères ».

L'univers de la littérature engendre de grands voyageurs solitaires, tels Montaigne, lord Byron ou Goethe qui, de septembre 1786 à mai 1788, parcourt toute la péninsule italique. Ministre, à l'époque, il se déplace en grande pompe, dans une calèche conçue spécialement pour son usage, avec jusqu'à cinq serviteurs, faisant halte dans les meilleurs établissements. Par la suite, Goethe dépeindra la multitude de ses impressions dans son *Voyage en Italie*. Déjà, il ne s'agit plus de conquérir de lointaines contrées, mais de savourer le dépaysement.

C'est seulement à l'ère moderne, toutefois, que le voyage devient synonyme de loisir. Dès le début du XIXe siècle apparaissent les conditions nécessaires à cette approche : nouveaux moyens de transport, confort des hébergements et facilité de communication. Mais dans un premier temps, seuls les privilégiés qui disposent de suffisamment de temps – et d'argent – y ont encore accès.

Comme beaucoup d'autres tendances, le tourisme organisé nous vient du Royaume-Uni. C'est dans la ville anglaise de Melbourne que naît Thomas Cook, le 22 novembre 1808. Prêtre itinérant, et résolument engagé dans la lutte contre l'alcoolisme, Thomas Cook propose, en juillet 1841, le premier voyage de groupe organisé. Pour la somme forfaitaire d'un shilling par personne, 570 abstinents font l'aller-retour en train dans un wagon de troisième classe à découvert entre Leicester, dans le centre du pays, et Loughborough, à 13 kilomètres de là. Sandwich et tasse de thé compris. Objectif de l'excursion : prendre l'air pour oublier les pintes !

En 1836, John Murray, compatriote de Thomas Cook, publie le premier de ses *Red Books* ; il présente les sites à visiter aux Pays-Bas, en Belgique et en Rhénanie. Un libraire de Coblence du nom de Karl Baedeker a eu la même idée ; lui aussi vante le charme roman-

tique des rives du Rhin qui, dès la fin du XVIIIe siècle, attirent nombre d'artistes dans la région. En 1827, Baedeker fonde sa maison d'édition ; en 1835 paraît le premier *Baedeker* de poche, qui n'est autre qu'une réédition mise à jour de son *Voyage autour du Rhin de Mayence à Cologne*. Un petit livre rouge dont le nom restera synonyme de guide de voyage tout au long du XIXe siècle et une bonne partie du XXe siècle. Karl Baedeker est un visionnaire – et un maniaque du détail et de la précision. Il va jusqu'à semer un petit pois sur chaque marche du clocher de la cathédrale de Milan pour être sûr que le compte est bon.

En abordant le voyage sous l'angle de l'organisation, Thomas Cook, John Murray et Karl Baedeker posent les fondements du tourisme moderne. Thomas Cook, lui, est le pionnier du voyage organisé. Après sa première excursion, il fonde, en 1845, une agence de voyages dont l'offre est sans cesse renouvelée et les destinations toujours plus lointaines. Ses premiers circuits restent circonscrits au territoire du Royaume-Uni. Le premier séjour sur le continent organisé par Thomas Cook remonte à 1855. En 1866, il découvre le potentiel touristique de l'Amérique du Nord ; peu après, il mène en personne son premier voyage organisé en Égypte, à l'occasion de l'inauguration du canal de Suez. Et puis dès 1872, Thomas Cook propose un tour du monde – un périple de près de huit mois.

Au-delà des grands sites culturels qui, depuis toujours, attirent les voyageurs, stations thermales et balnéaires deviennent, au début du XIXe siècle, des destinations de plus en plus prisées. En Europe, les villes d'eaux, leurs sources et leurs bienfaits pour la santé s'inscrivent dans une longue tradition qui remonte à l'Antiquité romaine. La mode du bain de mer, qui consiste à se ressourcer en se baignant dans l'eau salée, remonte seulement, quant à elle, à la fin du XVIIIe siècle.

Se lancer à l'assaut d'océans indomptables par pur plaisir ? Grimper au sommet des montagnes de son plein gré ? Voilà qui reste longtemps impensable. Puis l'époque romantique voit s'épanouir le naturalisme inspiré

de Rousseau. Dès lors, les versants alpins les plus hostiles ne font plus peur ; ils sont désormais convoités par les voyageurs en quête de nature vierge, d'autant qu'ils sont devenus accessibles avec un maximum de confort grâce au chemin de fer. Dans les années 1860, les premiers alpinistes, en majorité britanniques, tel Edward Whymper, vainquent une cinquantaine de sommets alpins, dont le mont Cervin, en Suisse – pour le simple plaisir, de parvenir à la cime.

Avec l'apparition des grands hôtels se développe une nouvelle forme de voyage : le séjour dans une résidence dotée de tout le confort, d'équipements techniques de pointe et d'un luxe omniprésent – de l'aménagement des chambres jusqu'aux cafés et restaurants installés dans l'enceinte même de l'établissement. Tout en y dégustant une cuisine raffinée,

Stephenson achemine le premier train à vapeur de Shildon, sur la côte nord-est de l'Angleterre, à Stockton, à 40 kilomètres de là. Sa vitesse de pointe est de 24 kilomètres à l'heure. Bateaux et trains à vapeur se répandent dans le monde entier. La traversée depuis l'Europe jusqu'au Nouveau Monde est réduite à deux semaines, alors qu'en voilier, elle prenait cinq pénibles semaines. Sur terre aussi, les voyages s'accélèrent considérablement : le train supplante l'inconfortable voiture à cheval à la cadence pesante qui, en général, ne dépassait guère 7 kilomètres à l'heure. Dès lors, la course au record s'engage. En 1873, un an après le premier tour du monde organisé par Thomas Cook, le roman de Jules Verne *Le Tour du monde en 80 jours* raconte l'histoire d'un autre Anglais excentrique. Le héros, Phileas Fogg, nourrit une obsession pour la ponctualité qui le conduit à relever un défi fou : faire le tour

font même accrocher leur propre wagon-salon. Quelques trains de luxe, comme l'*Orient-Express* qui, à partir de 1883, relie Paris à Constantinople, restent exclusivement réservés à une poignée de privilégiés.
La navigation, aussi, se métamorphose : les premiers bateaux à voile et à vapeur, aux équipements spartiates, font désormais place à d'immenses paquebots au luxe inimaginable. À la fin du XIXe siècle, ces palais flottants atteignent près de 200 mètres de long et dépassent 20 nœuds, soit près de 40 kilomètres à l'heure.

Au XXe siècle, le chemin de fer et la navigation à vapeur sont bientôt concurrencés par deux rivaux de taille qui, à leur tour, vont révolutionner les transports. En 1914, la Ford T, la première automobile abordable, sort des chaînes de montage. Dès lors, la voiture ne va cesser de se banaliser. Le voyageur n'est plus tenu à une ligne de chemin de fer. Il peut désormais explorer à son gré les grands espaces américains, grâce à un dense réseau routier, et accéder à une foule de nouvelles destinations, comme les parcs nationaux ou de loisirs.

Parallèlement, on assiste aux débuts de l'exploitation commerciale de la navigation aérienne. Le Junkers F 13 à six places, développé en 1919 par Hugo Junkers, est le premier avion entièrement construit en métal. Le F 13 ouvre la marche triomphale du transport de passagers, qui rapproche encore les continents et efface de la carte du monde les dernières zones inexplorées.

> ## « ON NE VOYAGE PAS POUR ARRIVER, MAIS POUR VOYAGER. »
>
> *JOHANN WOLFGANG VON GOETHE*, ENTRETIENS, *1788*

les clients s'y affichent, à la fois pour voir et être vus. C'est pourquoi certains y prennent leurs quartiers non pas pour quelques jours, mais d'emblée pour des semaines ou des mois entiers. Il est vrai qu'ils y disposent parfois de commodités qu'ils n'ont même pas chez eux.

Grâce à la machine à vapeur, les moyens de transport terrestres et maritimes sont désormais indépendants des conditions météorologiques, ou presque. Ils atteignent des vitesses qui, naguère, restaient inconcevables. En 1807, le *Clermont* de l'ingénieur américain Robert Fulton remonte pour la première fois l'Hudson, de New York à Albany. Il ne lui faut que deux jours pour parcourir 240 kilomètres. En 1825, la locomotive à vapeur *Locomotion* de l'ingénieur anglais George

du monde en moins de trois mois ; il gagnera son pari dans les dernières minutes.
À la fin du XIXe siècle, l'apparition du télégraphe et le développement du réseau postal facilitent échanges et communications. Les pays, autrefois lointains, désormais, se rapprochent.

En Europe, le réseau de chemin de fer se ramifie à vue d'œil. Calèches et autres voitures à chevaux ne sont plus les seuls moyens de transport. Entrent désormais en ligne de compte les trains, à l'aménagement parfois très sophistiqué. Ils proposent des voitures-lits et des voitures-restaurants, des wagons couverts, aux sièges capitonnés, ou découverts, et s'adressent à toutes les bourses. Les voyageurs les plus exigeants

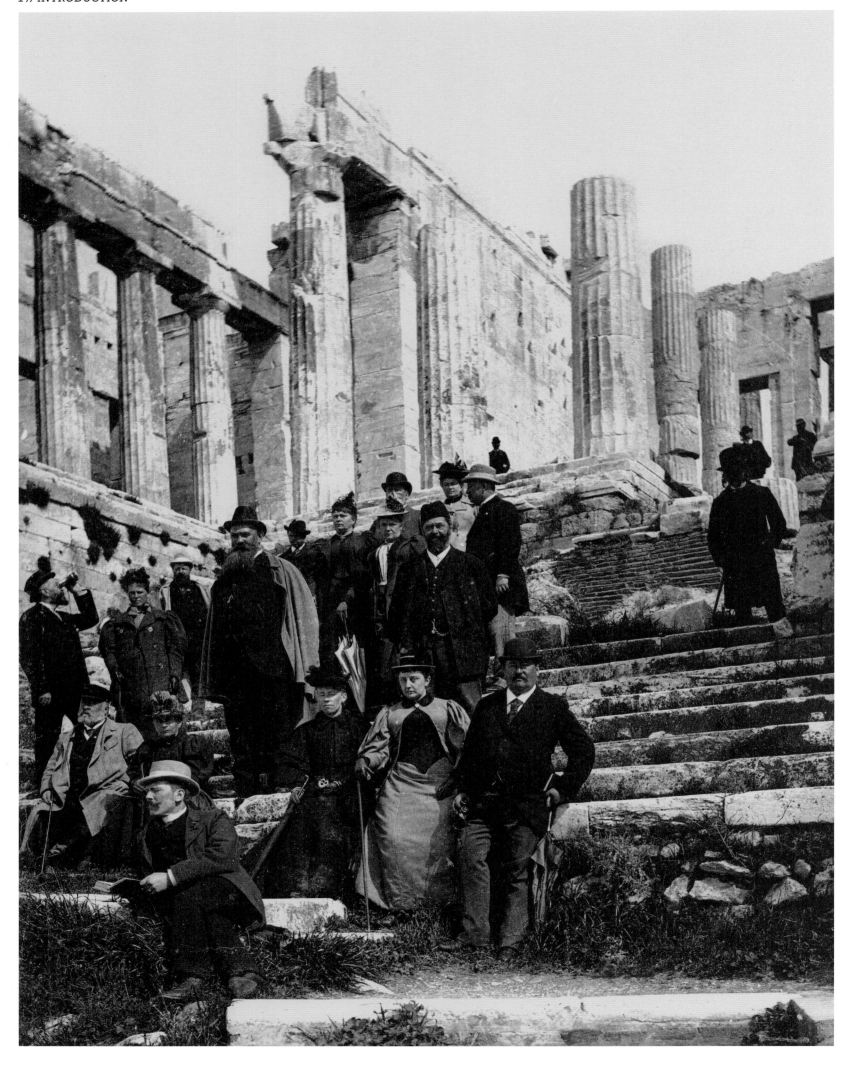

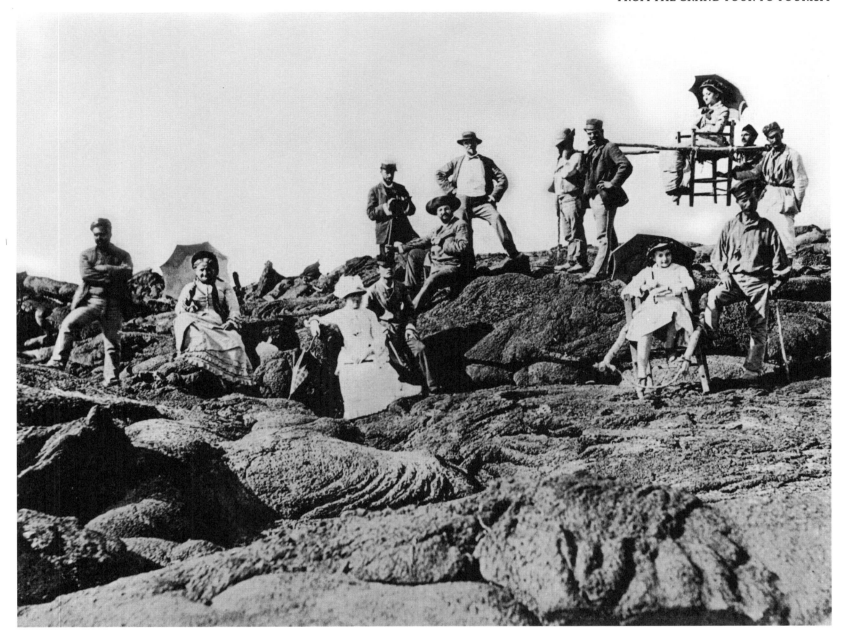

LONGING FOR ANTIQUITY

Opposite: Travelers at the Acropolis in Athens, 1874.
Above: Climbing Mount Vesuvius near Naples, 1888.

ANTIKENSEHNSUCHT

Links: Reisende auf der Akropolis in Athen, 1874;
oben: Besteigung des Vesuv bei Neapel, 1888

À LA RECHERCHE DU TEMPS PERDU

Ci-contre : visite de l'acropole d'Athènes, 1874 ;
ci-dessus : sur les flancs du Vésuve à Naples, en 1888

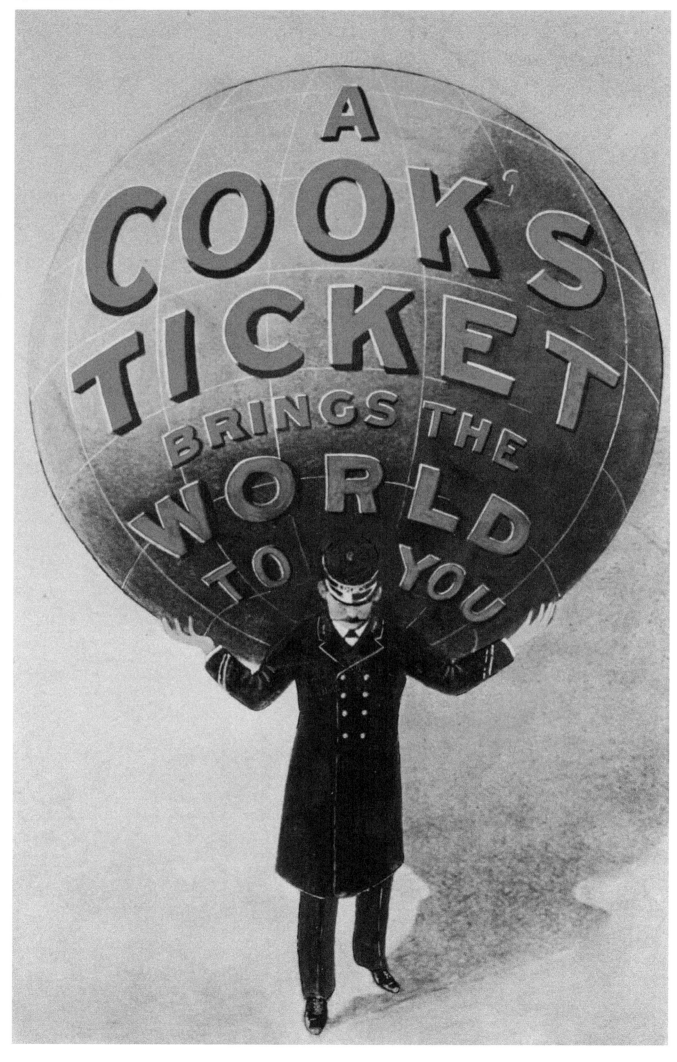

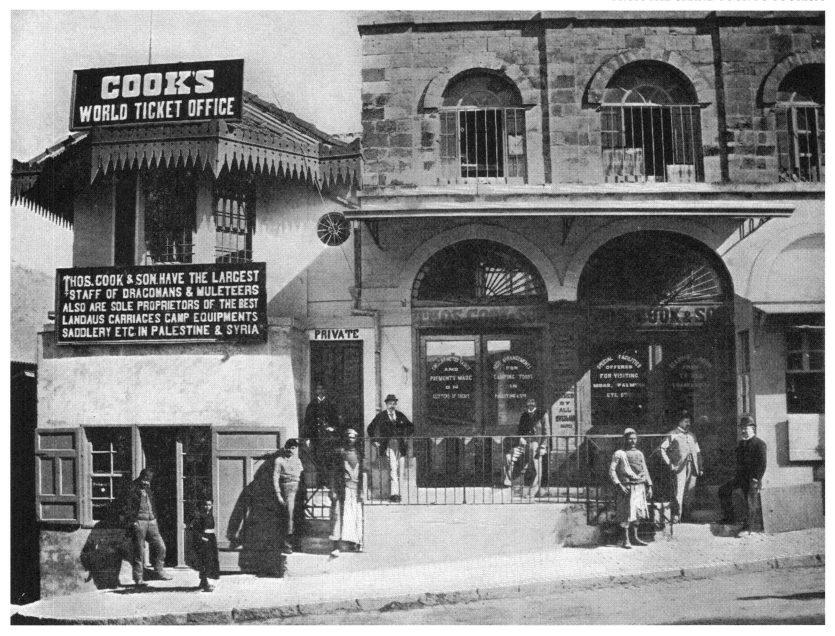

AROUND THE WORLD IN EIGHT MONTHS

Opposite: In 1872, tour operator Thomas Cook began offering the first
trips around the world. Advertising poster from 1888.
Above: Thomas Cook's office in Jerusalem, circa 1900.

IN 8 MONATEN UM DIE WELT

Links: 1872 hatte der Reiseveranstalter Thomas Cook die erste
Weltreise im Angebot. Werbeplakat von 1888;
oben: Thomas-Cook-Büro in Jerusalem, um 1900

LE TOUR DU MONDE EN HUIT MOIS

Ci-contre : en 1872, Thomas Cook propose le premier tour du monde.
« Un billet Cook et le monde est à vous » – affiche publicitaire de 1888 ;
ci-dessus : l'agence Thomas Cook de Jérusalem, vers 1900

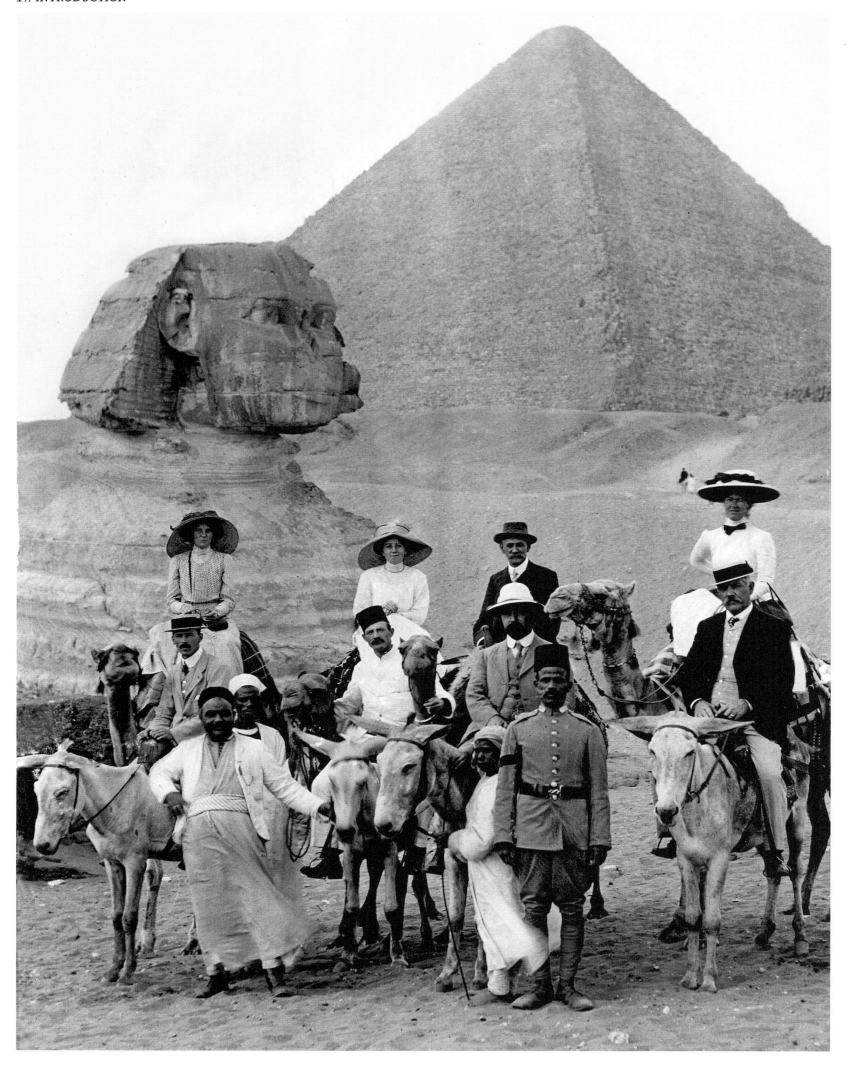

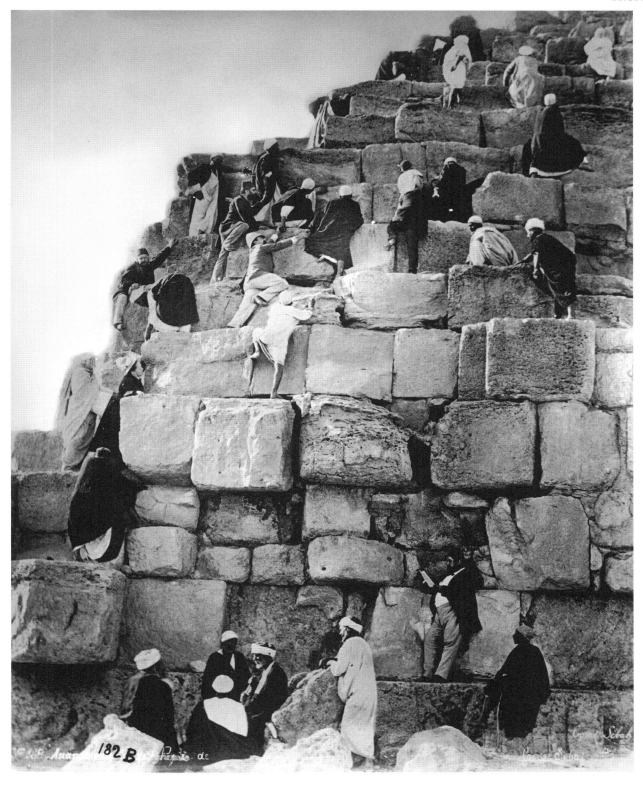

WORLD WONDER UP CLOSE

Opposite: Camel tour to the Sphinx in Egypt, circa 1900.
Above: Climbing the Great Pyramid of Giza, 1880.

WELTWUNDER ZUM ANFASSEN

Links: Kameltour zur Sphinx in Ägypten, um 1900;
oben: Besteigung der Cheops-Pyramide, 1880

LES MERVEILLES DU MONDE À PORTÉE DE MAIN

Ci-contre : les sphinx d'Égypte à dos de chameau, vers 1900 ;
ci-dessus : à l'assaut de la pyramide de Khéops, 1880

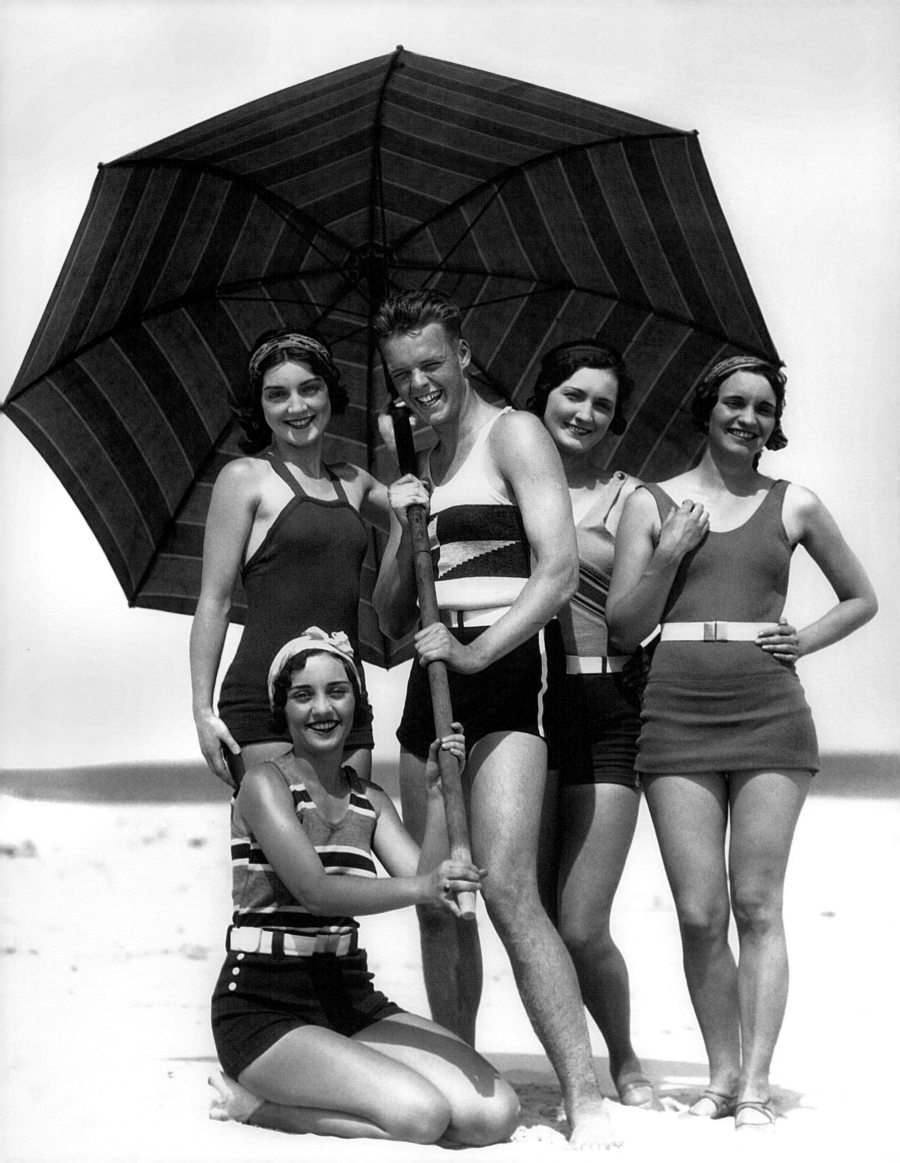

2

DRAWN TO THE SEA

MEERESLUST
PLAISIRS AQUATIQUES

SPAS AND SEASIDE RESORTS

The fact that long days spent at the beach once stemmed from therapeutic treatments is a long-forgotten legacy. And yet the famous seaside resorts from the past are inconceivable without their older relatives: the spas. The first European spas began to appear sporadically at the beginning of the modern era. Word of mouth gradually spread that bathing in mineral-rich springs and drinking their waters was beneficial to health and wellbeing. This knowledge was not entirely new. Egyptians, Greeks, and Romans turned to baths for hygienic reasons as well as for their therapeutic effects. Thermal springs in Roman ruins and numerous pictorial representations and texts bear eloquent testimony to this history.

Bathing culture initially disappeared after the fall of the Roman empire along with so many other insights and achievements of ancient civilization. Only gradually did people begin to recollect the Romans' medicinal legacy. Starting in the late Middle Ages, a growing number of medicinal springs were recorded in documents. Salt baths were mentioned along with spas featuring mineral springs. The first health resorts for aristocrats seeking relaxation evolved in England in the mid-eighteenth century. Bath, the former Roman bath in southern England, was one such resort, as well as Brighton, Buxton, and Harrogate.

With his 1834 book *Bubbles from the Brunnen of Nassau*, the British physician Francis Bond Head inspired a veritable boom in the Hesse-Nassau baths in Germany's Taunus region. Resorts such as Bad Ems on the Lahn River, the Bohemian spa towns of Karlsbad and Marienbad, and the spa town of Baden-Baden grew and evolved into fashionable resorts whose relaxing facilities far exceeded a mere course of treatment. With their comfort, casinos, and racecourses, it was not long before large hotels mesmerized wealthy citizens and aristocrats as well as artists and literati. In September 1786, a young Goethe set out on

his journey to Italy from Karlsbad. And it was in Marienbad in 1821 that an aging Goethe fell in love with seventeen-year-old Ulrike von Levetzow. During his lifetime, the writer traveled to spas twenty-two times, staying for several months each time.

With the expansion of the railway network, central European spas attracted the wealthy and the beautiful from throughout Europe. The purpose of these spa towns had long since extended beyond treatments. Instead, the primary focus shifted to social life, which rapidly evolved to meet the needs of the wealthy spa guests. In the mid-nineteenth century, Bad Ems on the Lahn River was a world-renowned spa, and Spa, the health resort in Belgium whose name is now synonymous with wellness, was considered the "Café de l'Europe," where even the Russian Czar Peter the Great and Austrian Emperor Joseph II took cures. In the nineteenth century, Baden-Baden viewed itself as the "summer capital" of Europe. Diverse individuals met there: guests and locals, relaxation-seekers and gamblers, the old elite and the nouveau riche, refined women and mistresses, famous painters such as August Wilhelm Schirmer and Gustave Courbet, world-renowned musicians including Johannes Brahms and Clara Schumann (who lived for a time in Baden-Baden), writers such as Fyodor Dostoyevsky and Leo Tolstoy, and, last but not least, members of the higher nobility like the British King Edward VII and German Emperor William I. The enticing aspect of a spa was the possibility of meeting others in public areas, such as the spa gardens, where strict status boundaries were ostensibly suspended. The "spa town" business model became an international success.

Around 1750, the British physician Richard Russell wrote about the medicinal effect of sea water in a dissertation. He employed thalassotherapy, particularly in cases of infectious diseases and respiratory infections. Beginning in 1753, the doctor began receiving his patients—usually relaxation-seeking aristocrats of considerable means—on his estate

Old Steine in Brighton, on southern England's Channel coast. In 1780, Brighton was a spa town with all the benefits of a continental European health spa. To exercise this kind of appeal, it had to offer corresponding attractions.

Brighton experienced a genuine boom after the young Prince Regent decided in 1786 to spend the majority of his leisure time on the idyllic coast rather than in London. The future King George IV acquired a country house, which he had expanded into a rather exotic palace similar to that of an Indian maharajah. It goes without saying that the heir to the throne's presence attracted the upper echelons of society. At the beginning of the eighteenth century, Brighton had a population of just 1,500. Over the course of just twenty-five years, 635 new houses were built, transforming the small fishing village into a fashionable residential city boasting every conceivable comfort and luxury. Spa guests were given onshore treatments with warm and cold seawater; very few actually bathed in the ocean. Almost no one could swim, and even fewer did so in the high-fitting swimwear that was common at the time, and that could scarcely be distinguished from streetwear.

Beach life in Brighton created a demand for appropriate seaside accommodations and distractions. In addition to a promenade, it was not long before hotels, restaurants, theaters, amusement parks, and piers made their appearance. The Chain Pier was built in 1823—the first of its kind—followed by the West Pier and the Palace Pier, which still remains the city's landmark today. A railway connection to London began in 1841. By the end of the nineteenth century, the city was attracting thousands of tourists: the petit bourgeois of London were the first to arrive in May and June, followed by doctors and lawyers in mid-summer, and, weary of the continent, the British aristocracy finally came in winter. Because Brighton remained a place of leisure for the British aristocracy and the wealthy, in the mid-nineteenth century members of the lower middle and working classes began searching for distraction in places with a

proletarian leaning, such as Blackpool on the Irish Sea. In the early 1840s, the coastal city became a popular destination for package getaways hosted by workers' associations.

With the emergence of thalassotherapy in England, seaside resorts in Germany and France soon began offering similar therapies. The oldest document of German seaside resort history dates back to 1783: in a petition to Frederick II, King of Prussia, Reverend Gerhard Otto Christoph Janus of the island of Juist proposed the establishment of a seaside resort on Juist. Despite his efforts, Heiligendamm on the Baltic Sea became the first German seaside resort to open in 1793. The first North Sea health resort was founded on the island of Norderney in 1797.

life on a drawing board, as well as for the neighboring Trouville-sur-Mer. Deauville arose as a "kingdom of elegance" on a marshy and sandy plain. The townscape was characterized by villas in a neo-Romanesque style; it drew Parisian society and an international audience to the Channel coast with its racetrack, luxury hotels, and eventually a casino. Guests of the Côte Fleurie even included the last French emperor, Napoleon III. The key to these seaside resorts' success was once again a fast and comfortable railway connection to the capital established in 1863.

Seaside resorts such as Menton, Cannes, and the sophisticated Monte Carlo were booming on the French Riviera, followed by Ventimiglia, Alassio, and San Remo on the Italian Riviera.

Yorkers preferred to travel to the "jewel of the Jersey coast," Asbury Park in the neighboring state of New Jersey. Similar to the piers in England, seaside resorts in the United States featured boardwalks—and sometimes even full-grown amusement parks, such as Luna Park on Coney Island. It was opened in 1903 and attracted less wealthy day trippers for a half century.

Further north, wealthy New Englanders were attracted to Newport, Rhode Island. Not far outside Boston were the beaches of Cape Cod, where the Pilgrims landed, as well as the whaling islands of Nantucket and Martha's Vineyard located off the peninsula's coast.

At the beginning of the twentieth century, Miami Beach in Florida gained appeal—not as a summer resort, but as a winter residence for wealthy families from the northern and Midwestern states of the U.S.

In the west, meanwhile, California underwent rapid growth. The Gold Rush, combined with better connections to the eastern and Midwestern states, acted as a magnet to boost the economy and attract more people. In show business during the 1920s and beyond, only one name was synonymous with New York and its Broadway musicals: Hollywood and its film industry. California was, after all, blessed not only with an especially mild climate, but also with gorgeous beaches, which locals and tourists alike viewed as the perfect destination for outings. And the attractiveness of California beaches only grew after surfing, imported from Hawaii, established itself as a popular sport.

" *BATHE! SLEEP! PRAY!* "
—*THOMAS AQUINAS*

Only gradually did it become common for guests to actually bathe in the ocean. Initially, this took place with guests strictly separated by gender. In the early twentieth century, people wore high-fitting bathing suits when entering the ocean, shielded from curious eyes by bathing machines—carts equipped with steps that could be wheeled out into shallow water. Though the beach may have started as a simple transition zone between the seaside promenade and the ocean, it later became the actual travel destination and was dotted with tents, sand castles, and beach chairs.

Starting in the mid-century in France, Parisians began to strike out for Deauville, a planned luxury seaside resort that sprang to

With its Promenade des Anglais, Nice adopted many design features from English seaside resorts in a deliberate attempt to attract guests from the British aristocracy. Resorts situated on the Côte d'Azur on the Mediterranean Sea were especially enticing due to their mild year-round climate. Their appeal to the nobility and members of the moneyed aristocracy has continued unabated for 150 years.

Even in the New World, a variety of resorts began to spring up, and offered guests a place to recuperate in addition to high-quality amusements. Wealthy New Yorkers from Manhattan have been relaxing on Coney Island since 1829. Unfortunately, it also became a favorite destination for prostitutes and bandits. As a result, many other New

BEACH FUN
Page 22: Modeling American swimwear under a beach umbrella, 1930s.

STRANDVERGNÜGEN
Seite 22: Amerikanische Bademode unterm Sonnenschirm, 1930er-Jahre

RENDEZ-VOUS À LA PLAGE
Page 22 : la dernière mode balnéaire sous un parasol aux États-Unis, dans les années 1930

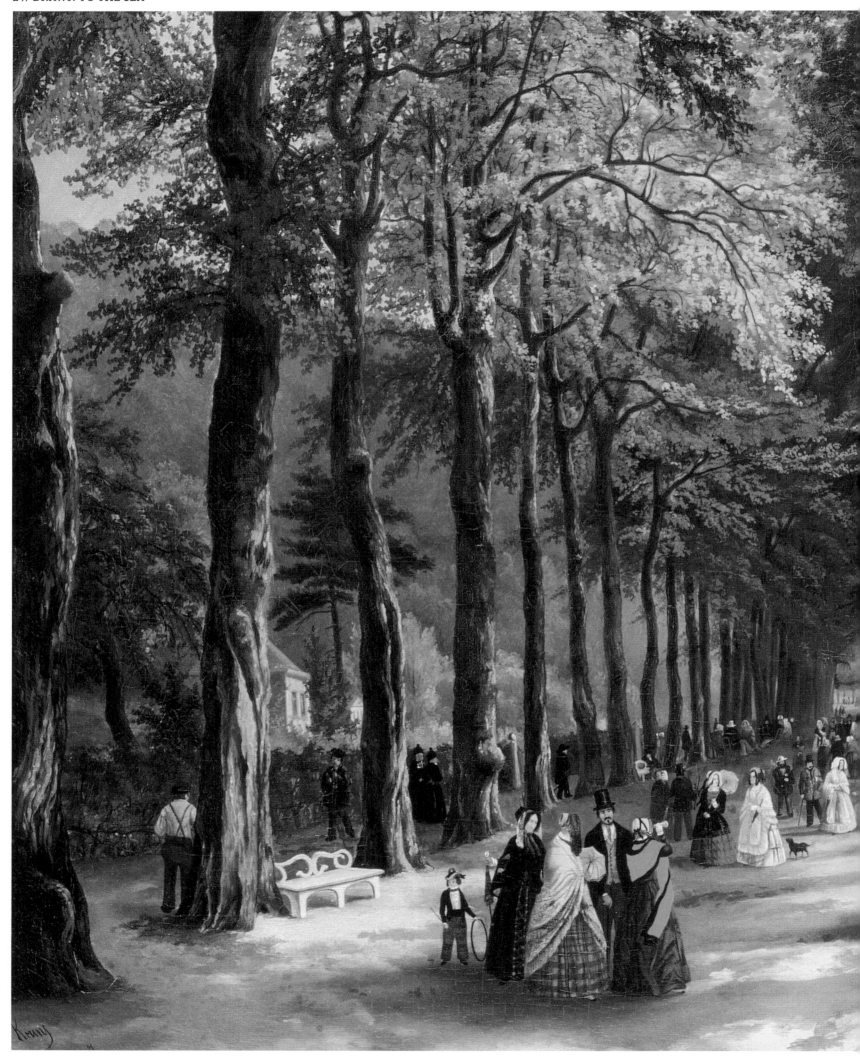

KURBÄDER UND SEEBÄDER

Dass die langen Tage an den Stränden dieser Welt einmal ihren Ursprung in therapeutischen Behandlungen haben, ist ein längst vergessenes Erbe. Und doch sind die berühmten Seebäder der Vergangenheit ohne ihre älteren Verwandten, die Heilbäder, nicht denkbar.

Die ersten Kurbäder tauchen in Europa vereinzelt zu Beginn der Neuzeit auf. Nach und nach verbreitete sich die Erkenntnis, dass das Baden in mineralienhaltigen Quellen sowie das Trinken ihrer Wässer der Gesundheit und dem Wohlbefinden zuträglich ist. Ganz neu war dieses Wissen freilich nicht. Schon Ägypter, Griechen und Römer wandten Bäder nicht nur aus hygienischen Gründen an, sondern kannten auch ihre therapeutische Wirkung. Die Thermenfunde in römischen Ruinen, zahlreiche bildliche Darstellungen und Texte legen davon beredt Zeugnis ab.

Die Badekultur verschwand nach dem Ende des Römischen Reichs – wie so viele andere Erkenntnisse und zivilisatorische Errungenschaften der Antike – erst einmal in der Versenkung. Erst allmählich besann man sich auf das heilkundliche Erbe der Römer. Ab dem späten Mittelalter sind wieder mehr Heilquellen in den Urkunden verzeichnet. Zu den Heilbädern mit Mineralquellen kamen Solebäder, etwa im Salzkammergut in Österreich. Mitte des 18. Jahrhunderts entstanden zunächst in England die ersten Kurorte für erholungssuchende Adelige. Das ehemalige Römerbad Bath in Südengland gehörte dazu, ebenso wie Brighton, Buxton oder Harrogate.

Der englische Arzt Francis Bond Head sorgte mit seinem Buch *Bubbles from the Brunnen of Nassau* von 1834 für einen wahren Boom der hessisch-nassauischen Bäder im Taunus. Badeorte wie Ems an der Lahn, die böhmischen Bäder Karlsbad und Marienbad oder Baden-Baden wuchsen und wurden mondäne Kurorte, deren Erholungsangebote die bloße Kur bei Weitem übertrafen. Bald schon zogen große Hotels mit ihrem Komfort, Spielbanken und Pferderennbahnen nicht nur reiche Bürger

und Adelige, sondern auch Künstler und Literaten in ihren Bann. Von Karlsbad aus brach der junge Goethe im September 1786 zu seiner Italienreise auf. Und in Marienbad verliebte sich der greise Goethe 1821 in die erst 17-jährige Ulrike von Levetzow. Insgesamt fuhr der Dichter in seinem Leben 22 Mal in Bäder und blieb jeweils für mehrere Monate.

Mit dem Ausbau des Eisenbahnnetzes trafen die Schönen und Reichen ganz Europas in den zentraleuropäischen Kurorten ein. Längst schon ging es dort nicht mehr nur um die eigentliche Kur, sondern vor allem um das rege Gesellschaftsleben, das sich nach den Bedürfnissen der wohlhabenden Kurgäste rege entwickelte. Ems an der Lahn war Mitte des 19. Jahrhunderts „Weltbad", und das belgische Heilbad Spa, dessen Ortsname heute ein Synonym für Wellness ist, galt als „Café de l'Europe", wo schon der russische Zar Peter der Große und der österreichische Kaiser Joseph II. kurten.

Baden-Baden sah sich im 19. Jahrhundert als „Sommerhauptstadt" Europas. Hier begegneten sich Gäste und Einheimische, Erholungssuchende und Glücksspieler, alte Eliten und Neureiche, vornehme Damen sowie Mätressen, bedeutende Maler wie August Wilhelm Schirmer oder Gustave Courbet, Musiker von Weltruhm wie Johannes Brahms oder Clara Schumann – die eine Zeit lang in Baden-Baden lebte –, Dichter wie Fjodor Dostojewski oder Leo Tolstoi, und, nicht zu vergessen, der europäische Hochadel wie der britische König Edward VII. oder der deutsche Kaiser Wilhelm I. Das Verführerische an einem Kurort war die Möglichkeit der Begegnung im öffentlichen Raum, wie dem Kurpark. An diesem Erlebnis- und Begegnungsort waren die strikten Standesgrenzen scheinbar aufgehoben. Das Geschäftsmodell „Kurort" fand weltweit seine Nachahmer.

Um 1750 befasste sich der englische Arzt Richard Russell in seiner Dissertation mit der heilenden Wirkung von Meerwasser. Die sogenannte Thalassotherapie wandte er vor allem bei Infektionskrankheiten oder Atemwegsinfekten an. Seine Patienten, meist erholungssuchende und begüterte Adelige,

empfing der Badearzt ab 1753 auf seinem Anwesen Old Steine in Brighton an der südenglischen Kanalküste. 1780 war auch Brighton ein Kurort, mit allen Vorzügen eines kontinentaleuropäischen Heilbades. Damit es dieselbe Anziehungskraft ausüben konnte, musste es auch mit entsprechenden Attraktionen aufwarten.

Brighton erfuhr einen wahren Boom, nachdem der junge Prinzregent 1786 entschieden hatte, einen Großteil seiner Freizeit nicht in London, sondern an der idyllischen Küste zu verbringen. Der künftige König George IV. erwarb ein Landhaus, das er zu einem recht exotisch anmutenden Palais ausbauen ließ, ähnlich dem Palast eines indischen Maharadschas. Die Gegenwart des Thronfolgers zog natürlich die gehobene Gesellschaft an. In nur 25 Jahren entstanden in Brighton, das Anfang des 18. Jahrhunderts nur 1 500 Einwohner zählte, 635 neue Häuser und machten so aus dem kleinen Fischerdorf eine mondäne Residenzstadt mit allem Komfort und Luxus. Die Anwendungen mit warmem und kaltem Meerwasser bekamen die Kurgäste dabei an Land, im Meer badeten die wenigsten. Schwimmen konnte sowieso fast niemand, und noch weniger ging dies in der damals üblichen hochgeschlossenen Schwimmbekleidung, die sich kaum von der Straßenkleidung unterschied.

Das Strandleben in Brighton weckte den Bedarf nach angemessenen Unterkünften und Zerstreuungen in der Nähe des Meeres. Neben einer Promenade entstanden bald Hotels, Restaurants, eine Reihe Theater, Vergnügungsparks und Seebrücken: Nach dem Chain Pier von 1823, dem ersten seiner Art, entstanden der West Pier und der Palace Pier, der noch heute das Wahrzeichen der Stadt ist. Ab 1841 gab es eine Eisenbahnverbindung nach London. Ende des 19. Jahrhunderts zog der Ort dann Tausende von Touristen an: Als Erste kamen im Mai und Juni die Londoner Kleinbürger, im Hochsommer Ärzte und Anwälte und im Winter schließlich der kontinentalmüde englische Adel. Da Brighton eher ein Vergnügungsort des englischen Adels und der Reichen blieb, suchten die Kleinbürger und Arbeiter ab Mitte des 19. Jahrhunderts Zerstreuung in Orten mit

proletarischer Anmutung, wie Blackpool an der Irischen See. Die Küstenstadt war bereits zu Beginn der 1840er-Jahre ein beliebtes Ziel für Pauschalausflüge, die von Arbeitersparvereinen ausgerichtet wurden.

Mit dem Aufkommen der Thalassotherapie in England gab es auch bald Seebäder in Deutschland und in Frankreich, die diese Anwendungen ebenfalls anboten. Das älteste Dokument der deutschen Seebädergeschichte datiert von 1783: Der Juister Inselpfarrer Gerhard Otto Christoph Janus schlug in einer Petition an den Preußenkönig Friedrich II. die Einrichtung eines Seebades auf Juist vor. Als erstes deutsches Seebad eröffnete dann jedoch Heiligendamm an der Ostsee 1793 den Badebetrieb. Das erste Nordseeheilbad entstand 1797 auf Norderney.

99 *BADE! SCHLAFE! BETE!* 66

THOMAS VON AQUIN

Erst allmählich wurde es üblich, dass die Gäste auch tatsächlich im Meer badeten. Zunächst geschah dies streng nach Geschlechtern getrennt. Anfang des 20. Jahrhunderts ging man noch in hochgeschlossenen Badekleidern ins Meer, von neugierigen Blicken durch Badewagen abgeschirmt, die mit Treppen ausgestattet waren und ins flache Wasser gerollt werden konnten. War der Strand anfangs nur eine Übergangszone zwischen Uferpromenade und Meer, so wurde er später selbst zum Reiseziel und mit Zelten, Sandburgen und Strandkörben besiedelt.

In Frankreich machten sich die Pariser ab Mitte des 19. Jahrhunderts in den am Reißbrett geplanten Luxusbadeort Deauville und das benachbarte Trouville-sur-Mer auf.

Deauville entstand als „Königreich der Eleganz" in einer Ebene aus Sand und Sumpf. Das Ortsbild war geprägt von Villen im neoromanischen Stil; es lockte mit einer Pferderennbahn, Luxushotels und schließlich auch einem Spielcasino die Pariser Gesellschaft und internationales Publikum an die Kanalküste. Unter den Gästen der Côte Fleurie befand sich auch der letzte französische Kaiser, Napoleon III. Der Schlüssel zum Erfolg war auch bei diesen Seebädern eine schnelle und bequeme Eisenbahnverbindung in die Hauptstadt, wie sie seit 1863 bestand.

An der französischen und italienischen Riviera boomten Badeorte wie Menton, Cannes oder das mondäne Monte Carlo, gefolgt von Ventimiglia, Alassio, Sanremo. Nizza mit seiner Promenade des Anglais übernahm viele Gestaltungsmerkmale von den englischen Seebädern und versuchte dabei vor allem, Gäste aus dem englischen Adel anzuziehen. Die am Mittelmeer gelegenen Orte an der Côte d'Azur konnten vor allem mit ihrem ganzjährig milden Klima locken. Ihre Attraktivität für den Adel und den Geldadel ist seit 150 Jahren ungebrochen.

Auch in der Neuen Welt schossen Bade- und Erholungsorte aus dem Boden, die ihren Gästen nicht nur Genesung versprachen, sondern auch Zerstreuung auf höchstem Niveau. Reiche New Yorker aus Manhattan entspannten sich bereits seit 1829 auf der knapp 20 Kilometer entfernten „Kanincheninsel" Coney Island am Atlantik. Der Ort wurde freilich auch zum beliebten Ziel für Prostituierte und Banditen. Deshalb fuhren

andere New Yorker zum Baden lieber zum „Juwel der Jersey-Küste", Asbury Park im benachbarten Staat New Jersey. Ähnlich wie die Piers in England besaßen amerikanische Seebäder sogenannte Boardwalks – oder gleich ausgewachsene Vergnügungsparks, wie den Lunapark auf Coney Island. Dieser Themenpark wurde 1903 eröffnet und zog ein halbes Jahrhundert lang auch die weniger vermögenden Ausflügler an.

Weiter nördlich zog es den Geldadel Neuenglands nach Newport. Vor den Toren Bostons gab es außerdem die Strände von Cape Cod, dem Landungsort der Pilgerväter, sowie die der Halbinsel vorgelagerten Walfängerinseln Nantucket und Martha's Vineyard.

Miami Beach in Florida lockte dagegen nicht als Sommerfrische, sondern als Winterquartier für reiche Bürger aus den Nordstaaten und dem Mittleren Westen der USA, dies jedoch erst ab Beginn des 20. Jahrhunderts.

Kalifornien im Westen erfuhr unterdessen einen rasanten Aufstieg: Der Goldrausch, endlich die bessere Anbindung an die Staaten im Mittleren Westen und im Osten – all dies wirkte wie ein Magnet auf die Wirtschaft und damit auch auf die Menschen. Für das Showbusiness gab es nach dem New Yorker Broadway mit seinen Musicals ab den 1920er-Jahren nur noch ein Synonym: Hollywood mit seiner Filmindustrie. Nun war Kalifornien nicht nur mit einem besonders milden Klima, sondern auch mit traumhaften Stränden gesegnet. Die kalifornischen Strände wurden so zu selbstverständlichen Ausflugszielen für Einheimische und Touristen gleichermaßen, besonders nachdem sich das aus Hawaii eingeführte Surfen zum Massensport entwickelt hatte.

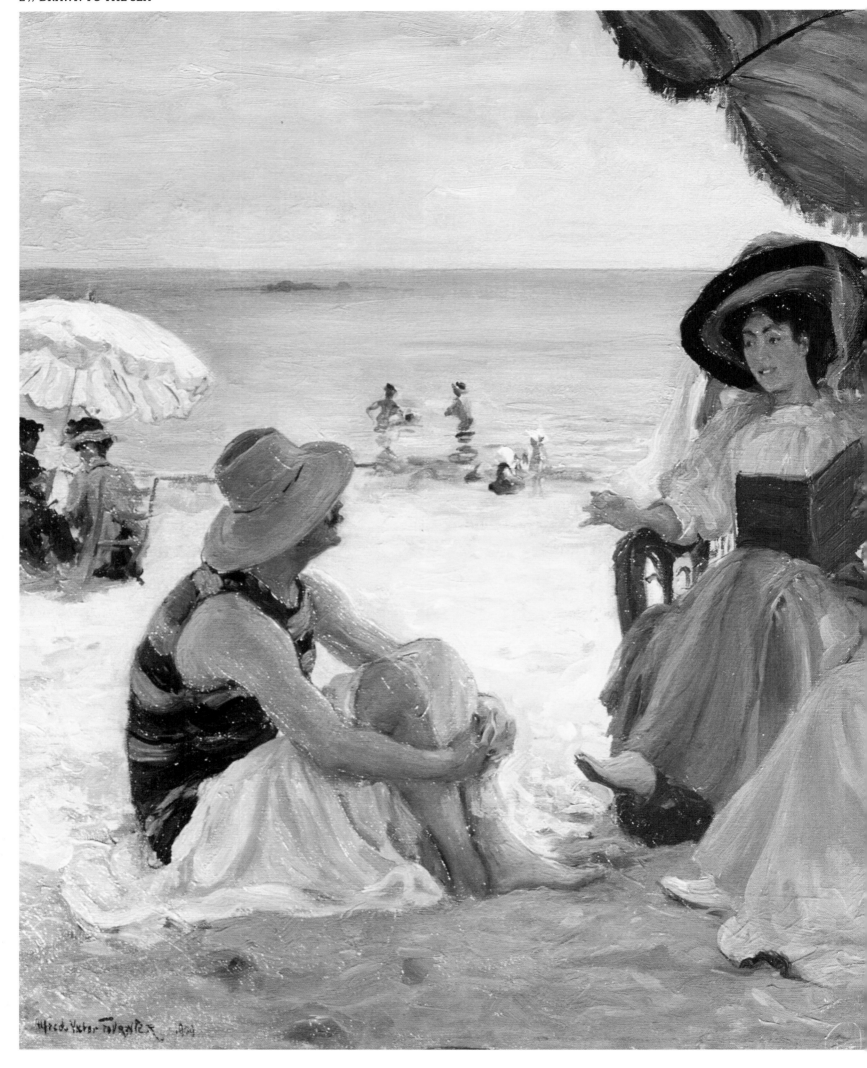

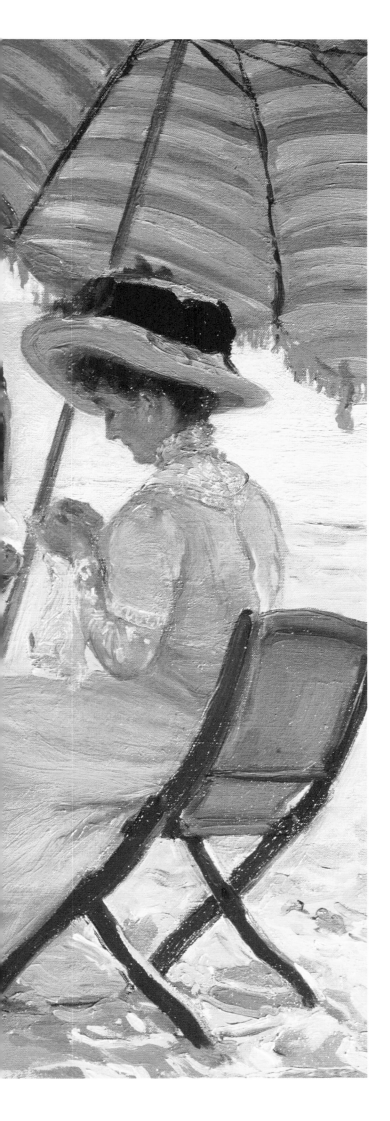

BRETON SUMMER

Women on the beach wearing clothing appropriate for their social status.
La Plage, painting by Alfred Victor Fournier, circa 1900.

BRETONISCHER SOMMER

Damen in standesgemäßer Kleidung am Strand.
La Plage, Gemälde von Alfred Victor Fournier, um 1900

UN ÉTÉ EN BRETAGNE

Dames en costume de plage. *La Plage*, tableau d'Alfred Victor Fournier, vers 1900

CURES THERMALES
ET BAINS DE MER

On l'oublie souvent, mais les longues journées de plage qu'affectionnent aujourd'hui les vacanciers du monde entier sont un héritage des traitements thérapeutiques d'hier. Or les célèbres bains de mer d'antan sont indissociablement liés à leur ancêtre : le bain thermal. Les premières cures thermales apparaissent çà et là en Europe au début de l'époque moderne. Puis la certitude se répand peu à peu : se baigner dans des sources riches en minéraux, et même en boire les eaux, s'avère propice à la santé et au bien-être. Bien sûr, ces connaissances ne sont pas tout à fait nouvelles. Les Égyptiens, déjà, puis les Grecs et les Romains, étaient de fervents adeptes des thermes. Pour des raisons d'hygiène, bien sûr, mais ils en connaissaient aussi les effets thérapeutiques. En témoignent d'impressionnants vestiges de thermes romains, ainsi que nombre de textes et illustrations issus de l'Antiquité.

Puis, avec le déclin de l'Empire romain, la culture des bains sombre dans l'oubli, comme tant d'autres avancées et connaissances des civilisations antiques. Il faut attendre le bas Moyen Âge pour voir ressurgir l'héritage médical des Romains. Peu à peu, les sources thermales sont à nouveau mentionnées dans les écrits. Aux bienfaits des eaux minérales s'ajoutent bientôt ceux des bains d'eau saline, comme dans la région de Salzkammergut, en Autriche. C'est au milieu du XVIIIe siècle, en Angleterre, que les premières stations thermales voient le jour, à l'intention des aristocrates qui éprouvent le besoin de se ressourcer – à Bath, par exemple, une ancienne ville d'eaux romaine, dans le sud du pays, ou encore à Brighton, Buxton et Harrogate.

Avec son livre intitulé *Bubbles from the Brunnen of Nassau*, publié en 1834, le médecin britannique Francis Bond Head provoque une véritable explosion des bains dans la région prussienne de Hesse-Nassau, au pied des monts Taunus. Ainsi se développent des stations thermales comme Bad Ems, sur la Lahn, et les villes d'eaux de Bohême, comme Karlsbad, Marienbad ou Baden-Baden. Elles deviennent bientôt des rendez-vous mondains, recelant bien davantage que les simples vertus thérapeutiques de leurs sources. Les grands hôtels offrant tout le confort, tables de jeu et courses hippiques, n'attirent plus seulement la bourgeoisie et la noblesse fortunée, mais aussi artistes et écrivains. C'est de Karlsbad que le jeune Goethe, en septembre 1786, débute son voyage en Italie. Et c'est à Marienbad qu'en 1821, ce même Goethe, à l'automne de sa vie, s'éprend d'Ulrike von Levetzow qui n'a que dix-sept ans. Au cours de sa vie, le poète allemand fera vingt-deux cures thermales de plusieurs mois.

À mesure que s'étoffe le réseau de chemins de fer, célébrités et grandes fortunes du vieux monde se retrouvent dans les villes d'eaux d'Europe centrale. Depuis longtemps déjà, ce n'est plus seulement pour les bienfaits de la cure, mais surtout pour la vie sociale qui s'y épanouit au gré des agendas des grands de ce monde. Au milieu du XIXe siècle, Bad Ems, en Allemagne, est devenue les « bains du monde », tandis qu'en Belgique, la ville thermale de Spa, dont le nom est aujourd'hui synonyme de détente et bien-être, est surnommée le « café de l'Europe ». Au XVIIe siècle, déjà, c'est à Spa que le tsar Pierre le Grand et l'empereur d'Autriche Joseph venaient en cure.

Au XIXe siècle, Baden-Baden se considère comme la « capitale d'été » de l'Europe. S'y croisent Allemands et étrangers, convalescents et amateurs de jeux de hasard, aristocrates et nouveaux riches, dames et demi-mondaines de la haute société, de grands peintres tels que Gustave Courbet ou l'Allemand August Wilhelm Schirmer, musiciens de renom mondial, comme Johannes Brahms ou Clara Schumann, qui vivra pendant un temps à Baden-Baden, poètes et écrivains célèbres comme Fiodor Dostoïevski ou Léon Tolstoï, mais aussi de haute société comme le roi Édouard VII d'Angleterre ou l'empereur allemand Guillaume Ier. Tout le charme de ces stations thermales réside dans les multiples occasions de rencontres, au hasard d'une promenade dans le parc, par exemple. Bien sûr, ces lieux de l'entre-soi et de la vie sociale restent protégés par de strictes barrières de classe. Le principe de la ville d'eaux s'exporte dans le monde entier.

Vers 1750, le médecin anglais Richard Russell consacre une thèse aux effets thérapeutiques de l'eau de mer. Ce qu'il appelle thalassothérapie traite surtout les maladies infectieuses et les affections des voies respiratoires. Dès 1753, ce pionnier de la médecine thermale accueille ses patients – en majeure partie des aristocrates fortunés en convalescence – dans son domaine de Old Steine, à Brighton, sur la côte anglaise de la Manche. En 1780, Brighton s'est pourvue de tous les attraits qui font la réputation des stations thermales d'Europe continentale. Pour séduire le beau monde, il lui a fallu se parer d'atours à la hauteur de ses ambitions.

Brighton prend véritablement son essor en 1786, lorsque le jeune prince régent décide de passer son temps libre, non pas à Londres, mais dans le cadre idyllique de la côte. Le futur George IV y fait l'acquisition d'une maison de campagne qu'il transforme en une somptueuse ville résidentielle au charme exotique, inspirée des palais des maharadjahs indiens. Bien sûr, l'héritier du trône draine toute la haute société dans son sillage. En vingt-cinq ans seulement, 635 nouvelles demeures sont érigées à Brighton qui, au début du XVIIIe siècle, ne comptait que 1 500 habitants. Le modeste village de pêcheurs devient une ville mondaine offrant tout le luxe et le confort de l'époque. Traités à l'eau de mer, froide et chaude, les curistes continuent toutefois à recevoir les soins sur la terre ferme. Rares sont ceux qui se baignent dans la mer. De toute façon, personne, ou presque, ne sait encore nager, d'autant que les costumes de bain d'usage, couvrant le corps des pieds à la tête, ne sont guère plus pratiques que les vêtements de ville.

À mesure que les plages de Brighton s'animent, un impérieux besoin d'hébergements et de distractions se fait sentir. Une promenade est aménagée sur la côte, bientôt suivie d'hôtels, restaurants, plusieurs théâtres, parcs de loisirs et jetées qui s'avancent dans la mer. Bâtie en 1823, Chain Pier, la première du genre, est suivie de West Pier et de Palace Pier, qui, aujourd'hui encore, reste emblématique de

la ville. Dès 1841, Brighton est reliée à Londres par le chemin de fer. À la fin du XIXe siècle, la ville attire des milliers de touristes : Dès mai et juin débarquent les petits-bourgeois londoniens, suivis, au cœur de l'été, par les médecins et hommes de loi, puis enfin, l'hiver, de la noblesse britannique lassée de l'agitation continentale.

Brighton demeurant une destination privilégiée par les aristocrates et les classes aisées, ouvriers et petits-bourgeois commencent, dès le milieu du XIXe siècle, à rechercher des villégiatures à l'atmosphère plus populaire, comme Blackpool, sur la mer d'Irlande. Au début des années 1840, cette ville côtière est devenue le point de chute des voyages en groupe organisés par les associations d'épargnes ouvrières.

l'eau à l'abri des regards indiscrets, à bord d'une charrette de bain pourvue de marches, qui peut avancer les baigneurs dans l'eau. Si la plage, au début, reste une transition entre la promenade et la mer, elle devient bientôt un lieu de détente à part entière, où fleurissent dais d'ombrage, châteaux de sable et corbeilles de plage.

En France, dès le milieu du XIXe siècle, les Parisiens fréquentent les luxueuses stations balnéaires créées de toutes pièces sur la côte normande, comme Deauville ou sa voisine, Trouville-sur-Mer. Le « royaume de l'élégance » que va devenir Deauville se développe sur une plaine de sable marécageuse qui, peu à peu, se peuple de villas de style néoroman, d'un hippodrome, d'hôtels de luxe, puis d'un casino

Dans le Nouveau Monde, stations thermales et balnéaires éclosent aussi, qui promettent aux vacanciers de se ressourcer, mais aussi de se divertir. Dès 1829, les riches New-Yorkais de Manhattan, dès qu'ils ont une journée libre, se précipitent à Coney Island, à une vingtaine de kilomètres à peine, sur la côte atlantique. Mais l'« île aux lapins » attire aussi bandits et prostituées. Aussi certains New-Yorkais préfèrent-ils prendre les bains à Asbury Park, le « joyau de la côte de Jersey », dans l'État voisin du New Jersey. Sur le modèle des jetées anglaises, les *piers*, les stations balnéaires américaines ont des *boardwalks*, et leurs parcs de loisirs, comme Lunapark, à Coney Island, n'ont rien à envier à ceux d'Angleterre. Ouvert en 1903, ce parc à attractions fera pendant un demi-siècle la joie de tous les vacanciers, riches et pauvres.

Au nord de New York, les grandes fortunes de la Nouvelle-Angleterre partent en villégiature à Newport. Aux portes de Boston s'étirent les plages du cap Cod, où ont débarqué les pères Pèlerins. Au-delà, Nantucket, l'île de baleiniers, et Martha's Vineyard, restent des fiefs de la haute société.

En Floride, Miami Beach s'impose moins auprès des vacanciers en quête de repos estival qu'auprès des riches Américains des États du Nord et de l'Est qui, depuis le début du XXe siècle, viennent y passer l'hiver.

Pendant ce temps-là, à l'ouest, la Californie connaît un essor rapide : la ruée vers l'or, alliée, enfin, à de meilleures liaisons avec les États du centre et de l'est du pays – tout cela fait l'effet d'un aimant sur l'économie et les hommes. Dans le show-business, après Broadway et ses comédies musicales, à New York, les années 1920 voient émerger Hollywood et son industrie du cinéma. En outre, à la douceur du climat californien s'ajoutent des plages de rêve. Ainsi la côte ouest devient-elle une destination de prédilection à la fois pour les habitants de la région et pour les touristes, surtout quand le surf, venu d'Hawaii, devient un sport de masse.

« BAIGNEZ-VOUS ! DORMEZ ! PRIEZ ! »

SAINT THOMAS D'AQUIN

Le succès de la thalassothérapie en Angleterre ne tarde pas à gagner le continent, à commencer par l'Allemagne et la France. Le premier document attestant de la pratique des bains de mer en Allemagne remonte à 1783 : il est signé de la main du prêtre de l'île de Juist, Gerhard Otto Christoph Janus, qui envoie au roi de Prusse Frédéric II une requête proposant d'aménager un bain de mer sur cette petite île de la mer du Nord. Il faudra toutefois attendre 1793 pour que soient inaugurés les premiers bains de mer du pays, à Heiligendamm, sur la Baltique. En mer du Nord, le premier établissement thermal ouvrira en 1797 à Norderney.

Peu à peu, les curistes se risquent dans les vagues. Dans un premier temps, femmes et hommes se baignent séparément. Au début du XXe siècle, il faut encore revêtir une combinaison très couvrante pour entrer dans

qui attire sur la côte de la Manche toute la haute société parisienne et internationale. Le dernier empereur de France, Napoléon III, compte parmi les habitués de cette côte Fleurie. Dès 1863, ces villégiatures sont reliées à la capitale par un chemin de fer rapide et confortable, qui explique leur succès.

En France, comme en Italie, la riviera voit, elle aussi, exploser des stations balnéaires comme Menton, Cannes ou Monte-Carlo, haut lieu de la société mondaine, suivies de Vintimille, Alassio et San Remo. À Nice, la promenade des Anglais s'inspire des villes balnéaires d'outre-Manche, dans l'intention d'attirer en priorité les aristocrates et les grandes fortunes d'Angleterre. Rien ne pouvant rivaliser avec la douceur du climat méditerranéen, ceux-ci ne s'y sont pas trompés, dont la fidélité, en cent cinquante ans, ne s'est jamais démentie.

KINGS AND EMPERORS TAKING A COURSE OF TREATMENT

Opposite: View of the spa resort in Bad Ems, circa 1890.
Above: A glass with the king. British Monarch Edward VII in the Bohemian spa town of Marienbad, 1909.

KÖNIGE UND KAISER AUF KUR

Links: Blick auf das „Weltbad" Bad Ems, um 1890;
oben: Auf ein Glas mit dem König. Der britische Monarch Edward VII. im böhmischen Marienbad, 1909

ROIS ET EMPEREURS EN CURE THERMALE

Ci-contre : panorama sur Bad Ems les « bains du monde », vers 1890 ;
ci-dessus : prendre un verre avec le roi. Le souverain britannique Édouard VII à Marienbad, en Bohème, 1909

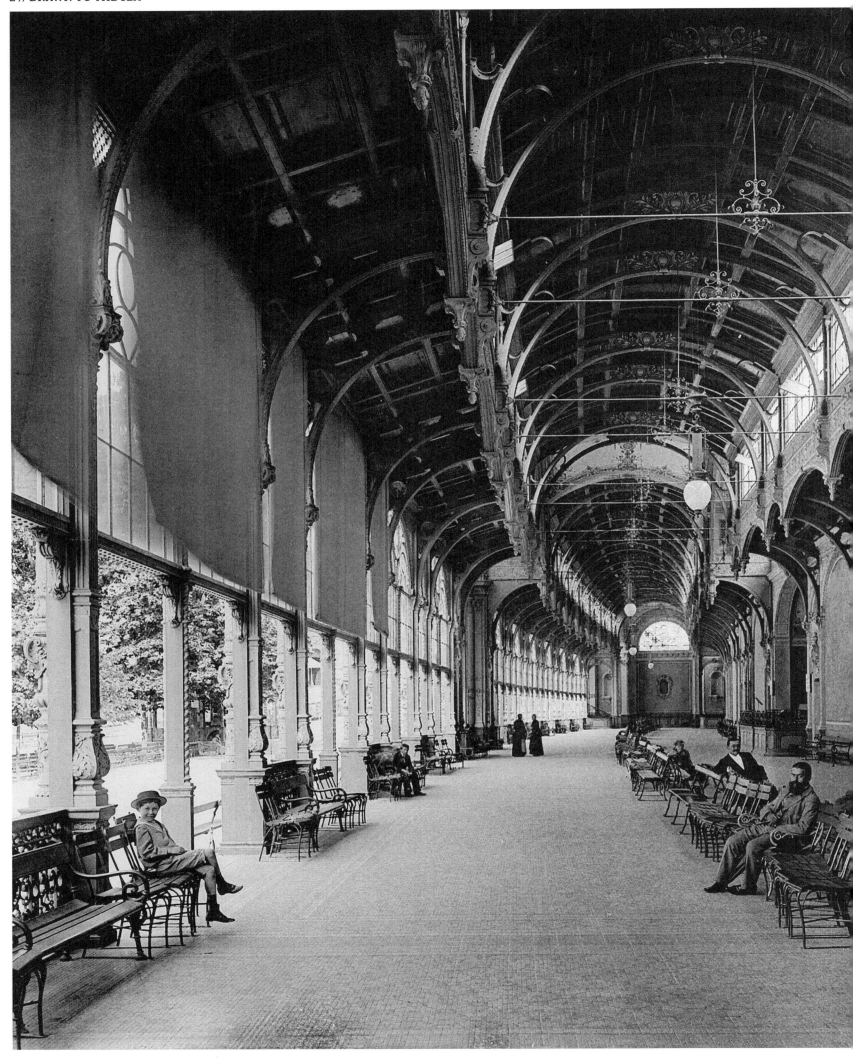

THE HEALTH CONSCIOUS

Opposite: The colonnade in Marienbad, 1897.
Below: Mineral spring in Carlsbad, Bohemia, 1915.

GESUNDHEITSBEWUSSTE

Links: Die Kolonnade in Marienbad, 1897;
unten: Heilquelle in Karlsbad, Böhmen, 1915

SE REFAIRE UNE SANTÉ

Ci-contre : la colonnade de Marienbad, 1897 ;
ci-dessus : source thermale à Karlsbad, en Bohème, 1915

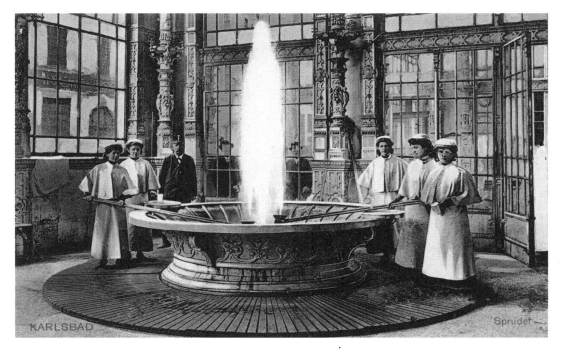

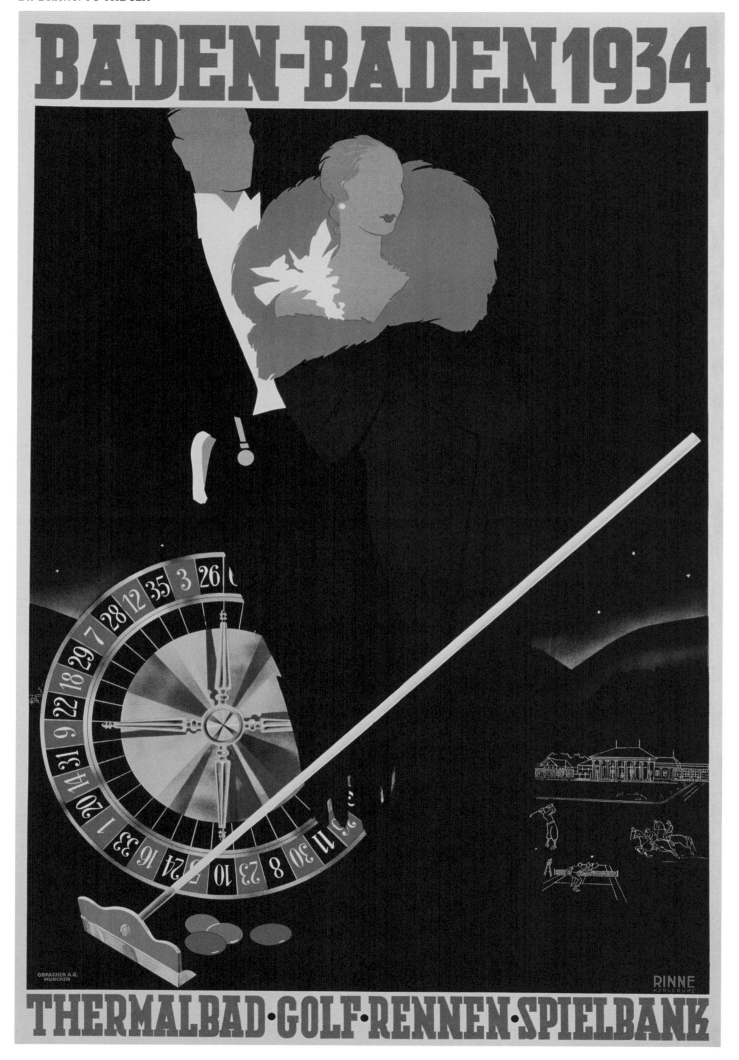

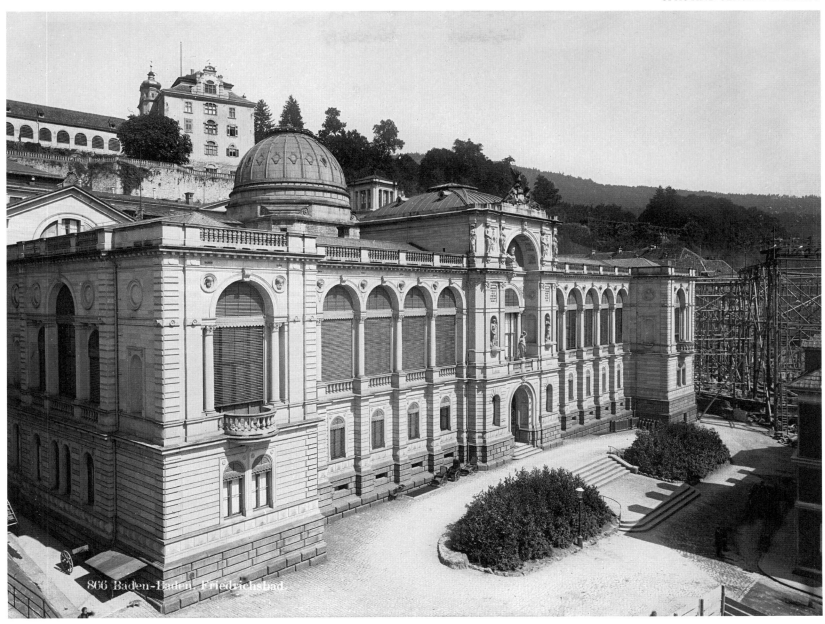

866 Baden-Baden. Friedrichsbad.

THE SUMMER CAPITAL OF EUROPE

Opposite: Due to a prohibition on gambling, the popular casino in Baden-Baden was closed for over sixty years and was not reopened until 1933.
Above: The Friedrichsbad in Baden-Baden, 1895.

DIE SOMMERHAUPTSTADT EUROPAS

Links: Das beliebte Casino von Baden-Baden war wegen Glücksspielverbot über 60 Jahre geschlossen und wurde erst 1933 wiedereröffnet;
oben: Das Friedrichsbad in Baden-Baden, 1895

LA CAPITALE D'ÉTÉ DE TOUTE L'EUROPE

Ci-contre : le casino très couru de Baden-Baden, fermé pendant soixante ans après l'interdiction des jeux d'argent, ne rouvre qu'en 1933 ;
ci-dessus : l^{es} thermes Friedrichsbad, à Baden-Baden, portent le nom du grand-duc Frédéric I^{er}, 1895

LONDON ON THE SEA

Opposite: Bathhouse of Sake Dean Mahomed, referred to as "Dr. Brighton," who brought Bengali massage therapies to England, around 1820.
Following pages: The new sea promenade on Kings Road, view from West Pier to the Metropole Hotel and the Grand Brighton Hotel, 1895.

LONDON AN DER SEE

Rechts: Badehaus von Sake Dean Mahomed, genannt „Dr. Brighton", der bengalische Massagebehandlungen nach England brachte, um 1820
Seite 42/43: Die neue Strandpromenade an der Kings Road, Blick vom West Pier auf das Metropole Hotel und das Grand Brighton Hotel, 1895

LONDRES-SUR-MER

Ci-contre : l'établissement thermal de l'Indien Sake Dean Mahomed, alias « Dr Brighton », qui introduisit le massage thérapeutique en Angleterre, vers 1820
Pages 42-43 : à Brighton, la toute nouvelle promenade de la plage longe Kings Road ; vue de West Pier sur les hôtels Metropole et Grand Brighton, 1895

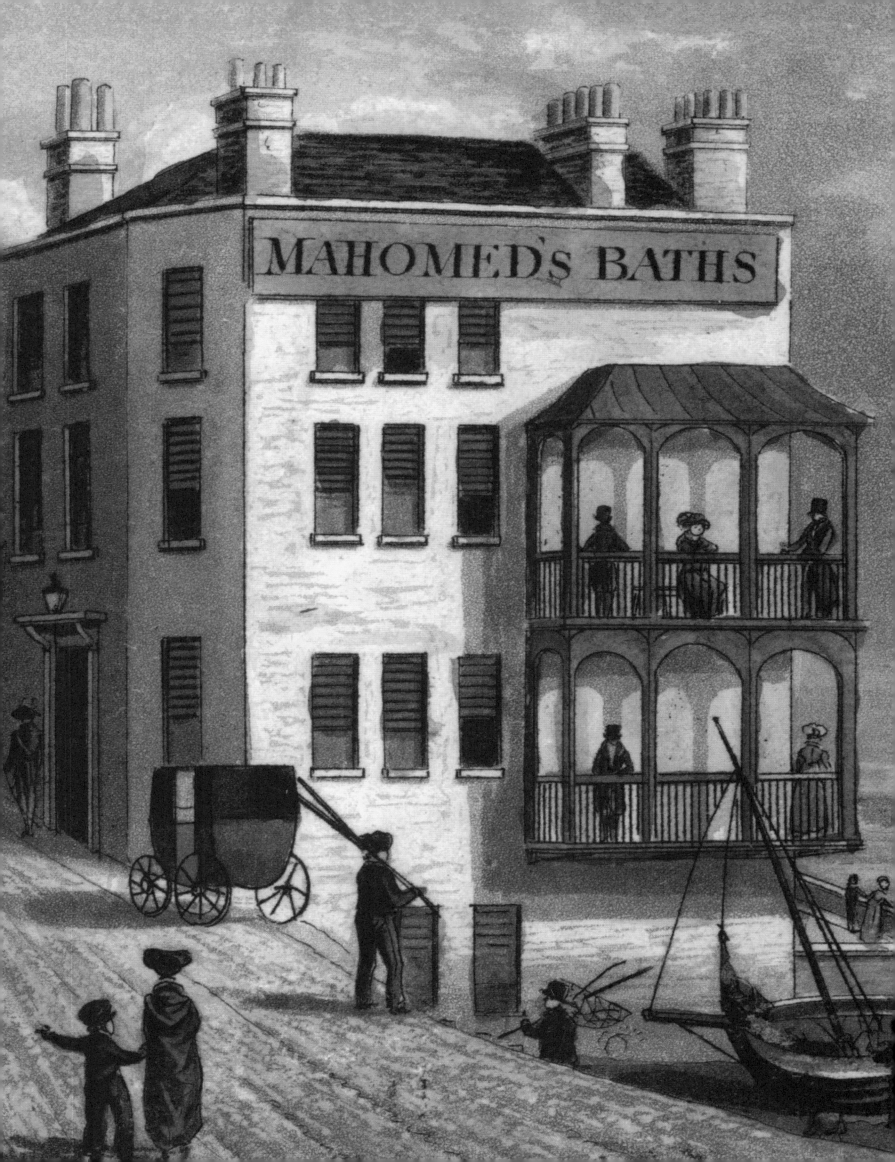

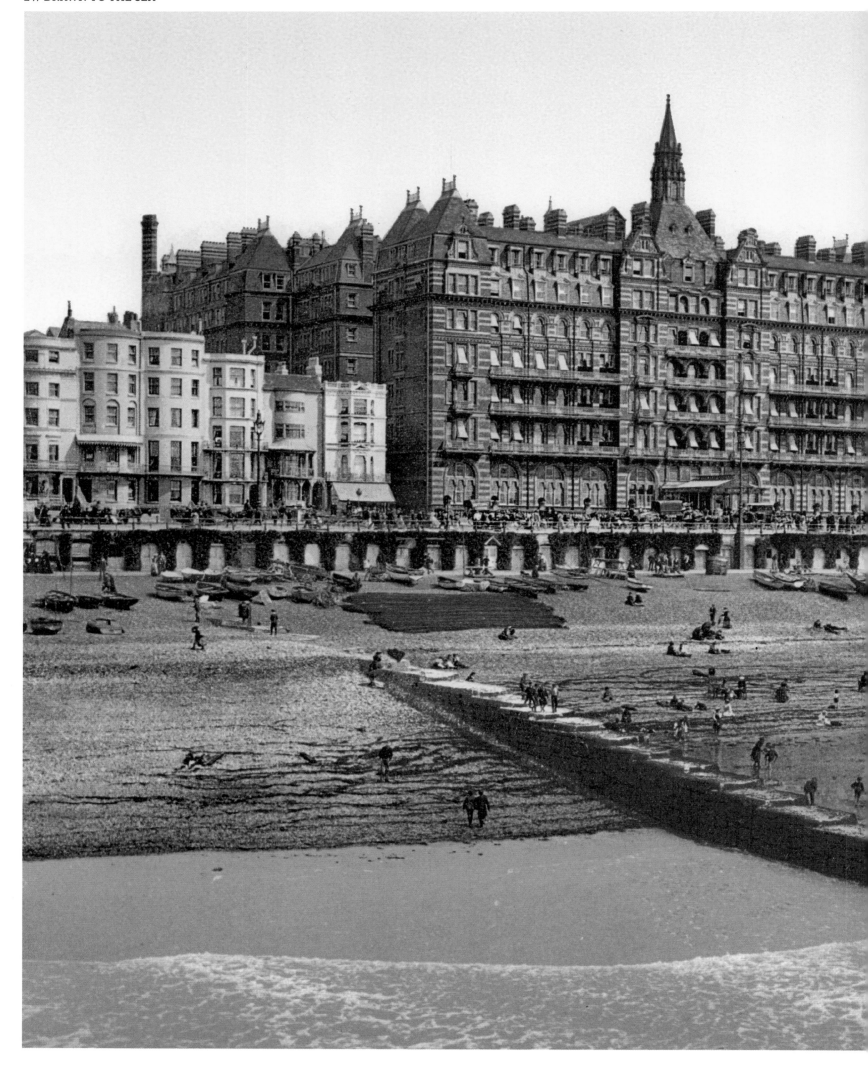

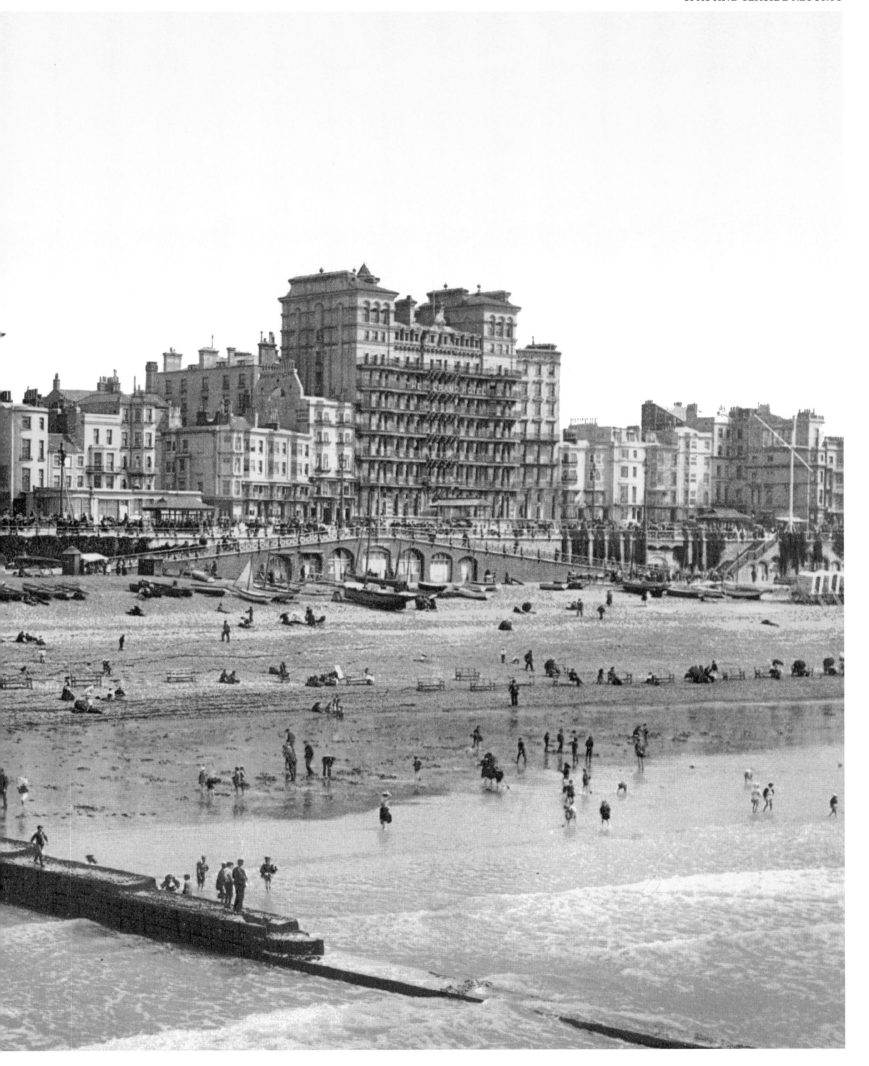

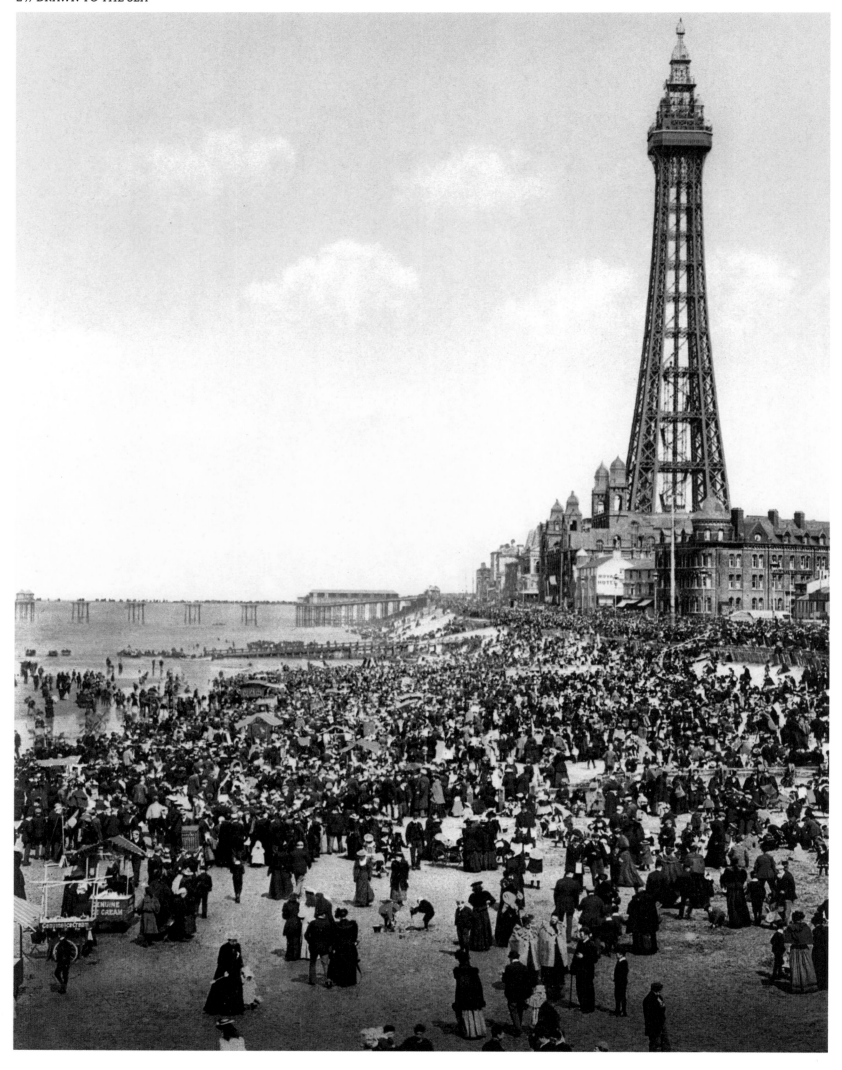

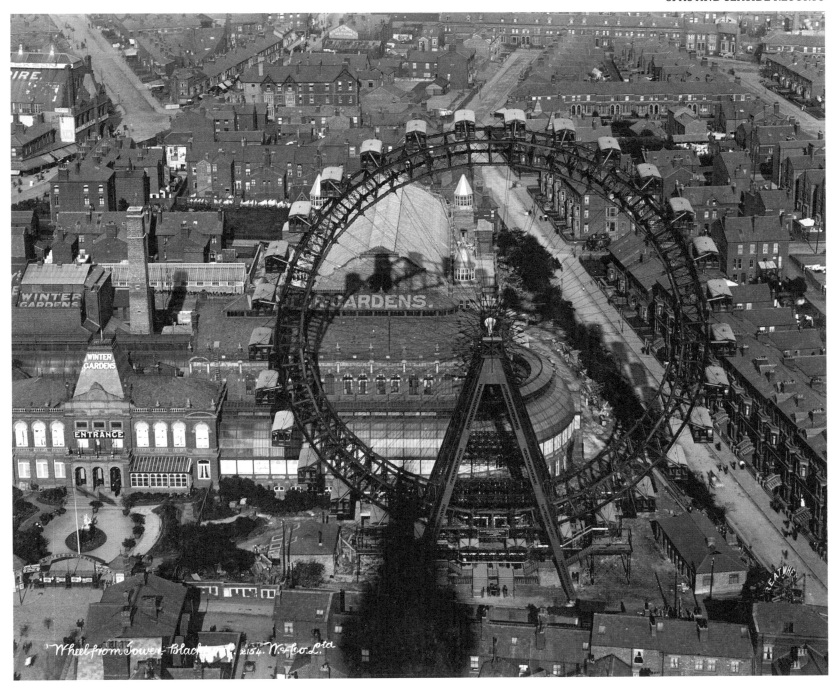

AMUSEMENT PARK

Opposite: Inspired by the Eiffel Tower, Blackpool Tower with the North Pier of Blackpool in the background, circa. 1900.
Above: The Joy Wheel, an early attraction at the Blackpool Pleasure Beach amusement park, circa 1910.
Following pages: German vacation furniture. Early versions of the beach chair on Norderney, 1890s.

VERGNÜGUNGSPARK

Links: Vorbild Eiffelturm – der Blackpool Tower mit dem North Pier von Blackpool im Hintergrund, um 1900;
oben: Das Joy Wheel, eine frühe Attraktion im Vergnügungspark Blackpool Pleasure Beach, um 1910
Seite 46/47: Ein deutsches Urlaubsmöbel. Frühform des Strandkorbes auf Norderney, 1890er-Jahre

PARCS DE LOISIRS

Ci-contre : une reproduction de la tour Eiffel – la tour de Blackpool sur la toile de fond du North Pier de Blackpool, vers 1900 ;
ci-dessus : la grande roue, l'une des premières attractions du parc Blackpool Pleasure Beach, vers 1910
Pages 46-47 : l'ancêtre de la corbeille de plage, un incontournable en Allemagne, à Norderney, dans les années 1890

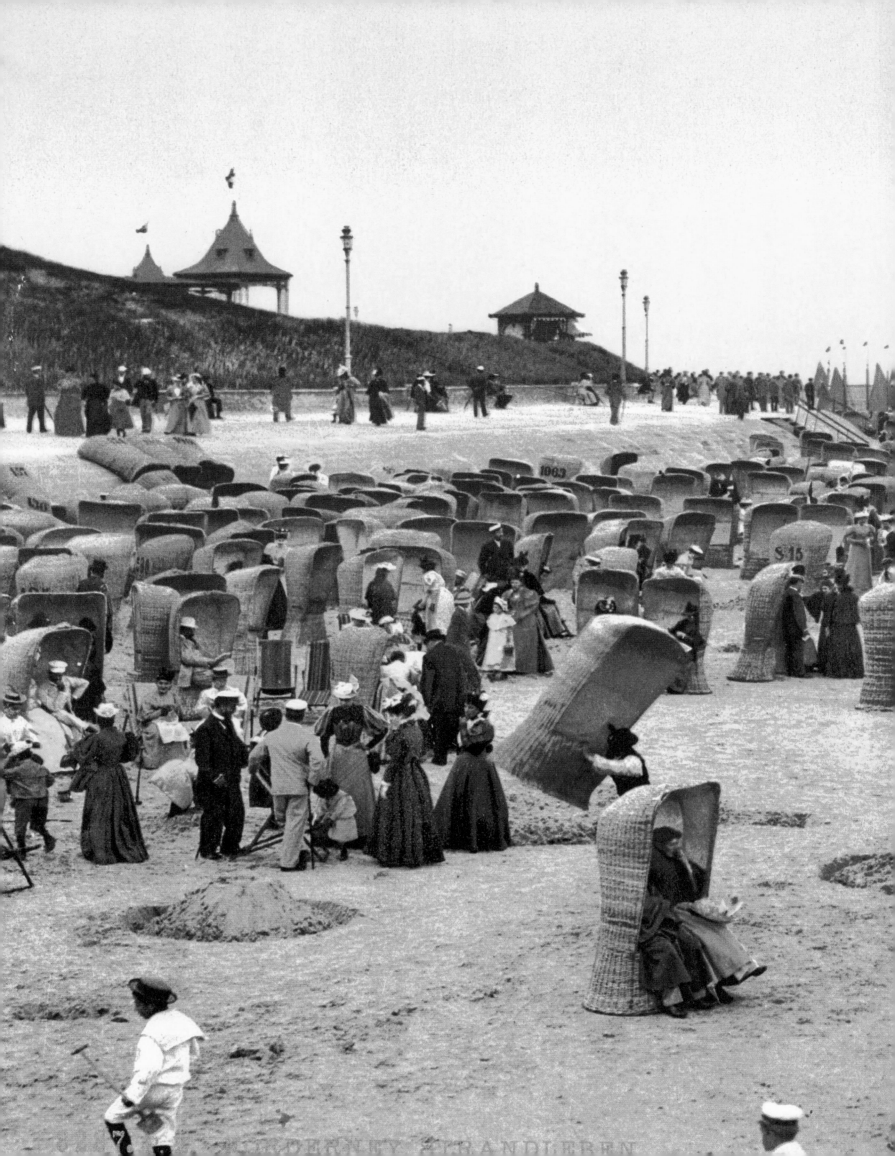

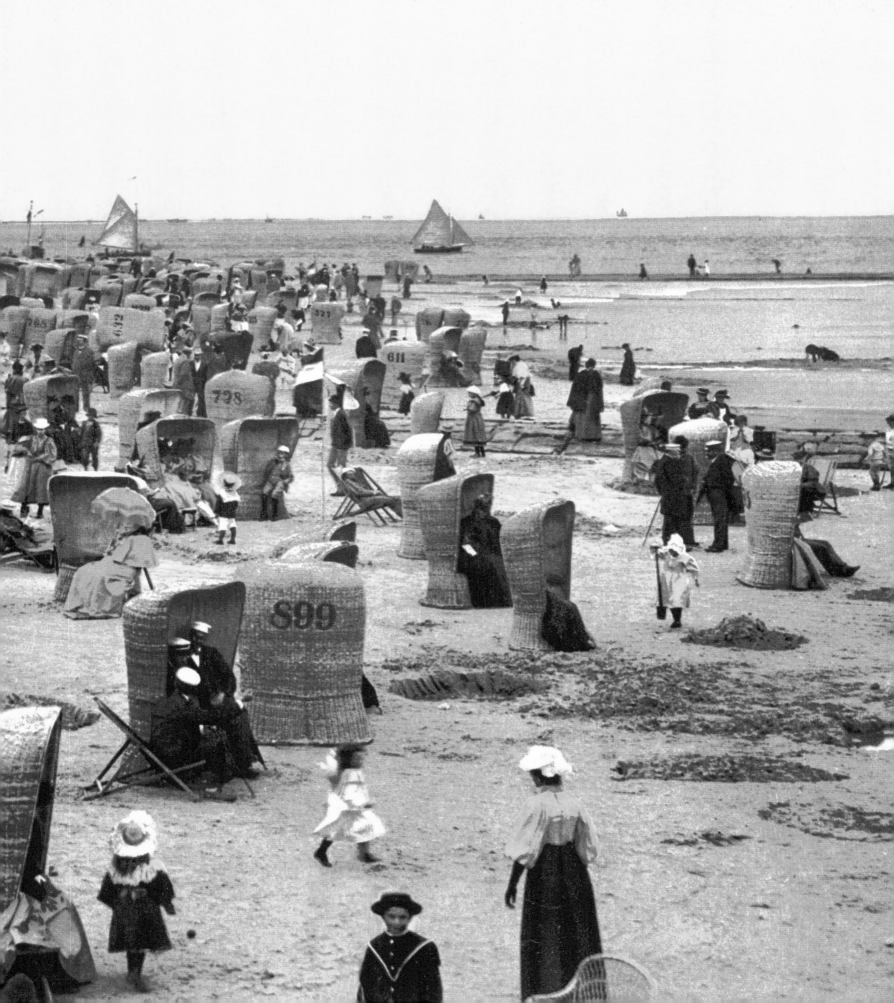

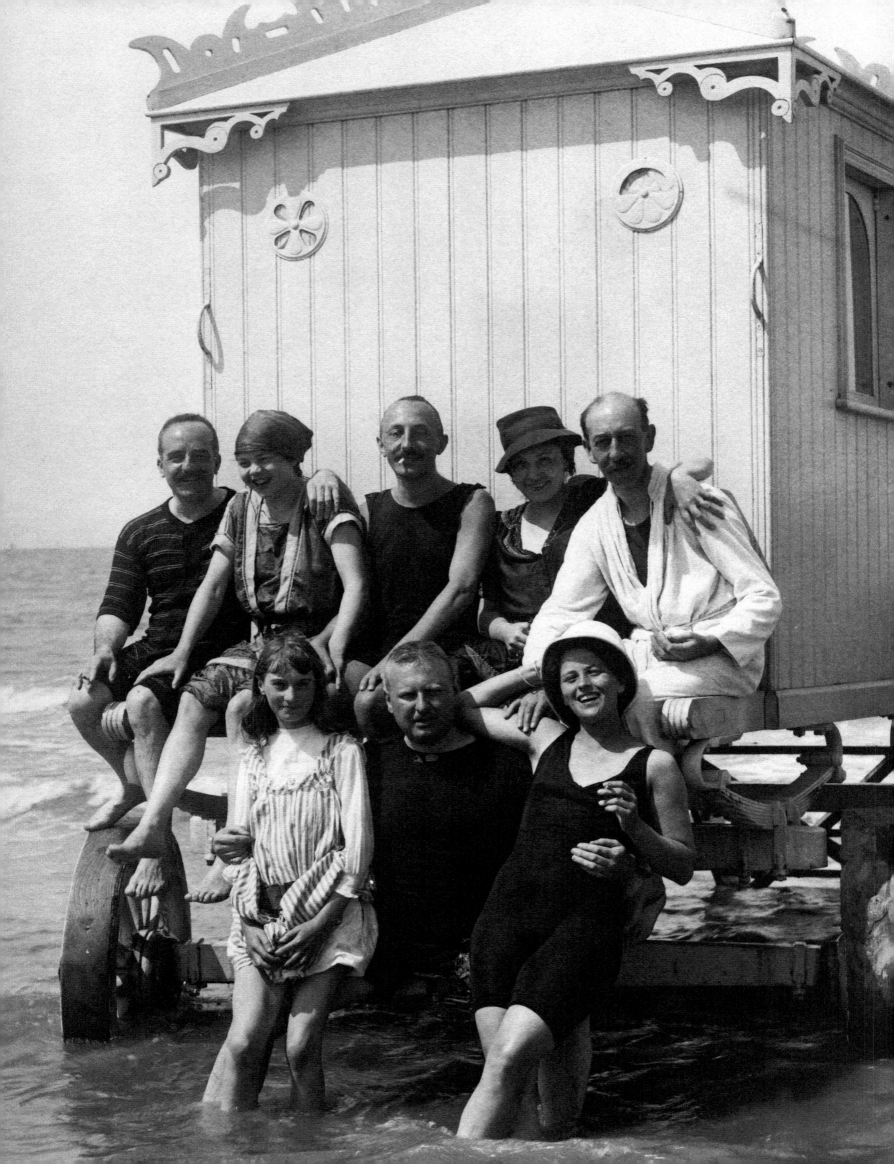

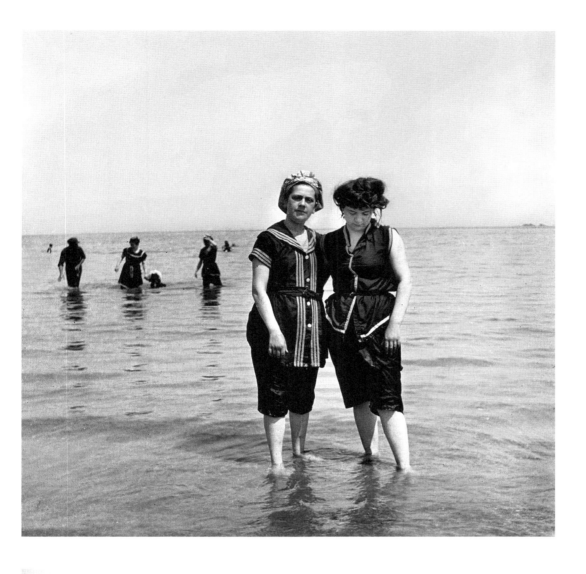

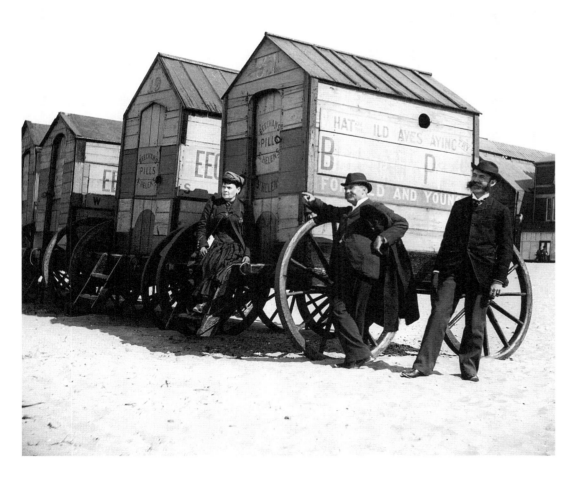

EUROPEAN BATHING PLEASURE

Opposite: Summer vacationers in front of a bathing machine on the German North Sea coast, 1913.
Above: French two-piece swimsuit, circa 1900.
Below: Bathing machine in New Brighton near Liverpool, 1895.
Following pages: Development of a seaside resort in France. Beach at Trouville-sur-Mer, circa 1890.
Pages 52–53: English influence. The Jetée promenade in Nice, circa 1895.

EUROPÄISCHE BADEFREUDEN

Links: Sommergesellschaft vor einem Badewagen an der deutschen Nordseeküste, 1913;
oben: Französische Badezweiteiler, um 1900;
unten: Badewagen in New Brighton bei Liverpool, 1895
Seite 50/51: Französischer Badeort im Bau.
Strand von Trouville-sur-Mer, um 1890
Seite 52/53: Englischer Einfluss.
Die Jetée-Promenade in Nizza, um 1895

BAINS DE MER À L'EUROPÉENNE

Ci-contre : vacanciers devant une charrette de bain sur la côte de la mer du Nord, en Allemagne, 1913 ;
en haut : maillots deux-pièces français, vers 1900 ;
en bas : charrettes de bain à New Brighton, près de Liverpool, 1895
Pages 50-51 : une station balnéaire en devenir.
Plage de Trouville-sur-Mer, vers 1890
Pages 52-53 : influences anglaises. La jetée-promenade de Nice, vers 1895

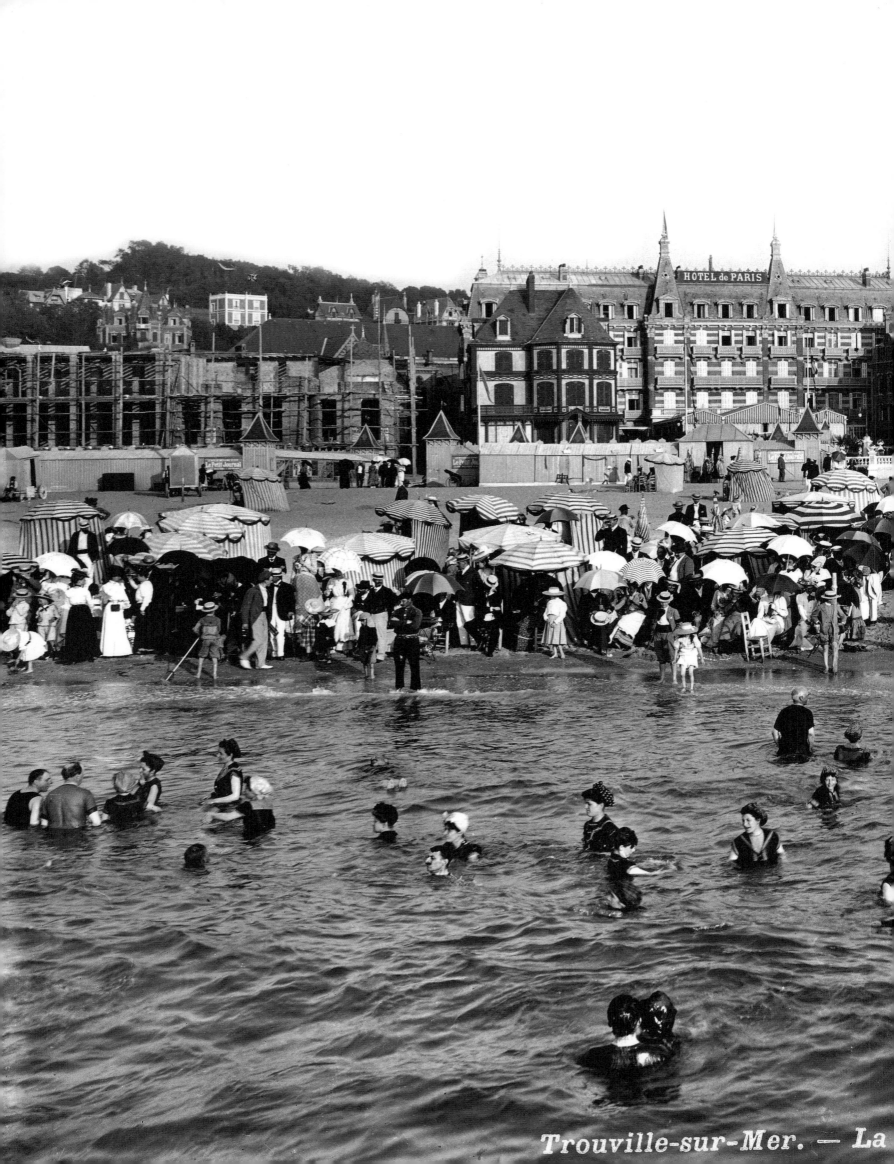

Trouville-sur-Mer. — La

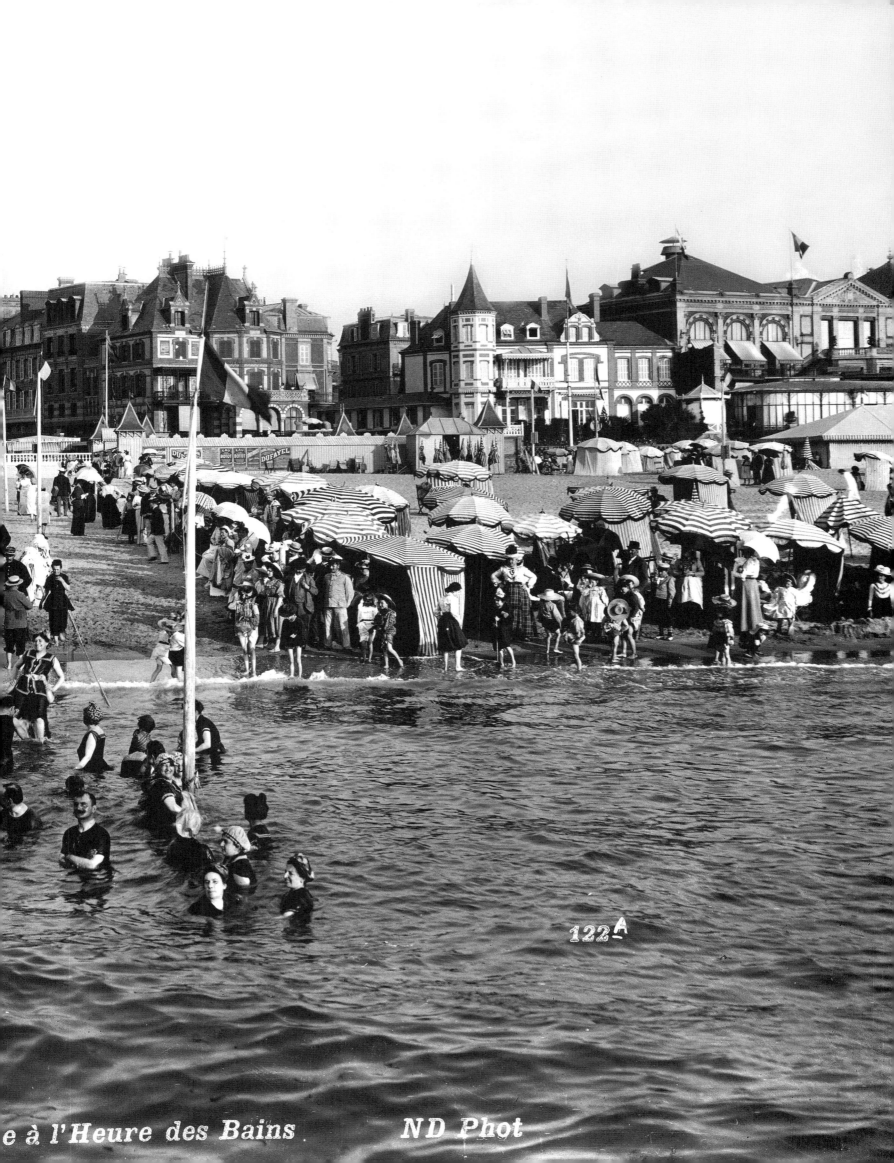

...e à l'Heure des Bains ND Phot

122A

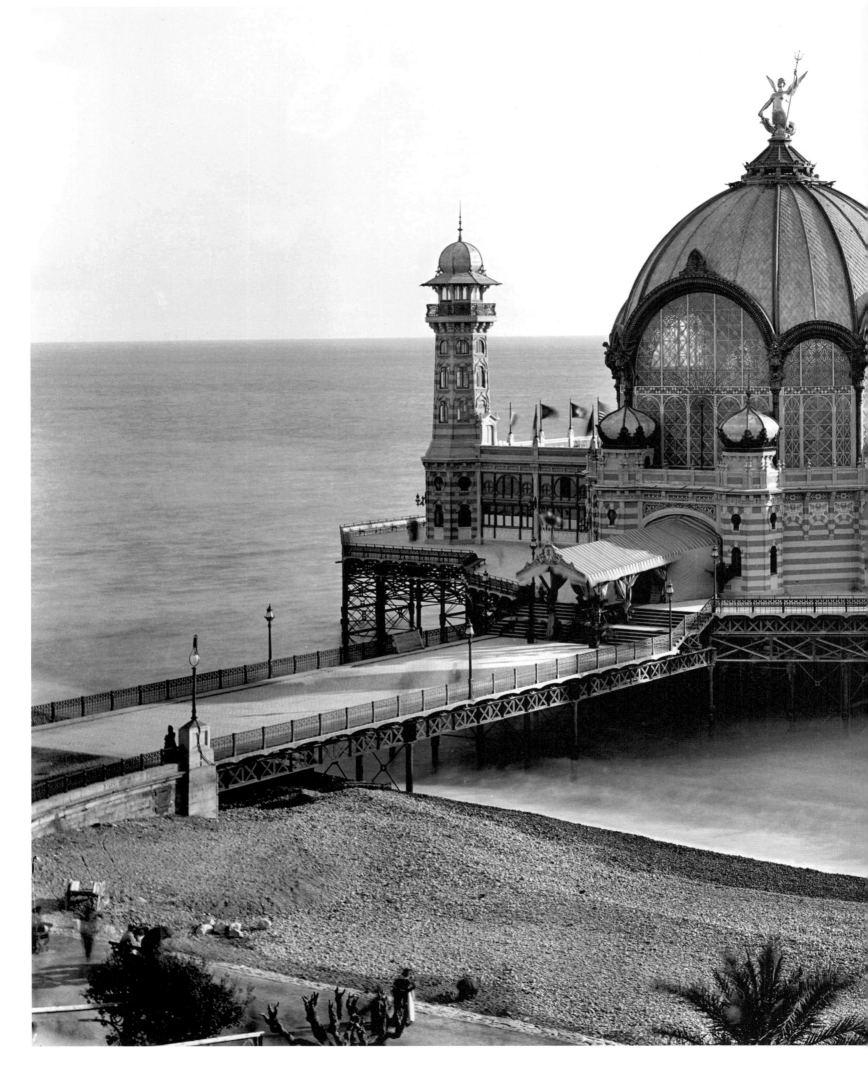

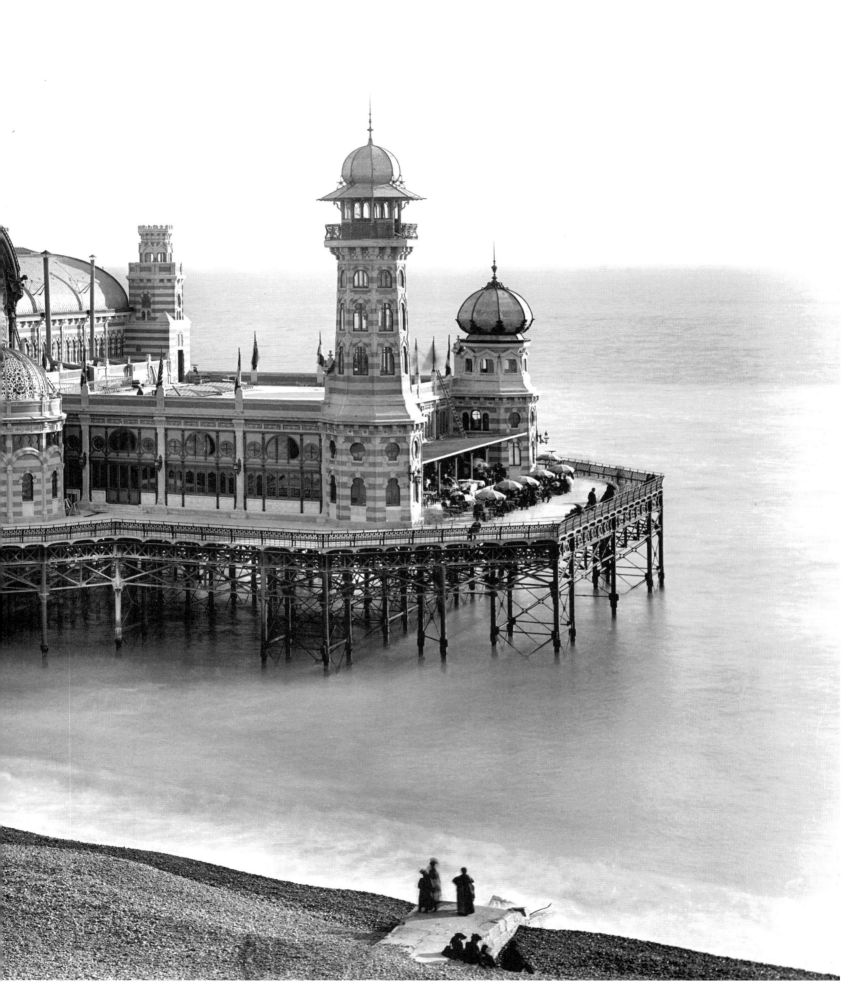

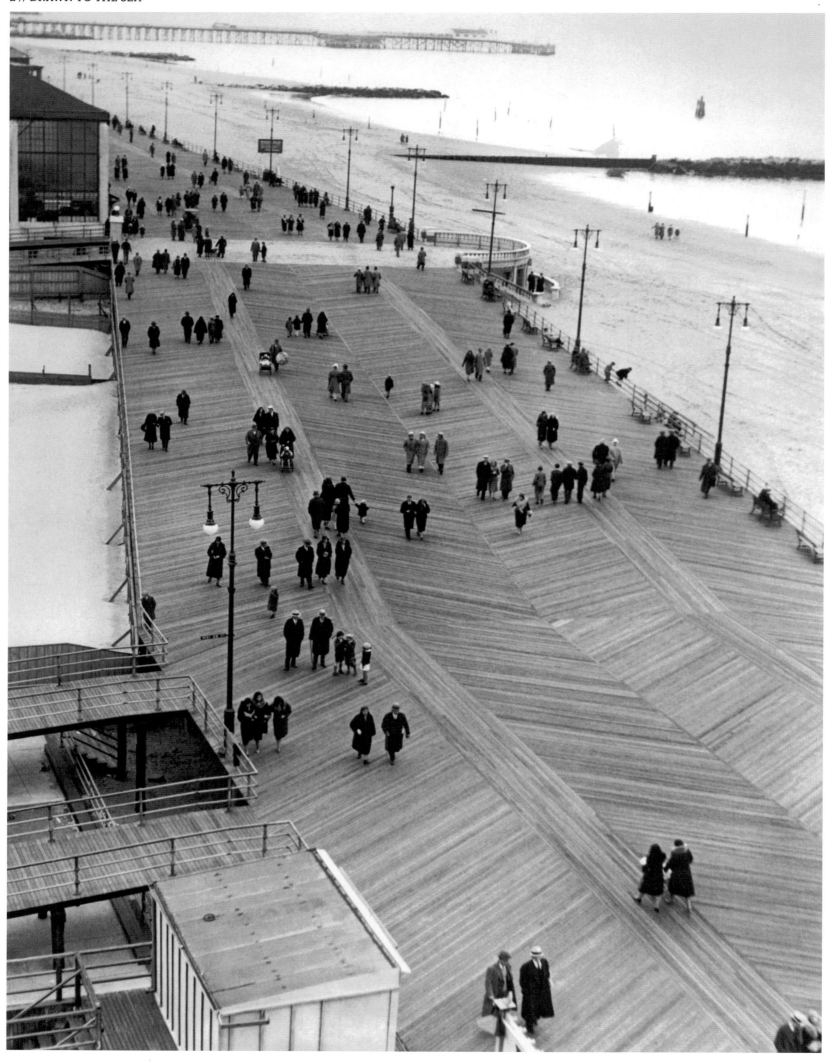

NEW YORK'S BATHTUB

Opposite: The beach isn't everything. Sunday walkers on the Coney Island boardwalk, 1927.
Above: Entrance to Luna Park, 1920s.
Following pages: Room to stretch out on the beach was in very short supply at Coney Island. In the background, the rides at Luna Park, 1940s.

NEW YORKS BADEWANNE

Links: Der Strand ist nicht alles. Sonntagsspaziergänger auf dem Boardwalk von Coney Island, 1927;
oben: Eingang zum Luna Park, 1920er-Jahre
Seite 56/57: Liegeplätze waren Mangelware am Strand von Coney Island. Im Hintergrund Fahrgeschäfte des Luna Parks, 1940er-Jahre

LA BAIGNOIRE DE NEW YORK

Ci-contre : la plage n'est pas tout. Promeneurs du dimanche sur la passerelle de Coney Island, 1927 ;
ci-dessus : l'entrée de Luna Park dans les années 1920
Pages 56-57 : les places sont chères sur la plage de Coney Island. En toile de fond, les manèges de Luna Park, dans les années 1940

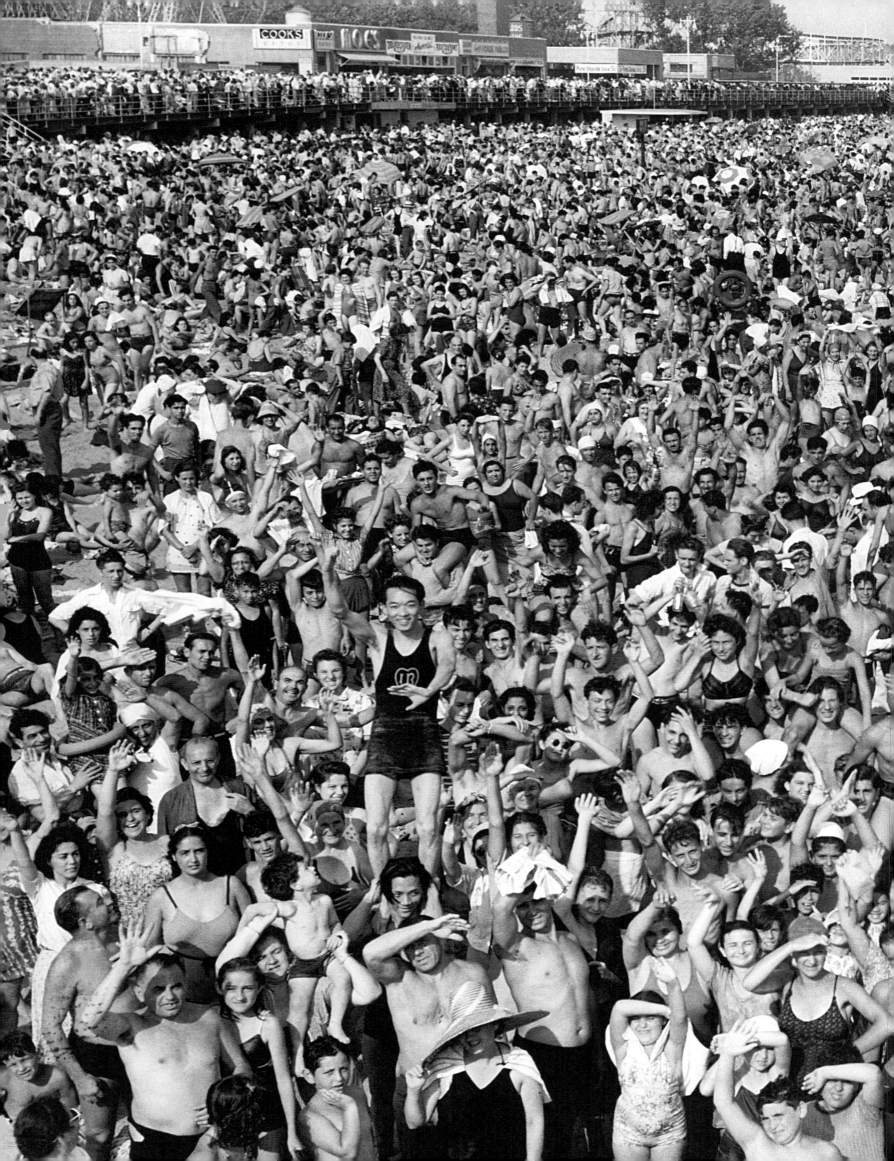

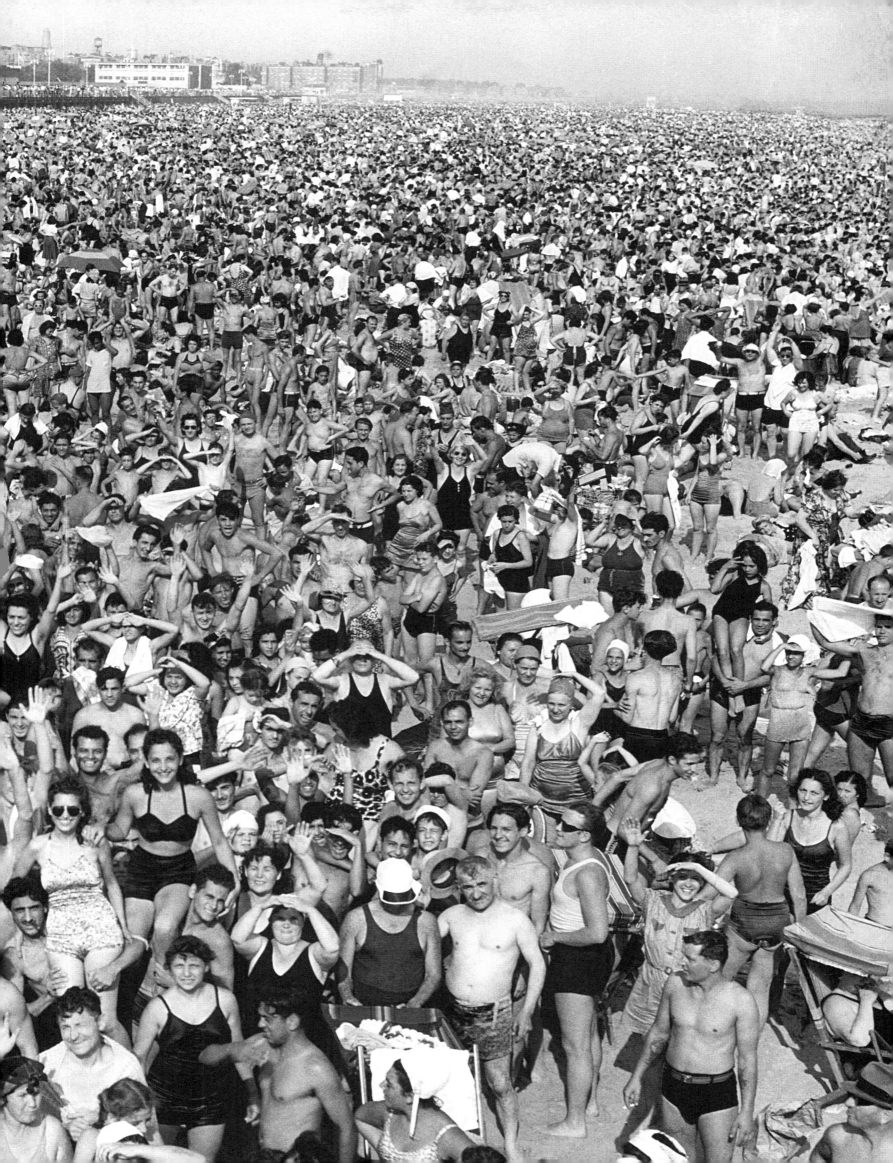

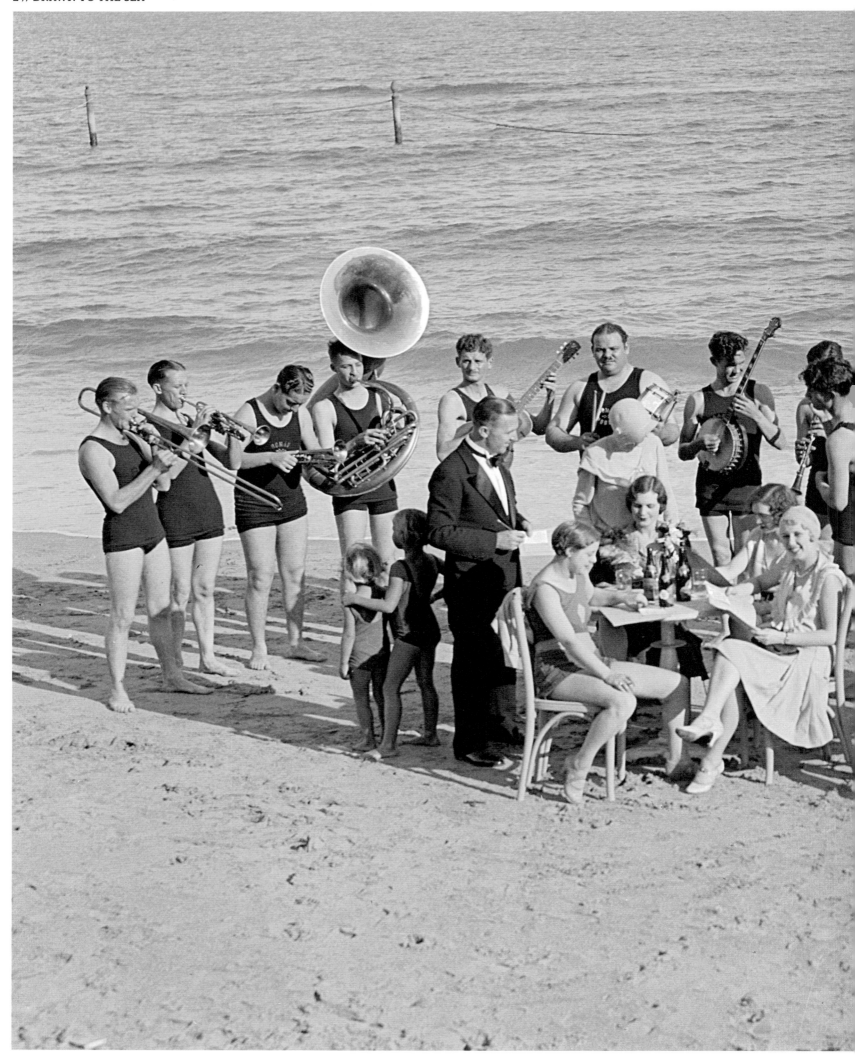

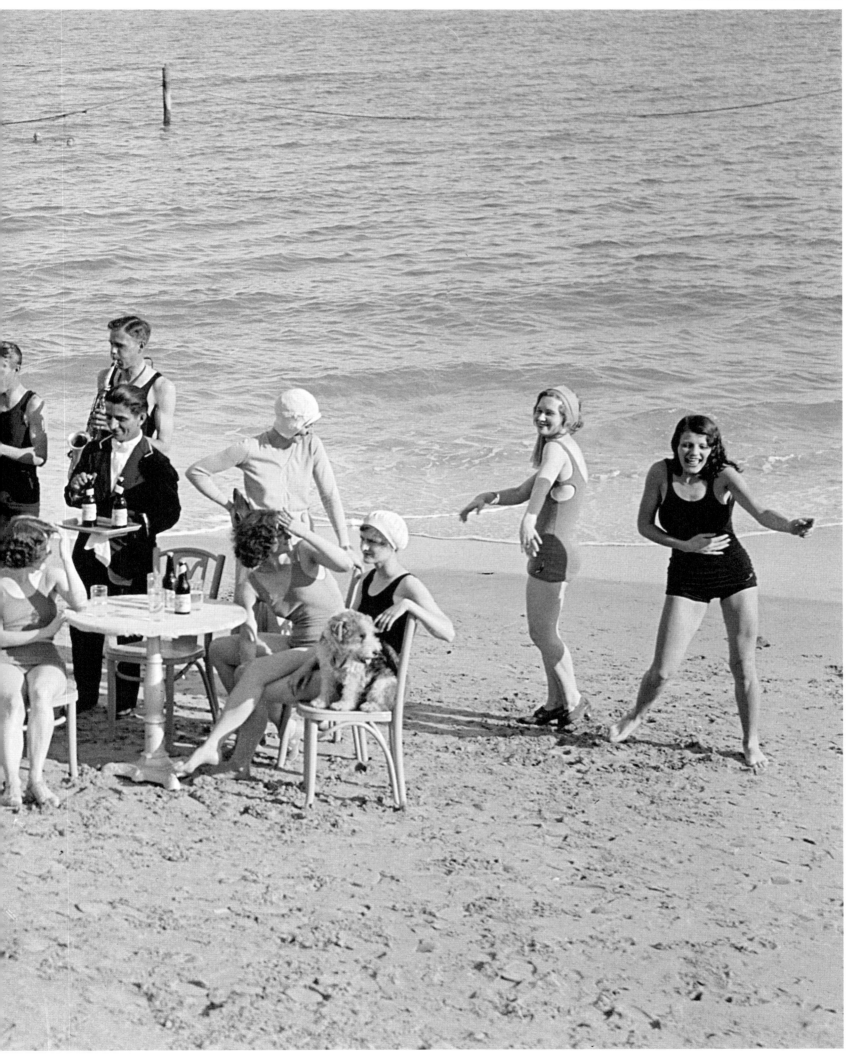

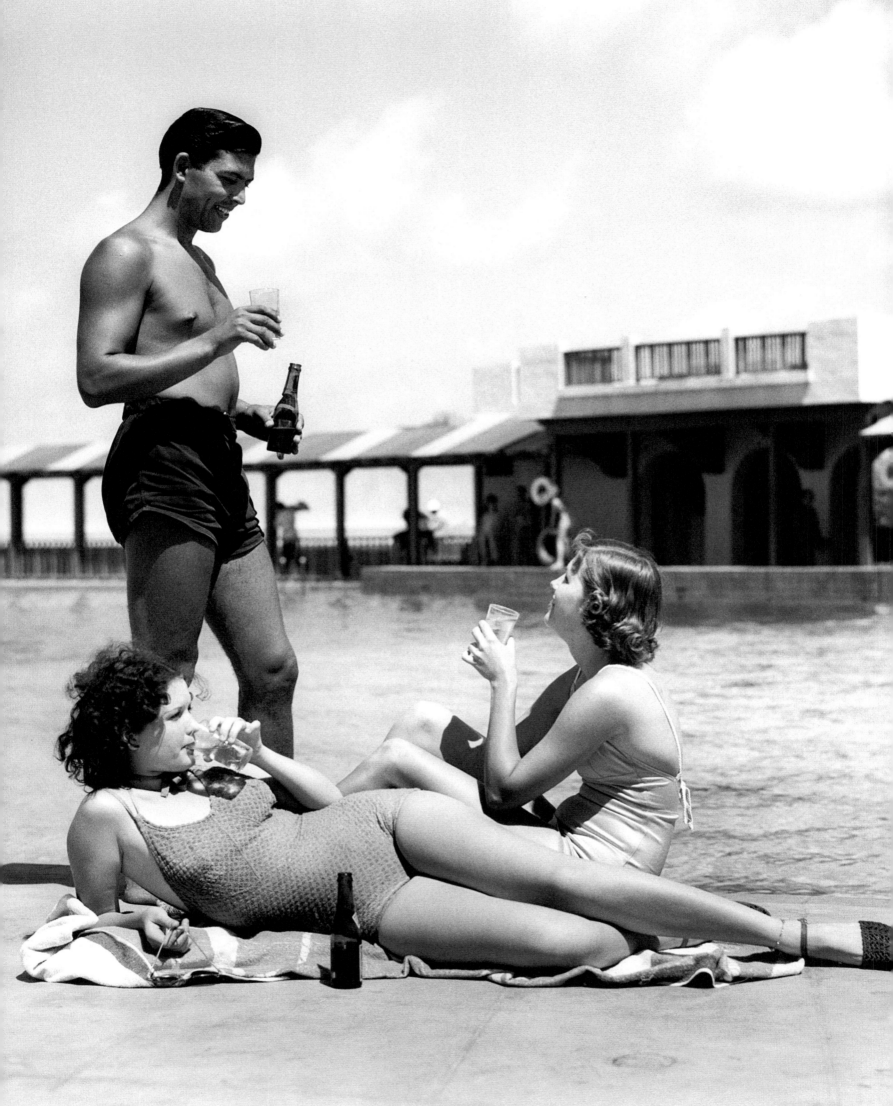

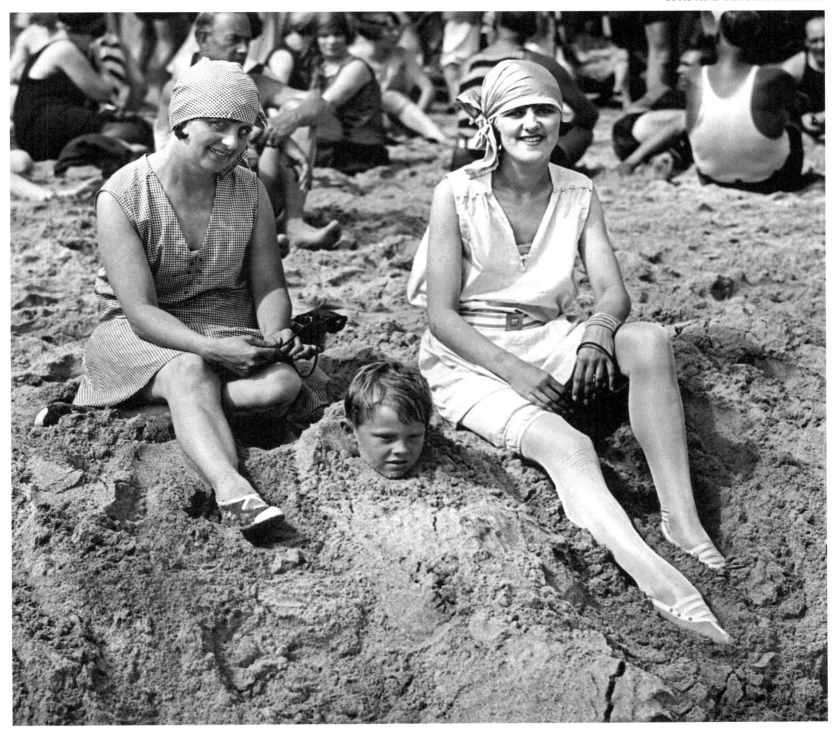

FLAPPERS IN FLORIDA

Previous pages: Jazz party in Miami Beach, 1930.
Opposite: Refreshments by the swimming pool, Florida, 1930s.
Above: On the beach at Miami Beach, 1925.

FLAPPERS IN FLORIDA

Seite 58/59: Jazzparty in Miami Beach, 1930
Links: Erfrischungen am Swimmingpool, Florida, 1930er-Jahre;
oben: Am Strand von Miami Beach, 1925

JEUNES GENS DANS LE VENT EN FLORIDE

Pages 58-59 : concert de jazz à Miami Beach, 1930
Ci-contre : un rafraîchissement au bord de la piscine, en Floride dans les années 1930 ;
ci-dessus : sur la plage de Miami Beach, 1925

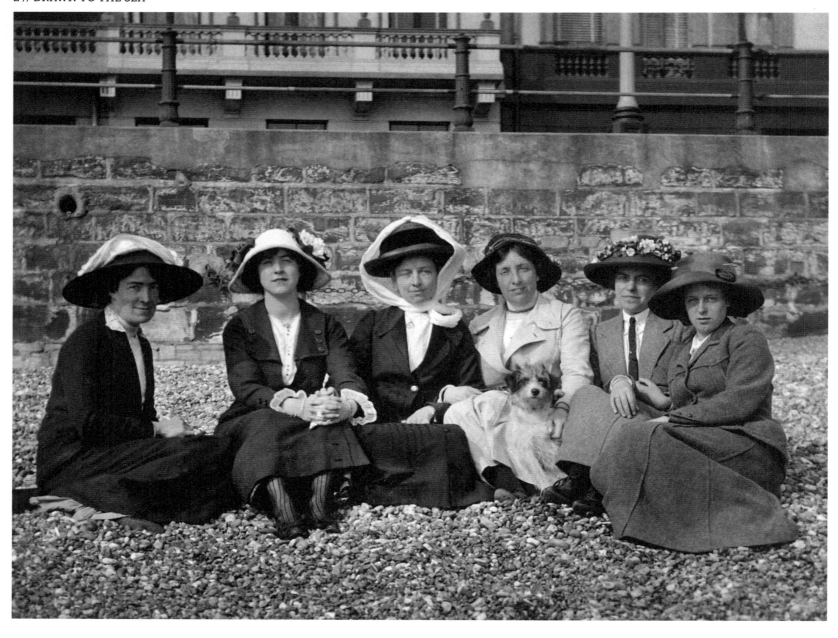

CHANGING SWIMWEAR

Above: Women with a dog on the beach at Brighton, 1905.
Opposite: American bathing beauties, 1950s.

STRANDMODEN IM WANDEL

Oben: Damen mit Hund am Strand von Brighton, 1905;
rechts: Amerikanische Badenixen, 1950er-Jahre

LA MODE DE PLAGE ÉVOLUE

Ci-dessus : dames avec chien sur la plage de Brighton, 1905 ;
ci-contre : naïades des années 1950 aux États-Unis

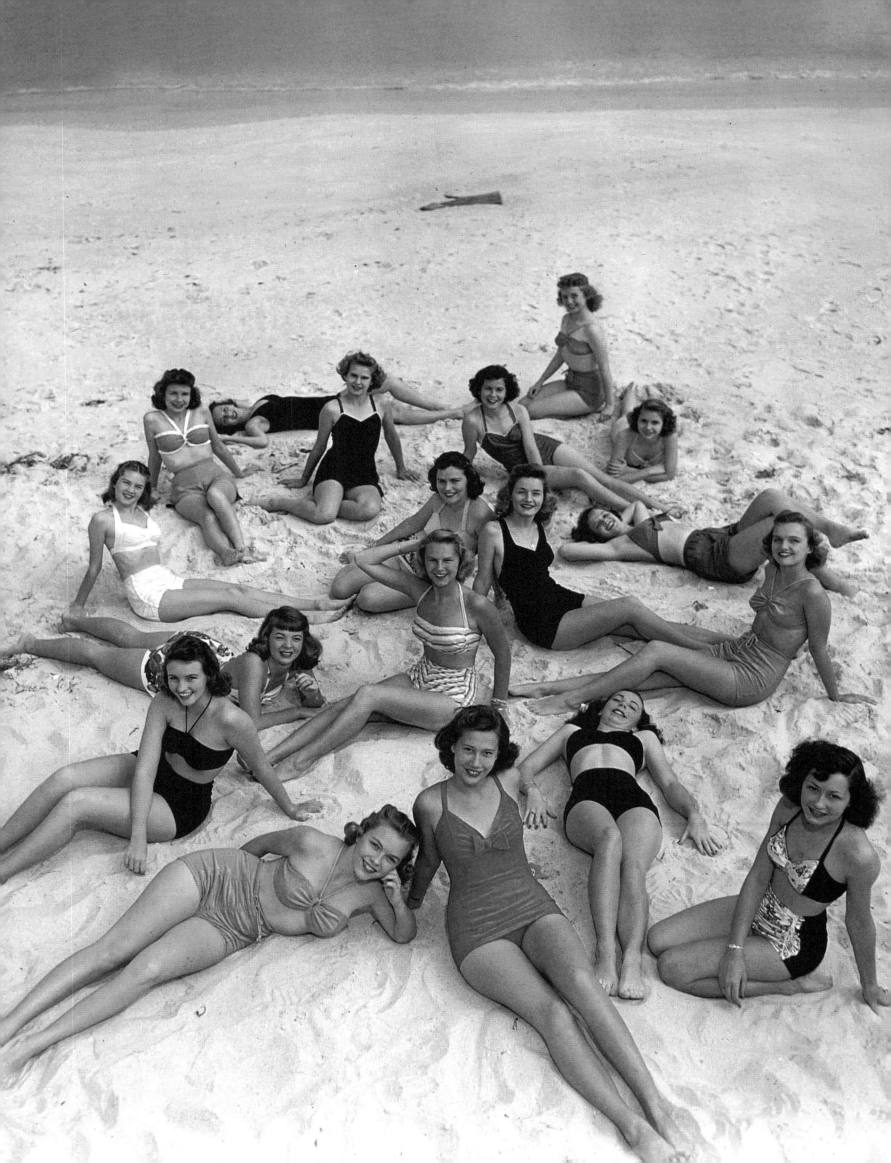

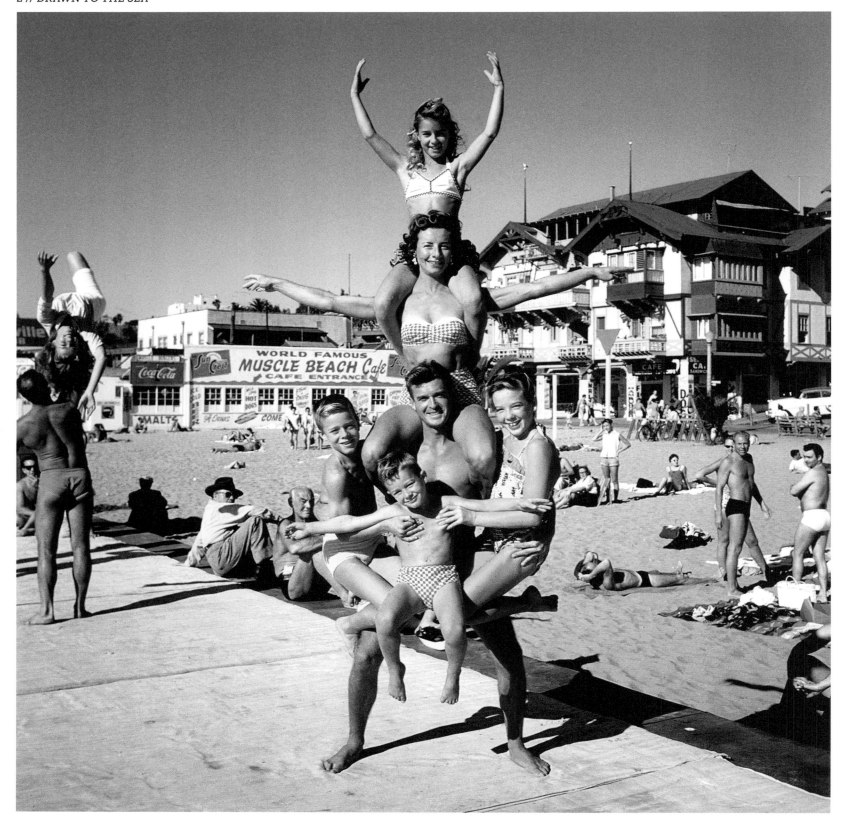

CALIFORNIA BEACH GAMES

Above: Family pyramid at Muscle Beach, Santa Monica, 1956.
Opposite: Surfer in Los Angeles, 1949.
Following pages: California beach boys and surfer girls, 1960s.

KALIFORNISCHER STRANDSPORT

Oben: Familienpyramide an der Muscle Beach in Santa Monica, 1956;
rechts: Surferin in Los Angeles, 1949
Seite 66/67: Kalifornische Beach Boys und Surfer Girls, 1960er-Jahre

SPORTS DE PLAGE EN CALIFORNIE

Ci-dessus : pyramide familiale à Muscle Beach, la plage de Santa Monica, 1956 ;
ci-contre : surfeuse à Los Angeles, 1949
Pages 66-67 : surfeuses et beach boys californiens dans les années 1960

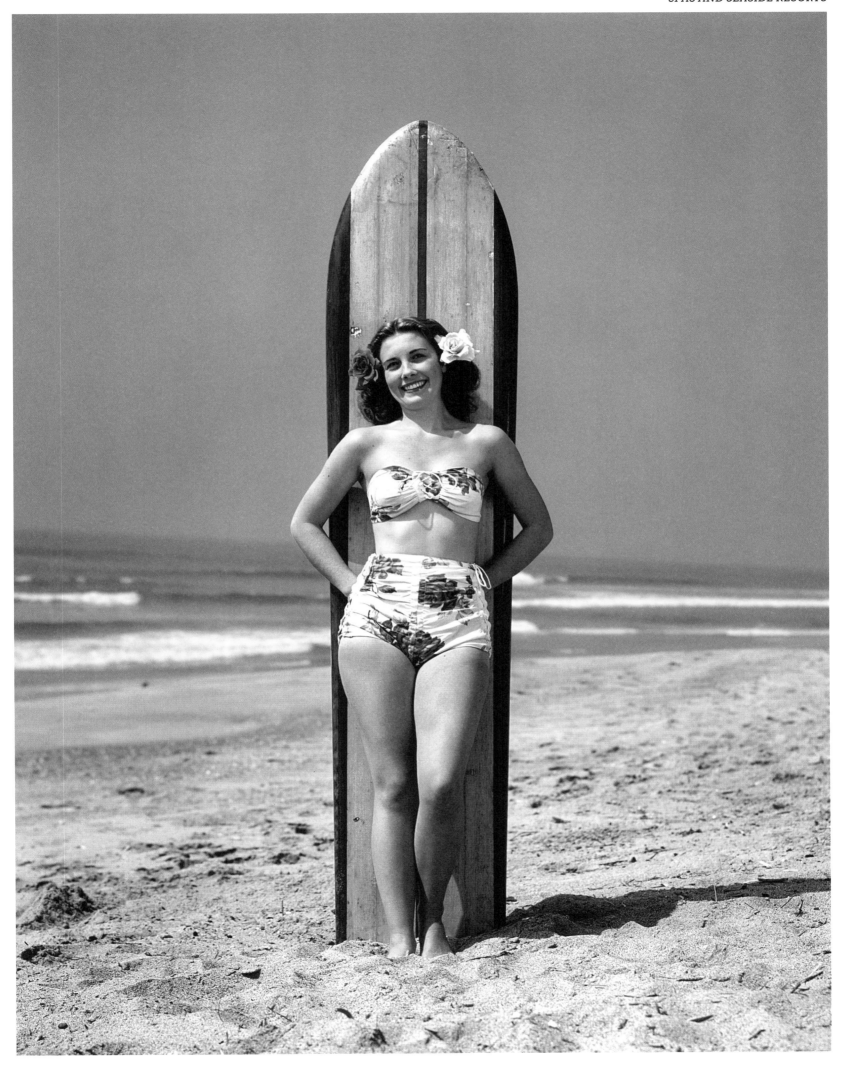

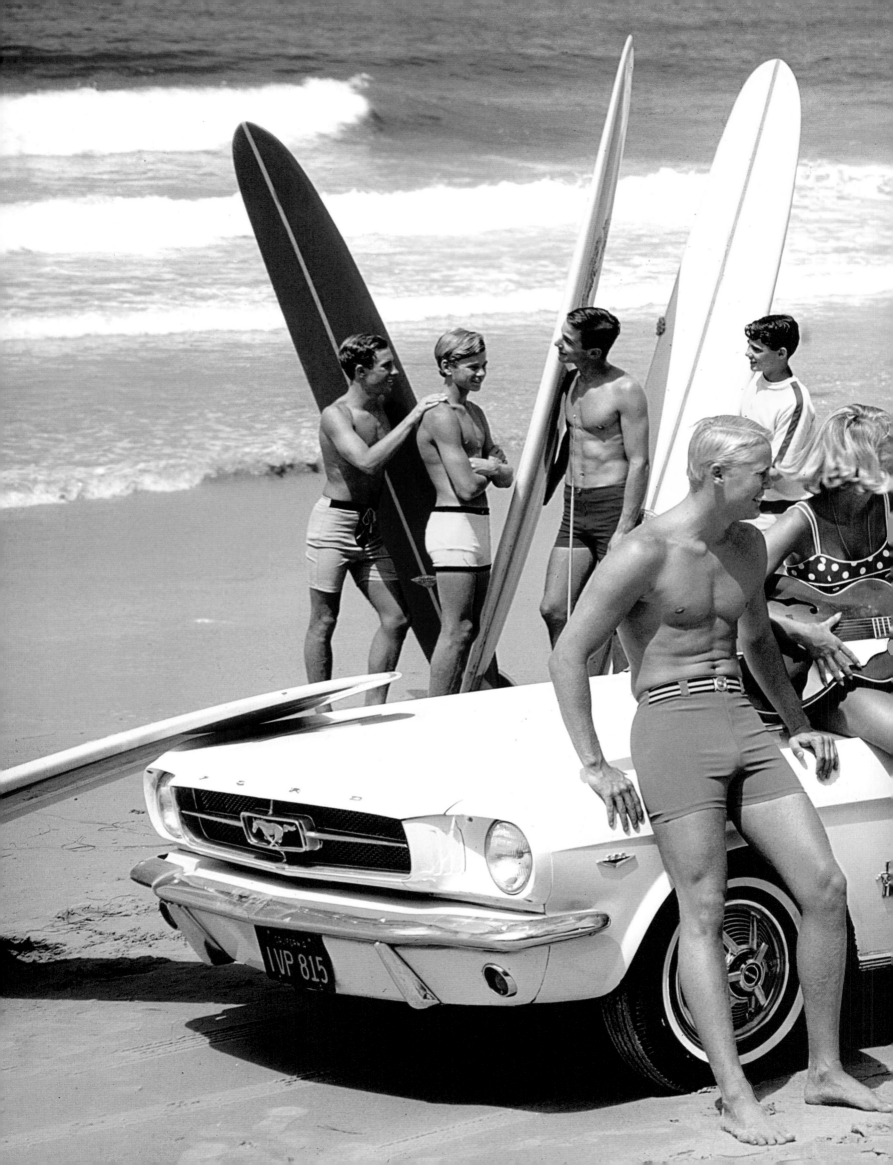

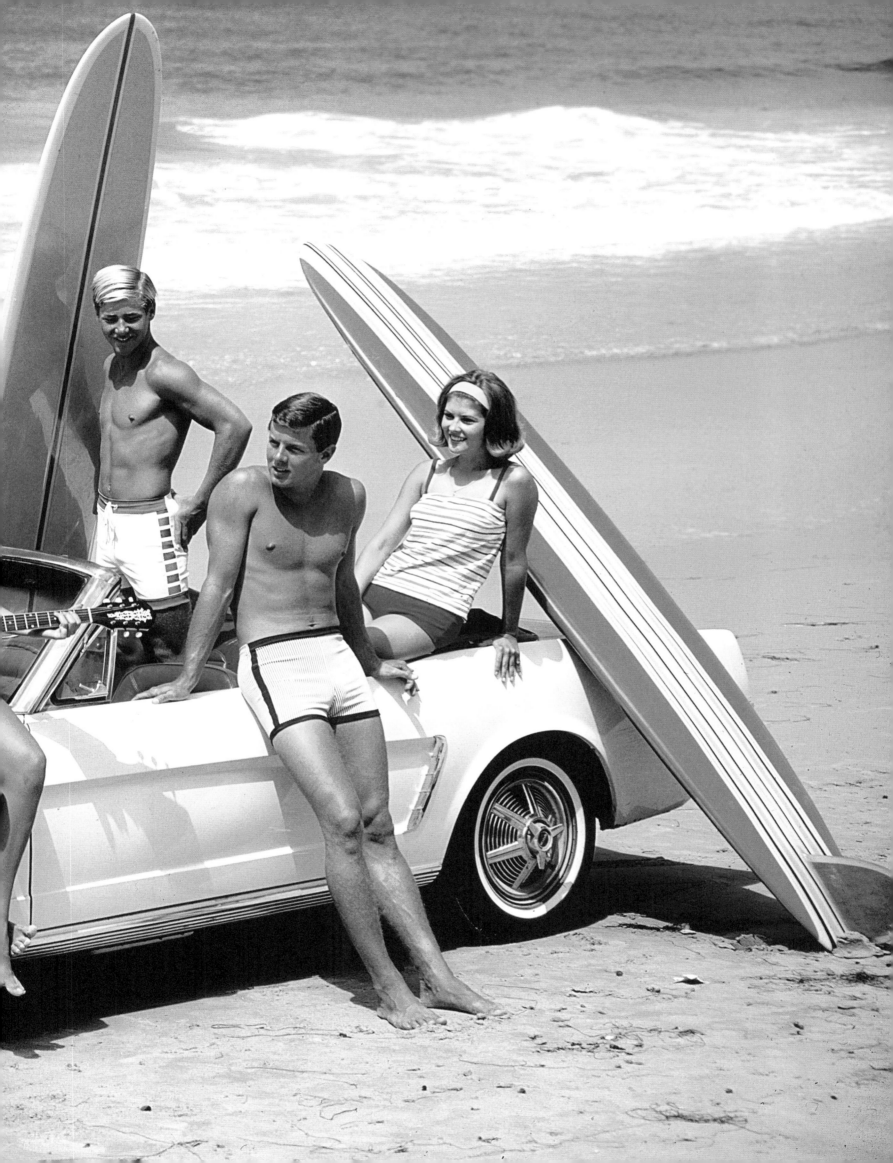

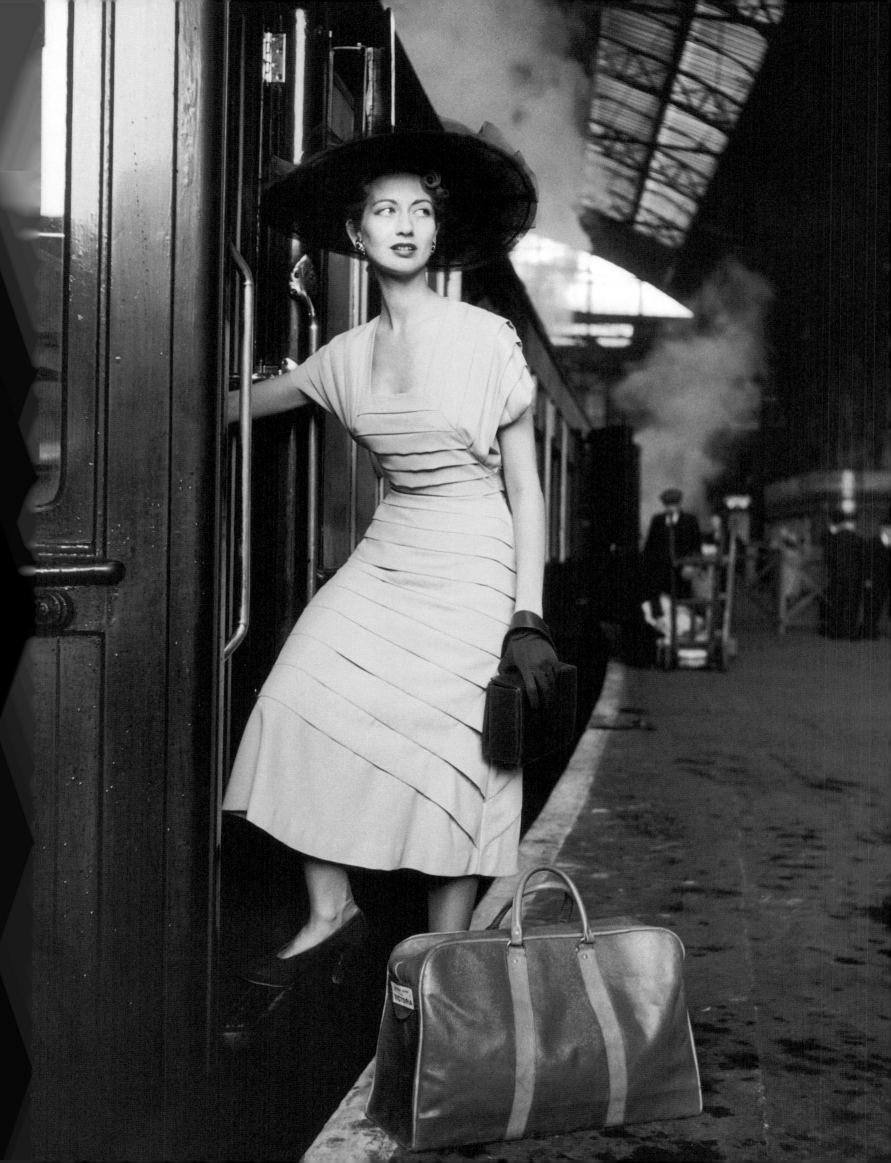

3

FULL STEAM AHEAD

UNTER DAMPF
À TOUTE VAPEUR

RAILROADS AND LUXURY TRAINS

When Thomas Cook offered his first train trip in 1841, the railroad as we know today was barely sixteen years old. The era of rail travel was ushered in on September 27, 1825, when the *Locomotion*, a thirty-eight-car train built by the self-taught British mining engineer George Stephenson, traveled from Shildon to Stockton with six hundred passengers on board. In 1829, George Stephenson and his son Robert entered their *Rocket* locomotive in the legendary Rainhill Trails. The engine pulled the train at a velocity of up to twenty English miles per hour—a record speed for the time. That same year, the United States and France launched their first railway lines, with Germany and Belgium following in 1835, Russia in 1837, and Austria in 1838. The European rail network expanded in the 1840s and 1850s, and during the same period Asia, Latin America, Australia, and Africa all introduced rail systems of their own.

The straight railway lines, along with viaducts and, permanently transformed the landscape and the way travelers viewed it. As one English author complained in 1844, "In traveling on most of the railways, the face of nature, the beautiful prospects of hill and dale, are lost or distorted to our view. The alternation of high and low ground, the healthful breeze, and all those exhilarating associations connected with 'the road,' are lost or changed to doleful cuttings, dismal tunnels, and the noxious effluvia of the screaming engine." Passengers began reading instead of gazing out at the countryside racing past their windows. Early on, resourceful entrepreneurs

such as W. H. Smith and Louis Hachette recognized the potential for bookstore concessions in railroad stations, and even published their own series of novels for travelers.

While the first stations were modest, they grew over time into modern, cathedral-like buildings. The ones in major European cities were typically terminus stations with each major railroad line ending in its own terminus. Enormous halls arose—industrial structures built of iron and glass connected to magnificent terminals designed to evoke bygone eras. Outside historic city centers, railway stations became hubs of rapid urban development in the nineteenth century, surrounded by bustling, often questionable neighborhoods with restaurants, cafés, and hotels. The facade of London's St. Pancras Station was dominated by the formidable Gothic Revival Midland Grand Hotel, while the Hotel Excelsior in Berlin had its own pedestrian underpass connecting it to the Anhalter Bahnhof across the street. In Paris, passengers could kill time waiting for their trains by admiring the paintings in the posh Buffet de la Gare de Lyon, known today as the Le Train bleu. In New York, travelers flocked to the famous Oyster Bar in Grand Central Station.

By 1885, some fifty years after England's first rail journey, Europe had opened up, with a 120,000-mile rail network crisscrossing its borders—a true revolution in mobility. Trains became the means of mass transportation, and forty years after Thomas Cook's first excursions, they now formed the ideal tourism platform.

The 1880s also marked the beginning of a new era: that of luxury trains. In the United States, the entrepreneur and inventor George M. Pullman developed his eponymous railcar in 1858, which he modeled after the spacious interiors of American riverboats. The Europeans, however, remained ever faithful to their compartment trains, a configuration left over from the days of stagecoach travel. It wasn't until the 1890s that the corridor train gradually began to prevail, with its side aisle and compartments accessed via sliding doors.

In Europe, luxury trains were synonymous with one company: Compagnie Internationale des Wagons-Lits (CIWL), founded by the Belgian entrepreneur Georges Nagelmackers. In his youth, he visited the United States in 1867 and saw the potential for luxury trains for the European market. This banker's son organized a trial run in 1882: in the early evening of October 10, the *Train éclair de luxe* left the Gare de l'Est station in Paris and set out on a 1,250-mile trip to Vienna, where it was scheduled to arrive the following evening at 10:30 p.m. Consisting of four sleepers, a restaurant, and two luggage cars, the train seated forty-eight passengers and afforded them the utmost in luxurious comfort. The dining car served a nine-course menu, accompanied by select wines and champagnes, which passengers could enjoy while watching the evening landscape of eastern France pass by. The return trip began two days later in Vienna and ended on the evening of October 14 in Strasbourg, Alsace-Lorraine. The trial was a complete success.

The *Orient Express*, the quintessential luxury train, began service between Paris and Vienna on June 5, 1883, adding a route to Constantinople in October 1883. Instead of connecting these cities directly, however, the train first went to Giurgiu, Romania, where passengers had to cross the Danube by ferry. Another train then took them onward to Varna, Bulgaria, where they boarded a ship bound for Constantinople. This arrangement continued until the rail connection was completed in 1889. Additional routes quickly followed. The *Sud Express* began carrying passengers from Lisbon and Madrid to Paris in 1887. Those coming from London transferred to the CIWL network in Ostend and Brussels. From Paris, they could take the *Calais Méditerranée Express*, later renamed the *Train bleu*, to Monte Carlo and on to Ventimiglia. Starting in 1896, the *Nord Express* linked the French capital with Saint Petersburg and Moscow, where travelers could catch a train to the Urals on the completed western sections of the *Trans-Siberian Railway*. From 1903 on, trains traveled as far as Beijing and Manchuria.

The German diplomat Alfons Mumm von Schwarzenstein was one of the first passengers to travel this route when he set out for his post in Beijing. He had nothing but praise for the *Nord Express* and *Manchurian Express* segments of the journey: "The accommodations met my every expectation. The *Trans-Siberian* company's famous luxury train consists of 5 French cars and is more luxurious than any of its European counterparts. The new *Manchurian Express* offers at least the same level of comfort," the diplomat wrote to his boss at the Foreign Office in June. The only amenity the cultured passenger found lacking on board was a piano, although he had, in fact, been promised one. However, such luxury came with a hefty price tag: first-

political landscape. In 1919, the old *Orient Express* began operating as the *Simplon Orient Express* on a new route that passed through Switzerland and on to the Bosporus. Starting in 1925, CIWL added Pullman cars to its sleepers on what became known as the *Pullman Express* line.

The company added more routes as railway lines multiplied. Debuting in 1914, Mitropa began managing luxury trains in Germany and Austria. The catering company offered exclusively first-class service on the *Rheingold*, a Pullman train that launched in 1928, running between Hook of Holland and Switzerland. In 1930, travelers could take CIWL's *Taurus Express* from Istanbul toward Bagdad

completed on November 7, 1885. At the turn of the century, wealthy North Americans enjoyed riding in trains as a way to travel rapidly—and in comfort. As early as 1888, the Canadian Pacific Rail had built a number of luxury hotels in the Rocky Mountains with the purpose of enticing prosperous East Coast Canadians to venture out west.

The *20th Century Limited* took up service between New York and Chicago in 1902. With the new 1938 streamlined design, this opulent night train became a popular set for musicals and Hollywood movies. It was memorialized in film when Alfred Hitchcock used it in his thriller *North by Northwest*. In the final scene, Cary Grant pulls his costar Eva Marie Saint up into his sleeper bunk, while the train races through a tunnel, turning the compartment into the backdrop for what Hitchcock termed, "probably one of the most impudent shots I ever made."

> ## 66 *SPACE IS KILLED BY THE RAILWAYS, AND WE ARE LEFT WITH TIME ALONE* 99
> —*HEINRICH HEINE*, LUTETIA, PART TWO, *1843*

In 1967, the *20th Century Limited* was taken out of service. It had been "the most amazing train in the world," as the *New York Times* described it during the year of its final run. It was the last of the great American luxury trains, and airplanes replaced rail travel as the fastest and most luxurious means of mobility. The monumental Pennsylvania Station in New York, which dated back to 1910, was torn down in 1963 despite massive protests on the part of New Yorkers. The demolition marked a turning point, as the great era of American railroads came to an end.

class tickets for the 6,960-mile route from Berlin to Beijing cost 727.47 marks, while a second-class ticket cost 476.16 marks, sleeper included. In today's money, they would be approximately $11,000 and $6,500, respectively.

CIWL operated nearly all luxury trains in Europe from the time the *Orient Express* began service in 1883 until the outbreak of war in 1914. The First World War interrupted this lucrative business because most of these trains crossed national boundaries, and thus also front lines. Ironically, the November 1918 Armistice was signed in the dining car of a CIWL train in Compiègne, in northern France. Business continued after the war, although under much altered conditions. The Russian revolutionaries seized CIWL's rolling stock, and the routes were adapted to the new

or Beirut, and in 1929, the *Sunshine Pullman Express* offered service between Cairo and Luxor. In South Africa, ship passengers could transfer to the *Union Limited* and complete their journey to Johannesburg by rail. This luxury train was renamed the *Blue Train* in 1939—and it's still in service today. In Australia, *The Ghan* has been connecting Adelaide on the continent's southern coast to Alice Springs since 1929 and later ran as far as the northern city of Darwin.

It goes without saying that luxury trains were also in great demand in North America. The final spike on the first transcontinental railway was hammered into place on May 10, 1869, in Promontory Point, Utah. The trouble-plagued Canadian line that ran from the East Coast to Vancouver, British Columbia, was finally

FASHION ON THE PLATFORM
Page 68: A satin gown isn't necessarily the most comfortable clothing for travel. Fashion shot by photographer Lee Miller, 1950.

REISEN À LA MODE
Seite 68: Ein Satinkleid ist nicht unbedingt die bequemste Reisekleidung. Modeaufnahme der Fotografin Lee Miller, 1950

LES ÉLÉGANTES PRENDRONT LE TRAIN
Page 68 : la robe en satin n'est pas forcément ce qu'il y a de plus confortable pour voyager. Photo de mode signée de la photographe Lee Miller, 1950

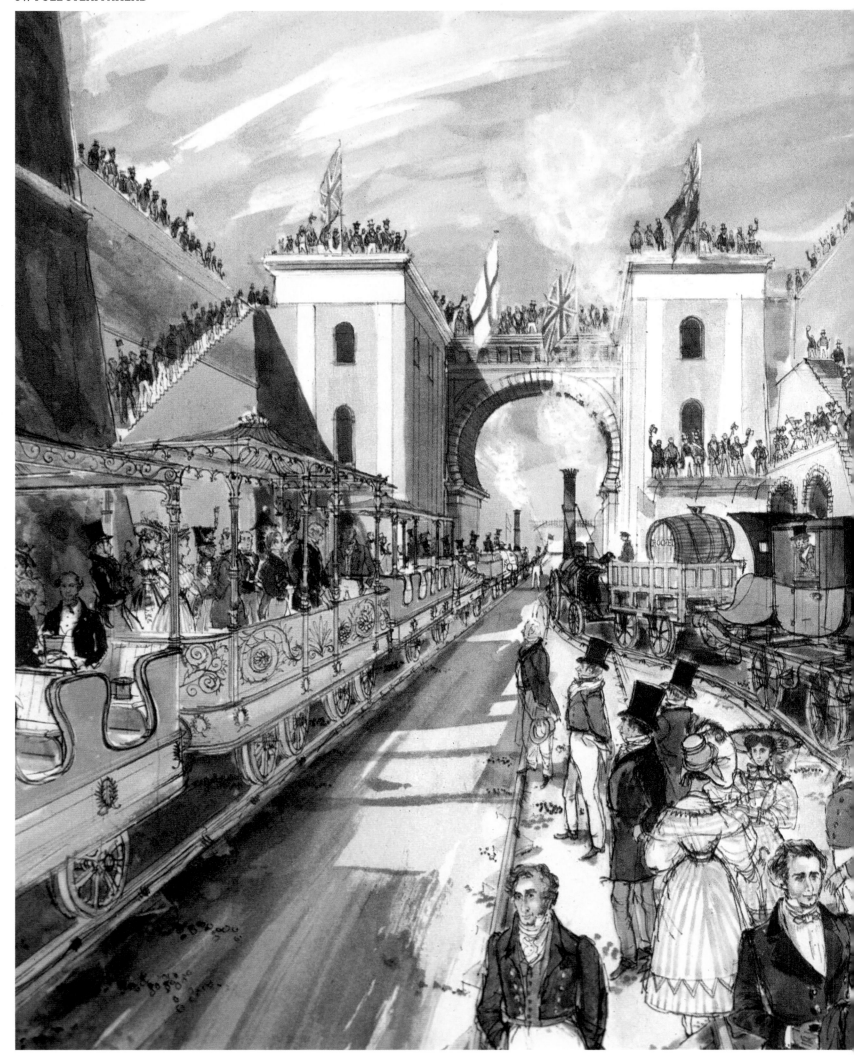

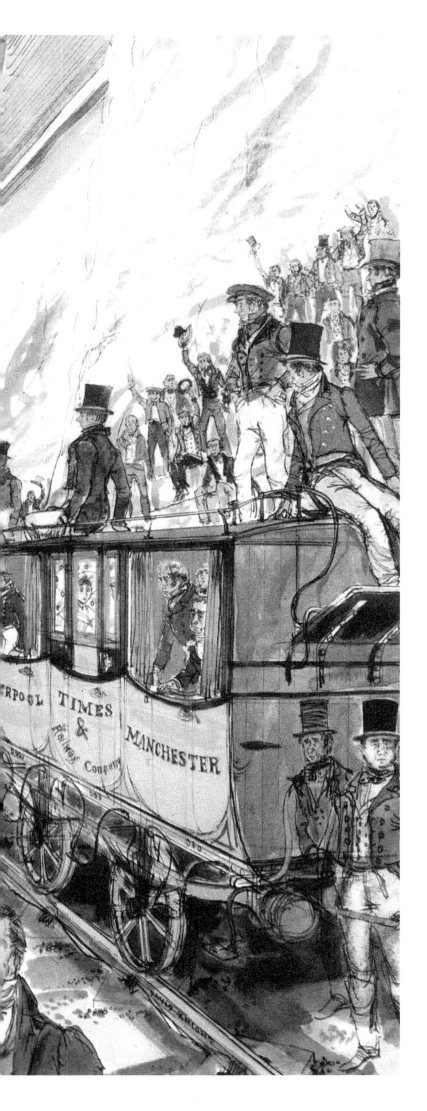

CARRIAGE ON RAILS

Opening of the rail line between Liverpool and Manchester on September 15, 1830. The locomotive *Rocket* from George and Robert Stephenson is in the background.

KUTSCHEN AUF SCHIENEN

Eröffnung der Bahnstecke zwischen Liverpool und Manchester am 15. September 1830, Im Bildhintergrund die Lokomotive *Rocket* von George und Robert Stephenson

CALÈCHES SUR RAILS

Inauguration de la ligne de chemin de fer Liverpool-Manchester, le 15 septembre 1830, avec la locomotive *Rocket* de George et Robert Stephenson

EISENBAHNEN UND LUXUSZÜGE

Als Thomas Cook 1841 seine erste Bahnreise anbot, war die Eisenbahn, wie wir sie heute kennen, gerade erst einmal 16 Jahre alt: Am 27. September 1825 hatte der britische Bergbauingenieur und Autodidakt George Stephenson seine *Locomotion* mit 38 Wagen und 600 Festgästen an Bord von Shildon nach Stockton geschickt.

Beim legendären Eisenbahnrennen von Rainhill 1829 holte die von George Stephenson und seinem Sohn Robert gebaute *Rocket* den Geschwindigkeitsrekord mit bis zu 30 englischen Meilen in der Stunde (45 km/h). Im gleichen Jahr wurden erste Bahnstrecken in den USA und in Frankreich eröffnet, Deutschland und Belgien folgten 1835, Russland 1837 und Österreich 1838. Die 1840er- und 1850er-Jahre sahen den Ausbau des europäischen Schienennetzes sowie die Einführung der Eisenbahn in Asien, Lateinamerika, Australien und Afrika.

Die geraden Eisenbahnstrecken mit ihren Viadukten und Tunnels veränderten die Landschaft und ihre Wahrnehmung durch die Reisenden nachhaltig. 1844 klagte ein englischer Autor: „Beim Reisen mit der Eisenbahn gehen in den meisten Fällen der Anblick der Natur, die schönen Ausblicke auf Berg und Tal, verloren und werden entstellt. Das Auf und Ab im Gelände, die gesunde Luft und all die munteren Assoziationen, die man mit ‚der Straße' verbindet, verschwinden oder werden zu tristen Einschnitten, düsteren Tunnels und dem ungesunden Auswurf der dröhnenden Lokomotive."

Statt auf die vorbeirasende Landschaft richtete sich der Blick nun eher in die Reiselektüre. Findige Unternehmer wie W. H. Smith oder Louis Hachette hatten sich schon frühzeitig um Konzessionen für Bahnhofsbuchhandlungen bemüht und brachten sogar eigene Romanreihen für Bahnreisende auf den Markt.

Die anfangs bescheidenen Bahnhöfe wandelten sich mit der Zeit zu modernen Kathedralen des Verkehrs. Typischerweise waren Bahnhöfe in europäischen Großstädten Kopfbahnhöfe. Jede große Eisenbahnstrecke besaß so ihre eigene Endhaltestelle. Es entstanden riesige, industriell geprägte Bahnhofshallen aus Eisen und Glas, die mit prächtigen, historisierenden Empfangsgebäuden verbunden waren.

Vor den Toren der historischen Altstädte wurden die Bahnhöfe zum Dreh- und Angelpunkt der rasanten Stadtentwicklung im 19. Jahrhundert, umgeben von lebendigen, oftmals verrufenen Stadtvierteln mit Restaurants, Cafés und Hotels. Die Fassade des Londoner Bahnhofs St. Pancras wurde vom trutzigen neogotischen Midland Grand Hotel dominiert, während das Hotel Excelsior in Berlin mit dem gegenüberliegenden Anhalter Bahnhof durch einen eigenen Fußgängertunnel verbunden war. In Paris konnte man sich die Wartezeit im Bahnhof mit dem Betrachten der Gemälde im Nobelrestaurant Buffet de la Gare de Lyon vertreiben, das heute Le Train bleu heißt, in New York in der berühmten Oyster Bar in der Grand Central Station.

Um 1885, ein gutes halbes Jahrhundert nach der ersten Eisenbahnfahrt in England, war Europa grenzüberschreitend mit einem Schienennetz von über 190 000 Kilometern Länge erschlossen – eine wahre Verkehrsrevolution. Die Bahn wurde damit zum Massentransportmittel und 40 Jahre nach Thomas Cooks erster Bahnpauschalreise zur idealen Plattform für den Tourismus.

Die 1880er-Jahre markieren auch den Beginn des Zeitalters der Luxuszüge. In den USA entwickelte der Unternehmer und Erfinder George M. Pullman 1858 den nach ihm benannten Salonwagen, der sich die großzügigen Innenräume amerikanischer Flussdampfer zum Vorbild nahm. In Europa blieb man hingegen lange den aus dem Postkutschenzeitalter geerbten Abteilwagen treu. Erst in den 1890er-Jahren setzte sich allmählich der D-Zug-Wagen mit einem seitlichen Gang durch, dessen Abteile durch Schiebetüren zugänglich sind.

In Europa war der Luxuszug gleichbedeutend mit einer Gesellschaft, der Compagnie Internationale des Wagons-Lits (CIWL) des bel-

gischen Unternehmers Georges Nagelmackers. Als junger Mann hatte er 1867 die USA bereist und das Potenzial von Luxuszügen für den europäischen Markt erkannt. Im Herbst 1882 startete der Bankierssohn einen Versuch: Am frühen Abend des 10. Oktober verließ der *Train éclair de luxe* den Pariser Bahnhof Gare de l'Est, um ins 2 000 Kilometer entfernte Wien zu fahren, wo er am nächsten Abend um 22 Uhr 30 ankommen sollte. Der Zug bestand aus vier Schlafwagen, einem Restaurantwagen und zwei Gepäckwagen und bot Platz für 48 Gäste, die auf keinerlei Komfort verzichten mussten. Im Speisewagen wurde ein Neun-Gänge-Menü serviert, dazu erlesene Weine und Champagner, während an den Fenstern die abendliche Landschaft Ostfrankreichs vorüberzog. Die Rückfahrt begann zwei Tage später in Wien und endete am 14. Oktober abends im elsässischen Straßburg. Der Versuch war ein voller Erfolg.

Ab dem 5. Juni 1883 verkehrte dann der *Orient-Express*, der Klassiker aller Luxuszüge, zwischen Paris und Wien, ab Oktober 1883 auch bis nach Konstantinopel. Allerdings mit Umstiegen – die Fahrt ging zunächst nach Giurgiu in Rumänien, wo die Donau per Fähre überquert wurde. Ein weiterer Zug fuhr anschließend nach Warna in Bulgarien. Von dort fuhren die Gäste mit dem Schiff nach Konstantinopel, bis die Schienenverbindung 1889 fertig war.

Schnell folgten weitere Routen: Der *Sud-Express* brachte ab 1887 Passagiere von Lissabon und Madrid nach Paris. Von London kommend, stießen Gäste über Ostende und Brüssel zum Netz der CIWL-Verbindungen. Von Paris aus konnten sie im *Calais-Méditerranée-Express*, dem späteren *Train bleu*, nach Monte Carlo und weiter nach Ventimiglia reisen. Ab 1896 verband der *Nord-Express* die französische Hauptstadt mit Sankt Petersburg und Moskau. Von dort bestand auf den bereits gebauten westlichen Abschnitten der *Transsibirischen Eisenbahn* schon Anschluss zum Ural, ab 1903 dann weiter bis nach Peking und in die Mandschurei.

Der deutsche Diplomat Alfons Mumm von Schwarzenstein unternahm im Mai 1903 als einer der ersten Passagiere seine Dienst-

antrittsreise nach Peking mit dem *Nord-Express* und dem *Mandschurien-Express* und war des Lobes voll: „In Bezug auf Bequemlichkeit fand ich mich in meinen Erwartungen nicht getäuscht. Der bekannte Luxuszug der internationalen Schlafwagengesellschaft ‚Trans-sibérien', aus 5 französischen Wagen bestehend, übertrifft an Komfort alle in Europa laufenden Luxuszüge, und der neue mandschurische Expreßzug steht demselben zum mindesten gleich", schrieb der Diplomat im Juni seinem Chef im Auswärtigen Amt. Einzig ein Klavier vermisste der kultivierte Passagier an Bord, und dies, obwohl es ihm zugesagt worden war. Der Komfort hatte natürlich seinen Preis: Für die 11 202 Kilometer lange Strecke Berlin–Peking war ein Fahrpreis von 727,47 Mark in der ersten Klasse oder von 476,16 Mark in der zweiten Klasse zu entrichten, Schlafwagen inklusive. Nach heu-

1919 als *Simplon-Orient-Express* auf einer neuen Strecke durch die Schweiz bis an den Bosporus. Ab 1925 setzte die CIWL in Kontinentaleuropa zusätzlich zu ihren Schlafwagenzügen Pullmanwagen auf sogenannten *Pullman-Express*-Verbindungen ein.

Das CIWL-Angebot wuchs mit dem Ausbau der Bahnstrecken. Während ab 1914 in Deutschland und Österreich die Mitropa die Luxuszüge bewirtschaftete und mit dem *Rheingold* ab 1928 eine reine Erste-Klasse-Verbindung in Pullmanwagen zwischen Hoek van Holland und der Schweiz anbot, konnten Reisende 1930 mit dem *Taurus-Express* der CIWL von Istanbul aus in Richtung Bagdad oder Beirut fahren. Ab 1929 verkehrte zwischen Kairo und Luxor bereits der *Sunshine Pullman Express* der CIWL. In Südafrika konnten Seereisende aus Europa

Nordamerikaner die Eisenbahn gerne, um schnell und komfortabel zu reisen. Schon 1888 hatte die Canadian Pacific Railway eine Reihe von Luxushotels in den Rocky Mountains errichtet, um wohlhabende Kanadier aus dem Osten anzulocken.

Ab 1902 verkehrte zwischen New York und Chicago der *20th Century Limited*. 1938 bekam dieser luxuriöse Nachtzug eine Stromlinienform und war fortan ein beliebtes Set für Musicals oder Hollywoodfilme. In seinem Thriller *Der unsichtbare Dritte* hat Alfred Hitchcock dem Zug ein filmisches Denkmal gesetzt. Als Cary Grant seine Filmpartnerin Eva Marie Saint in der Schlussszene in sein Schlafwagenbett hinaufzieht, während der Zug in einen Tunnel rast, wurde das Abteil zur Kulisse für die „impertinenteste Schlusseinstellung, die ich jemals gemacht habe", so Alfred Hitchcock.

> ## 99 *DURCH DIE EISENBAHNEN WIRD DER RAUM GETÖTET, UND ES BLEIBT UNS NUR NOCH DIE ZEIT ÜBRIG.* 66
>
> *HEINRICH HEINE, LUTETIA, ZWEITER TEIL, 1843*

1967 stellte der *20th Century Limited*, „der großartigste Zug der Welt", wie ihn die *New York Times* im Abschiedsjahr nannte, den Betrieb ein. Er war der letzte der großen amerikanischen Luxuszüge. Was Komfort und Geschwindigkeit anging, übernahm nun der Luftverkehr die Rolle, die früher die Eisenbahn gespielt hatte. Schon 1963 war in New York trotz heftiger Proteste der New Yorker die 1910 vollendete monumentale Pennsylvania Station abgerissen worden. Der Abbruch markierte den Anfang vom Ende der großen Zeit der amerikanischen Eisenbahnen.

tiger Rechnung wären das etwa 10 000 bzw. 6 000 Euro.

Von der Einführung des *Orient-Expresses* im Jahre 1883 bis zum Kriegsausbruch 1914 betrieb die CIWL fast alle Luxuszüge in Europa. Der Erste Weltkrieg unterbrach das lukrative Geschäft, weil die meisten dieser Züge über Grenzen und damit auch durch Fronten fuhren. Ironischerweise wurde der Waffenstillstand im November 1918 im nordfranzösischen Compiègne in einem Speisewagen der CIWL unterzeichnet.

Nach dem Krieg ging das Geschäft weiter, allerdings unter stark veränderten Bedingungen. Im revolutionären Russland wurden die Fahrzeuge der CIWL beschlagnahmt. Die Verbindungen wurden der neuen politischen Landschaft angepasst. So verkehrte der alte *Orient-Express* beispielsweise ab

in Kapstadt in die Waggons des *Union Limited* umsteigen, der sie weiter nach Johannesburg brachte. Seit 1939 heißt dieser Luxuszug *Blue Train* – er verkehrt noch heute. In Australien verbindet seit 1929 *The Ghan* Adelaide an der Südküste mit Alice Springs; später fuhr er sogar bis Darwin im Norden Australiens.

Auf dem klassischen Eisenbahnkontinent Nordamerika gab es natürlich ebenfalls eine große Nachfrage nach luxuriösen Zügen. Am 10. Mai 1869 wurde in Promontory Point im US-Bundesstaat Utah der letzte Nagel für die erste transkontinentale Eisenbahnverbindung eingeschlagen. Die kanadische Strecke zwischen der Ostküste und Vancouver in British Columbia wurde nach vielen Schwierigkeiten am 7. November 1885 fertig. Um die Jahrhundertwende nutzten reiche

CHEMINS DE FER ET TRAINS DE LUXE

Lorsque Thomas Cook, en 1841, organise son premier voyage en train, le chemin de fer tel que nous le connaissons aujourd'hui existe depuis seize ans à peine : c'est le 27 septembre 1825 que l'ingénieur des mines et autodidacte britannique George Stephenson lance sa *Locomotion* entre Shildon et Stockton, qui tracte 38 wagons avec 600 invités à bord. Lors de la légendaire course de locomotives de Rainhill, en 1829, la *Rocket* construite par George Stephenson et son fils Robert remporte le record de vitesse de pointe de 45 km/h. La même année, la France et les États-Unis inaugurent leurs premières lignes de chemin de fer, suivis par la Belgique et l'Allemagne en 1835, puis la Russie en 1837 et l'Autriche en 1838. Dans les années 1840 et 1850, tandis que le réseau européen s'étoffe, le chemin de fer arrive en Asie, en Amérique latine, en Australie et en Afrique.

Dès lors, les rails rectilignes, les viaducs et les tunnels qui compensent les dénivellations altèrent à jamais les paysages et leur perception par les voyageurs. En 1844, un auteur anglais le déplore en ces termes : « Au cours des voyages en train, le visage de la nature, les belles perspectives sur les monts et les vallées, le plus souvent, se perdent ou se dégradent. Les côtes et les creux, l'air pur et toutes les sensations grisantes de "la route", disparaissent, remplacés par de mornes percées, de lugubres tunnels et les fumées malsaines de la locomotive hurlante. » Au lieu de s'attarder sur des paysages qui, désormais, défilent trop vite, le regard se porte alors sur la lecture. Très tôt, d'ingénieux entrepreneurs, comme W. H. Smith ou Louis Hachette, raflent les concessions de librairie dans les gares et lancent des séries de romans spécialement destinés aux voyageurs.

Si les premières ne sont que de modestes bâtiments, les gares se muent, avec le temps, en véritables cathédrales des transports des temps modernes. La plupart des métropoles européennes sont les terminus de grandes lignes de chemin de fer. S'y élèvent alors d'immenses halls d'inspiration industrielle, alliant le fer et le verre, près de somptueux édifices historisants destinés à l'accueil des voyageurs.

Au XIXe siècle, la gare, aux portes du centre-ville historique, devient le pivot et le pôle d'un développement urbain galopant. Elle est entourée de quartiers à la réputation souvent sulfureuse, mais animés de restaurants, cafés et hôtels. La façade de Saint-Pancras, à Londres, est dominée par l'imposante silhouette néogothique du Midland Grand Hotel, tandis que l'Excelsior de Berlin est relié à la gare d'Anhalt, située en face, par un tunnel piéton. À Paris, on tue le temps entre deux trains en admirant les fresques du très chic Buffet de la gare de Lyon, qui sera rebaptisé par la suite Le Train bleu, tandis qu'à New York, le célèbre Oyster Bar s'installe dans la Grand Central Station.

Vers 1885, soixante ans après le premier voyage en train, en Angleterre, l'Europe est d'ores et déjà recouverte d'un vaste maillage de plus de 190 000 kilomètres de voies ferrées qui traversent les frontières – c'est une véritable révolution. Le train est devenu un moyen de transport de masse, et quarante ans après le premier voyage de groupe organisé par Thomas Cook, il s'impose comme vecteur idéal du développement touristique. Les années 1880 inaugurent l'ère des trains de luxe. Aux États-Unis, l'inventeur et homme d'affaires George M. Pullman imagine, en 1858, le wagon qui porte son nom. Il s'est directement inspiré des cabines spacieuses des bateaux à vapeur qui naviguent sur les fleuves d'Amérique. L'Europe, en revanche, reste longtemps fidèle aux wagons à compartiment unique, hérités de l'ère post-calèche. Ce n'est que dans les années 1890 que s'impose, peu à peu, la voiture à couloir latéral desservant des compartiments fermés par des portes coulissantes.

En Europe, train de luxe rime avec Compagnie internationale des wagons-lits (CIWL), une société créée par l'homme d'affaires belge Georges Nagelmackers. À la faveur d'un voyage aux États-Unis qu'il fait dans ses jeunes années, il entrevoit, dès 1867, le potentiel des trains de luxe sur les marchés européens. À l'automne 1882, ce fils de banquier fait un petit test : le 10 octobre, en début de soirée, son *Train éclair de luxe* quitte la gare de l'Est, à Paris, pour rejoindre Vienne, à 2 000 kilomètres de là, où il doit arriver le lendemain soir à 22 h 30. Composé de quatre voitures-lits, d'une voiture-restaurant et de deux wagons pour les bagages, ce train promet aux 48 voyageurs qu'il transporte des conditions de confort optimales. Dans le wagon-restaurant leur est proposé un menu de neuf plats, à déguster avec du champagne et des grands crus, tandis que, derrière les vitres, défilent les paysages de l'est de la France baignés dans la lumière du crépuscule. Le retour de Vienne a lieu deux jours plus tard. Destination Strasbourg où le train entre en gare le 14 octobre. L'essai est transformé.

Dès le 5 juin 1883, l'*Orient-Express*, qui reste la quintessence du train de luxe, assure la liaison entre Paris et Vienne. En octobre de la même année, il mène jusqu'à Constantinople, même s'il doit faire halte à Giurgiu, en Roumanie, pour que les voyageurs traversent le Danube en bac. Ils embarquent ensuite à bord d'un autre train pour Varna, en Bulgarie, d'où ils prennent le bateau pour Constantinople – et ce jusqu'à l'achèvement de la voie ferrée, en 1889.

Puis d'autres lignes voient le jour : à compter de 1887, le *Sud-Express* achemine les passagers de Lisbonne et Madrid jusqu'à Paris. Quant aux voyageurs en provenance de Londres, ils se raccrochent, via Ostende et Bruxelles, au réseau de la Compagnie des wagons-lits. Une fois à Paris, ils embarquent à bord du *Calais-Méditerranée-Express*, le futur *Train bleu*, à destination de Monte-Carlo, puis Vintimille. À partir de 1896, le *Nord-Express* relie la capitale française à Saint-Pétersbourg et Moscou. De là, les passagers rejoignent l'Oural par le tronçon occidental du *Trans-sibérien*, déjà opérationnel, en attendant la mise en service du prolongement jusqu'à Pékin et la Mandchourie, en 1903.

Le diplomate allemand Alfons Mumm von Schwarzenstein est l'un des premiers, en mai 1903, à faire le voyage à bord du *Nord-Express*, puis du *Mandchourie-Express*, jusqu'à Pékin, où il doit prendre ses fonctions. Et il ne tarit pas d'éloges : « Pour ce qui concerne l'agrément, mes attentes ne sont pas déçues. Le célèbre *Transsibérien* de la Compagnie internationale des wagons-lits, avec ses cinq voitures françaises, surpasse en confort tous les autres trains de luxe qui circulent en Europe, et le nouveau *Mandchourie-Express* n'a rien à lui envier », écrit le diplomate à son chef au ministère des Affaires étrangères, en juin de la même année. Seul manquait un piano à bord, précise le passager mélomane, et ce malgré qu'on le lui eût promis.

la Compagnie internationale des wagons-lits et les liaisons ferroviaires doivent s'adapter au nouveau paysage politique. Ainsi l'ancien *Orient-Express* devient-il, en 1919, le *Simplon-Orient-Express*, qui passe par la Suisse pour rejoindre le Bosphore. En 1925, la CIWL introduit des voitures Pullman en Europe continentale, qui viennent s'ajouter aux voitures-lits sur les lignes *Pullman Express*.

L'offre de la CIWL évolue à mesure que s'étoffe le réseau des lignes chemin de fer. En Allemagne et en Autriche, c'est la Mitropa qui, à partir de 1914, exploite les trains de luxe ; dès 1928, elle propose le *Rheingold*, un train exclusivement composé de voitures Pullman première classe qui relie la Suisse à la ville hollandaise de Hoek van Holland. À partir

du premier chemin de fer transcontinental des États-Unis. Quant à la ligne canadienne, entre la côte est et Vancouver en Colombie-Britannique, elle est achevée le 7 novembre 1885, après bien des péripéties. Au début du XXe siècle, les Américains fortunés aiment à prendre le train, qui leur permet de voyager vite en prenant leurs aises. Dès 1888, la Canadian Pacific Railway bâtit plusieurs hôtels de luxe dans les Rocheuses, afin d'attirer les nantis de l'est du Canada.

Le *20th Century Limited*, entre New York et Chicago, est inauguré en 1902. En 1938, ce luxueux train de nuit se pare des lignes aérodynamiques qui en feront un décor de choix pour les comédies musicales et les films hollywoodiens. Avec son thriller *La Mort aux trousses*, Alfred Hitchcock lui offre un inoubliable hommage cinématographique. À la fin du film, Cary Grant attire sa partenaire, Eva Marie Saint, sur la couchette de sa voiture-lit, tandis que le train s'engouffre dans un tunnel – une scène dont Hitchcock dira qu'elle reste la « conclusion la plus osée [qu'il ait] jamais réalisée ».

« PAR LES CHEMINS DE FER, L'ESPACE EST ANÉANTI, ET IL NE NOUS RESTE PLUS QUE LE TEMPS. »

HEINRICH HEINE, LUTÈCE, IIe PARTIE, *1843*

Le *20th Century Limited* circule jusqu'en 1967. Au moment des adieux, le *New York Times* le qualifiera de « plus grand train du monde ». Il était le dernier des grands trains de luxe d'Amérique. Pour voyager plus rapidement et plus confortablement, c'est l'avion, désormais, qui prend le relais des liaisons ferroviaires. À New York, la gigantesque Pennsylvania Station, achevée en 1910, sera démantelée en 1963, malgré les vives protestations des riverains. Cette rupture marquera le début de la fin de l'âge d'or du chemin de fer aux États-Unis.

Tout ce confort a un prix, naturellement : pour parcourir les 11 202 kilomètres qui séparent Berlin de Pékin, il faut débourser 727,47 marks en première classe ou 476,16 en seconde, voiture-lit comprise, soit l'équivalent d'environ 10 000 euros et 6 000 euros. De l'inauguration de l'*Orient-Express*, en 1883, jusqu'au début de la guerre, en 1914, la CIWL exploite tous les trains de luxe en Europe, ou presque. Mais la plupart des lignes traversant frontières et lignes de front, la Première Guerre mondiale met un terme à cette activité lucrative. Ironie de l'histoire, c'est dans un wagon-restaurant de la CIWL que sera signé l'armistice de novembre 1918, à Compiègne.
Les affaires reprennent après la guerre, même si le contexte a profondément changé. La Russie révolutionnaire saisit les trains de

de 1930, les voyageurs au départ d'Istanbul pour Bagdad ou Beyrouth empruntent le *Taurus-Express* de la CIWL. Dès 1929, le *Sunshine Pullman Express* de la même compagnie circule entre Le Caire et Louxor. En Afrique du Sud, les Européens qui débarquent au Cap prennent place à bord de l'Union Limited pour gagner Johannesburg. En 1939, ce train de luxe sera rebaptisé *Blue Train* – il circule encore aujourd'hui. En Australie, c'est *The Ghan* qui, en 1929, relie Adelaïde, sur la côte sud, à Alice Springs ; depuis, la ligne a été prolongée jusqu'à Darwin, au nord d'Australie.

L'Amérique du Nord, continent du chemin de fer par excellence, est très demandeuse de trains de luxe. Le 10 mai 1869, à Promontory Point, dans l'Utah, on serre le dernier écrou

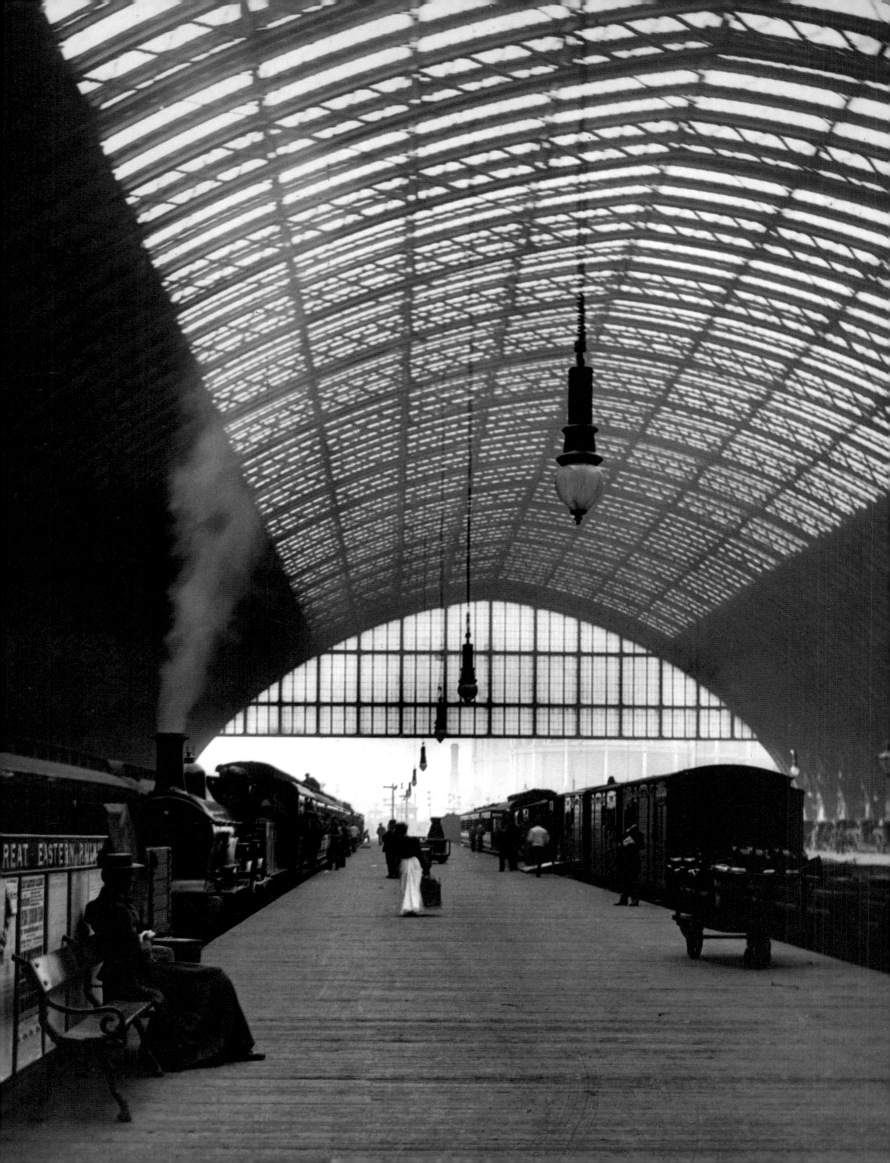

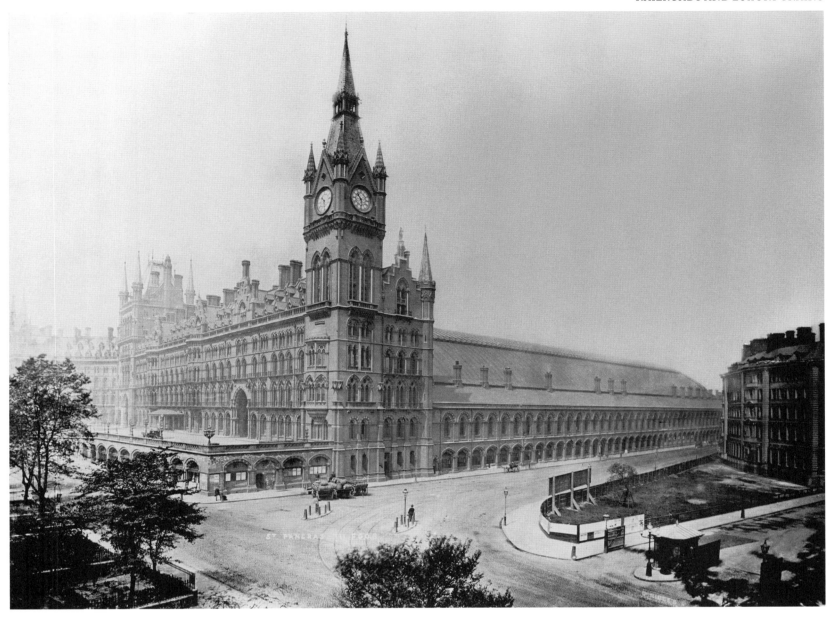

TRAFFIC CATHEDRALS

Opposite: Rail hall of St. Pancras railway station in London, circa 1896.
Above: St. Pancras station building with the Midland Grand Hotel, circa 1880.
The three-hundred-room structure designed by architect George Gilbert Scott
opened in 1873 and closed in 1935. Much like Sleeping Beauty, it reawakened
as a hotel in 2011 after many years of slumber.

KATHEDRALEN DES VERKEHRS

Links: Gleishalle des Londoner Bahnhofs St. Pancras, um 1896;
oben: Empfangsgebäude von St. Pancras mit dem Midland Grand Hotel, um 1880.
Das 300-Zimmer-Haus des Architekten George Gilbert Scott wurde 1873 eröffnet,
1935 geschlossen und als Hotel erst 2011 wieder aus dem Dornröschenschlaf erweckt

CATHÉDRALES DU VOYAGE

Ci-contre : les quais de la gare Saint-Pancras, à Londres, vers 1896 ;
ci-dessus : le hall de Saint-Pancras accolé au Midland Grand Hotel, vers 1880.
L'édifice de 300 chambres conçu par l'architecte George Gilbert Scott est inauguré en
1873 et fermé en 1935. Il faudra attendre 2011 pour que l'hôtel sorte de sa léthargie.

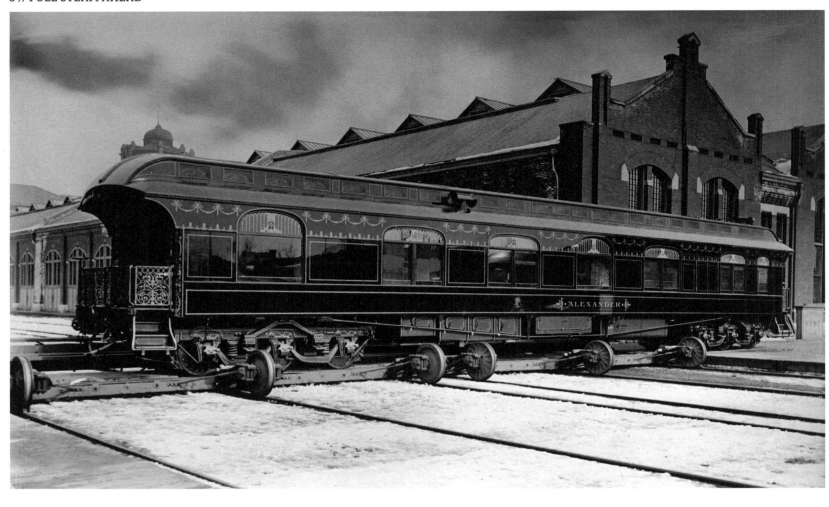

EXCLUSIVE TRAVEL PLEASURE

Above: "Alexander," a private Pullman car manufactured by the Pullman Car Company, 1890.
Opposite: Travel group enjoying a private twenty-six-day tour through Great Britain in Pullman cars, 1876.

EXKLUSIVES REISEVERGNÜGEN

Oben: Privater Salonwagen „Alexander", gefertigt von der Pullman Car Company, 1890;
rechts: Reisegruppe, die in Pullmanwagen eine private 26-tägige Rundfahrt durch Großbritannien unternahm, 1876

VOYAGE TRÈS SÉLECT

Ci-dessus : la voiture-salon privée « Alexander », fabriquée par la Pullman Car Company, 1890 ;
ci-contre : groupe de voyageurs partis pour un tour de Grande-Bretagne de vingt-six jours en train Pullman, 1876

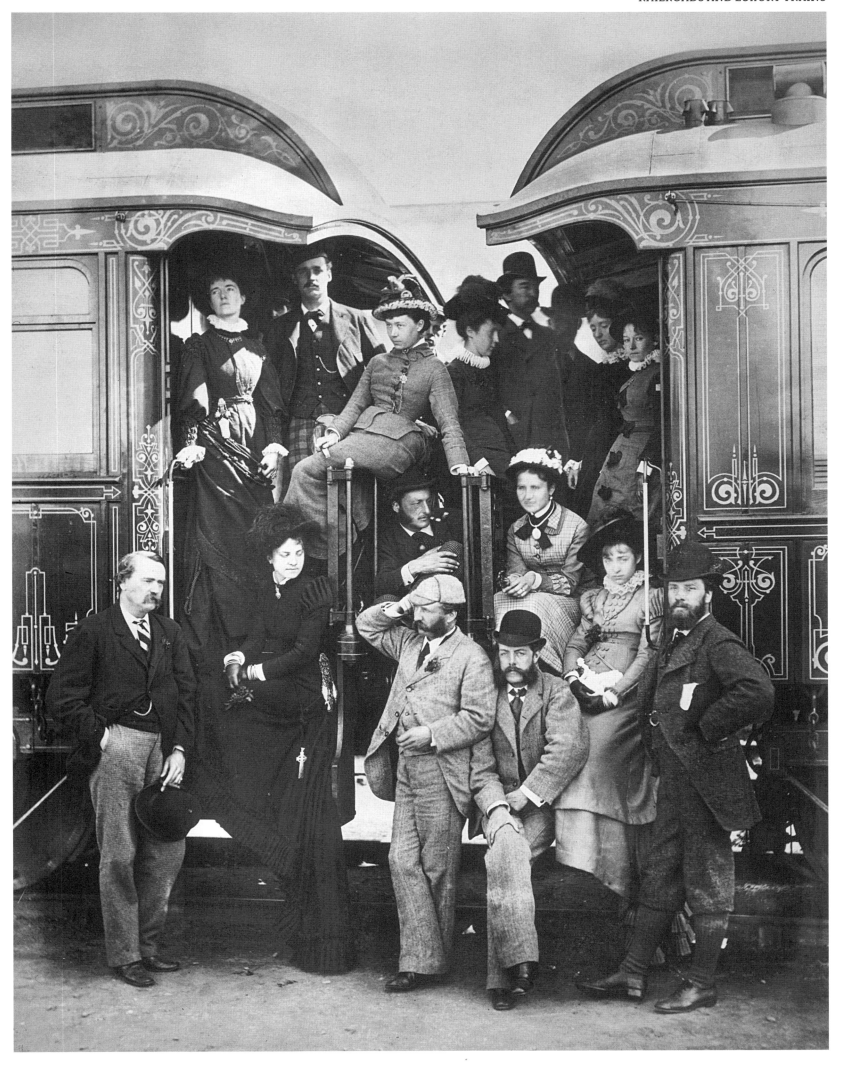

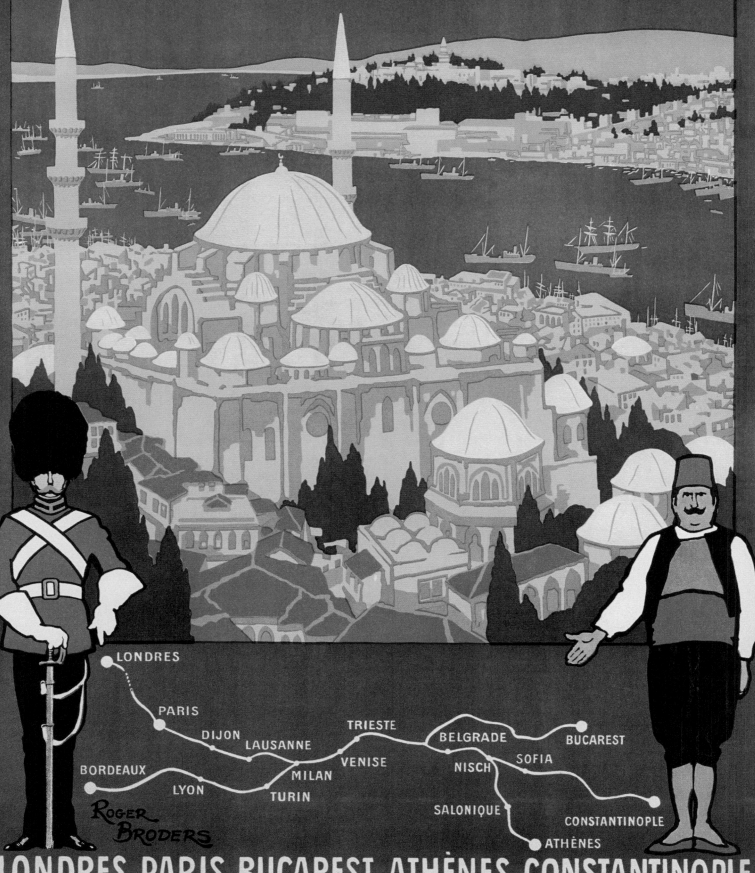

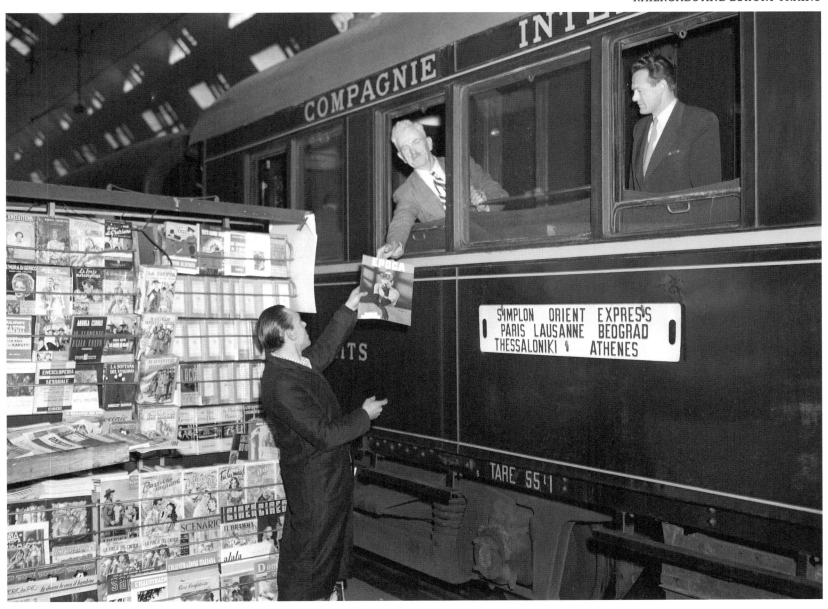

LUXURY TRAIN PAR EXCELLENCE

Opposite: Poster for the *Simplon Orient Express*, 1920s.
Above: A passenger purchases reading material at a railway station in Italy, 1951.

LUXUSZUG PAR EXCELLENCE

Links: Plakat für den *Simplon-Orient-Express*, 1920er-Jahre;
oben: Ein Passagier erwirbt Reiselektüre an einem italienischen Bahnhof, 1951

LE TRAIN DE LUXE PAR EXCELLENCE

Ci-contre : affiche publicitaire pour le *Simplon-Orient-Express*, dans les années 1920 ;
ci-dessus : un passager achète un magazine lors d'un arrêt dans une gare italienne, 1951

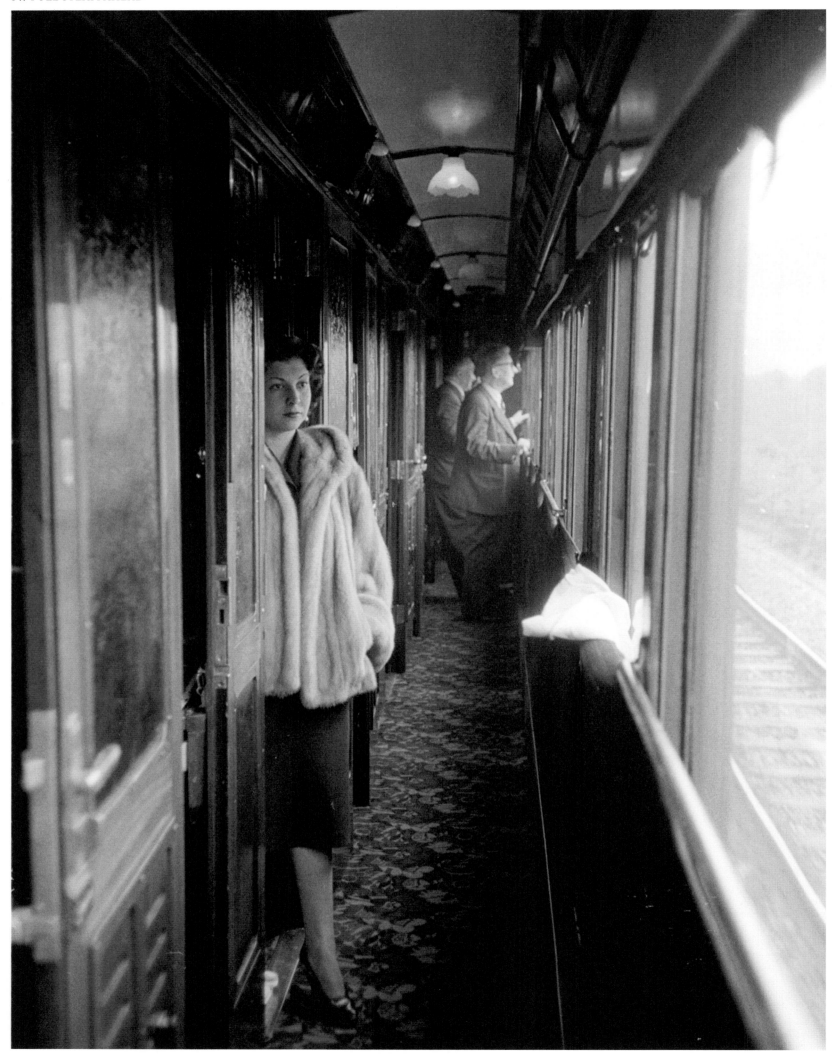

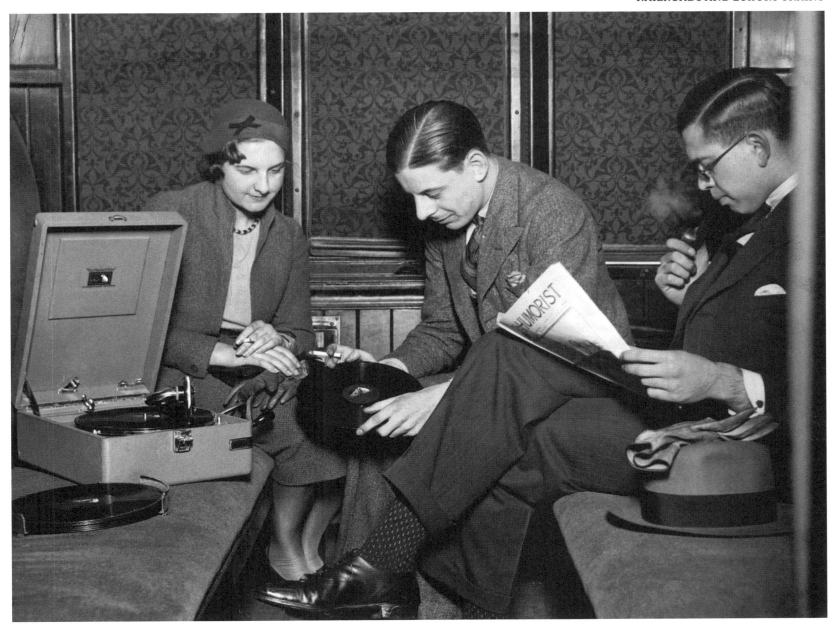

TRAVELING THE RAILS IN STYLE

Opposite: Lady in a fur coat on board the *Simplon Orient Express*, 1950.
Above: Passengers with a mobile gramophone on the *Flying Scotsman*, the legendary express train from London to Edinburgh, 1931.
Following pages: Posters for the express trains of the Compagnie Internationale des Wagons-Lits, 1925 and 1929.

BAHNREISEN MIT STIL

Links: Dame im Pelzmantel an Bord des *Simplon-Orient-Expresses*, 1950;
oben: Fahrgäste mit mobilem Grammofon im *Flying Scotsman*, dem legendären Expresszug von London nach Edinburgh, 1931
Seite 88/89: Plakate für den für die Expresszüge der Compagnie Internationale des Wagons-Lits, 1925 und 1929

LE GOÛT DU VOYAGE

Ci-contre : dame en fourrure à bord du *Simplon-Orient-Express*, 1950 ;
ci-dessus : passagers équipés d'un gramophone portatif à bord du *Flying Scotsman*, l'express de légende qui relie Londres à Édimbourg, 1931
Pages 88-89 : affiches pour les expresses de la Compagnie internationale des wagons-lits, 1925 et 1929

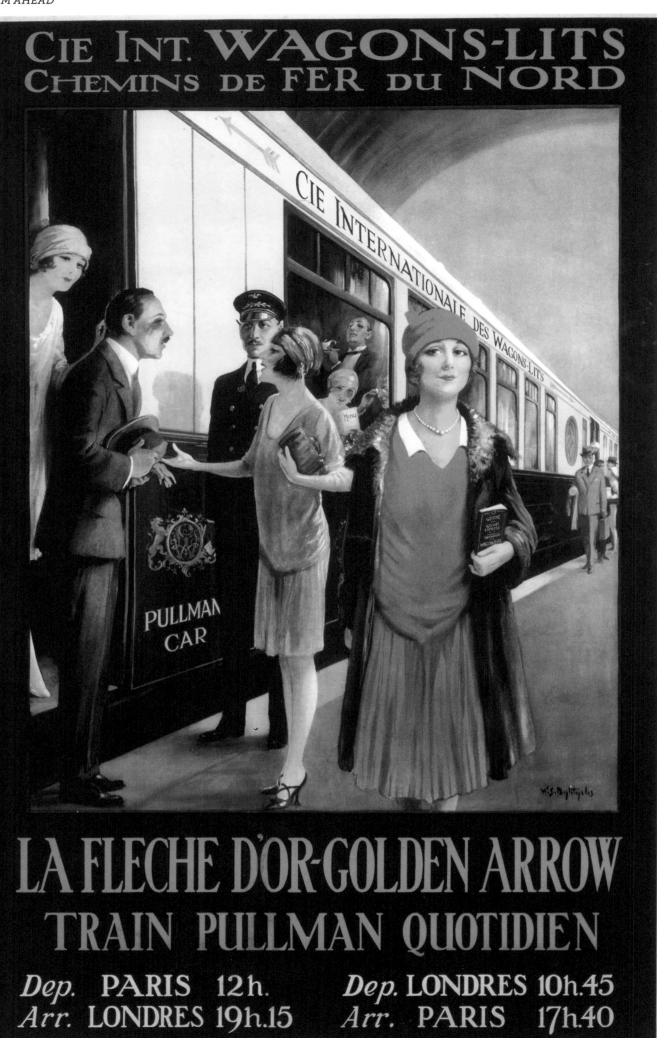

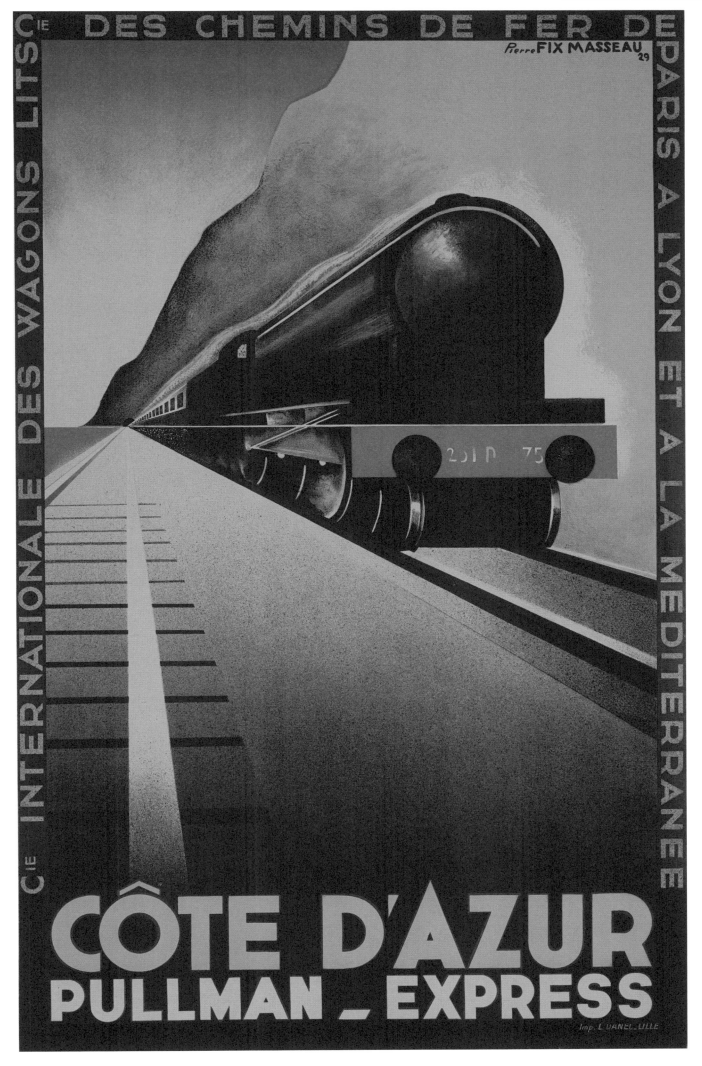

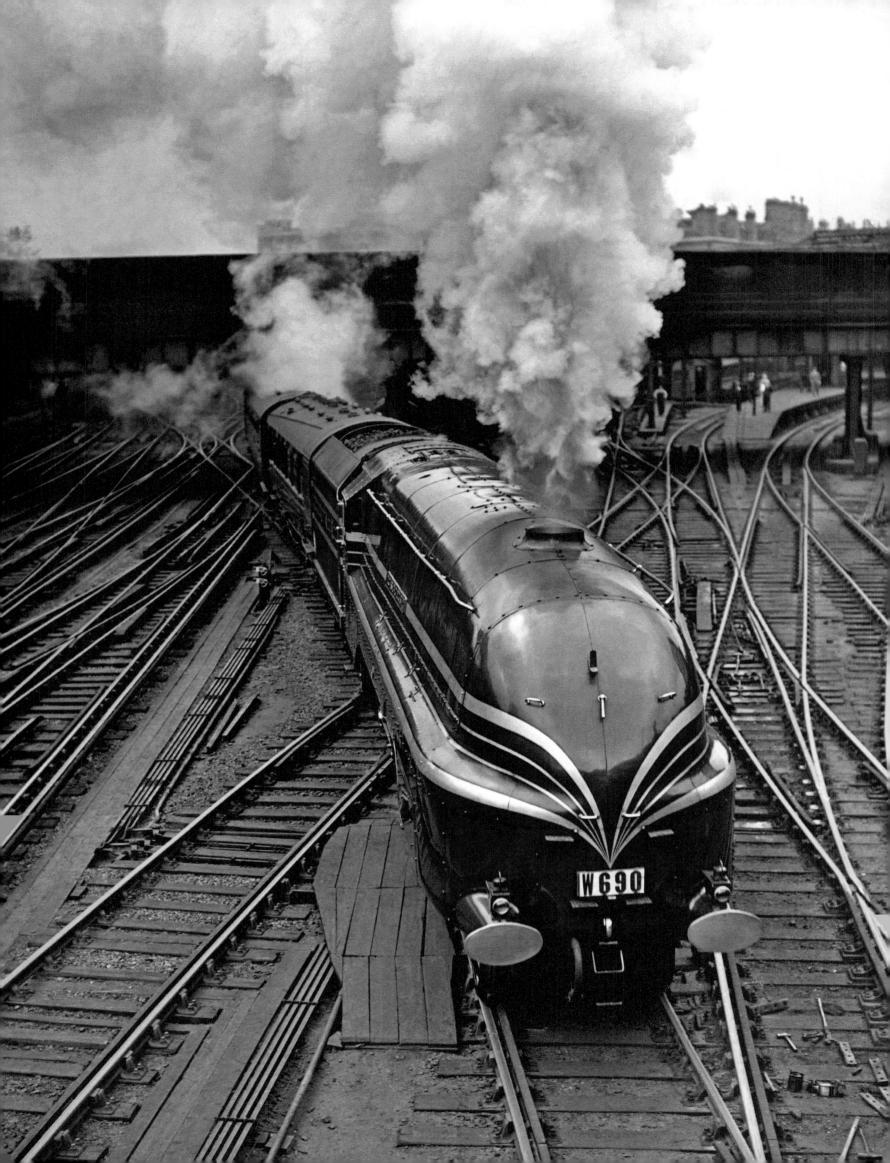

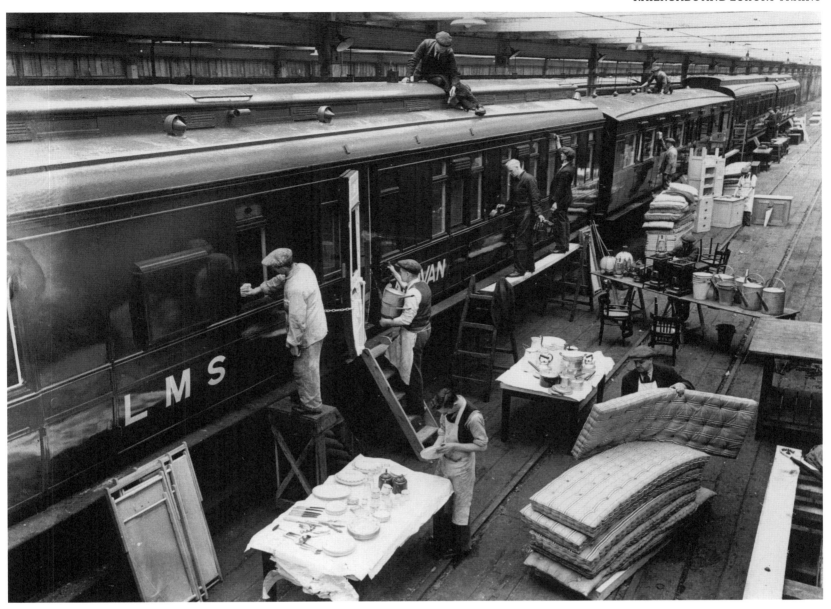

STREAMLINED

Opposite: The *Duchess of Gloucester* of the London, Midland and Scottish Railway (LMS), 1938. The streamlined steam locomotives of the 1930s along with electric multiple units (EMU) and diesel trains heralded a new heyday for rail travel.
Above: LMS sleepers being polished up for new passengers, 1937.

STROMLINIENFÖRMIG

Links: Die *Duchess of Gloucester* der London Midland and Scottish Railway (LMS), 1938. Die stromlinienförmigen Dampflokomotiven der 1930er-Jahre läuteten zusammen mit Elektrotriebwagen und Dieselzügen eine neue Blütezeit des Bahnreisens ein;
oben: LMS-Schlafwagen werden für neue Fahrgäste auf Hochglanz gebracht, 1937

AÉRODYNAMIQUE

Ci-contre : le *Duchess of Gloucester* de la London, Midland and Scottish Railway (LMS), 1938. Les locomotives à vapeur aux lignes aérodynamiques des années 1930, puis les rames électriques et les trains diesel, annoncent un renouveau du chemin de fer ;
ci-dessus : on donne un coup de jeune aux voitures-lits de la LMS pour accueillir de nouveaux passagers, 1937

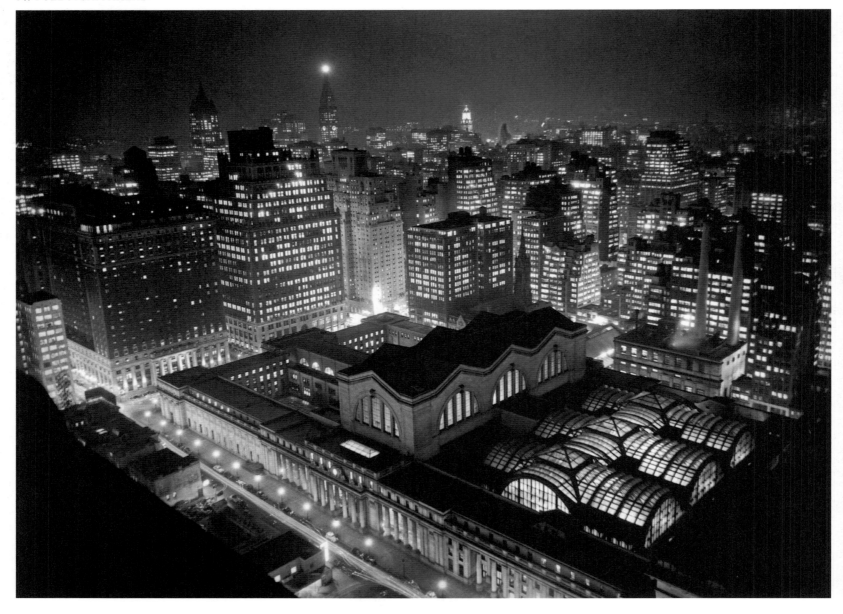

CITY LIGHTS

The two largest railway stations in Manhattan. Above: The old Pennsylvania Station, circa 1940.
Opposite: Entrance hall to Grand Central Station, circa 1940.
Following pages, from left: The furnishings of American luxury trains featured a streamlined aesthetic.
Pullman sleepers with closable berths, 1934; dining car in the *20ᵗʰ Century Limited*, 1938.

LICHTER DER GROSSSTADT

Die beiden großen Bahnhöfe Manhattans. Oben: Die alte Pennsylvania Station, um 1940;
rechts: Eingangshalle der Grand Central Station, um 1940
Seite 94: Eine stromlinienförmige Ästhetik prägte auch die Einrichtung der amerikanischen Luxuszüge.
Pullman-Schlafwagen mit verschließbaren Kojen, 1934;
Seite 95: Speisewagen des *20ᵗʰ Century Limited*, 1938

LES LUMIÈRES DE LA VILLE

Les deux grandes gares de Manhattan. Ci-dessus : l'ancienne Pennsylvania Station, vers 1940 ;
ci-contre : hall d'accueil de la Grand Central Station, vers 1940
Page 94 : l'aménagement intérieur des trains de luxe américains est, lui aussi, empreint
d'esthétique aérodynamique. Voiture-lit Pullman à couchettes fermées, 1934 ;
page 95 : le wagon-restaurant du *20ᵗʰ Century Limited*, 1938

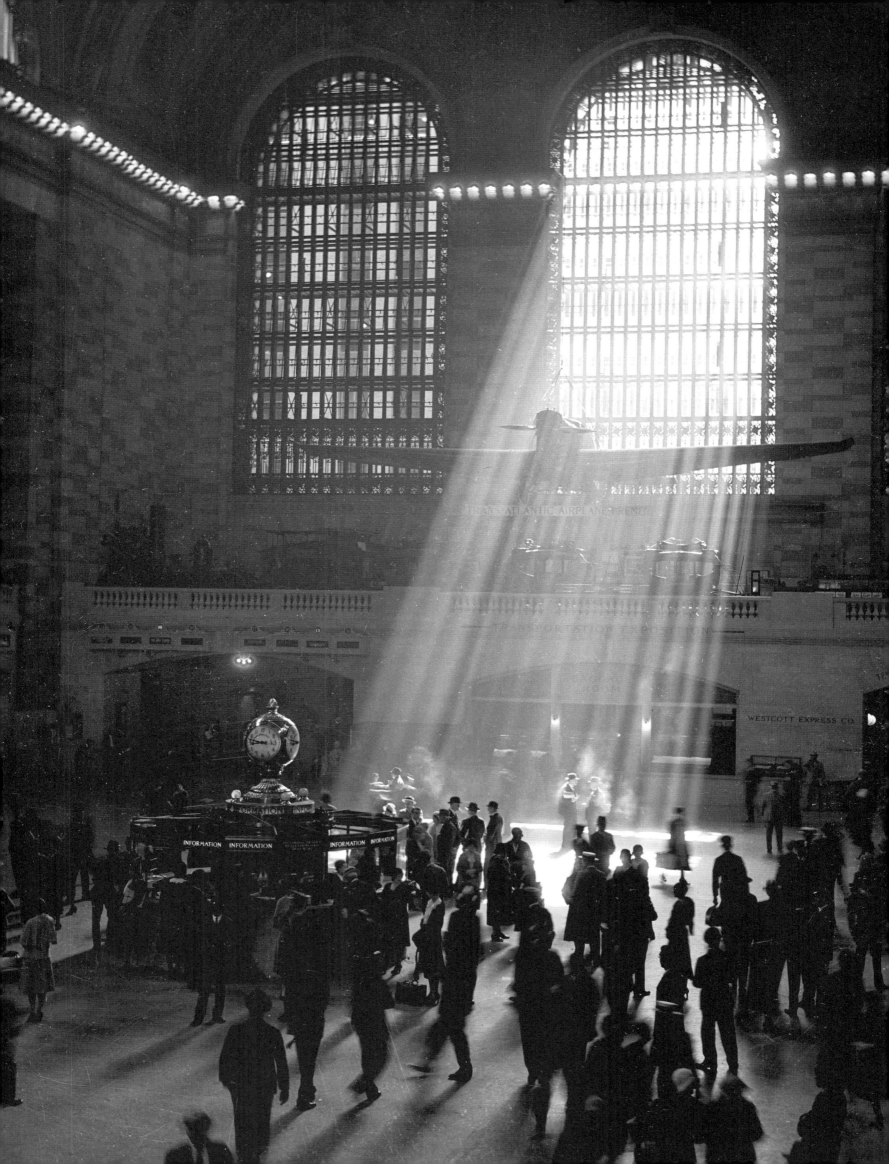

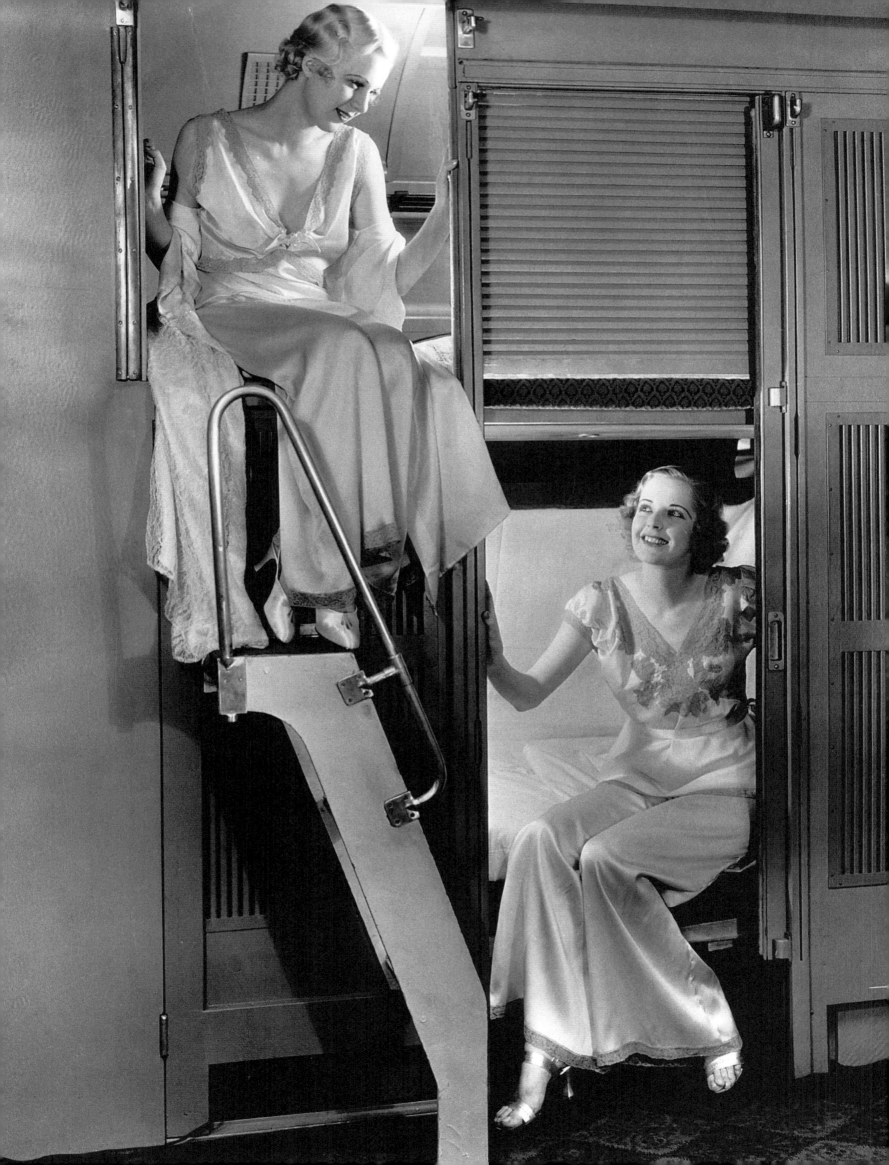

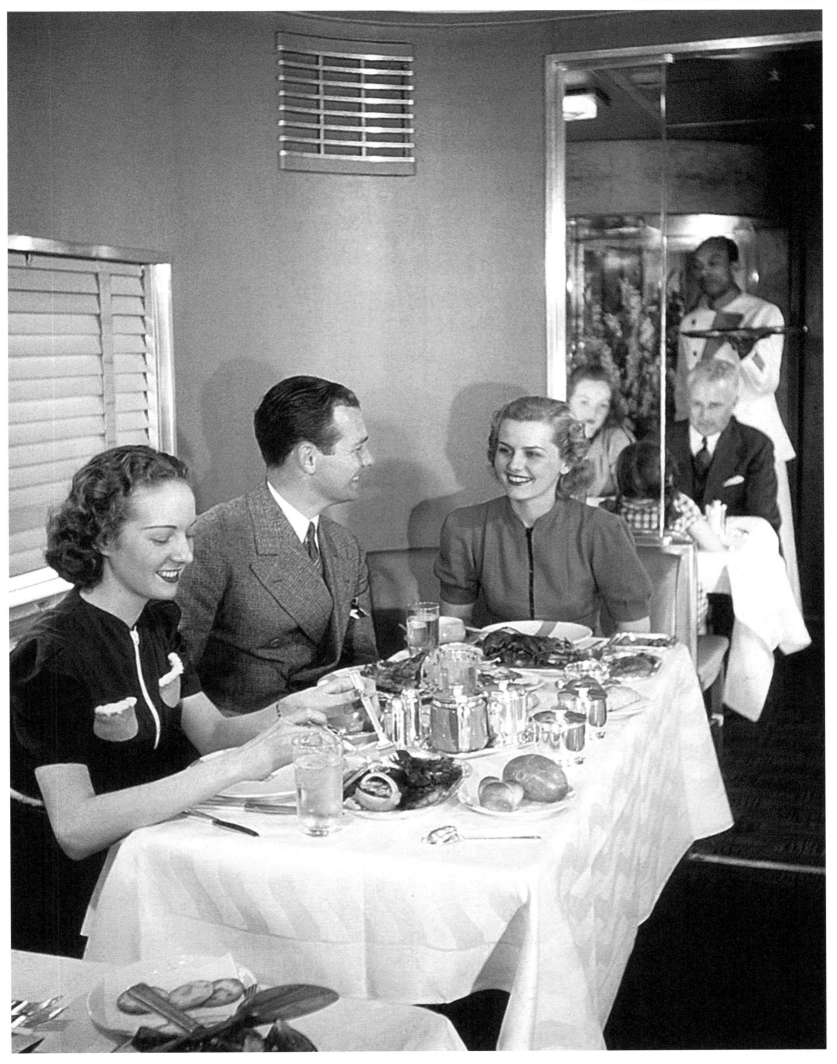

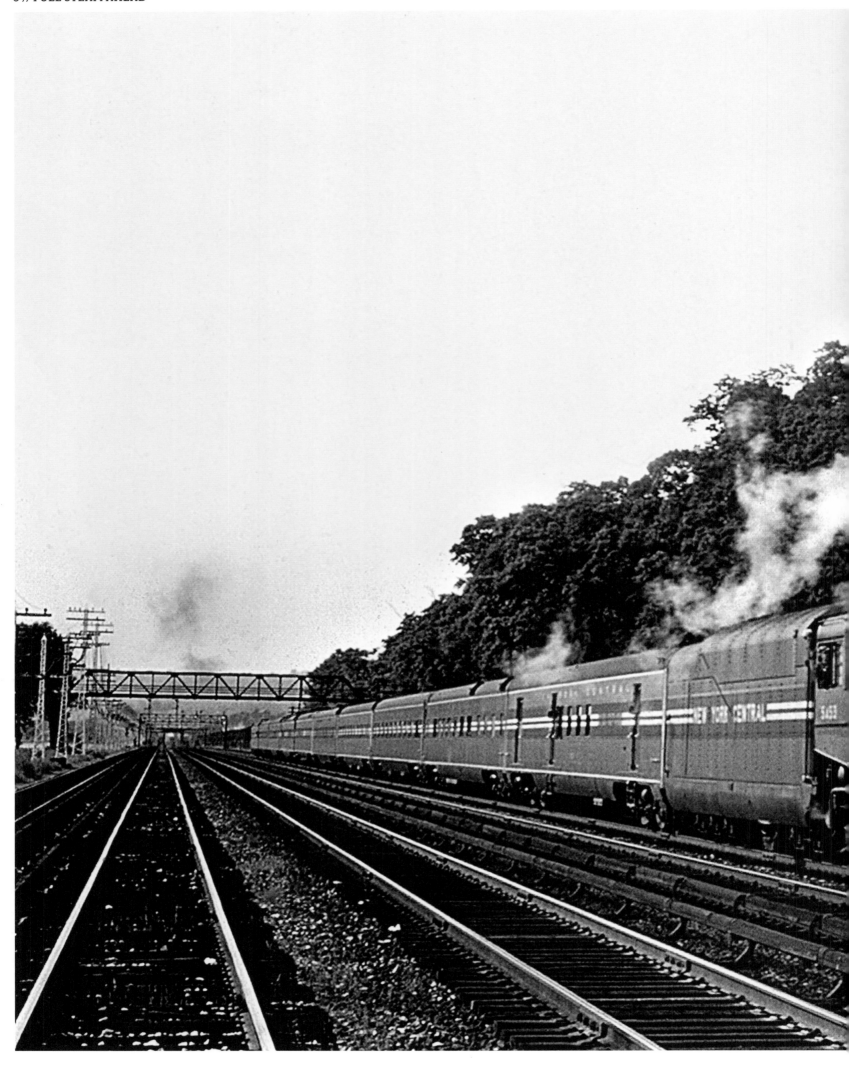

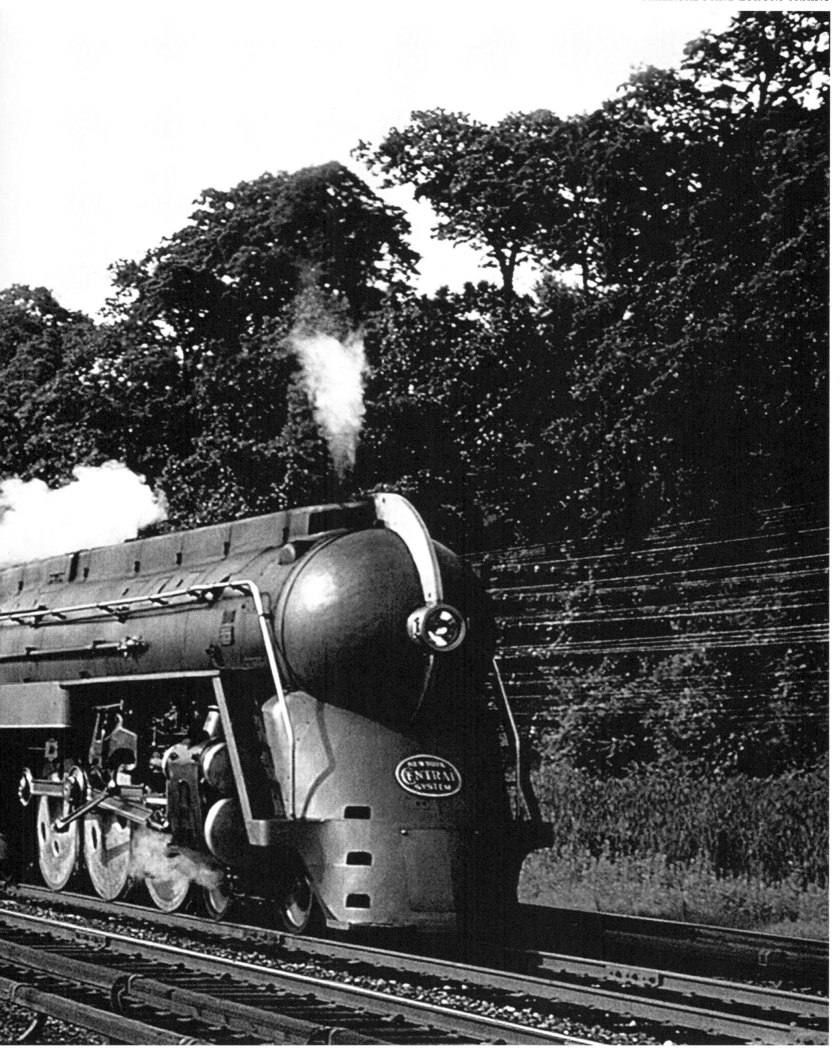

THE MOST AMAZING TRAIN IN THE WORLD

Previous pages: The *20ᵗʰ Century Limited* at
full speed, 1938.
Opposite: Cary Grant and Eva Marie Saint in front of
the *20ᵗʰ Century Limited* in Alfred Hitchcock's thriller
North by Northwest, 1959.

DER GROSSARTIGSTE ZUG DER WELT

Seite 96/97: Der *20ᵗʰ Century Limited* in
voller Fahrt, 1938
Rechts: Cary Grant und Eva Marie Saint vor dem
20ᵗʰ Century Limited in Alfred Hitchcocks Thriller
Der unsichtbare Dritte, 1959

LE PLUS GRAND TRAIN DU MONDE

Pages 96-97 : le *20ᵗʰ Century Limited* à toute vapeur, 1938
Ci-contre : Cary Grant et Eva Marie Saint devant le
20ᵗʰ Century Limited dans le thriller d'Alfred Hitchcock
La Mort aux trousses, 1959

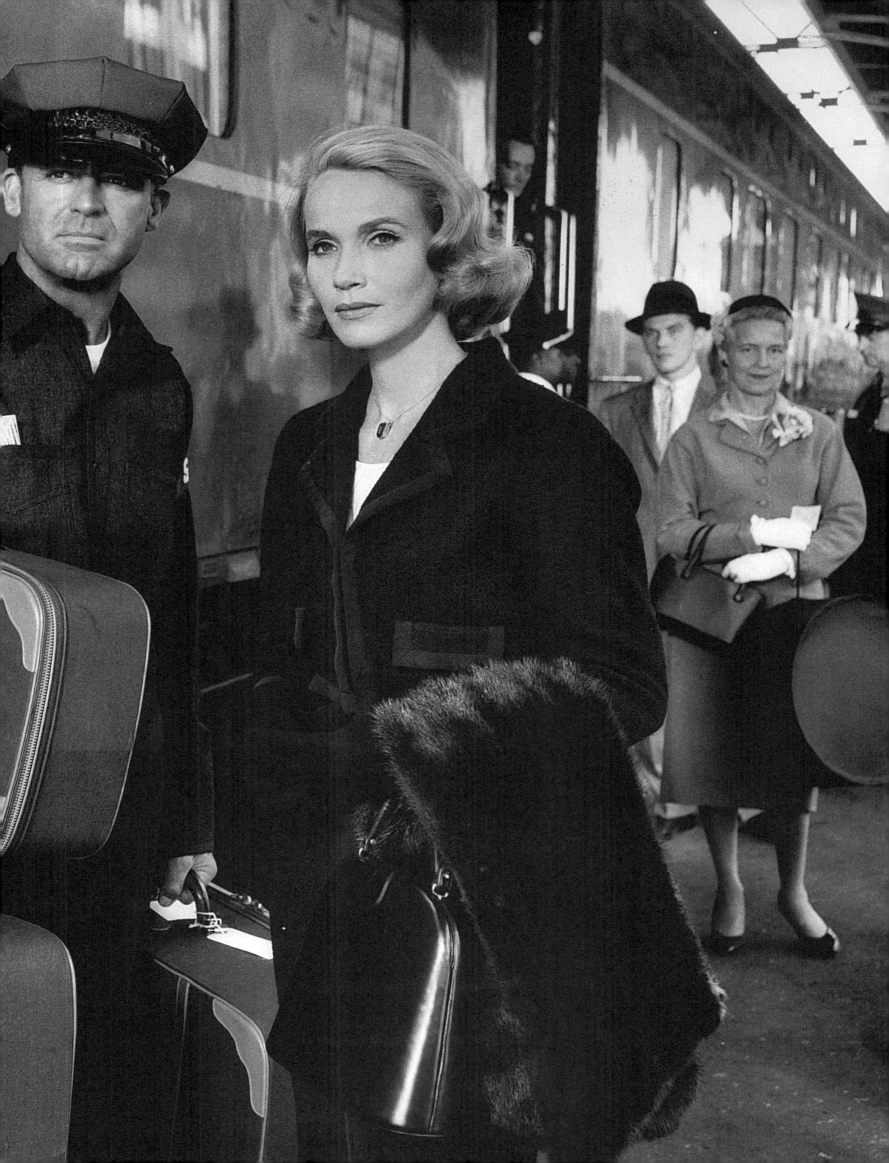

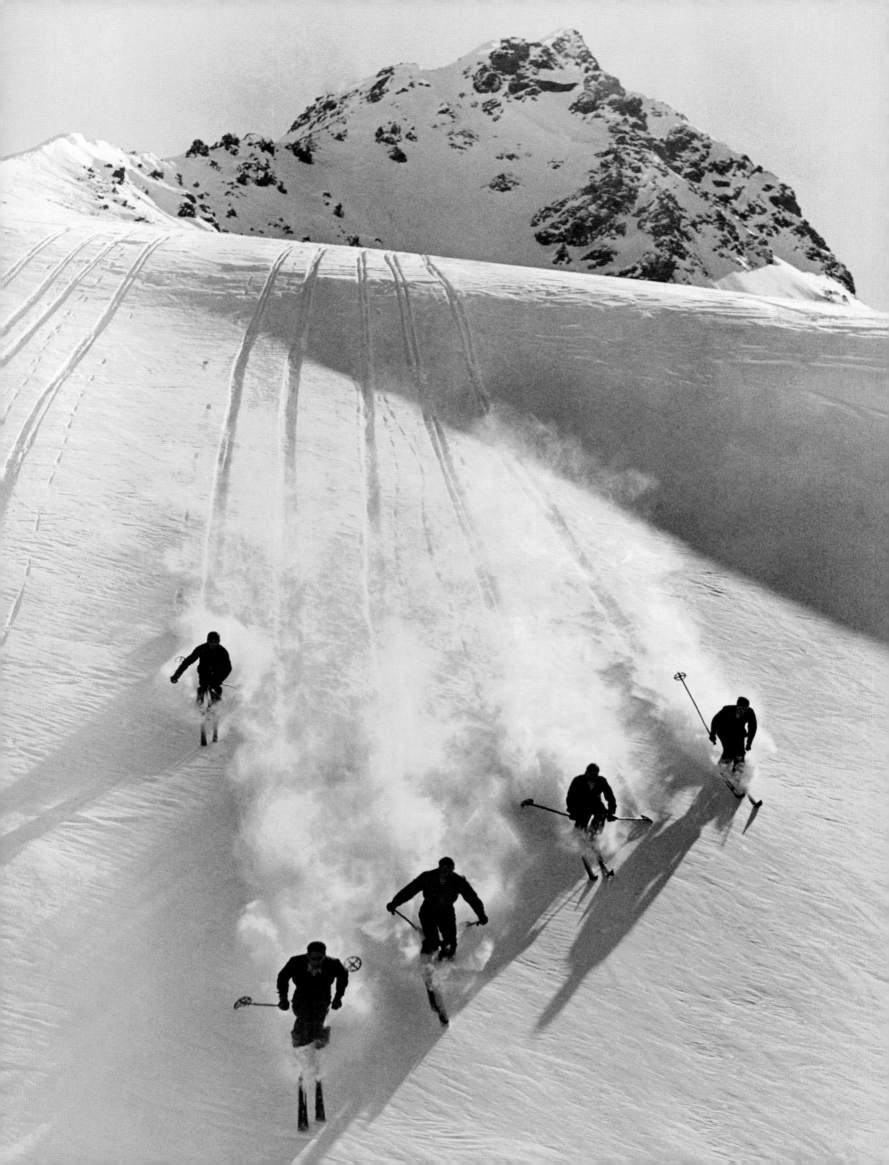

4

THE CALL OF THE MOUNTAINS

DER BERG RUFT
L'APPEL DE LA MONTAGNE

HIKING AND WINTER SPORTS

On August 8, 1786, two Frenchmen from Chamonix, Jacques Balmat and Michel-Gabriel Paccard, were the first to reach the top of Mont Blanc, the highest mountain in Europe. Until that time, no one had felt compelled to climb mountains, which people had seen as just part of the landscape.

Then came the Enlightenment and everything changed. In the mid-eighteenth century, people began feeling drawn to nature. Most mountain climbers were well-heeled, came from abroad, and had read the Swiss philosopher Jean-Jacques Rousseau. They sought to understand the connections between nature, culture, and their own place within the natural world. These mountaineers sketched and mapped terrain, gathered rock samples, and surveyed the landscape. They also ventured as far as the unexplored, icy wasteland of the Alps—adventures that elicited excitement as well as a measure of danger.

Poor Alpine farmers usually shook their heads in bewilderment over these eccentric amateur scientists and their strange destinations. And yet, because the locals knew every inch of the terrain as well as the kind of equipment needed to explore it, alpinists depended on their help. From 1750 to 1850, mountain climbers scaled nearly all of the "easier" Alpine peaks—at a leisurely pace and with little rivalry. The western Alpine peaks and glaciers cast an almost magical spell on travelers. No longer an impoverished transit country between northern and southern Europe, Switzerland became a destination in its own right.

The competitive sport of alpinism didn't gain a foothold until the nineteenth century. Most of its aficionados were Britons seeking the challenge of reaching the top of a steep mountain by scaling dangerous cliffs, blazing new trails, and ultimately conquering the summit. Edward Whymper, an extreme mountain sports enthusiast and the first man to climb the Matterhorn, may well offer the best example of how difficult and merciless this challenge could be. He finally reached the peak on July 14, 1865, and while he may have won the race against his competitor, Jean-Antoine Carrel, during the descent down the north face four of his rope mates plunged to their deaths.

Small groups of elite climbers who shared similar interests formed early Alpine clubs, the first of which was the British Alpine Club. Founded in 1857, it remained exclusively male for many years. As a result, women formed their own Ladies' Alpine Club in 1907. These clubs didn't really take root in the Alpine countries until some time later; Austria was the first in 1862 and France the last in 1874. With many thousands of members and a mandate to educate the public about mountaineering, these small clubs quickly grew into mass organizations.

Beginning in the mid-nineteenth century, visitors to the Alps weren't solely interested in rock climbing and hiking: they also came for their health. In the spa town of Davos, the invigorating Alpine climate healed lung ailments—or at least brought relief. As described in *The Magic Mountain*, Thomas Mann's famous novel that memorializes a fictional sanatorium in the canton of Grisons, these elegant high-altitude medical facilities not only treated the sick, but also saw their share of fun.

Visitors flocked to Bad Ischl in the Austrian Alps for its brine baths. After opening for regular business in 1823, the spa quickly drew crowds from all over Europe, including the Prince of Metternich, Austria's state chancellor. Bad Ischl became the emperor's official summer residence from 1849 until the outbreak of World War I in 1914.

While the mountains were once a popular destination only in summer, winter tourism gradually began to catch on. The first town to actively promote this new fad was St. Moritz. In the fall of 1864, the hotelier Johannes Badrutt of the St. Moritz Hotel-Pension Engadiner Kulm invited six of his English summer guests to spend the winter in the Engadine. He proposed a challenge: to sit on a sunny terrace in their shirtsleeves on a winter's day. If they couldn't tolerate the cold, he'd pay their travel expenses from England to St. Moritz. He won the bet, and in doing so invented the winter holidays.

News of a winter resort that offered luxurious accommodations and leisure activities soon spread throughout Europe, especially in England. Guests could enjoy bobsledding or skeleton sled rides down the Cresta Run at breakneck speeds. Those less inclined to risk their necks would book a moonlight ride in a horse-drawn sleigh across the upper Engadine lakes. After curling was introduced to the Continent in 1880, Badrutt built an ice rink specifically for the sport. Fascinated by the technological innovations he'd seen at the World Exposition in Paris, the entrepreneur also installed electric lights on his premises in 1879, including the hotel's very own hydroelectric power plant.

The rapidly expanding European railway network also helped make remote areas of Switzerland more accessible. Beginning in the mid-nineteenth century, bold engineers began planning an ambitious tunnel project beneath the St. Gotthard Massif allowing traffic to pass from north to south without being hindered by inclement weather. Work on the tunnel began in 1880.

Other engineers laid track all the way up mountain peaks. In 1871, Europe's first mountain cog railway opened near Lucerne. Known as the Vitznau Rigi Railway, it initially ran to an elevation of 5,000 feet. The train carried tourists up the mountain, including the American author Mark Twain. After chronicling his adventures in a travelogue, his readers began flocking to Switzerland. At the same time, engineers also began planning the Jungfraubahn, a railway that climbed the 11,371-foot Jungfraujoch peak. Another means of transportation would go on to shape the Alpine region in the twentieth century: the first funicular railway was com-

pleted in 1907 and transported tourists from St. Moritz to the Muottas Muragl summit. One year later, the first passenger aerial tramway began running between Bolzano and Mount Colle in Italy. Also in 1908, the first T-bar ski lift went into operation in Bödele, a town in the state of Vorarlberg, Austria, which paved the way for establishing today's most popular winter sport: Alpine skiing.

As early as the eighteenth century, residents of Norway's Telemark province began strapping long wooden boards to their feet to help them cross snowy terrain without sinking into the snow. In the Scandinavians' view, those who hurtled down slopes on skis were either

Lunn outfitted hotels in the Swiss towns of Mürren, Klosters, and Wengen with T-bar lifts, which then led him to establish the first English national championships in downhill skiing. In 1922, he brought a new challenge to the sport by setting up slalom gates on a ski run. At his instigation, Alpine skiing and slalom became athletic disciplines for the first time at the 1936 Winter Olympic Games in Garmisch-Partenkirchen, Germany.

Later, after a terrible ski accident left him with one leg much shorter than the other, Lunn grew appalled at the excesses of his favorite sport; he's said to have even contemplated setting up an organization to discourage skiing.

crowds of autograph seekers, whom they are more likely to encounter in Zermatt and St. Moritz. The French town of Chamonix, situated at the foot of the Mont Blanc Massif, is one of the oldest and largest winter sports venues in France. The first Winter Olympics were held there in 1924. The mountains in Tyrol and Vorarlberg, Austria, were drawing sports enthusiasts to the region with ski resorts such as St. Anton, Zürs, Lech, and Kitzbühel. Winter sports venues in Italy included the Aosta Valley and the Dolomites, the location of Cortina d'Ampezzo, which hosted the Winter Olympics in 1956.

American mountaineers and skiers had plenty of choices for practicing their sport without traveling all the way to Europe. The world's first mountain cog railway, built in 1869, connected Marshfield to Mount Washington in New Hampshire. Early on, the rugged White Mountains became the destination of choice for New England's winter sports fans. Mount Washington itself is the northern end of the Appalachian Trail, a 2,200-mile hiking trail that stretches from northern Georgia to the White Mountains and continues to draw thousands of hiking enthusiasts today.

After World War II, ski areas also arose in the Rocky Mountains, most notably in Colorado, on the eastern side of the mountain range. The former silver mining town of Aspen is a legendary winter sports venue in this region. The resort was established in 1947 when the German ski instructor Klaus Obermeyer introduced the snowbound sport to the small town of Victorian homes.

> 66 *IT IS THE GENERAL IMPRESSION EXPERIENCED BY ALL MEN THAT ON HIGH MOUNTAINS, WHERE THE AIR IS PURE AND SUBTLE, ONE BREATHES MORE FREELY AND FEELS MORE LIGHTNESS IN THE BODY, GREATER SERENITY IN THE SPIRIT.* 99
> —JEAN-JACQUES ROUSSEAU, JULIE, OR THE NEW HELOISE, *1761*

not fit enough to undertake a long and strenuous cross-country ski trek, or they lacked the courage to leap off a ski jump.

Downhill skiing didn't really become popular until Arnold Lunn appeared on the scene. Lunn's father ran a travel agency that organized winter trips and, as a result, the young English mountaineer and Oxford graduate paid frequent visits to Switzerland. In 1919, he established the Public Schools Alpine Sports Club, an elitist organization with restrictive enrollment rules. Candidates (or their parents) had to have attended an expensive private school (British public school) in England, which kept the membership exclusive. However, even ordinary mortals could book trips through his agency, Sir Henry Lunn Travel.

In the twentieth century, mountain villages dedicated themselves almost exclusively to tourism, attracting visitors from around the world: mountain climbers in the summer and skiers in the winter. Interlaken, nestled between Lake Thun and Lake Brienz in Switzerland's Bernese highlands, become a popular starting point for excursions to the Eiger, Mönch, and Jungfrau mountains. Zermatt, a town at the foot of the Matterhorn, has preserved its small-town charm and remains car-free to this very day. The village of Gstaad in the Bernese highlands still maintains a traditional atmosphere with its Swiss chalet architectural style. From early twentieth century to the present, international jetsetters have been coming to the village for quiet winter vacations and to escape oppressive

DEEP SNOW RUNS
Page 100: Skiers in the Swiss Alps, 1928.

TIEFSCHNEEFAHRTEN
Seite 100: Skiläufer in den Schweizer Alpen, 1928

IMMENSITÉS DE NEIGE FRAÎCHE
Page 100 : skieurs dans les Alpes suisses, 1928

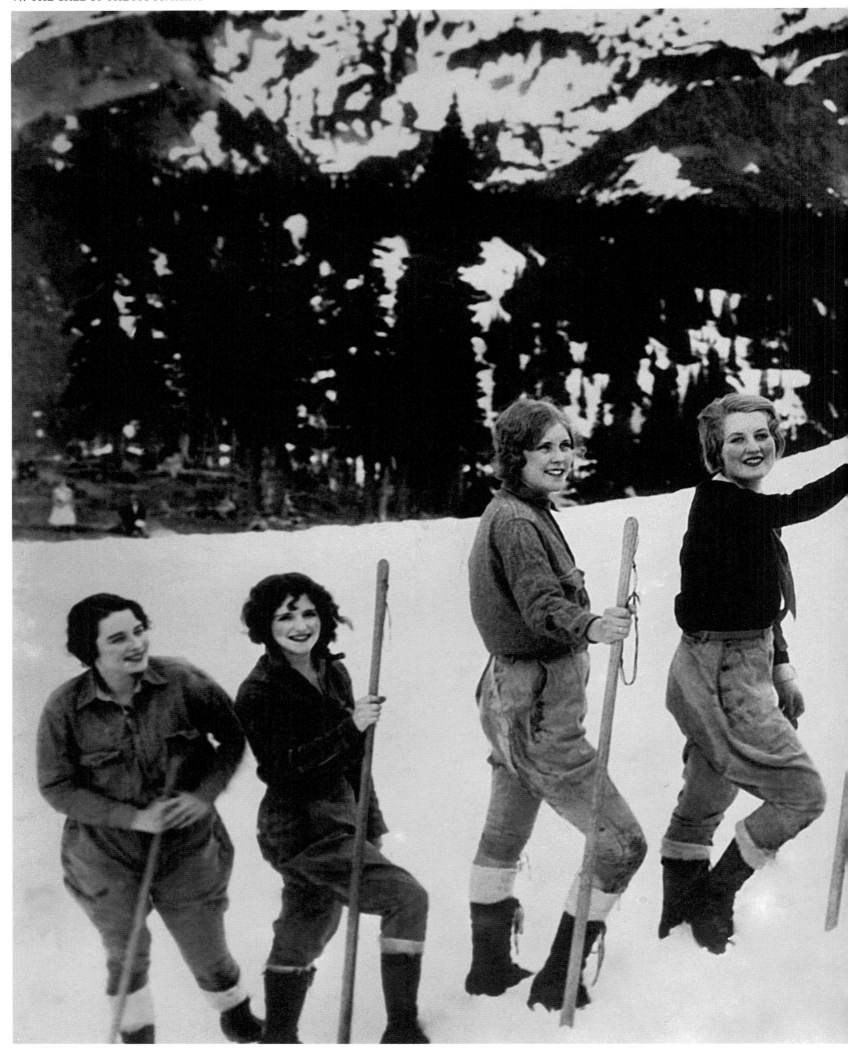

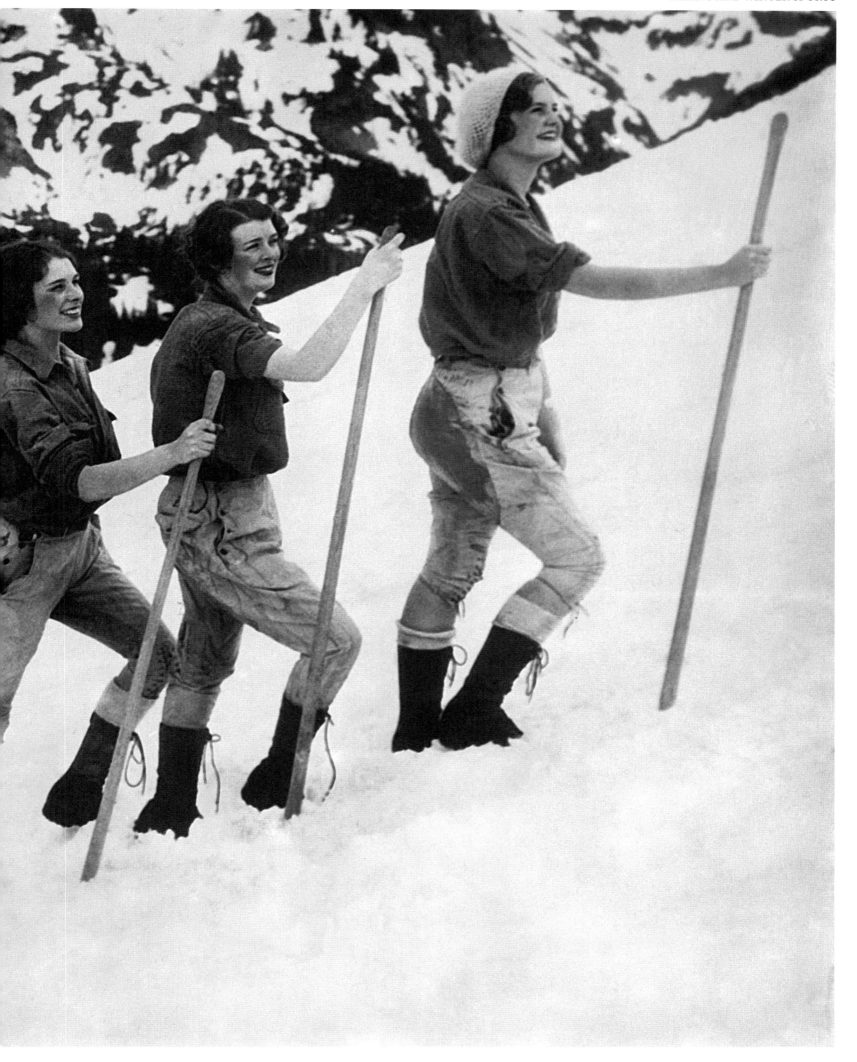

WANDERN UND WINTERSPORT

Am 8. August 1786 standen die beiden Franzosen Jacques Balmat und Michel-Gabriel Paccard aus Chamonix als erste auf dem Gipfel des Montblanc, des höchsten Berges Europas. Davor hatte niemand die Notwendigkeit gesehen, Gipfel zu ersteigen. Sie waren einfach da.

Erst mit der Zeit der Aufklärung änderte sich das. Seit Mitte des 18. Jahrhunderts zog es die Menschen in die Natur. Die Gipfelstürmer waren meist wohlhabende Menschen, kamen aus dem Ausland und hatten den Schweizer Naturphilosophen Jean-Jacques Rousseau gelesen. Sie wollten die Zusammenhänge zwischen Natur und Kultur und die Rolle des Menschen darin verstehen. Sie zeichneten, kartografierten, nahmen Gesteinsproben, vermaßen Gebiete. So zog es sie auch in die nie bestiegenen Eiswüsten der Alpen. Das war spannend, aber nicht ungefährlich.

Die armen Alpenbauern schüttelten meist den Kopf über die exzentrischen Wissenschaftler und ihre seltsamen Ziele. Weil sie aber über genaue Kenntnisse der Gegend und die richtige Ausrüstung verfügten, wurden sie für die Alpinisten zu unentbehrlichen Helfern. Von 1750 bis 1850 erklommen Bergsteiger so fast alle „einfacheren" Gipfel der Alpen, gemächlich und nahezu ohne Wetteifer. Die Gipfel und Gletscher der Westalpen übten eine fast magische Anziehungskraft auf Reisende aus. Die Schweiz, bis dahin lediglich ein armes Transitland zwischen Nord- und Südeuropa, wurde nun selbst zum Reiseziel.

Der sportliche Alpinismus mit seinem Wettkampfgedanken kam erst Mitte des 19. Jahrhunderts auf. Es waren hauptsächlich Briten, die die sportliche Herausforderung suchten, schwierige Gipfel zu erklettern, durch eine gefährliche Wand zu steigen, neue Wege zu beschreiten und schließlich dann hoch oben anzukommen.

Wie hart und erbarmungslos dieser Wettkampf sein konnte, wird vielleicht am deutlichsten am Beispiel der Erstbesteigung des Matterhorns durch den englischen Extremalpinisten Edward Whymper. Am 14. Juli 1865 stand er endlich auf dem Gipfel. Das Duell mit seinem Konkurrenten Jean-Antoine Carrel hatte er zwar gewonnen, beim Abstieg über die Nordwand stürzten jedoch vier Männer seiner Seilschaft in den Tod.

Die ersten Alpenvereine waren zunächst kleine Gruppierungen von Eliten mit gleichen Interessen. Der erste Bergsteigerbund war der britische Alpine Club. Er wurde 1857 gegründet und war lange Zeit eine reine Männervereinigung. Bergsteigerinnen organisierten sich deshalb 1907 im Ladies' Alpine Club. In den Alpenländern selbst gründeten sich die Verbände etwas später: Österreich machte 1862 den Anfang, Frankreich kam mit seinem Alpenverein 1874 zuletzt. Schnell wurden aus den kleinen Vereinen Massenorganisationen mit bildungsbürgerlichem Auftrag und vielen Tausenden Mitgliedern.

Nicht nur zum Bergsteigen und Wandern reisten die Menschen ab Mitte des 19. Jahrhunderts in die Alpen, sondern auch der Gesundheit wegen. Im Schweizer Luftkurort Davos brachte das alpine Reizklima Lungenkranken Heilung – oder zumindest Erleichterung. Dass in den mondänen Hochgebirgssanatorien nicht nur gekurt, sondern auch gefeiert wurde, ist bekannt aus Thomas Manns Roman *Der Zauberberg*, der einer Heilanstalt in Graubünden ein literarisches Denkmal gesetzt hat.

In den österreichischen Alpen lockte Bad Ischl Gäste mit seinen Solebädern. 1823 begann der reguläre Kurbetrieb und zog schnell europäisches Publikum an, darunter den österreichischen Staatskanzler Fürst von Metternich. 1849 wurde Bad Ischl die offizielle kaiserliche Sommerresidenz und blieb dies bis zum Ausbruch des Ersten Weltkrieges.

Waren die Berge zuvor meist Ziele für die Sommermonate, so wurde der Wintertourismus allmählich immer wichtiger. Der erste Ort, der diese Mode gezielt vermarktete,

war St. Moritz. Der Hotelier Johannes Badrutt, Betreiber der St. Moritzer Hotel-Pension Engadiner Kulm, lud im Herbst 1864 sechs englische Sommergäste dazu ein, auch den Winter im Engadin zu verbringen. Er schlug ihnen eine Wette vor: Sollten sie im Winter nicht hemdsärmelig im Sonnenschein auf der Terrasse sitzen können, würde er die Reisekosten aus England nach St. Moritz übernehmen. Er gewann und erfand so die Winterferien.

Die Nachricht von einer Schweizer „Winterfrische" mit luxuriöser Unterkunft und vielen Freizeitangeboten machte schnell die Runde – zunächst in England. Die Gäste konnten halsbrecherische Bob- oder Skeletonfahrten auf der Cresta-Bahn unternehmen. Wer es ruhiger liebte, buchte eine Pferdeschlittenfahrt bei Mondschein über die verschneiten Oberengadiner Seen. 1880 wurde auf dem Kontinent dann erstmals Curling gespielt; dafür hatte Badrutt eigens eine Eisbahn angelegt. Fasziniert von den technischen Neuerungen der Pariser Weltausstellung, stattete der Unternehmer seine Einrichtungen ab 1879 außerdem mit elektrischer Beleuchtung aus – eigenes Wasserkraftwerk inklusive.

Mit dem rasanten Ausbau des europäischen Eisenbahnnetzes wurde auch die Schweiz immer besser erschlossen. Kühne Ingenieure planten bereits ab Mitte des 19. Jahrhunderts die Untertunnelung des Gotthardmassivs für eine wetterunabhängige Verkehrsverbindung von Nord nach Süd. 1880 erfolgte schließlich der Durchbruch.

Andere verlegten sogar Gleise zu den Berggipfeln: 1871 eröffnete mit der *Vitznau-Rigi-Bahn* bei Luzern die erste Zahnradbergbahn Europas, die anfangs auf 1550 Meter Höhe hinauffuhr. Fahrgäste waren Touristen, unter ihnen der amerikanische Autor Mark Twain. In der Folge lockte seine Reisebeschreibung viele Gäste in die Schweiz. Zur gleichen Zeit begann auch die Planung der Jungfraubahn auf das 3466 Meter hohe Jungfraujoch. Ein weiteres Verkehrsmittel sollte im 20. Jahrhundert die Bergwelt prägen: Die erste Standseilbahn wurde 1907 fertig und beförderte Gäste aus dem nahen St. Moritz auf den

Muottas Muragl. Ein Jahr später führte die erste Personenluftseilbahn von Bozen nach Kohlern. Ebenfalls 1908 nahm im Bödele im österreichischen Vorarlberg der erste Schlepplift seinen Betrieb auf. Beste Voraussetzungen dafür, dass sich die heute beliebteste Wintersportart durchsetzen konnte: das alpine Skifahren.

In der norwegischen Provinz Telemark schnallte man sich bereits seit dem 18. Jahrhundert lange Holzbretter unter die Füße, um sich in der Ebene im Schnee fortzubewegen ohne einzusinken. Menschen, die sich auf Skiern einen Hang hinabstürzten, waren nach Auffassung der Skandinavier entweder nicht gut genug in Form, um lange und anstrengende Ski-

und Wengen Hotels mit Schleppanlagen ausstatten und folgerichtig in Mürren die erste englische Landesmeisterschaft im Abfahrtslauf ausrichten. 1922 brachte er Abwechslung ins Skifahren, indem er Slalomtore auf der Piste aufstellen ließ. Abfahrtslauf und Slalom wurden auf sein Betreiben Wettkampfdisziplinen bei den Olympischen Winterspielen 1936 in Garmisch-Partenkirchen.

Später war Arnold Lunn, der von einem schweren Skiunfall ein stark verkürztes Bein davongetragen hatte, entsetzt über die Auswüchse des Skisports. Er soll sogar darüber nachgedacht haben, eine Organisation gegen das Skifahren zu gründen.

Aus Bergdörfern wurden im 20. Jahrhundert

orte Frankreichs. 1924 fanden hier die ersten olympischen Winterspiele statt. In Österreich lockten die Berge Tirols und Vorarlbergs mit Skiorten wie St. Anton, Zürs, Lech und Kitzbühel. In Italien gab es für den Wintersport das Aostatal und die Dolomiten mit Cortina d'Ampezzo, wo im Jahre 1956 die Olympischen Winterspiele stattfanden.

Amerikanische Bergwanderer und Skifahrer mussten nicht unbedingt nach Europa reisen, um ihrem Sport nachgehen zu können. Die weltweit erste Zahnradbergbahn führte ab 1869 von Marshfield auf den Mount Washington in New Hampshire. Die wilden White Mountains waren schon früh das Ziel der Wahl für die Wintersportler Neuenglands. Der Mount Washington selbst ist der nördliche Abschluss des Appalachian Trail, eines Fernwanderweges, der sich mit 3 500 Kilometern Länge vom Norden Georgias bis in die White Mountains zieht und bis heute Tausende begeisterte Wanderer anlockt.

Nach dem Zweiten Weltkrieg entstanden auch in den Rocky Mountains Skigebiete, die bekanntesten in Colorado auf der Ostseite der Gebirgskette. Ein legendärer Wintersportort ist dort die ehemalige Silberminenstadt Aspen. 1947 brachte der deutsche Skilehrer Klaus Obermeyer den Weißen Sport in das Örtchen mit den viktorianischen Häusern.

> ## 99 ALLE MENSCHEN WERDEN DIE WAHRNEHMUNGEN MACHEN, DASS MAN AUF HOHEN BERGEN, WO DIE LUFT REIN UND DÜNN IST, FREIER ATMET UND SICH KÖRPERLICH LEICHTER UND GEISTIG HEITERER FÜHLT. 66
>
> *JEAN-JACQUES ROUSSEAU, JULIE ODER DIE NEUE HELOISE, 1761*

wanderungen zu bewältigen. Oder sie waren zu feige, von einer Schanze zu springen.

Der Abfahrtsskilauf wurde erst richtig populär, als Arnold Lunn auf den Plan trat. Lunns Vater betrieb ein Reisebüro, das auch Winterreisen organisierte. So war der junge englische Bergsteiger und Oxford-Absolvent häufig in der Schweiz. 1919 gründete er den Public Schools Alpine Sports Club. Die Grundbedingung für die Mitgliedschaft war extrem snobistisch: Der Anwärter oder seine Eltern mussten eine Public School, also eine teure englische Privatschule, besucht haben. Entsprechend überschaubar war die Mitgliederzahl zunächst. Mit seiner Agentur Sir Henry Lunn Travel konnten aber auch Normalsterbliche verreisen. Lunn ließ in der Schweiz in Mürren, Klosters

nahezu reine Touristenziele für Gäste aus aller Welt, im Sommer für Bergsteiger, im Winter für Skifahrer. Interlaken zwischen dem Thunersee und dem Brienzersee im Berner Oberland empfahl sich als Ausgangsort für Touren auf Eiger, Mönch und Jungfrau. Zermatt am Fuße des Matterhorns erhielt sich seinen dörflichen Charme – bis heute ist es autofrei. Ganz als Dorf mit Gebäuden im Chaletstil präsentiert sich noch heute Gstaad im Berner Oberland. Hier genoss und genießt der internationale Jetset seine Winterferien, anders als in Zermatt oder St. Moritz meist in Ruhe gelassen von aufdringlichen Autogrammjägern. Das französische Chamonix liegt am Fuße des Montblanc-Massivs und ist einer der ältesten und größten Wintersport-

SUMMITEERS
Previous pages: Snow hike on Mount Rainier in the U.S. state of Washington, 1931.

GIPFELSTÜRMERINNEN
Seite 104/105: Schneewanderung auf den Mount Rainier im US-Bundesstaat Washington, 1931

À L'ASSAUT DES SOMMETS
Pages 104-105 : randonnée dans la neige sur les flancs du mont Rainier, dans l'État américain de Washington, 1931

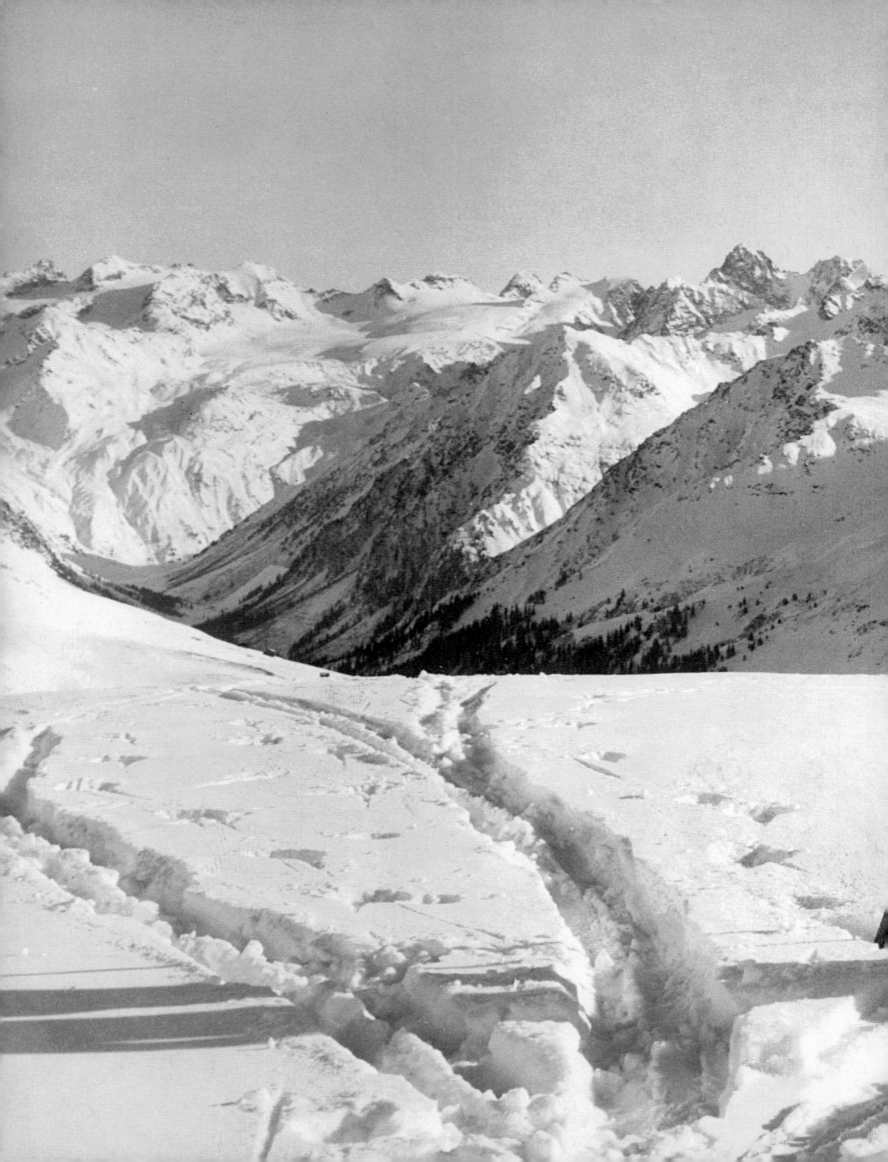

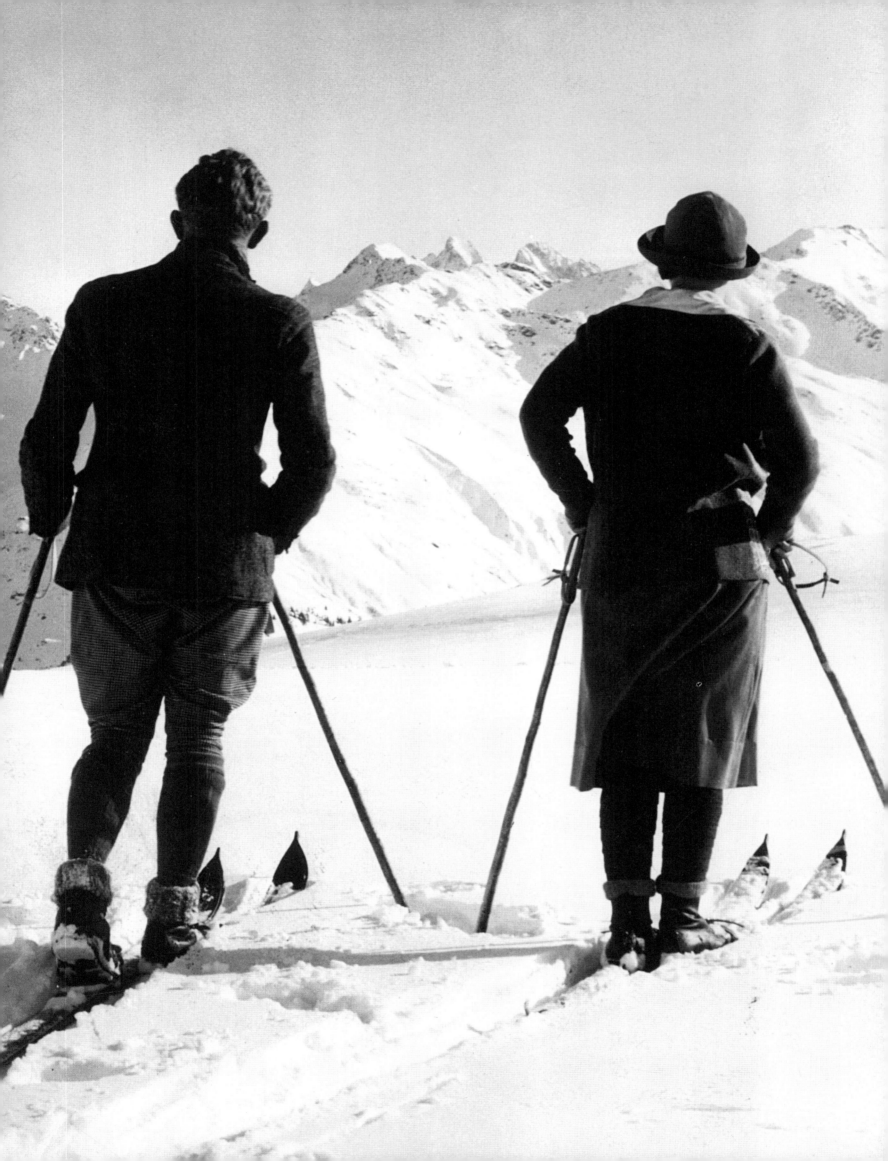

RANDONNÉE ET SPORTS D'HIVER

Le 8 août 1786, deux Français de Chamonix, Jacques Balmat et Michel-Gabriel Paccard, atteignent pour la première fois le sommet du mont Blanc, le point culminant de l'Europe. Auparavant, nul n'avait éprouvé le besoin de gravir les cimes. Les pics montagneux faisaient partie du paysage, voilà tout.

Tout change à l'ère des Lumières. Depuis le milieu du XVIIIe siècle, l'homme redécouvre la nature. Les premiers alpinistes sont en majorité de riches étrangers, admirateurs de l'œuvre du philosophe naturaliste suisse Jean-Jacques Rousseau. Ils aspirent à comprendre la corrélation entre nature et culture, et à appréhender le rôle de l'homme dans ces interactions. Ils dessinent, cartographient, arpentent et prélèvent des échantillons de roche. Ainsi se hasardent-ils à la découverte des déserts de glace inexplorés des Alpes. L'aventure est passionnante, mais périlleuse.

Devant ces excentriques et leurs étranges desseins, les montagnards, qui vivent dans la pauvreté, n'en croient pas leurs yeux. Mais leur aide est indispensable aux scientifiques, car ils connaissent la région sur le bout des doigts et disposent d'équipements adaptés. Entre 1750 et 1850, les alpinistes viennent à bout de presque tous les sommets « faciles » des Alpes, sereinement et sans se livrer de course acharnée, ou presque. Désormais, sommets et glaciers de l'ouest des Alpes exercent sur les voyageurs une irrésistible fascination. Petit pays de transit entre le nord et le sud de l'Europe, jusqu'alors sans ressources, la Suisse devient une destination en soi.

L'alpinisme sportif, animé par l'esprit de compétition, n'apparaît qu'au milieu du XIXe siècle. Dans un premier temps, ce sont surtout des Britanniques qui recherchent le défi : gravir un versant escarpé, vaincre une paroi dangereuse, défricher de nouveaux passages et, enfin, parvenir au sommet.

La concurrence entre les alpinistes de l'extrême se durcit et se fait parfois impitoyable, comme lors de la première ascension du mont Cervin par l'Anglais Edward Whymper. Le 14 juillet 1865, il parvient enfin au sommet. Certes, il a gagné le duel qui l'oppose à son concurrent Jean-Antoine Carrel, mais il a perdu quatre hommes de sa cordée lors d'une chute sur le versant nord.

Les premiers clubs alpins sont de petits regroupements d'alpinistes issus de l'élite, qui partagent les mêmes intérêts. Le premier, fondé en 1857, est le Club alpin britannique, qui restera longtemps exclusivement masculin. Aussi les femmes créent-elles leur propre club alpin, en 1907. Dans les pays de montagne, les fédérations d'alpinistes s'organisent un peu plus tardivement : en 1862, l'Autriche ouvre la marche, alors que la France sera la dernière à fonder son club alpin, en 1874. Ces petites associations confidentielles deviendront vite des organisations de masse comptant plusieurs milliers de membres et véhiculant les valeurs culturelles des classes aisées.

Si l'on se rue vers les Alpes à partir du milieu du XIXe siècle, ce n'est pas seulement pour marcher en altitude et gravir les cimes, c'est aussi pour des raisons de santé. L'air sec et vivifiant de Davos, en Suisse, soigne les affections pulmonaires – du moins elle les soulage. Pourtant, les sanatoriums chics de haute montagne ne sont pas uniquement des lieux de cure – on y mène aussi la grande vie. Situé dans la région des Grisons, le roman de Thomas Mann *La Montagne magique* est un éloquent témoignage de la vie en sanatorium, vue de l'intérieur.

Dans les Alpes autrichiennes, les bains d'eau saline de Bad Ischl ont un succès fou. Inauguré en 1823, le premier établissement de cure y est fréquenté par toute l'Europe, à commencer par le chancelier autrichien, le prince de Metternich. En 1849, Bad Ischl devient la résidence d'été officielle de l'empereur, et le restera jusqu'à la Première Guerre mondiale.

Si la montagne reste longtemps une destination avant tout estivale, le tourisme d'hiver commence peu à peu à s'y développer. Saint-Moritz sera la première station à vanter les charmes hivernaux de la montagne. Dès lors, la mode est lancée. À l'automne 1864, un hôtelier du nom de Johannes Badrutt, exploitant de l'hôtel-pension Kulm de Saint-Moritz, engage six Anglais, parmi ses clients habituels de l'été, à s'attarder l'hiver dans la vallée de l'Engadine. Il leur lance un défi : s'ils ne peuvent pas se prélasser sur la terrasse en bras de chemise cet hiver-là, il leur remboursera le voyage depuis l'Angleterre. Il gagne – et invente ainsi les vacances d'hiver.

La réputation de ce petit coin de Suisse, où l'on vient faire le plein de vitalité tout en profitant d'une foule d'activités de plein air, sans renoncer au luxe de l'hébergement, se répand outre-Manche comme une traînée de poudre. Les casse-cou se lancent dans de folles descentes en luge ou en bobsleigh sur la piste de Cresta, tandis que les amateurs d'émotions moins fortes préfèrent une excursion en traîneau au clair de lune sur les lacs gelés de la haute Engadine. En 1880, Johannes Badrutt organise la première partie de curling du continent sur une surface de jeu spécialement aménagée à cet effet. Fasciné par les innovations techniques présentées à l'Exposition universelle de Paris, il équipe ses installations d'un éclairage électrique dès 1879, non sans se doter de sa propre centrale hydraulique.

À mesure que se développe le réseau de chemin de fer en Europe, la Suisse est de mieux en mieux desservie. Dès le milieu du XIXe siècle, d'audacieux ingénieurs planifient le percement de tunnels sous le massif du Saint-Gothard, de façon à assurer une liaison nord-sud indépendante des intempéries. En 1880, c'est chose faite.

D'autres ingénieurs imaginent des rails pour grimper la montagne et gravir les sommets : le premier train à crémaillère d'Europe est inauguré en 1871 près de Lucerne. Il dessert le mont Rigi depuis la petite ville de Vitznau, et grimpe, dans un premier temps, à 1 550 mètres d'altitude. Parmi les touristes qui empruntent ce petit train se trouve l'écrivain américain Mark Twain. La description qu'il fera de son voyage en Suisse beaucoup de lecteurs à lui emboîter le pas. Dans les mêmes années, les ingénieurs commencent à planifier le train de la Jungfrau qui permet de rejoindre le col du Jungfraujoch, à 3 466 mètres d'altitude.

Un autre moyen de transport s'impose au XXe siècle dans l'univers de la haute montagne : achevé en 1907, le premier funiculaire transporte ses passagers de Saint-Moritz au sommet du Muottas Muragl. L'année suivante, le premier téléphérique monte de Bozen à

Kohlern. C'est aussi en 1908 qu'entre en service le premier remonte-pente, à Bödele, dans le Vorarlberg autrichien. Il fallait cela pour que puisse prendre son essor le sport d'hiver le plus prisé de nos jours : le ski alpin.

Dans la province norvégienne de Telemark, on se déplace déjà sur la neige avec de longues planches fixées sous les semelles depuis le XVIII^e siècle – tout droit, pour éviter de s'enfoncer en marchant. Aux yeux d'un Scandinave, ne s'amuse à dévaler les pentes à skis que celui qui n'a pas la forme physique pour tenir la distance lors d'une longue randonnée, ou celui qui n'a pas le courage de s'élancer d'un tremplin.

Arnold Lunn fait installer des remonte-pentes près des hôtels de Mürren, Klosters et Wengen, en Suisse, ce qui lui permet d'organiser le premier championnat anglais de ski alpin, à Mürren. En 1922, il varie les plaisirs de la glisse en équipant les pistes de portes de slalom. C'est sous son impulsion que le ski de descente et le slalom deviennent des disciplines olympiques aux Jeux olympiques d'hiver de 1936, à Garmisch-Partenkirchen.

Par la suite, Arnold Lunn, qui a gardé d'un grave accident sur les pentes une jambe sensiblement plus courte que l'autre, s'élèvera contre les excès du ski alpin. Il aurait même envisagé de fonder une organisation contre ce sport.

du temps, d'y être harcelée par les chasseurs d'autographes, comme cela arrive à Zermatt ou à Saint-Moritz. Blottie au pied du massif du mont Blanc, Chamonix est l'une des plus anciennes et des plus grandes stations de sport d'hiver de France. C'est ici que se tiennent les premiers Jeux olympiques d'hiver, en 1924. En Autriche, les stations de Sankt Anton, Zürs, Lech et Kitzbühel, dans les monts du Tyrol et du Vorarlberg, ont toujours attiré les amateurs de sports d'hiver. Les Italiens, eux, skient dans la vallée d'Aoste et les Dolomites, où Cortina d'Ampezzo accueille les Jeux olympiques d'hiver en 1956.

Aux États-Unis, skieurs et randonneurs n'ont pas besoin de se déplacer jusqu'en Europe pour se livrer à leur passion. Le premier train à crémaillère du monde est inauguré en 1869 entre Marshfield et le mont Washington, dans le New Hampshire. Très vite, les montagnes Blanches deviennent la destination de prédilection des amateurs de sports d'hiver de la Nouvelle-Angleterre. Quant au mont Washington en tant que tel, il ponctue le sentier des Appalaches, un itinéraire de grande randonnée de 3 500 kilomètres de long, qui serpente du nord de la Géorgie jusqu'aux montagnes Blanches, et qu'arpentent, aujourd'hui encore, des milliers de passionnés de marche en montagne.

Après la Seconde Guerre mondiale, les Rocheuses, elles aussi, se dotent de stations de ski, dont les plus connues se concentrent dans le Colorado, sur le flanc est de la chaîne montagneuse. En 1947, c'est là qu'un moniteur de ski allemand du nom de Klaus Obermeyer introduit le sport de glisse dans un ancien petit village minier aux maisons victoriennes. La légendaire station de sports d'hiver d'Aspen est née.

« *C'EST UNE IMPRESSION GÉNÉRALE QU'ÉPROUVENT TOUS LES HOMMES, [...] QUE SUR LES HAUTES MONTAGNES, OÙ L'AIR EST PUR ET SUBTIL, ON SE SENT PLUS DE FACILITÉ DANS LA RESPIRATION, PLUS DE LÉGÈRETÉ DANS LE CORPS, PLUS DE SÉRÉNITÉ DANS L'ESPRIT.* »

JEAN-JACQUES ROUSSEAU, JULIE OU LA NOUVELLE HÉLOÏSE, *1761*

C'est à un Anglais du nom d'Arnold Lunn que le ski de descente doit sa popularité. Son père dirige une agence de voyages qui propose aussi des vacances d'hiver. Ainsi le jeune alpiniste, diplômé d'Oxford, fait-il plusieurs séjours en Suisse. En 1919, il fonde le Public Schools Alpine Sports Club, un club alpin très sélect. Pour y adhérer, il faut remplir une condition terriblement élitiste : le postulant, ou ses parents, doivent sortir d'une « Public School » anglaise, autrement dit d'une école privée extrêmement chère. Voilà qui explique le nombre d'adhérents très restreint, du moins dans un premier temps. L'agence paternelle, sir Henry Lunn Travel, elle, s'adresse au commun des mortels.

Au cours du XX^e siècle, les villages de montagne se métamorphosent en stations touristiques accueillant des voyageurs du monde entier – alpinistes en été, skieurs en hiver. Nichée entre le lac de Thoune et le lac de Brienz, Interlaken, dans l'Oberland bernois, devient le point de départ des randonneurs partant à l'assaut des versants de l'Eiger, du Mönch et de la Jungfrau. Zermatt, au pied du mont Cervin, conserve son charme rural – aujourd'hui encore, les voitures n'y ont pas droit de cité. Dans l'Oberland bernois, Gstaad a lui aussi conservé ses airs de village avec ses bâtiments de style chalet. C'est ici que, depuis des lustres, la jet-set internationale passe ses vacances d'hiver, sans risquer, la plupart

SKIING SUBLIME
Previous pages: Skiers before descending the Silvretta Alps near Davos, Switzerland, 1927.

ERHABENE AUSBLICKE
Seite 108/109: Skifahrer vor der Abfahrt im Silvretta-Gebirge bei Davos, 1927

FACE AU GRAND BLANC
Pages 108-109 : skieurs sur le point de s'élancer dans le massif de la Silvretta, près de Davos, 1927

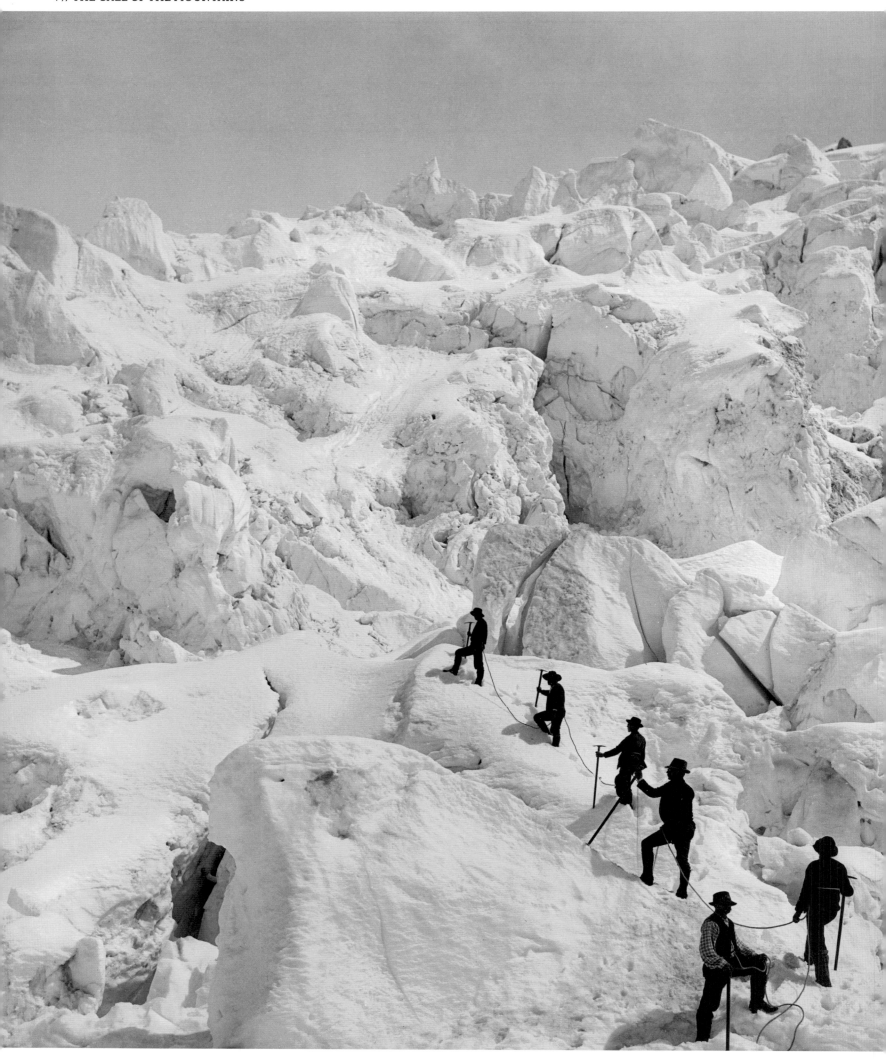

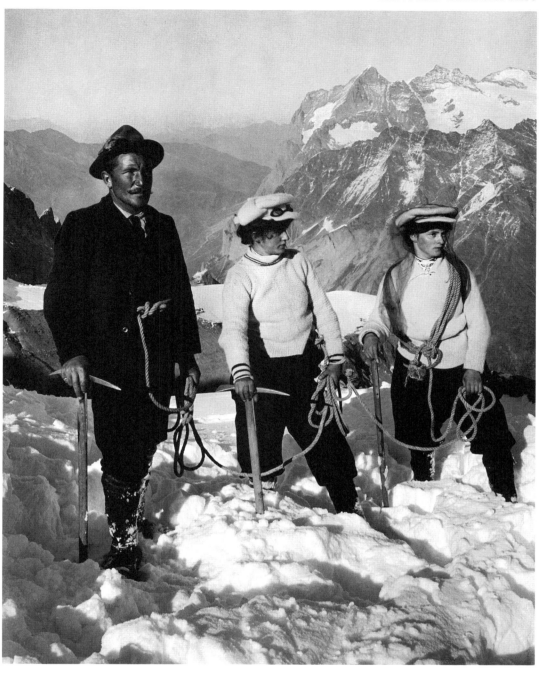

THROUGH THE ETERNAL ICE ON MONT BLANC

Opposite: Glacier crossing near Chamonix, France, circa 1890.
Above: En route with a mountain guide, Chamonix, circa 1890.

DURCHS EWIGE EIS AM MONTBLANC

Links: Gletscherüberquerung in der Nähe des französischen Chamonix, um 1890;
oben: Unterwegs mit einem Bergführer, Chamonix, um 1890

À L'ASSAUT DES GLACES ÉTERNELLES DU MONT BLANC

Ci-contre : traversée d'un glacier près de Chamonix, vers 1890 ;
ci-dessus : ascension avec un guide de haute montagne, Chamonix, vers 1890

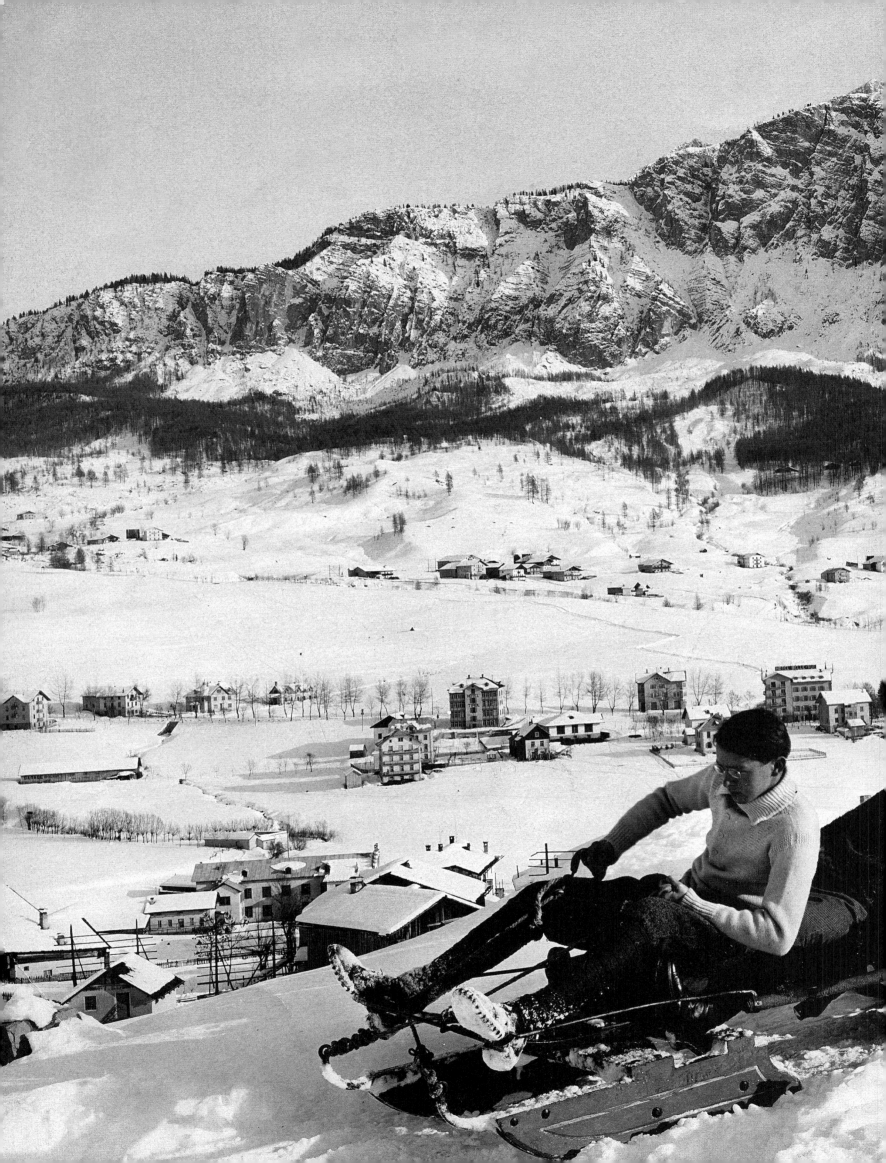

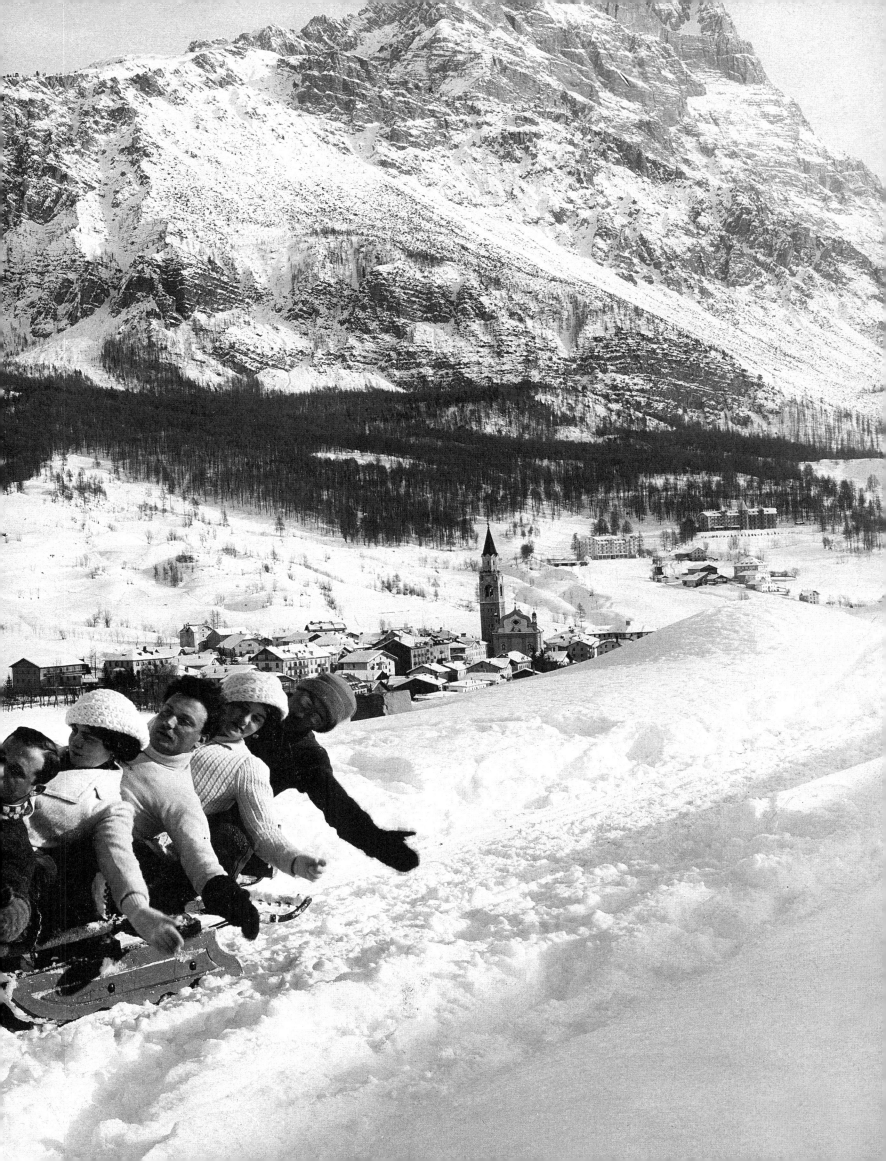

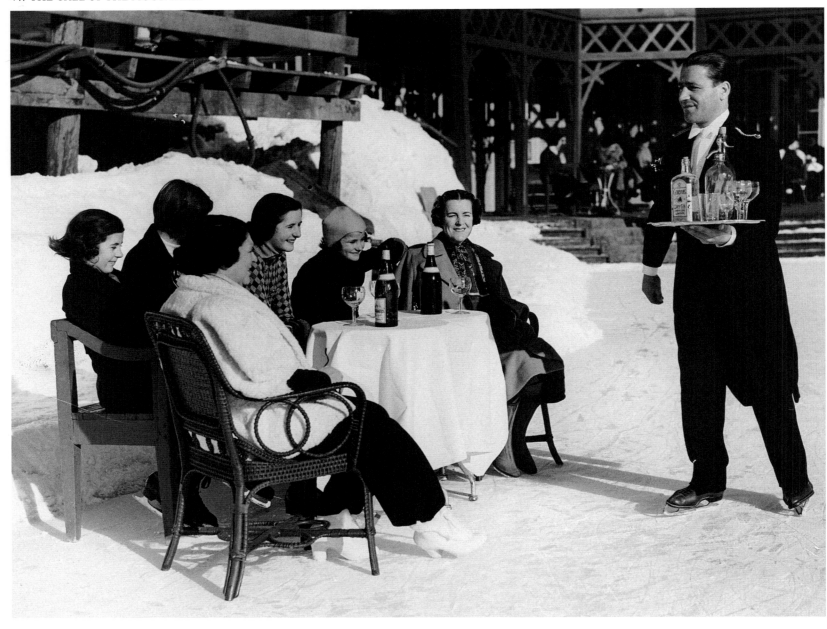

GRACE ON SKATES

Previous pages: Bobsledding in the Dolomites, with Cortina d'Ampezzo, Italy, in the background, 1917.
Above: An ice-skating waiter in St. Moritz, Switzerland, delivers gin and soda to British ladies, 1920s.
Opposite: Heir to the Austrian throne Franz Ferdinand with his wife Sophie and son Maximilian ice-skating on Lake St. Moritz, 1912.

ANMUT AUF KUFEN

Seite 114/115: Bobfahren in den Dolomiten, im Hintergrund Cortina d'Ampezzo, 1917
Oben: Ein Kellner in St. Moritz bringt englischen Ladys Gin und Soda auf Schlittschuhen, 1920er-Jahre;
rechts: Der österreichische Thronfolger Franz Ferdinand mit Frau Sophie und Sohn Maximilian beim Schlittschuhlaufen
auf dem zugefrorenen St. Moritzersee, 1912

GRACIEUSE DESCENTE

Pages 114-115 : bobsleigh dans les Dolomites, sur la toile de fond de Cortina d'Ampezzo, 1917
Ci-dessus : à Saint-Moritz, un serveur en patins à glace sert un gin limonade à des touristes anglaises, dans les années 1920 ;
ci-contre : l'héritier de la couronne d'Autriche-Hongrie François-Ferdinand et son épouse Sophie font du patin avec leur fils Maximilien
sur la surface gelée du lac de Saint-Moritz, 1912

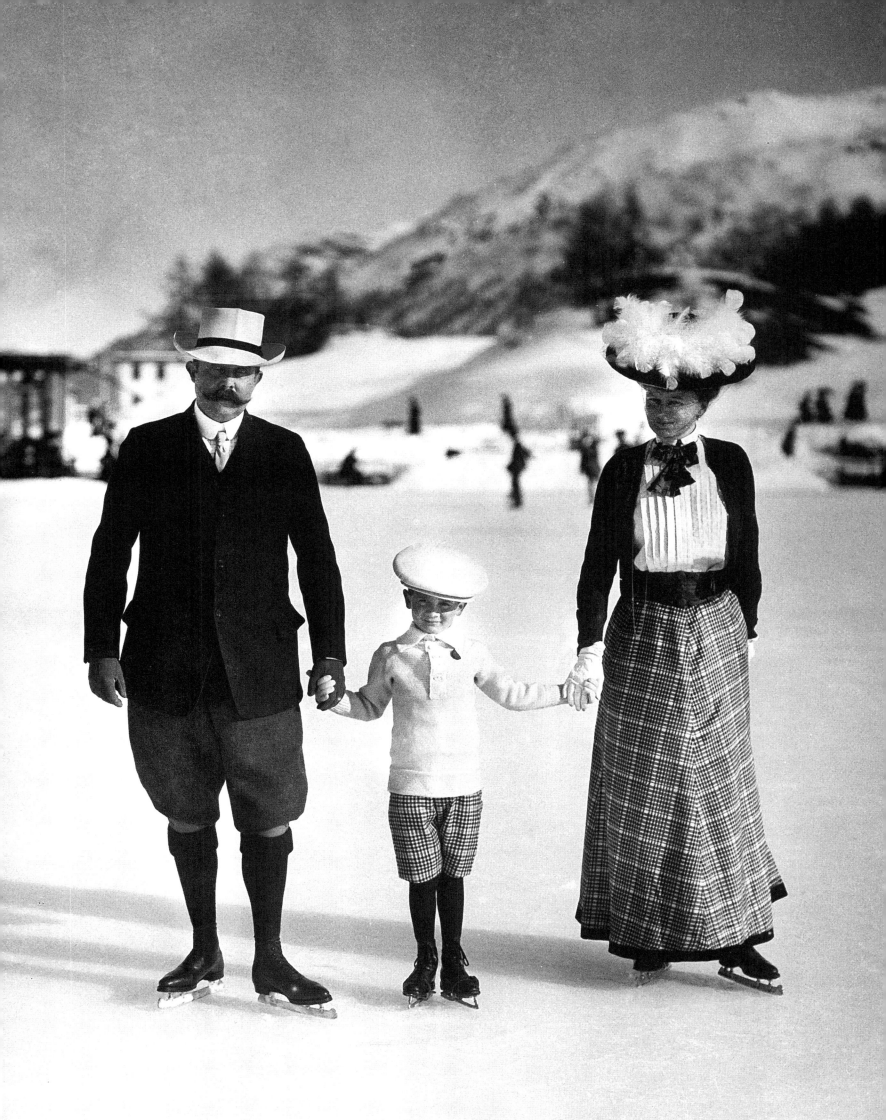

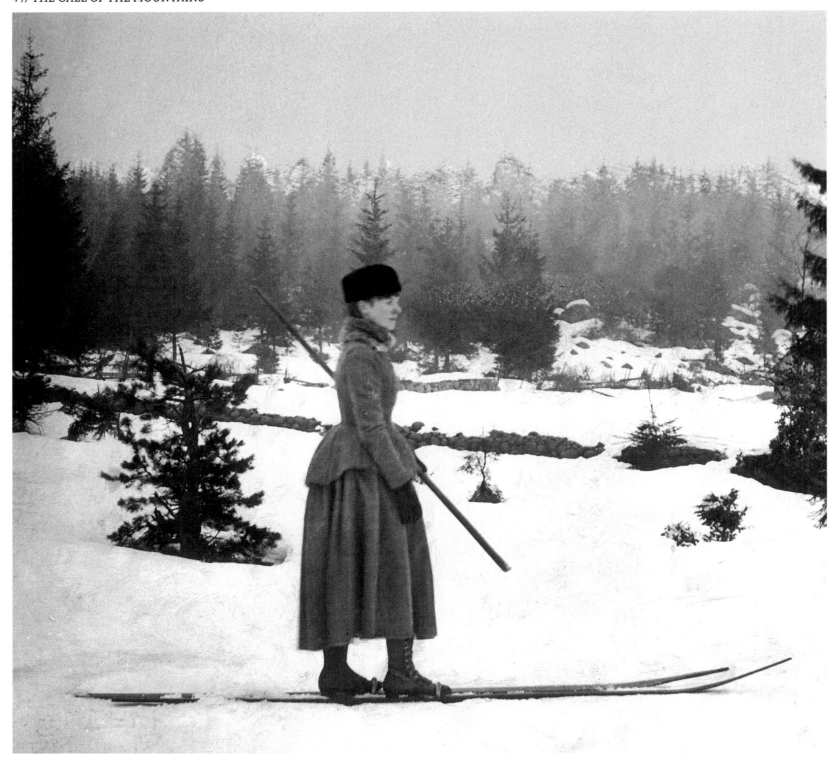

NORDIC COMBINED

Above: Colored photo of a skier with just a single ski pole—as was customary in the early days of skiing—circa 1900.
Opposite: Chamonix used skiers in advertising early on, circa 1905.

NORDISCHE KOMBINATION

Oben: Koloriertes Foto einer Skifahrerin, die – wie anfangs üblich – nur mit einem einzigen Skistock unterwegs ist, um 1900;
rechts: Chamonix wirbt bereits früh mit Skifahrern, um 1905

COMBINÉ NORDIQUE

Ci-dessus : photo colorisée d'une skieuse équipée d'un seul bâton – comme souvent aux débuts du ski – vers 1900 ;
ci-contre : Chamonix vante très tôt les plaisirs du ski, vers 1905

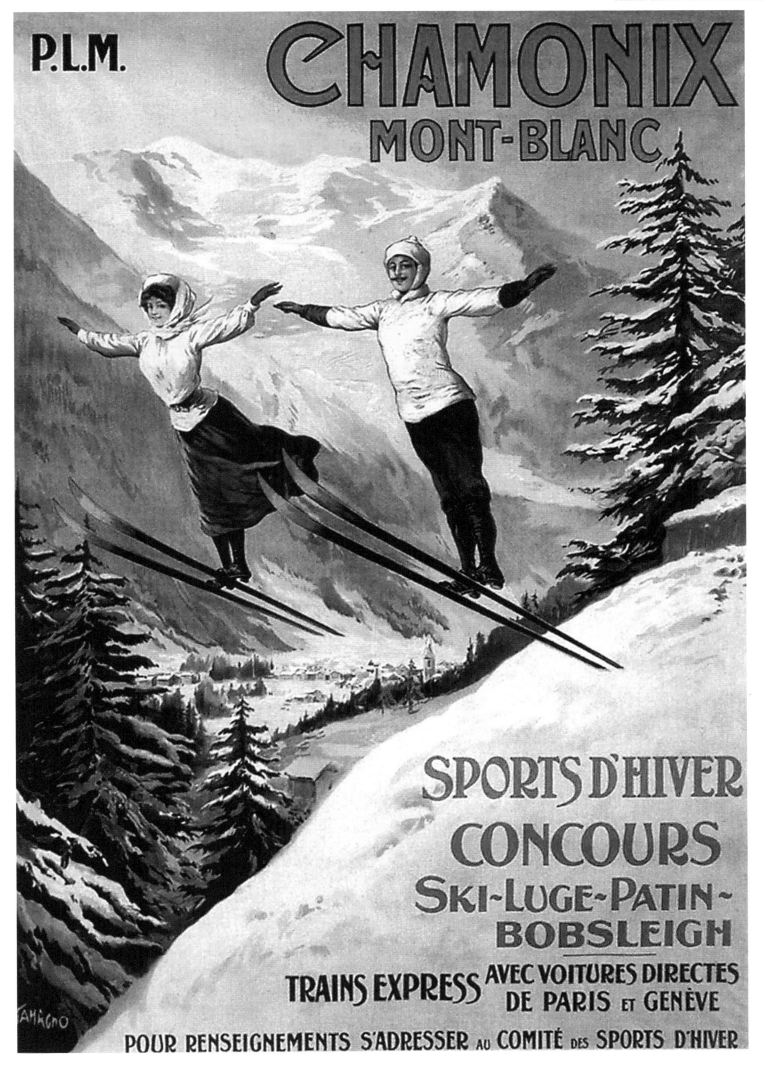

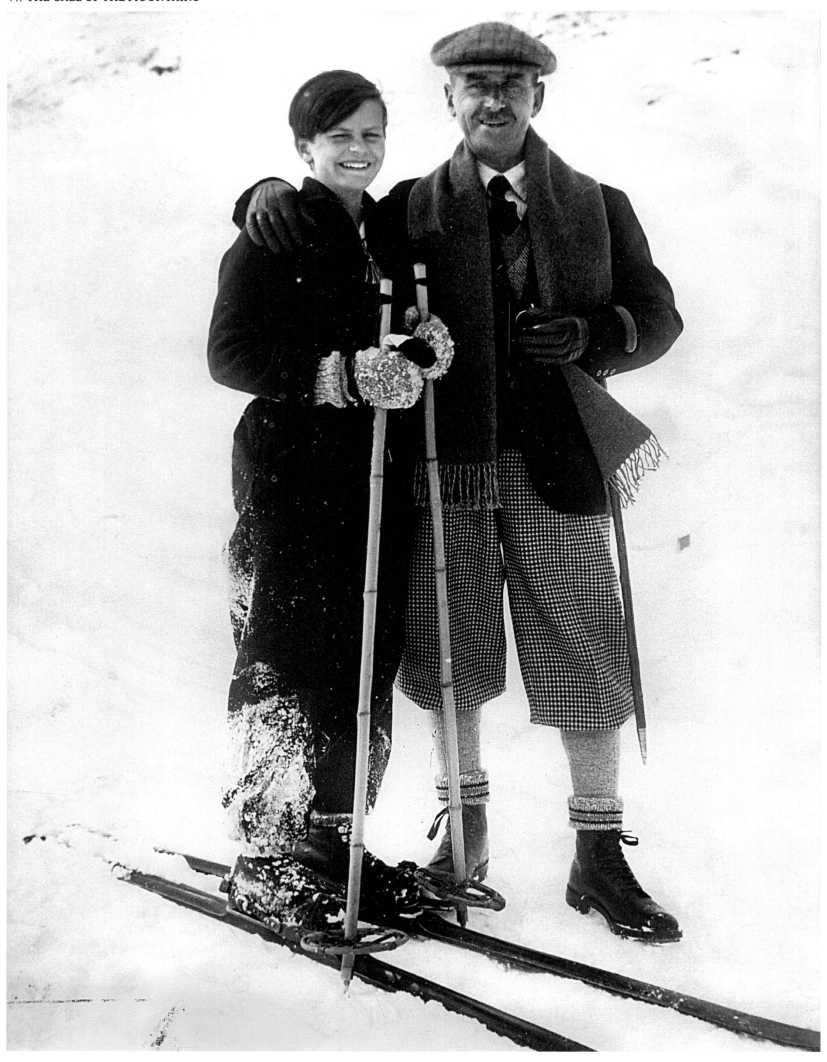

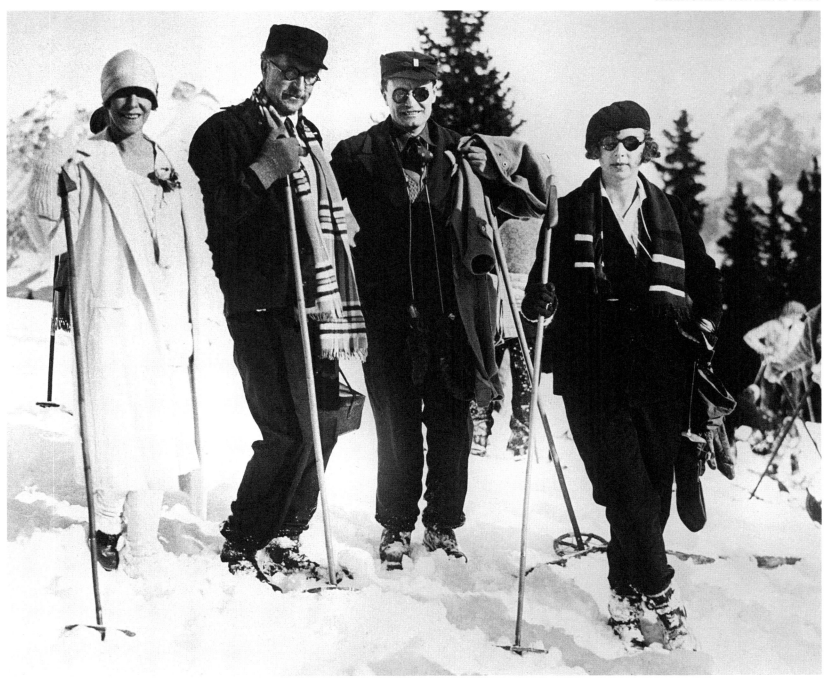

ON THE MAGIC MOUNTAIN

Opposite: Nobel Prize–winner for literature Thomas Mann with daughter Elisabeth on a winter vacation in St. Moritz, 1932.
Above: Ski innovator Arnold Lunn (second from right) with Belgian monarch Albert I, Queen Élisabeth Gabriele,
and Princess Marie-José in Mürren, Switzerland, venue of the first Alpine World Ski Championships, circa 1930.

AUF DEM ZAUBERBERG

Links: Literaturnobelpreisträger Thomas Mann mit Tochter Elisabeth im Winterurlaub in St. Moritz, 1932;
oben: Ski-Innovator Arnold Lunn (zweiter von rechts) mit dem belgischen König Albert I., Königin Élisabeth Gabriele
und Prinzessin Marie-José im Schweizer Mürren, Austragungsort der ersten Skiweltmeisterschaft, um 1930

LA MONTAGNE MAGIQUE

Ci-contre : le prix Nobel de littérature, Thomas Mann, en vacances d'hiver à Saint-Moritz avec sa fille Elisabeth, 1932 ;
ci-dessus : le père du ski de descente, Arnold Lunn (deuxième en partant de la droite), avec le roi des Belges Albert Iᵉʳ, la reine
Élisabeth Gabriele et la princesse Marie-José vers 1930 à Mürren, en Suisse, où se tinrent les premiers championnats du monde de ski alpin

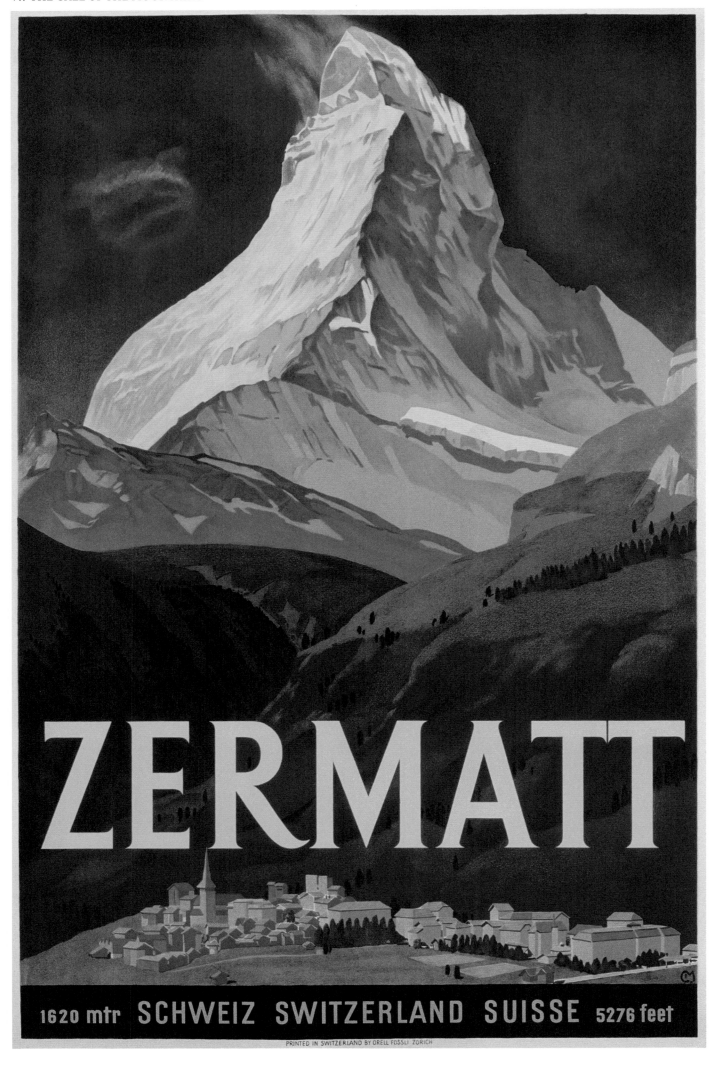

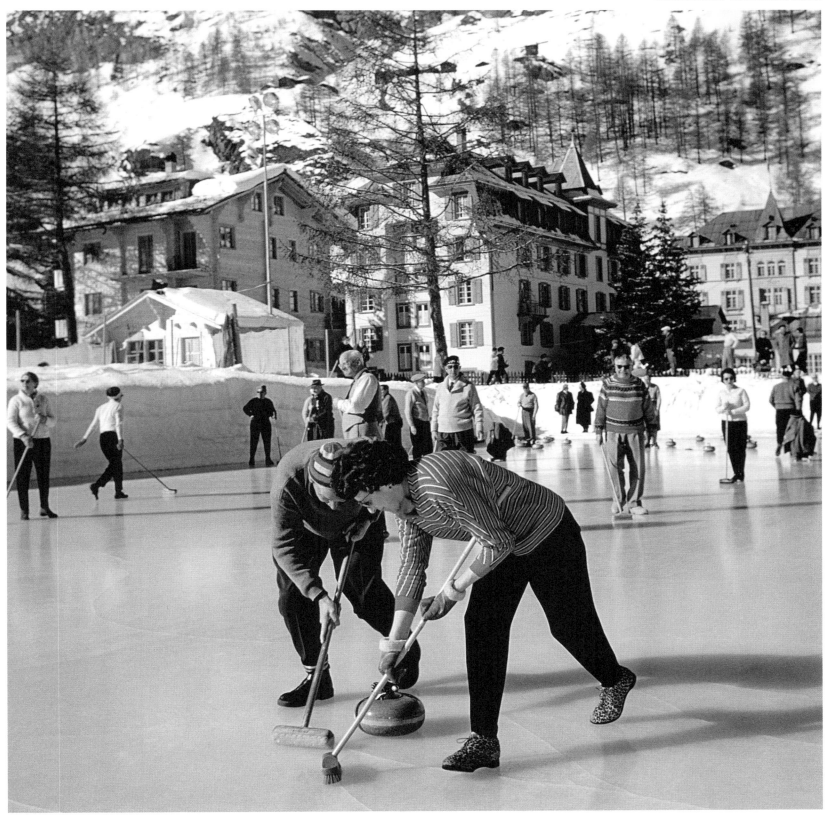

MOUNTAIN AND VALLEY

Opposite: Advertising poster for Zermatt, 1930s.
Above: Curling players in Zermatt, 1961.

BERG UND TAL

Links: Werbeplakat für Zermatt, 1930er-Jahre;
oben: Curlingspieler in Zermatt, 1961

LA MONTAGNE ET LA VALLÉE

Ci-contre : affiche publicitaire pour Zermatt, dans les années 1930 ;
ci-dessus : partie de curling à Zermatt, 1961

FIRST LADIES IN GSTAAD

Opposite: Jacqueline Kennedy goes sledding in the public eye, 1966.
Above: The Dutch Princess Beatrix on the slopes with her fiancé Claus von Amsberg, 1966.

FIRST LADYS IN GSTAAD

Links: Jacqueline Kennedy rodelt unter den Augen der Öffentlichkeit, 1966;
oben: Die niederländische Prinzessin Beatrix mit ihrem Verlobten Claus von Amsberg auf der Piste, 1966

FIRST LADIES À GSTAAD

Ci-contre : Jacqueline Kennedy fait de la luge au vu et au su de tous, 1966 ;
ci-dessus : la princesse Béatrix des Pays-Bas et son fiancé Claus von Amsberg sur les pistes, 1966

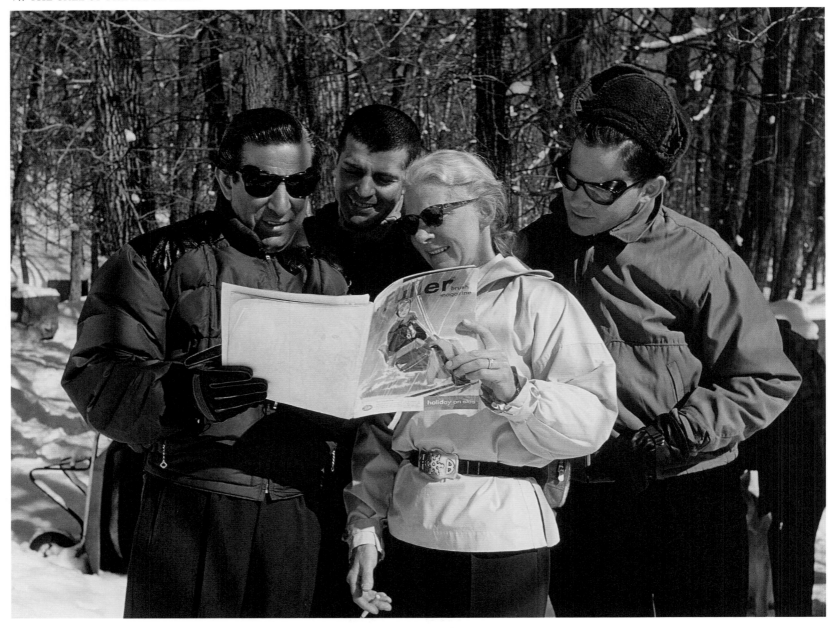

HOLIDAY ON SKIS

Above: Four winter sports fans in Aspen, Colorado, 1958.
Opposite: Poster for the Banff–Lake Louise ski region in Canada, circa 1944.
Following pages: *Canadian Pacific* express train from Montreal to Vancouver against
the backdrop of the Rocky Mountains, 1955.

HOLIDAY ON SKIS

Oben: Vier Wintersportler in Aspen, Colorado, 1958;
rechts: Plakat der Skiregion Banff–Lake Louise in Kanada, um 1944
Seite 128/129: *Canadian-Pacific*-Expresszug von Montreal nach Vancouver vor der Kulisse der Rocky Mountains, 1955

LA NEIGE, À LA FOLIE !

Ci-dessus : quatre adeptes des sports d'hiver à Aspen, Colorado, 1958 ;
ci-contre : affiche pour le domaine skiable Banff and Lake Louise, au Canada, vers 1944
Pages 128-129 : l'express *Canadian Pacific*, qui relie Montréal à Vancouver, sur la toile de fond des Rocheuses, 1955

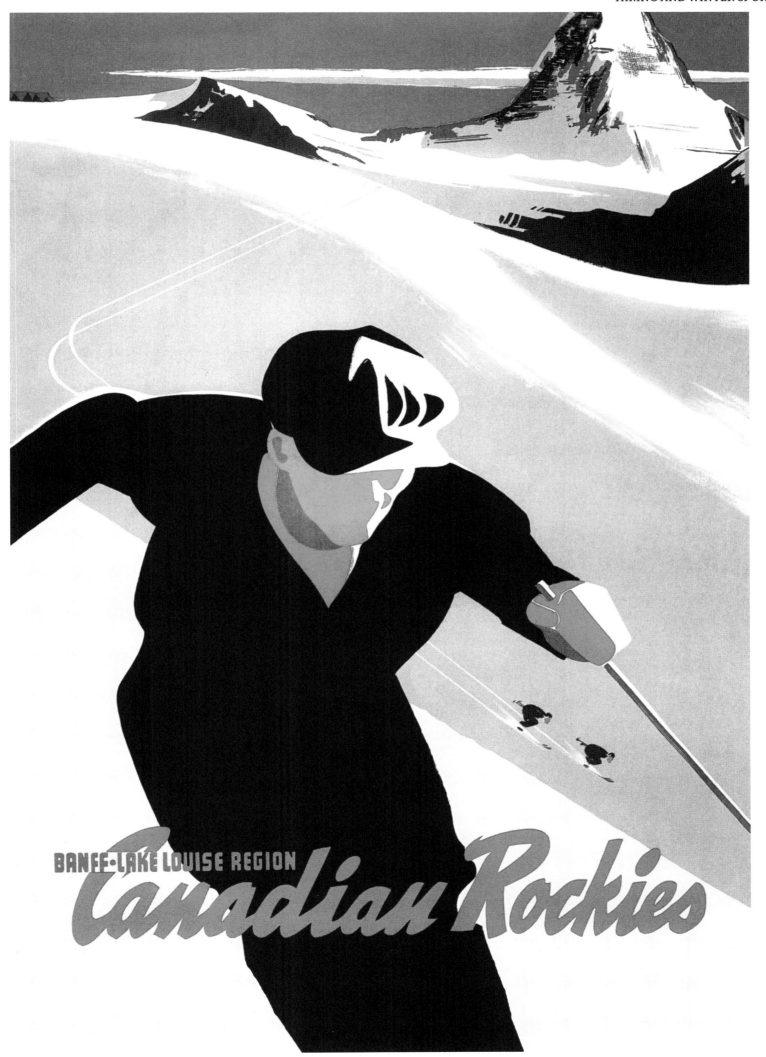

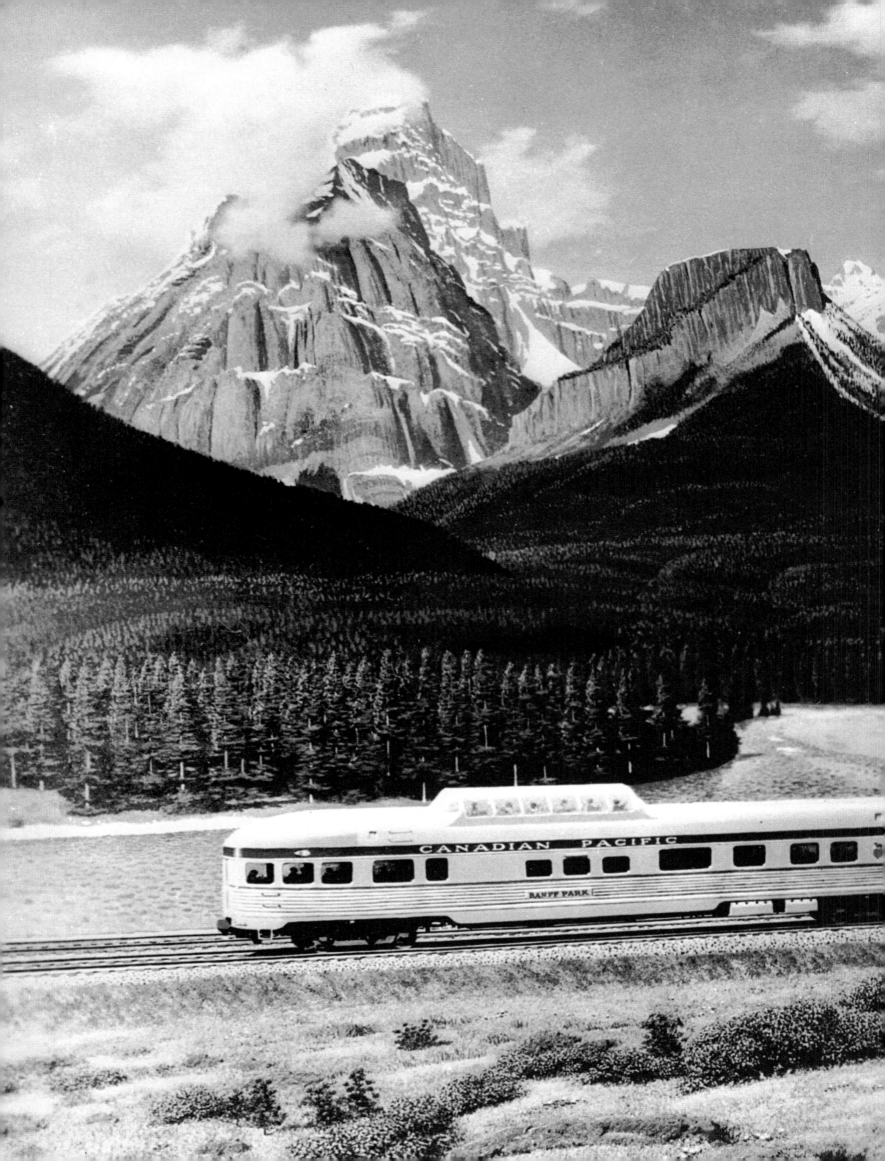

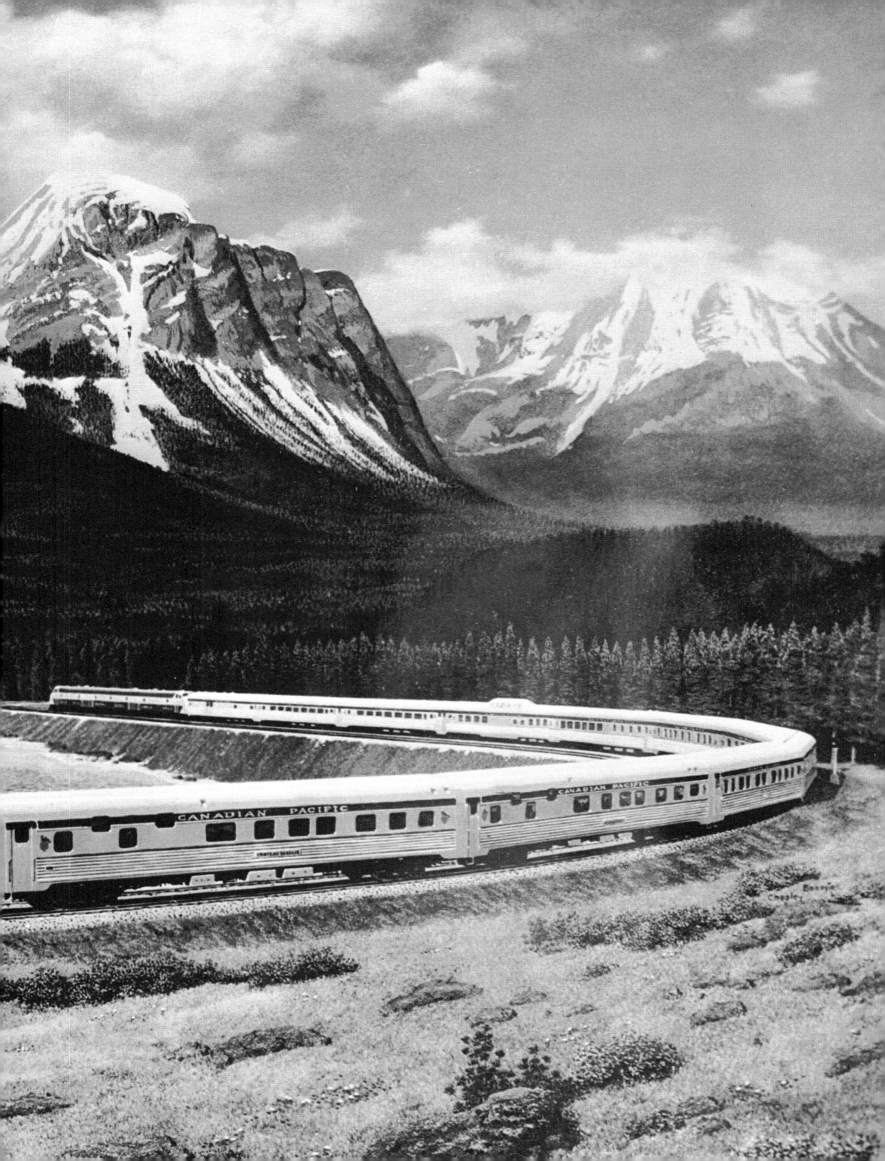

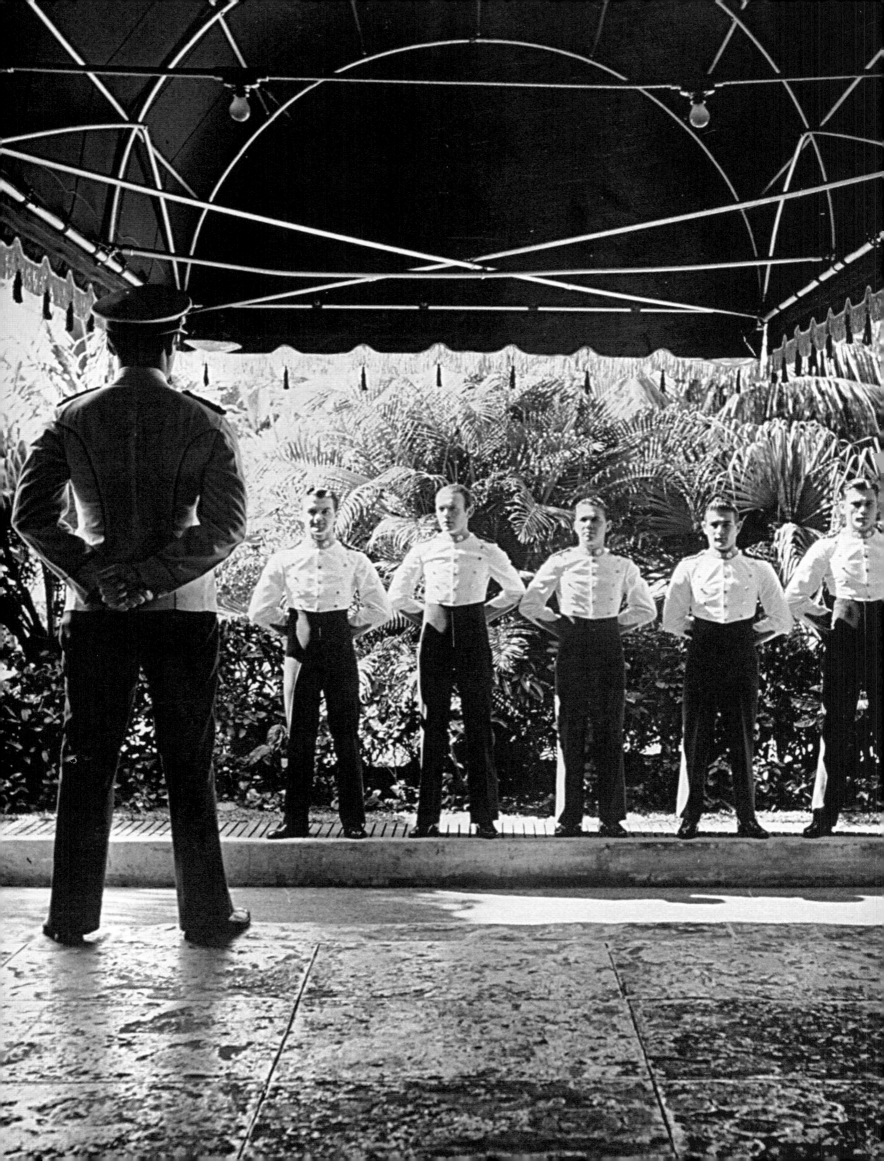

5

NEW PALACES

NEUE PALÄSTE
PALAIS MODERNES

GRAND HOTELS

In the age of stagecoaches, if travelers were seeking a roof over their heads, a bed, a bite to eat, and protection from the weather, they found it all in relatively simple surroundings. In addition to serving beverages, postal stations and village taverns also rented accommodations. Sometimes guests received a room for themselves, while at other times the bed was located in the innkeeper's living quarters. In especially unfortunate cases, guests were housed right alongside livestock. Establishments known today as "hotels" have only existed since the nineteenth century. As is so often the case, it was an increase in demand that triggered a corresponding supply. Until that point, a *hôtel* referred to a city palace in Paris, where French nobility lived while still remaining close to the king's court. These residences were closed off from the street and offered a wide range of amenities, however they didn't offer overnight accommodations in exchange for payment.

The first hotel that offered amenities as we know them today was once again a British invention—allegedly. January 25, 1774, marked the start of a new era when the hairstylist David Low opened his Grand Hotel in London's Covent Garden district. As was the case with all subsequent hoteliers, Low decided to target wealthy guests in an effort to get them to stay at his house while in the capital. It goes without saying that he would have to propose something special in return: for 15 shillings, guests could stay overnight in a two-room suite, including a reserved place in the church's best pew. The entrepreneur soon added more rooms as well as a "coffee room." The house remained in operation until 1880.

Before long other entrepreneurs around the world copied Low's idea, each trying to surpass the other in terms of amenities. In the nineteenth century, a Grand Hotel was an establishment that offered extraordinary comfort to the upper classes and members of the nobility who enjoyed traveling. Amenities included gas lighting and (later) electrical lighting, running water, central heating, and—once it was invented and became more widespread—telephones. These hotels' exteriors and interiors mirrored the architecture of European palaces, with rooms furnished with period furniture. One or more hotel restaurants headed by famous chefs made sure guests were well fed. The fact that the railway was able to transport travelers to almost anywhere in Europe within a single day was a major boost to the growth of the hotel industry.

These kinds of establishments began opening in Washington, New York, and Boston as early as 1800. Their amenities included rooms for private entertainment—such as games and smoking—libraries and cafés, as well as concert halls and ballrooms. During this period, American society played out far more in public than was the case in Europe. Its members needed the space to flaunt what they had, along with the appropriate facilities.

Likewise, there was no stopping the development of hotels in Europe. Zurich initially grew from a small lakeside town to a European financial metropolis, completely redesigning its labyrinthine historic section in the mid-nineteenth century. After the tremendous success enjoyed by the hotelier Johannes Baur with his first hotel on Paradeplatz, where all the major Swiss banks are still headquartered today, Baur opened his second hotel in 1844. The construction of Baur au Lac was considered boundary-pushing because it faced Lake Zurich rather than the city. It became the standard for all Grand Hotels whose appeal was centered on their unobstructed views of natural attractions such as lakes, mountains, and the ocean.

Many large hotels that still exist in Europe today date back to the belle epoque, the thirty years of cultural prosperity leading to the outbreak of World War I—or they were built shortly before that, such as the sophisticated Hôtel de Paris in Monte Carlo, which opened in 1863. During that time, there was a tremendous demand for luxury overnight accommodations, particularly in the booming capital cities of London and Paris. In London, the Savoy opened in 1889 and the Carlton in 1899. Both hotels were managed by the Swiss hotelier César Ritz. Ritz had been the first director of the Frankfurter Hof in 1877, and he took charge of Le Grand Hotel in Rome in 1894.

He started out as a shoeshine boy and rose through the ranks to become known as the "king of hoteliers and the hotelier to kings." There is no denying that Ritz was a major innovator in the golden era of Grand Hotels. London's Savoy was the first establishment to make en-suite bathrooms available to most guests—a tremendous luxury at a time when most apartments didn't even have running water. Together with master chef Auguste Escoffier, Ritz set new culinary standards in his hotels. The crowning achievement of his life's work came in 1898, when the first hotel named after him personally opened in a renovated palace on the place Vendôme in Paris.

What Ritz was for Paris and London, Lorenz Adlon was for Berlin. The German hotelier recognized the signs of the time: with the hotel that bore his name, located at the end of the boulevard Unter den Linden close to the Brandenburg Gate, he catered to the growing demands of Berlin society for a more public stage. The exclusive hotel was a resounding triumph from the time it opened in October 1907. There is little doubt that the hotel's success was buoyed by Adlon's excellent relationships with the German higher nobility. German Emperor Wilhelm II was a frequent guest there, as he preferred the heated, luxurious rooms of the hotel over his drafty city residence.

The Côte d'Azur magically attracted aristocrats from throughout Europe, especially members of the British royal family. No fewer than seven crowned heads of state were said to have attended the opening of the Hotel Negresco in Nice in 1913. The Hotel Carlton, which had opened just two years before in neighboring Cannes, enjoyed tremendous popularity among the Russian aristocracy;

its twin cupolas are said to have been inspired by the breasts of Caroline Otero, Europe's most sought-after courtesan at the turn of the century. After World War II, international movie stars attending the film festival preferred to stay at the Hotel Carlton. In 1954, the hotel also served as the backdrop to Alfred Hitchcock's *To Catch a Thief.*

Grand Hotels were a microcosm of the modern age, serving as both a reflection of and a yardstick for civilization. In 1853, American Elisha Graves Otis invented the crash-proof elevator. Thanks to the International Exposition of 1867 in Paris, Otis's invention became popular throughout Europe. Those with a high opinion of themselves no longer were content to stay on the second floor; instead, they

many of the hotel rooms into condominiums. The original Waldorf-Astoria Hotel on Fifth Avenue near Thirty-Fourth Street had to make way for a new building in 1929: after demolition, the Empire State Building was built on the site and held the title of the world's tallest building for nearly forty years.

The United States was also home to resort hotels catering to vacation seekers. One of the most famous resort hotels to this day is the Grand Hotel on Mackinac Island in Lake Huron, Michigan. The hotel opened on July 10, 1887, and its attractions include the "world's longest porch" with views of the water. Originally owned by two railroad companies and a steamship navigation company, the hotel was designed as a summer retreat for vacationers

had been laid to the rooms to provide gas lighting in the event of a power failure.

The Grand Hotel model swiftly caught on worldwide. In the British colonies in particular, travelers didn't want to do without the customary luxury and style. Magnificent establishments such as the Raffles Hotel in Singapore and the Taj Mahal Palace in Mumbai still bear witness to that today. With the new construction of the Imperial Hotel in Tokyo, the American star architect Frank Lloyd Wright decided to strike out in another direction. As an admirer of Japanese art and architecture, he played with open shapes and designed groups of buildings that evoked the style of Japanese palaces and temples. On September 1, 1923, the hotel's opening day, Tokyo was stricken by a powerful earthquake that devastated the city center. One of the buildings that survived the earthquake with almost no damage was the structure built by Wright.

> 66 *MOST HOTELS SELL SOMETHING THAT THEY DO NOT HAVE: PEACE.* 99
>
> —KURT TUCHOLSKY, SNIPPETS, 1932

Grand Hotels are never mere accommodations; instead, they serve as a stage for social life. Large hotels have been the setting of countless movies, novels, plays, and music videos. They've formed the backdrop for rendezvous enjoyed by famous politicians, actors, and musicians around the world. At Hotel Ambos Mundos in Havana, Cuba, travelers can still visit Ernest Hemingway's room. The suite where Lenin resided after the Russian Revolution still exists at the Hotel National in Moscow. His piano is still there today.

A distant echo of the fame of its residents is always reflected in the hotels—although they would never admit to it because discretion is always one of the key services offered by a luxury hotel.

had the elevator boy take them up to the penthouse on the top floor.

Without elevators, high-rise buildings and top hotels in New York would have been inconceivable. The Waldorf-Astoria came into being in 1897 following the fusion of two major hotels: the Waldorf owned by the entrepreneur and diplomat William Waldorf Astor, and the Astoria belonging to his cousin, John Jacob Astor IV. At thirteen and seventeen stories, these buildings situated not far from Times Square towered over comparable European hotels. They were surpassed only by the nineteen stories of the Plaza Hotel, which opened in 1907 on the southern side of Central Park. An overnight stay in those days cost $2.50. One of the former owners of the Plaza Hotel is the U.S. President Donald Trump, who initially had plans to convert

who arrived by rail and steamer. Prominent guests have included the inventor Thomas Edison, author Mark Twain, five U.S. presidents, and two Russian presidents.

San Diego, California, is home to the Hotel del Coronado. When it opened with more than nine hundred rooms in 1888, it was the largest resort in the world and soon became a popular destination for the Hollywood movie crowd. It comes as no surprise that it served as a filming location for movies such as Billy Wilder's *Some Like It Hot* from 1959 starring Marilyn Monroe, Tony Curtis, and Jack Lemmon. When it opened, the Hotel del Coronado was the first hotel in the world to be equipped with electric lighting, and Thomas Edison is said to have personally viewed the installation. In addition, gas lines

MINISTERING SPIRITS
Page 130: Doorman and bellboys at the Surf Club in Miami Beach, photo by Alfred Eisenstaedt, 1940.

DIENSTBARE GEISTER
Seite 130: Portier und Pagen des Surf Clubs in Miami Beach, Foto von Alfred Eisenstaedt, 1940

LE SENS DU SERVICE
Page 130 : portier et grooms au Surf Club de Miami Beach, photo d'Alfred Eisenstaedt, 1940

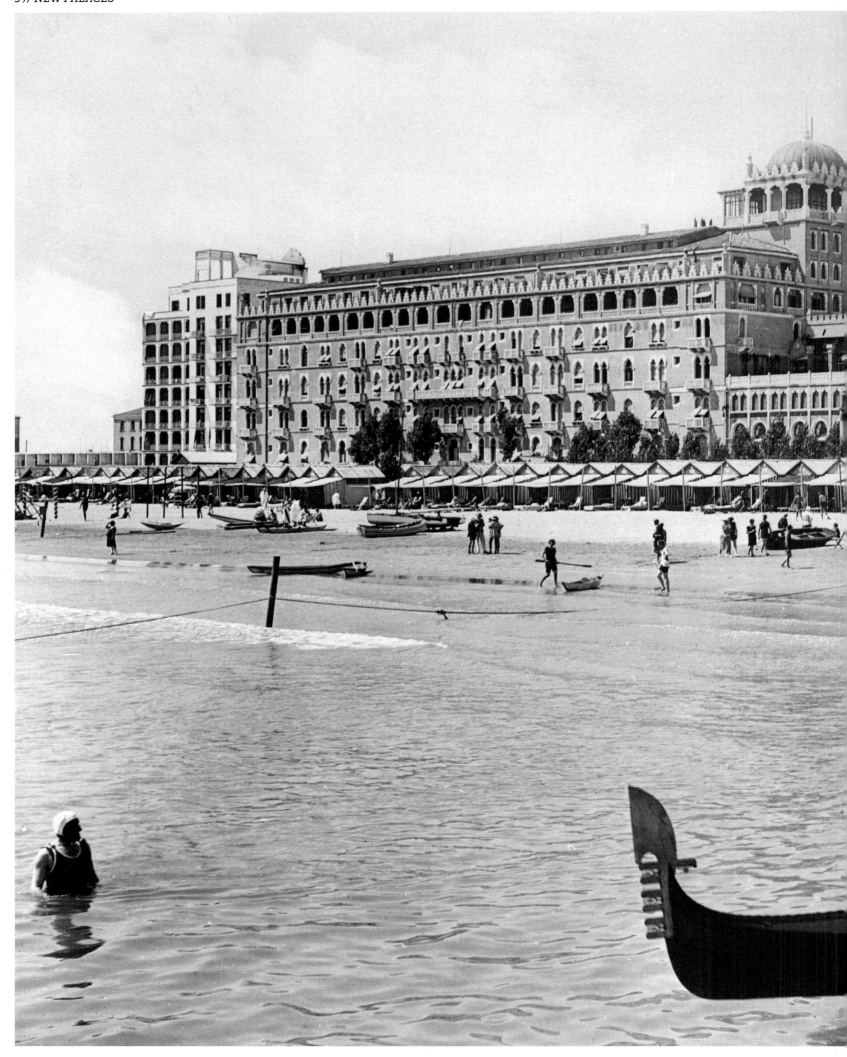

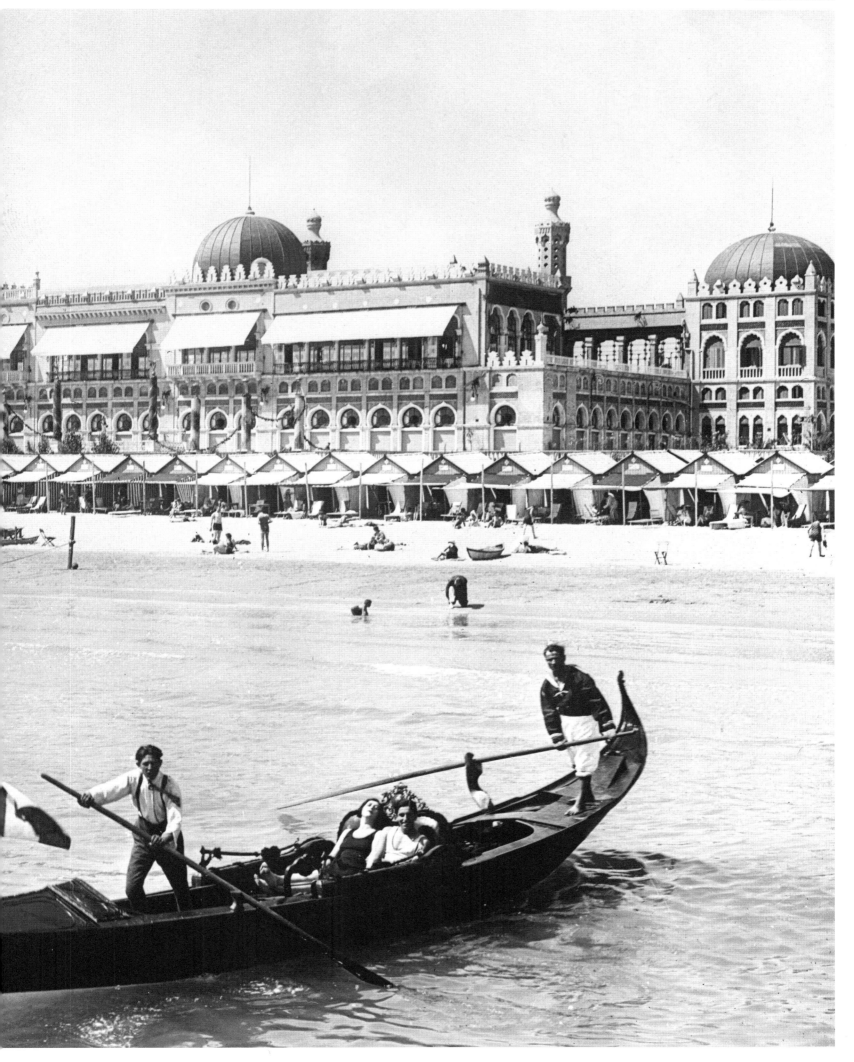

GRANDHOTELS

Wenn ein Reisender im Zeitalter der Post-
kutschen nach einem Bett über dem Kopf,
etwas zu essen und Schutz vor dem Wetter
suchte, fand er das in recht einfachen Verhält-
nissen. Poststationen und Dorfgaststätten
vermieteten zusätzlich zum Ausschank auch
Unterkünfte. Manchmal bekam der Gast eine
eigene Kammer, manchmal stand das Bett in
der guten Stube der Wirtsleute, und wenn es
ganz ungünstig lief, war dort auch noch das
Vieh untergebracht.
Was heute als „Hotel" firmiert, gibt es erst seit
dem 19. Jahrhundert. Wie so oft schuf erst
vermehrte Nachfrage ein entsprechendes
Angebot. Bis dahin verstand man unter *hôtel*
ein Stadtpalais in Paris, wo der französische
Adel für sich wohnte, dem Hof des Königs aber
trotzdem nahe sein konnte. Diese Residenzen
waren gegenüber der Straße abgeschlossene
Hofanlagen und boten sicherlich allerlei An-
nehmlichkeiten. Gegen Bezahlung übernach-
ten konnte man dort jedoch nicht.

Das erste Hotel mit einem Angebot, wie wir
es heute kennen, war wieder einmal eine eng-
lische Erfindung – angeblich. Am 25. Januar
1774 begann eine neue Zeitrechnung, als der
Friseur David Low sein „Grand Hotel" im
Londoner Stadtteil Covent Garden eröffnete.
Wie alle späteren Hoteliers hatte Low als
Zielgruppe zahlungskräftige Gäste im Auge,
die sein Haus für die Dauer ihres Aufent-
halts in der Hauptstadt als Unterkunft in
Betracht ziehen sollten. Dafür musste er na-
türlich etwas bieten: Für 15 Schilling gab es
die Übernachtung in der Zweizimmersuite,
bester Platz in der Kirche inbegriffen. Wenig
später fügte der Unternehmer weitere Zimmer
und einen *coffee room* hinzu. Das Haus war
bis 1880 in Betrieb.

Schon bald kopierten andere Unternehmer in
aller Welt die Idee des Londoner Coiffeurs
und übertrafen sich jeweils mit ihren Ange-
boten. Als Grandhotel galt dann im 19. Jahr-
hundert ein Haus mit außergewöhnlichem
Komfort für das gehobene Bürgertum und
den reisefreudigen Adel. Dazu gehörten Gas-
und später elektrische Beleuchtung, fließendes
Wasser, Zentralheizung, und – als es erfunden
und eingeführt war – natürlich auch Telefon.
Das Äußere und Innere eines solchen Hotels
orientierte sich an der Architektur europäischer
Paläste. Ausgestattet waren seine Räume
selbstredend mit Stilmöbeln. Für das leibliche
Wohl der Gäste sorgte mindestens ein Hotel-
restaurant, in dem ein renommierter Küchen-
chef wirkte. Die Eisenbahn konnte Reisende
innerhalb eines Tages fast überallhin in Europa
befördern und trug so ein Großteil zum Wachs-
tum der Hotellerie bei.

In Washington, New York und Boston eröff-
neten solche Häuser schon um das Jahr 1800.
Zu deren besonderen Angeboten zählten
Räumlichkeiten für private Vergnügungen wie
Spielezimmer, Rauchersalons, Bibliotheken und
Cafés, aber auch Konzerträume oder Ball-
säle. Die amerikanische Society inszenierte
sich zu dieser Zeit weitaus mehr in der
Öffentlichkeit als die europäische Gesell-
schaft. Sie brauchte entsprechend Raum,
um zu zeigen, was sie hatte – und die Einrich-
tungen dafür.

Aber auch in Europa war die Hotelentwicklung
nicht aufzuhalten. Zunächst war es Zürich,
das von einem kleinen Städtchen am See zur
europäischen Bankenmetropole aufstieg und
Mitte des 19. Jahrhunderts seine verwinkelte
Altstadt neugestaltete. Nachdem der Hotelier
Johannes Baur mit seinem ersten Haus am
Paradeplatz, wo noch heute alle großen
Schweizer Banken ihren Sitz haben, großen
Erfolg gehabt hatte, eröffnete er 1844 am
See sein zweites Haus. Der Bau des Baur
au Lac galt als mutig, weil es nicht zur Stadt,
sondern zum Zürichsee hin ausgerichtet war.
Es wurde zum Vorbild für alle Grandhotels,
die mit freier Sicht auf Naturschönheiten wie
Seen, Meer und Berge locken.

Viele große Hotels, die wir in Europa noch
heute kennen, stammen aus der Belle Époque,
den 30 Jahren kultureller Blüte vor dem Aus-
bruch des Ersten Weltkrieges – oder sie ent-
standen kurz davor, wie das mondäne Hôtel
de Paris in Monte Carlo aus dem Jahr 1863.
Gerade in den boomenden Hauptstädten
London und Paris gab es einen enormen
Bedarf an Übernachtungsmöglichkeiten der
Luxusklasse. Das Savoy eröffnete 1889 in
London, das Carlton ebenda 1899. Beide
Häuser wurden übrigens gemanagt von dem
Schweizer César Ritz, ebenso der Frankfurter
Hof, dessen erster Direktor er 1877 war, oder
das Le Grand Hotel in Rom von 1894.
César Ritz, der vom Schuhputzer zum „König
der Hoteliers und Hotelier der Könige" aufstieg,
war der große Innovator in der goldenen Ära
der Grandhotels. Im Londoner Savoy standen
den meisten Gästen erstmals eigene Bade-
zimmer zur Verfügung. Ein ungeheurer Luxus
zu einer Zeit, als die meisten Wohnungen
noch nicht einmal fließend Wasser besaßen.
Zusammen mit dem Meisterkoch Auguste
Escoffier setzte Ritz in seinen Hotels neue
kulinarische Standards. Zur Krönung seines
Lebenswerkes wurde 1898 schließlich das
erste nach ihm selbst benannte Hotel in einem
umgebauten Palais an der Place Vendôme in
Paris eröffnet.

Was Ritz für Paris und London war, war
Lorenz Adlon für Berlin. Der deutsche Hotelier
erkannte die Zeichen der Zeit: Mit dem Hotel,
das seinen Namen trug und das am Ende der
Flaniermeile Unter den Linden in unmittel-
barer Nähe des Brandenburger Tors stand,
bediente er das wachsende Bedürfnis der
Berliner Gesellschaft, sich öffentlich darzu-
stellen. Seit der Eröffnung im Oktober 1907
war das Nobelhotel ein voller Erfolg. Adlons
gute Beziehungen zum deutschen Hochadel
haben da sicherlich geholfen. Kaiser Wilhelm II.
war ein häufiger Gast im Adlon, er hielt sich
lieber in den geheizten und luxuriösen Räu-
men des Hotels auf als in seiner eigenen
zugigen Stadtresidenz.

Adlige aus ganz Europa, allen voran die Mit-
glieder des britischen Königshauses, wurden
von der Côte d'Azur gleichsam magisch ange-
zogen. Allein sieben gekrönte Häupter sollen
1913 der Eröffnung des Hotels Negresco in
Nizza beigewohnt haben. Das zwei Jahre zuvor
eingeweihte Carlton im benachbarten Cannes
erfreute sich großer Beliebtheit beim russi-

schen Adel. Die Turmkuppeln des Hotels sollen den Brüsten Caroline Oteros nachempfunden sein, Europas gefragtester Kurtisane der Jahrhundertwende. Nach dem Zweiten Weltkrieg stiegen internationale Stars der Filmfestspiele am liebsten im Carlton ab, 1954 übrigens die Kulisse für Alfred Hitchcocks *Über den Dächern von Nizza*.

Grandhotels waren ein Mikrokosmos der Moderne, ein Spiegelbild und Gradmesser der Zivilisation: 1853 erfand der Amerikaner Elisha Graves Otis den absturzsicheren Aufzug. Durch die Weltausstellung von Paris 1867 wurde die Vorrichtung auch in Europa beliebt. Wer auf sich hielt, stieg jetzt nicht mehr in der Beletage, ab, sondern ließ sich vom Liftboy in das Penthouse im obersten Stock befördern.

Astoria an der 5th Avenue, Ecke 34th Street musste 1929 einem neuen Gebäude weichen: Nach dem Abriss entstand hier das damals höchste Gebäude der Welt, das Empire State Building.

Auch in den USA gab es reine Urlaubshotels, sogenannte Resorts. Zu den bekanntesten Resorthotels zählt heute noch das Grandhotel, das auf der Insel Mackinac Island im Huronsee liegt und am 10. Juli 1887 eröffnete. Zu seinen Attraktionen gehört die „größte Terrasse der Welt", mit Blick aufs Wasser. Dieses Hotel gehörte ursprünglich zwei Eisenbahngesellschaften und einer Dampfschifffahrtsgesellschaft und war als Sommerfrische für Erholungsuchende gedacht, die mit der Bahn und mit dem Dampfschiff anreisten. Unter den zahlreichen prominenten Gästen be-

Das Modell des Grandhotels strahlte in alle Welt aus. Besonders in den britischen Kolonien wollten Reisende vom gewohnten Luxus und Stil nicht lassen. Prunkvolle Häuser wie das Raffles Hotel in Singapur oder das Taj Mahal Palace in Mumbai bezeugen das bis heute. Der amerikanische Stararchitekt Frank Lloyd Wright ging mit seinem Neubau des Imperial Hotels in Tokio einen anderen Weg. Als Bewunderer japanischer Kunst und Architektur spielte er mit offenen Formen und entwarf Gebäudegruppen, die den Stil japanischer Paläste und Tempel evozierten. Am 1. September 1923, dem Eröffnungstag, wurde Tokio von einem starken Erdbeben heimgesucht, die Innenstadt größtenteils zerstört. Eines der Gebäude, die das Beben nahezu unbeschädigt überstanden, war der Bau von Wright.

Grandhotels sind nie lediglich Unterkünfte, sondern immer auch Bühnen für das gesellschaftliche Leben. In ungezählten Filmen, Romanen, Theaterstücken oder Musikvideos ist der Handlungsort ein großes Hotel. In Hotels haben sich berühmte Politiker, Schauspieler und Musiker weltweit ein Stelldichein gegeben. Im Ambos Mundos in Havanna kann man noch heute Ernest Hemingways Zimmer besichtigen und im Moskauer Hotel National die Suite, wo Lenin nach der Revolution gelebt hat. Sein Klavier steht auch noch dort.

Ein Abglanz des Ruhms seiner Bewohner strahlt natürlich auch stets auf die Häuser zurück. Die das natürlich niemals zugeben würden, denn zu den Services eines Luxushotels gehört immer auch die Diskretion.

> 99 *DIE MEISTEN HOTELS VERKAUFEN ETWAS,*
> *WAS SIE GAR NICHT HABEN: RUHE.* 66
>
> KURT TUCHOLSKY, SCHNIPSEL, 1932

Ohne den Aufzug wären Hochhäuser gar nicht denkbar und auch nicht die gewaltigen Spitzenhotels in New York. Das Waldorf-Astoria entstand 1897 aus dem Zusammenschluss zweier großer Hotels: dem Waldorf des Unternehmers und Diplomaten William Waldorf Astor und dem Astoria seines Cousins John Jacob Astor IV. Mit 13 bzw. 17 Stockwerken überragten diese Gebäude in der Nähe des Times Square vergleichbare europäische Hotels bei Weitem, übertroffen nur noch von den 19 Stockwerken des Plaza Hotels, das 1907 an der Südseite des Central Parks aufmachte. Bei der Eröffnung kostete eine Übernachtung darin unglaubliche 2,50 US-Dollar. Einer der ehemaligen Plaza-Eigentümer ist der amerikanische Präsident Donald Trump, der die Hotelzimmer in Apartments umwandeln wollte. Das erste Waldorf-

fanden sich bisher schon der Erfinder Thomas Edison, der Schriftsteller Mark Twain, fünf amerikanische und zwei russische Präsidenten.
In San Diego an der Westküste steht das Hotel del Coronado, bei seiner Eröffnung 1888 mit über 900 Zimmern das größte Resort der Welt und schon bald beliebt bei Hollywoods Filmindustrie und ihren Stars. Klar, dass es auch als Filmschauplatz herhalten musste, etwa für Billy Wilders *Manche mögen's heiß* von 1959 mit Marilyn Monroe, Tony Curtis und Jack Lemmon. Als erstes Grandhotel war das Haus bereits bei seiner Eröffnung mit elektrischer Beleuchtung ausgestattet. Thomas Edison soll sich persönlich die Installation angesehen haben. Für den Fall, dass der Strom ausfallen sollte, waren jedoch auch Leitungen für Gasbeleuchtung auf den Zimmern verlegt.

RESORT HOTEL WITH ITS OWN BEACH
Previous pages: The Hotel Excelsior on the Lido, the setting of Thomas Mann's novel *Death in Venice*, circa 1910.

RESORTHOTEL MIT EIGENEM STRAND
Seite 134/135: Das Hotel Excelsior am Lido, Schauplatz von Thomas Manns Novelle *Der Tod in Venedig*, um 1910

« RESORT » AVEC PLAGE PRIVÉE
Pages 134-135 : l'hôtel Excelsior, sur le Lido, théâtre du roman de Thomas Mann *La Mort à Venise*, vers 1910

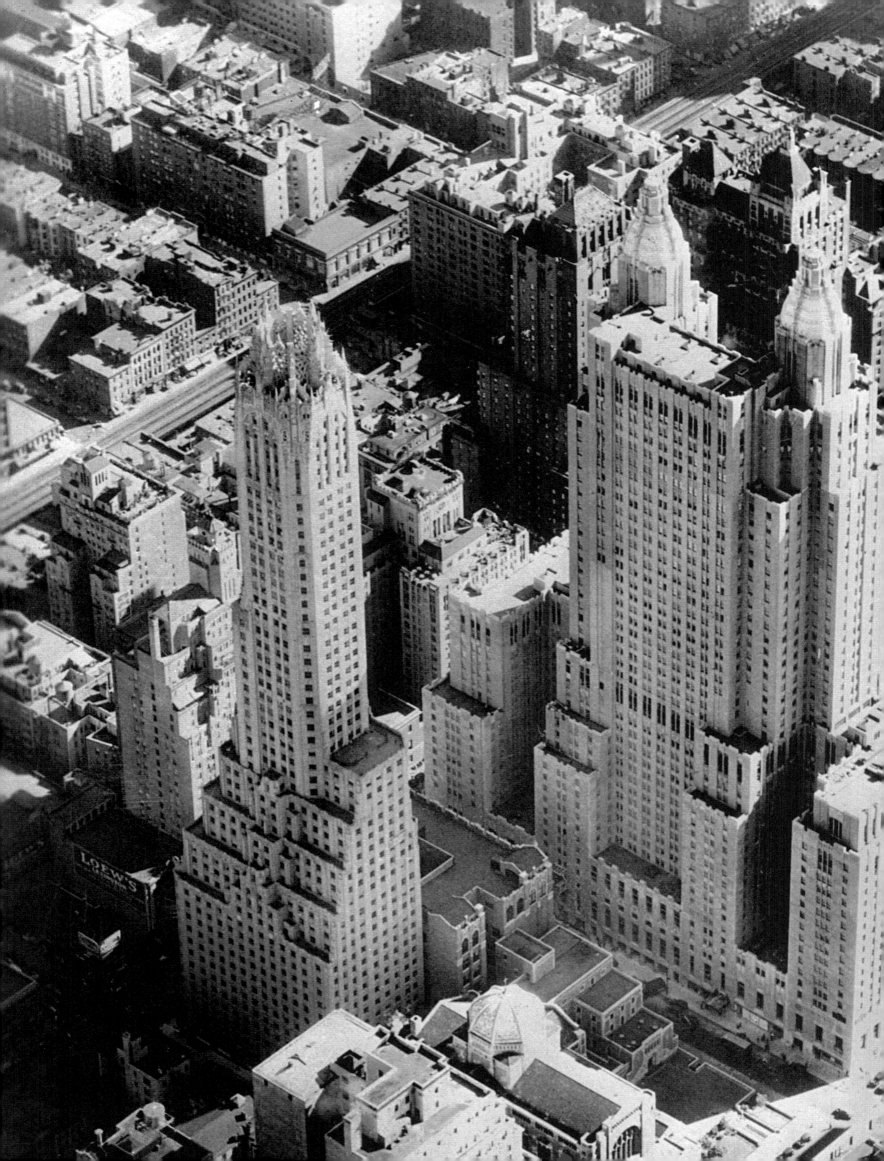

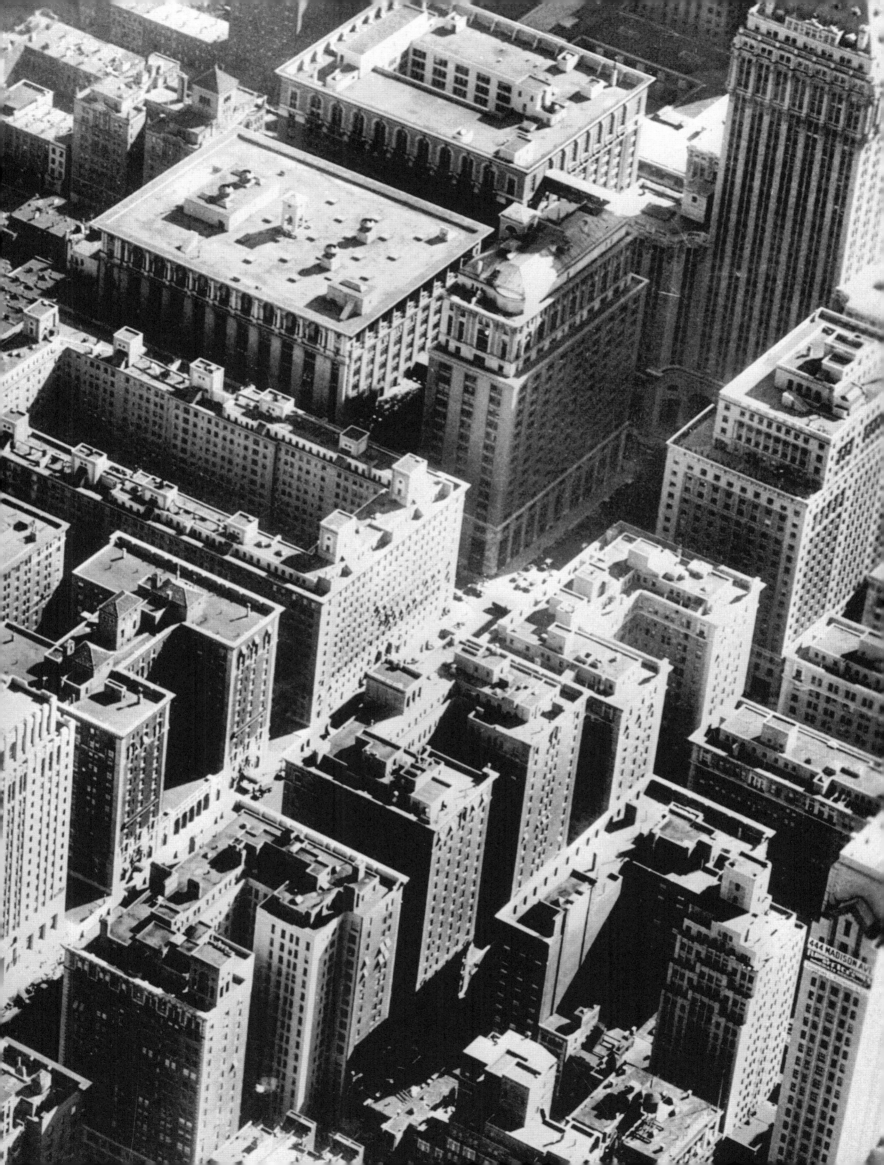

PALACES ET GRANDS HÔTELS

À l'ère des calèches postales, quand un voyageur cherchait un lit pour se reposer, une soupe pour se remplir l'estomac et un toit pour se protéger des intempéries, il devait se contenter de peu. Pour quelques sous, il trouvait à se sustenter et à se loger dans les relais de poste et les auberges de village. Parfois, il avait sa chambre ; souvent, il dormait dans la salle commune ; les mauvais jours, il devait partager sa couche avec le bétail.

L'hôtel, tel que nous le connaissons aujourd'hui, n'existe que depuis le XIXe siècle. Comme toujours, ou presque, c'est la demande qui suscite l'offre. Autrefois, le mot *hôtel* désignait une luxueuse résidence particulière à Paris, où les aristocrates français pouvaient préserver leur intimité sans s'éloigner de la Cour du souverain. Précédés d'une cour intérieure qui les protège de la rue, ces hôtels particuliers recèlent assurément tout le confort – mais impossible d'y passer la nuit contre espèces sonnantes et trébuchantes.

Le premier hôtel dans le sens moderne du terme serait, là encore, une invention britannique. Le 25 janvier 1774, un coiffeur londonien du nom de David Low inaugure une nouvelle ère en ouvrant son Grand Hotel à Covent Garden. Comme tous ceux qui, par la suite, vont s'inspirer de son exemple, l'hôtelier vise une clientèle à la bourse bien garnie, susceptible de rechercher un hébergement haut de gamme pendant son séjour dans la capitale britannique. Ses prestations sont à la hauteur : pour 15 shillings, David Low propose la nuit dans une suite de deux pièces et garantit la meilleure place à l'église. Peu après, il ajoute une autre chambre et un *coffee room* à son établissement, qui restera ouvert jusqu'en 1880.

L'idée du coiffeur londonien ne tarde pas à essaimer dans le monde entier. Bientôt, les hôteliers rivalisent d'offres, toutes plus alléchantes les unes que les autres. Au XIXe siècle, un « grand hôtel » est une résidence dotée d'un confort hors norme, destinée à héberger les aristocrates et les grands bourgeois en voyage. Il est d'abord équipé du gaz, puis de l'électricité, de l'eau courante et du chauffage central, sans oublier, dès son invention, du téléphone. L'architecture intérieure et extérieure de ces grands hôtels est directement inspirée de celle des palais bâtis par la noblesse un peu partout sur l'Ancien Continent. Salles et chambres sont décorées de meubles de style, bien entendu. Pour parfaire le confort du client, l'établissement propose au moins un restaurant orchestré par un chef cuisinier de renom. Et dès lors que le chemin de fer met toute l'Europe, ou presque, à la portée des voyageurs en moins de vingt-quatre heures, l'hôtellerie explose.

Idem outre-Atlantique où, dès les premières années du XIXe siècle, Washington, New York et Boston ont aussi leurs palaces. Les hôtels de luxe du Nouveau Monde se distinguent, entre autres, par des espaces consacrés aux loisirs – fumoir et salle de jeu, café et bibliothèque, mais aussi salle de bal et de concert. À l'époque, les Américains n'hésitent pas à se mettre en scène en public, bien davantage que les Européens. Pour faire montre de leur opulence, ils ont besoin d'espace et d'un décor à l'avenant.

Dans l'Ancien Monde, l'inexorable essor de l'hôtellerie se poursuit. En Suisse, la petite ville de Zurich, jusqu'alors assoupie au bord du lac, devient la capitale financière de l'Europe. Au milieu du XIXe siècle, à la faveur du réaménagement des rues tortueuses du centre-ville, Johannes Baur ouvre un premier établissement sur Paradeplatz. C'est là que, aujourd'hui encore, toutes les grandes banques ont leur siège. Le succès est énorme. Alors l'hôtelier réitère son pari en 1844, avec le Baur au Lac, qui, au lieu d'ouvrir côté ville, donne sur le lac de Zurich. Une innovation très audacieuse pour l'époque, mais qui fera école. Dès lors, tous les hôtels de luxe offrant une vue privilégiée sur les beautés de la nature – lac, mer ou montagne – feront valoir cet argument de poids.

Aujourd'hui encore, un grand nombre de palaces de renommée internationale datent de la Belle Époque, ces trois décennies d'essor culturel qui précèdent la Première Guerre mondiale. D'autres sont même un peu plus anciens, comme le très select Hôtel de Paris, inauguré en 1863 à Monte Carlo. Les capitales en pleine expansion que sont Londres et Paris, entre autres, accusent un énorme besoin d'hébergement haut de gamme. Le Savoy ouvre en 1889 à Londres, puis le Carlton en 1899. Tous deux sont gérés par le Suisse César Ritz, tout comme le Frankfurter Hof, en Allemagne, dont il est le premier directeur, en 1877, ou le Grand Hotel de Rome, qu'il inaugure en 1894.

Simple cireur de chaussures, César Ritz devient le « roi des hôteliers et l'hôtelier des rois », le grand novateur de l'âge d'or des palaces. Son Savoy, à Londres, est le premier établissement à proposer une salle de bains particulière dans chaque chambre, ou presque. Un formidable luxe, à une époque où la plupart des logements n'avaient même pas l'eau courante. De plus, avec la complicité du chef cuisinier Auguste Escoffier, César Ritz place haut la barre de la gastronomie dans ses hôtels. Le couronnement de sa carrière sera son premier palace éponyme : le Ritz, qu'il installe en 1898 dans un palais de la place Vendôme, à Paris.

Lorenz Adlon est à Berlin ce que César Ritz fut à Paris et à Londres. L'hôtelier allemand a su reconnaître le signe des temps, et il répond au besoin croissant de la société berlinoise de s'afficher en public. À quelques encablures de la porte de Brandebourg, l'hôtel qui porte son nom ponctue l'avenue Unter den Linden. Dès son ouverture, en octobre 1907, le somptueux établissement est un succès retentissant. L'entregent de Lorenz Adlon au sein de la haute société allemande n'y est certainement pas pour rien. L'empereur Guillaume II fréquente assidûment l'hôtel Adlon, dont il préfère les luxueuses chambres bien chauffées aux courants d'air de sa résidence berlinoise.

La Côte d'Azur a toujours exercé une fascination irrésistible sur la noblesse des quatre coins de l'Europe, à commencer par la famille royale britannique. En 1913, pas moins de sept têtes couronnées assistent, dit-on, à l'inauguration de l'hôtel Negresco, à Nice. Non loin de là, le Carlton de Cannes, ouvert deux ans plus tôt, devient la coqueluche des aristocrates

russes. Ses coupoles seraient inspirées des seins de Caroline Otero, grande courtisane de la Belle Époque. Après la Seconde Guerre mondiale, le Carlton devient le point de chute favori des vedettes et personnalités du cinéma du monde entier pendant le festival de Cannes. En 1954, c'est sous ses ors qu'Alfred Hitchcock situe l'intrigue de son film *La Main au collet*.

L'univers des palaces est un microcosme des temps modernes, à la fois miroir et indicateur de civilisation. En 1853, l'Américain Elisha Graves Otis invente l'ascenseur à frein de sécurité. Présentée à l'Exposition universelle de Paris, en 1867, son invention conquiert l'Europe. Désormais, un client qui se respecte ne descend plus à l'étage noble, mais il se fait escorter par un garçon d'ascenseur jusqu'à une suite, au dernier étage.

céder la place à ce qui est, à l'époque, le plus haut édifice du monde : l'Empire State Building.

Par ailleurs, les États-Unis inaugurent une nouvelle catégorie d'hôtels, destinés exclusivement aux vacanciers : les *resorts*. Inauguré le 10 juillet 1887, le Grand Hotel de l'île Mackinac, sur le lac Huron, compte, aujourd'hui encore, parmi les plus connus de ces établissements. L'un de ses principaux attraits demeure la « plus grande terrasse du monde », qui donne sur le lac. À l'origine, l'hôtel appartient à deux sociétés de chemin de fer qui le destinent à recevoir les vacanciers en quête de calme et de fraîcheur pendant l'été. Naturellement accessible en train et en bateau à vapeur, il verra défiler nombre de célébrités, dont l'inventeur Thomas Edison, l'écrivain Mark Twain, cinq présidents américains et deux présidents russes.

tués en Europe. Les somptueux édifices du Raffles Hotel de Singapour ou le Taj Mahal Palace, à Bombay, en témoignent encore aujourd'hui. Le célèbre architecte américain Frank Lloyd Wright, lui, innove au Japon en imprimant sa patte à l'hôtel Imperial de Tokyo. Grand admirateur d'art et d'architecture nippons, il joue avec des structures ouvertes et imagine des ensembles évoquant palais et temples du pays du Soleil-Levant. Le 1er septembre 1923, jour de l'inauguration de l'hôtel, un violent séisme secoue Tokyo, détruisant une grande partie du centre-ville. L'édifice de Wright est l'un des rares qui résistent au tremblement de terre sans dommage, ou presque.

Un palace n'est jamais un simple logement de luxe. Il est aussi, et toujours, un haut lieu de la vie sociale. D'innombrables films, romans, pièces de théâtre ou clips musicaux se jouent dans un grand hôtel. Combien de personnalités politiques, de vedette du cinéma et de stars de la musique se sont donné rendez-vous dans les palaces du monde entier ? À l'Ambos Mundos de La Havane, on visite encore la chambre d'Ernest Hemingway, et à l'hôtel National de Moscou, la suite où Lénine vécut après la révolution est restée en l'état – son piano est encore là.

Bien sûr, le parfum des célébrités qui s'y réfugient flotte toujours autour de ces établissements. Mais jamais un mot n'en filtre, car s'il est un service qu'un palace se doit de garantir, c'est bien la discrétion.

> ## « *LA PLUPART DES HÔTELS VENDENT QUELQUE CHOSE QU'ILS N'ONT PAS DU TOUT : LE CALME.* »
> KURT TUCHOLSKY, APHORISMES, 1932

Sans ascenseur, il n'y aurait jamais eu d'immeubles d'habitation, ni de palaces à New York. Le Waldorf-Astoria voit le jour en 1897, de l'union de deux grands hôtels : le Waldorf de l'homme d'affaires et diplomate William Waldorf Astor et l'Astoria de son cousin John Jacob Astor IV. Voisins de Times Square, ces édifices – l'un de 13 étages et l'autre de 17 – dépassent de loin les hôtels de même standing en Europe. Ils seront supplantés en 1907 par les 19 étages de l'hôtel Plaza, qui s'élève sur le flanc sud de Central Park. À l'ouverture de l'hôtel, une nuit coûte la somme incroyable de 2,50 dollars. Ancien propriétaire du Plaza, l'actuel président des États-Unis Donald Trump voulut, pendant un temps, transformer les chambres de l'hôtel en appartements. En 1929, le Waldorf-Astoria de la 5e Avenue, au coin de la 34e Rue, doit être démantelé pour

À San Diego, sur la côte ouest des États-Unis, l'Hotel del Coronado est inauguré en 1888. Avec ses 900 chambres, il est alors le plus grand du monde et devient vite le rendez-vous des célébrités d'Hollywood. Billy Wilder l'immortalisera en 1959 dans *Certains l'aiment chaud*, avec Marilyn Monroe, Tony Curtis et Jack Lemmon. Le palace de San Diego est aussi le premier à être équipé de l'éclairage électrique dès son ouverture. C'est Thomas Edison en personne qui en aurait, dit-on, supervisé l'installation. Mais pour parer à l'éventualité d'une coupure d'électricité, les chambres sont aussi pourvues de tuyaux et de becs de gaz.

Le modèle du grand hôtel est repris partout dans le monde. Dans les colonies britanniques, notamment, les voyageurs recherchent le luxe et l'élégance auxquels ils sont habi-

CITY HOTEL WITH ITS OWN CITY BLOCK
Previous pages: The Waldorf-Astoria in New York, 1930s. It was the largest and tallest hotel in the world when it opened on Park Avenue in 1931.

STADTHOTEL MIT EIGENEM HÄUSERBLOCK
Seite 138/139: Das Waldorf-Astoria in New York. Es war bei seiner Neueröffnung an der Park Avenue 1931 das größte und höchste Hotel der Welt, 1930er-Jahre

UN GRATTE-CIEL AU CŒUR DE LA VILLE
Pages 138-139 : le Waldorf-Astoria, à New York – à sa réouverture sur Park Avenue, en 1931, il sera le plus haut et le plus grand hôtel du monde des années 1930

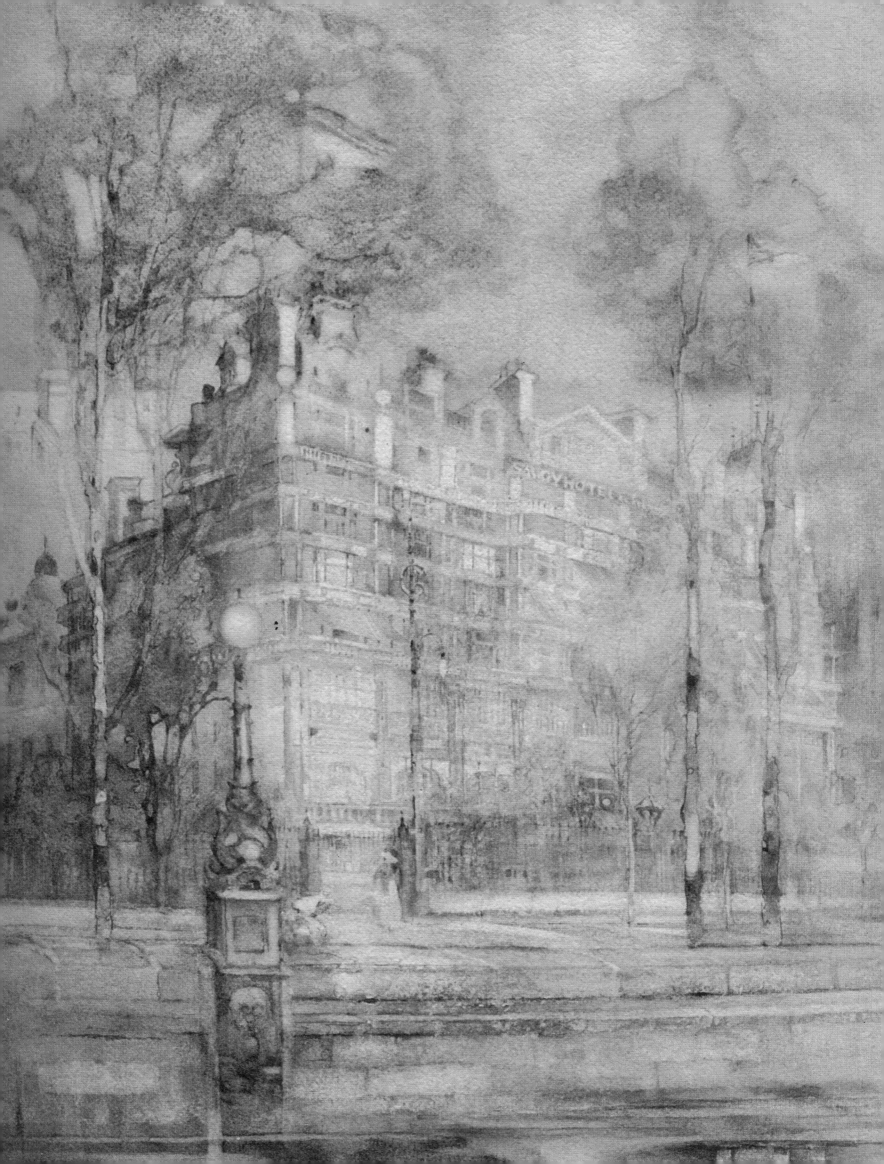

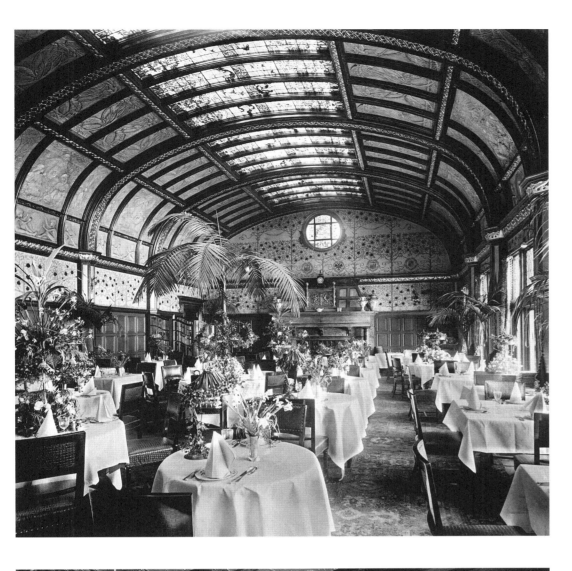

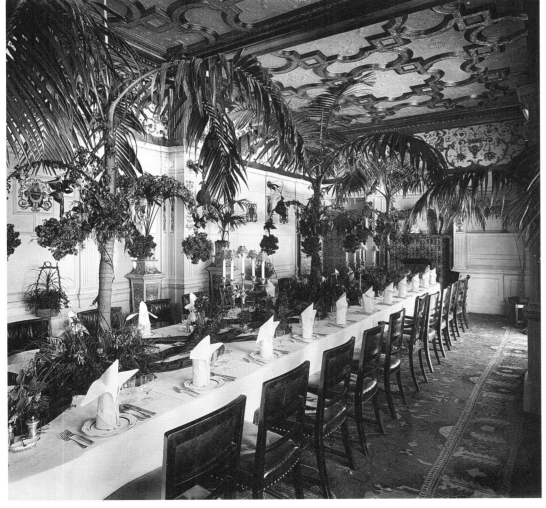

KING OF HOTELIERS

Opposite: A watercolor from 1905 depicts César Ritz's first masterpiece, the Savoy in London, which opened in 1889.
Above: Dining room at the Savoy, 1898.
Below: Pinafore Room at the Savoy, 1896.
Following pages: Culmination of a life's work—the first hotel named after Ritz opened in 1898 on the place Vendôme in Paris, 1919.

KÖNIG DER HOTELIERS

Links: César Ritz' erstes Meisterstück, das 1889 eröffnete Savoy in London, auf einem Aquarell von 1905;
oben: Speisesaal im Savoy, 1898;
unten: Pinafore Room des Savoy, 1896
Seite 144/145: Krönung eines Lebenswerkes – das erste nach Ritz benannte Hotel eröffnete 1898 an der Place Vendôme in Paris, 1919

LE ROI DES HÔTELIERS

Ci-contre : cette aquarelle de 1905 représente le Savoy de Londres, premier chef-d'œuvre de César Ritz, ouvert en 1889 ;
en haut : le restaurant du Savoy, 1898 ;
en bas : la Pinafore room, la salle à manger privée du Savoy, 1896
Pages 144-145 : le couronnement d'une vie – le premier hôtel portant le nom de Ritz ouvre en 1898 place Vendôme, à Paris, 1919

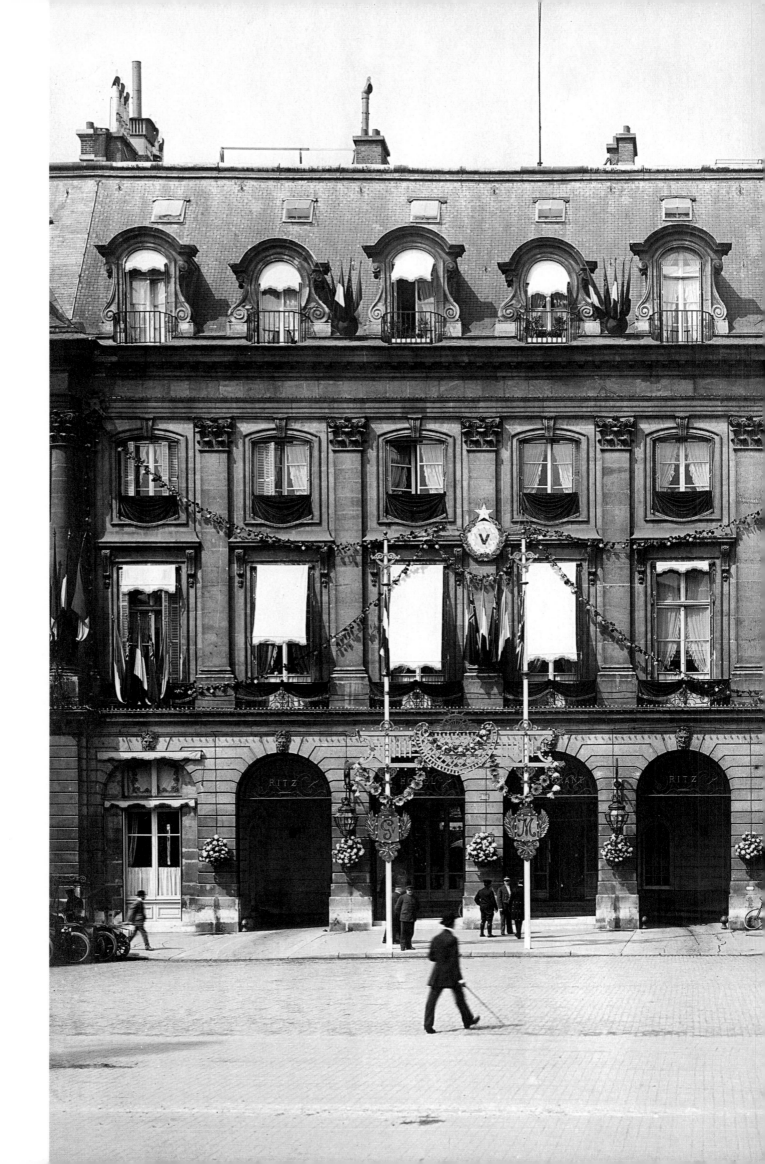

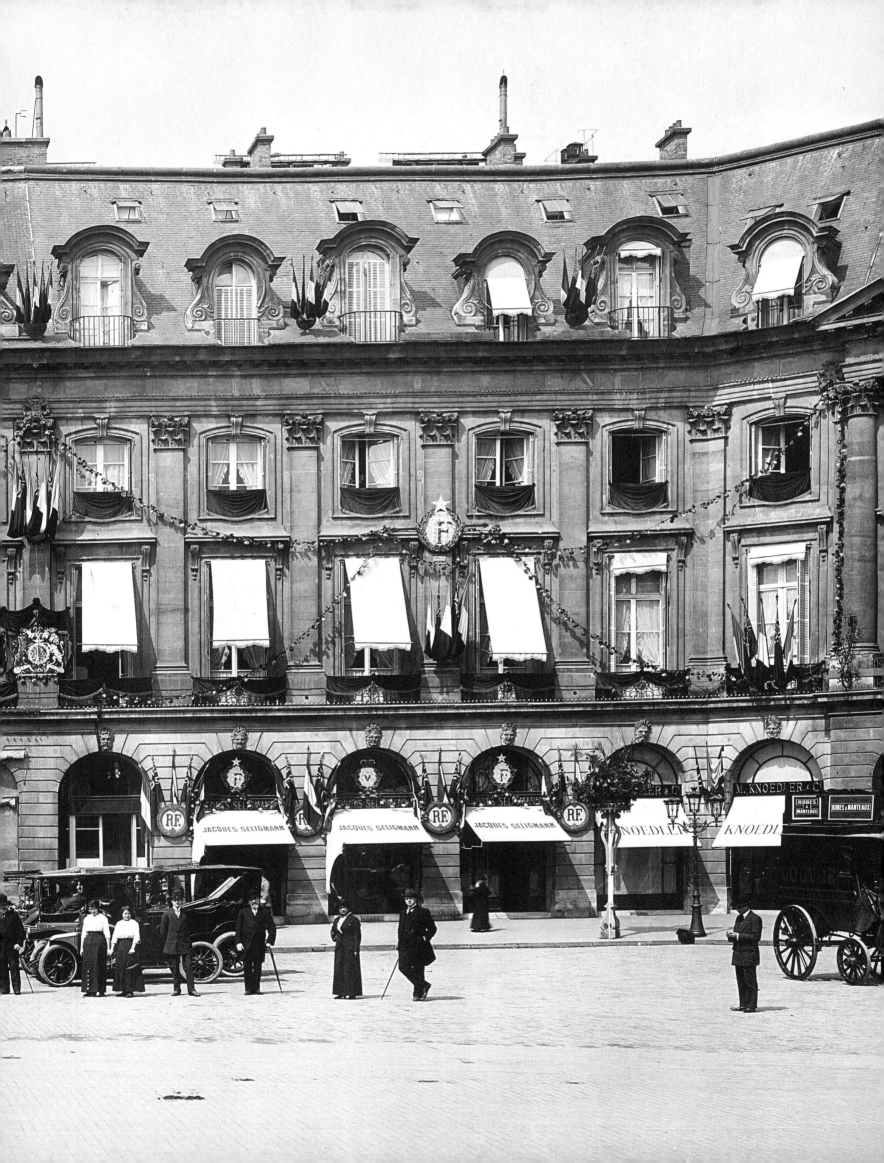

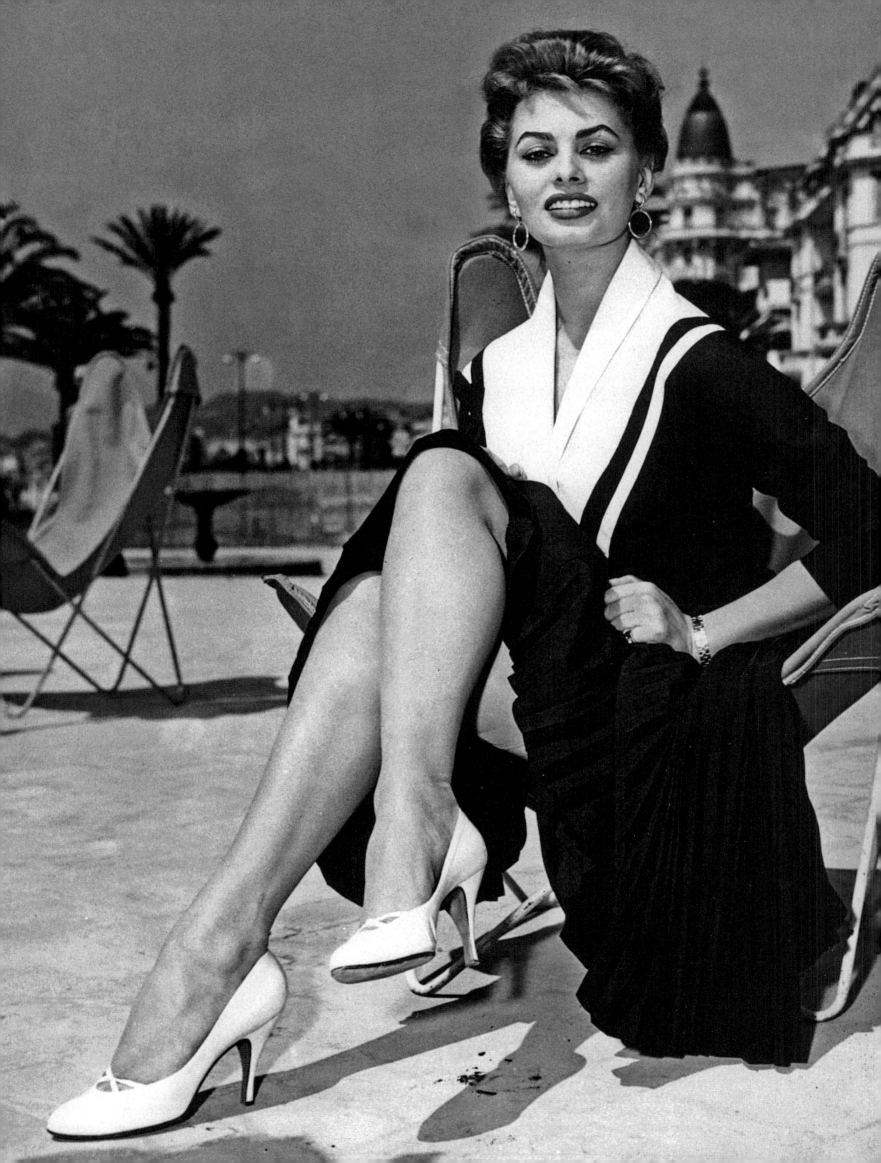

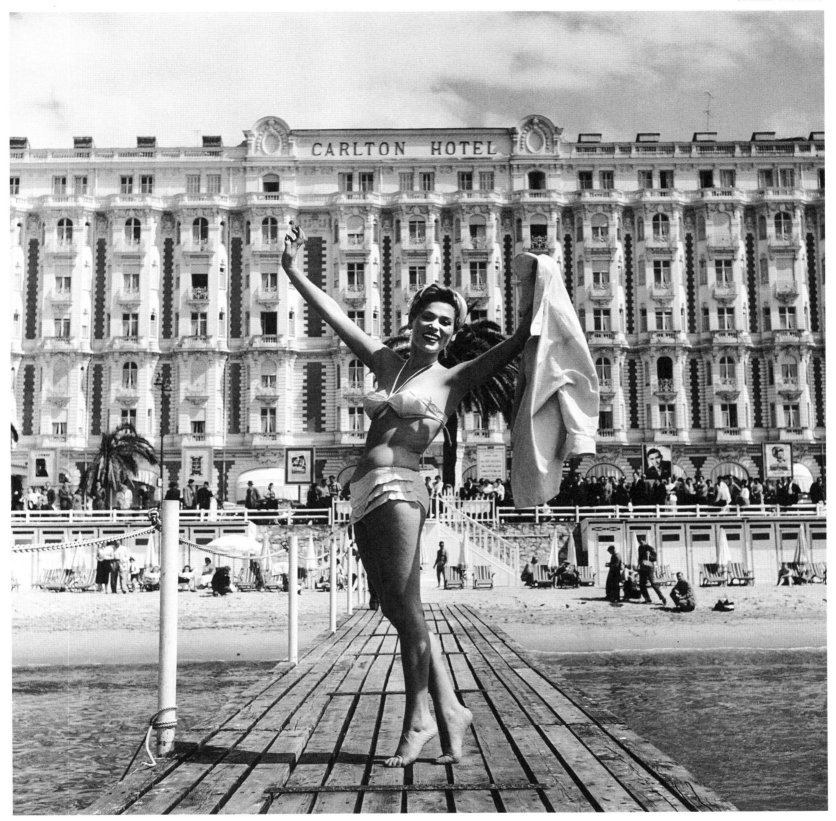

HOTEL OF MOVIE STARS

The Carlton Hotel on La Croisette traditionally takes center stage during the Cannes Film Festival.
Opposite: Italian film icon Sophia Loren, 1954. Above: Polish actress Bella Darvi, 1956.

HOTEL DER FILMSTARS

Das Carlton Hotel an der Croisette steht traditionell im Mittelpunkt der Filmfestspiele von Cannes.
Links: Die italienische Filmikone Sophia Loren, 1954; oben: Die polnische Schauspielerin Bella Darvi, 1956

HÔTEL DE STARS

Le Carlton, sur la Croisette, où bat le pouls du festival de cinéma de Cannes.
Ci-contre : l'icône du cinéma italien Sophia Loren, 1954 ; ci-dessus : l'actrice polonaise Bella Darvi, 1956

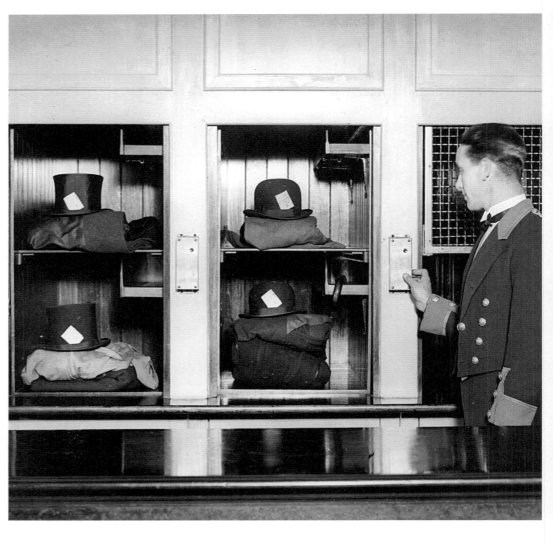

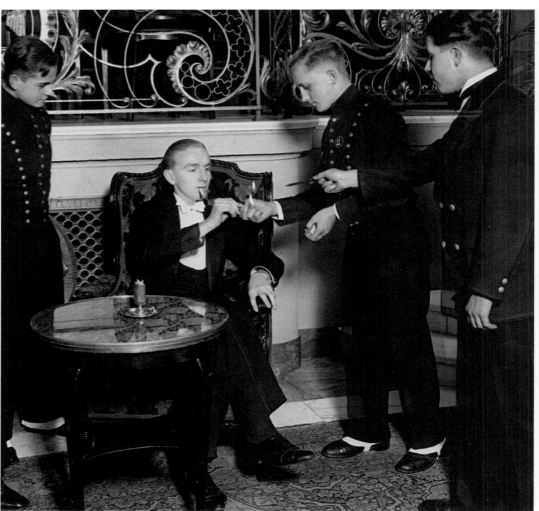

ALWAYS AT YOUR SERVICE

Above: A doorman operates the clothing dumbwaiter
at the London Savoy, 1925.
Below: Apprentice bellboys at a hotel in Berlin, 1920s.
Opposite: Bellboy at the Statler Hotel at Pennsylvania
Station, New York, 1950s.

STETS ZU DIENSTEN

Oben: Ein Portier bedient den Kleideraufzug
im Londoner Savoy, 1925;
unten: Pagenlehrlinge in einem Berliner Hotel,
1920er-Jahre;
rechts: Page des Statler Hotels an der
Pennsylvania Station, New York, 1950er-Jahre

TOUJOURS PRÊTS !

En haut : un portier aux commandes de l'élévateur de
vêtements du Savoy de Londres, 1925 ;
en bas : apprenti groom dans un hôtel de Berlin des
années 1920 ;
ci-contre : portier de l'hôtel Statler, en face de la gare
Pennsylvania Station, New York, dans les années 1950

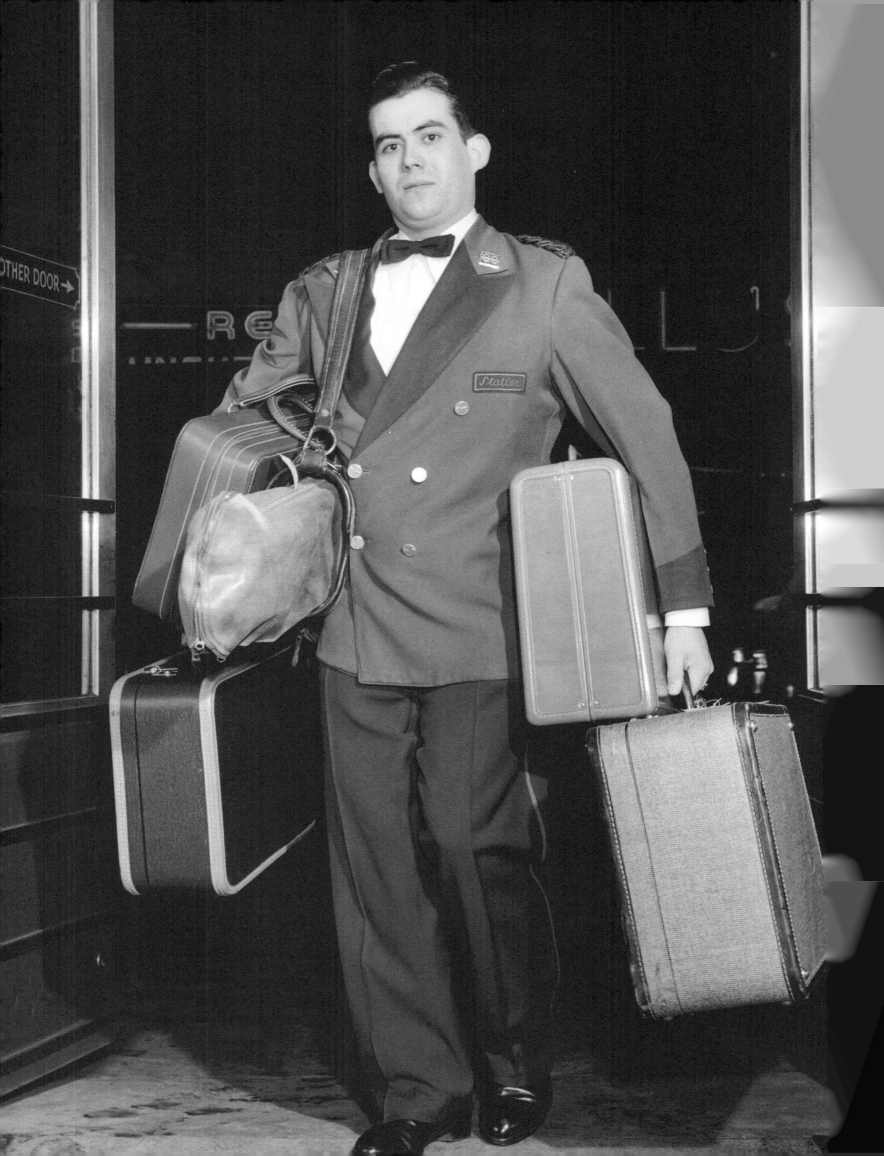

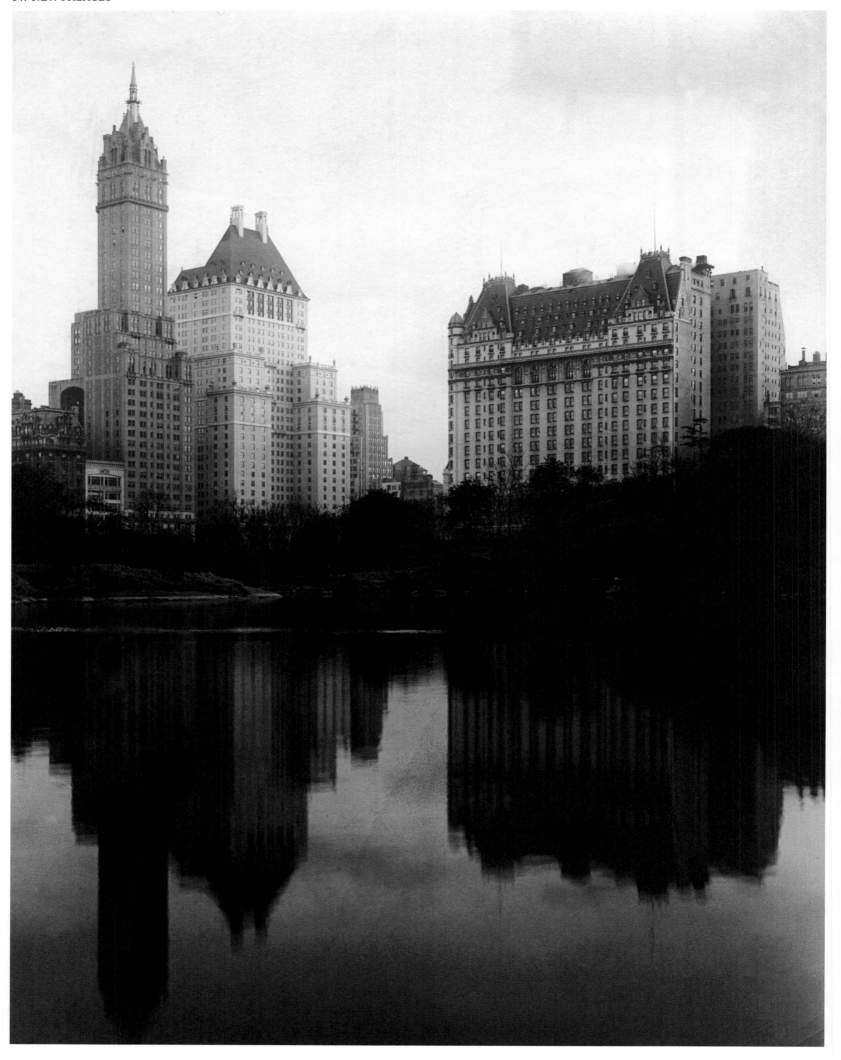

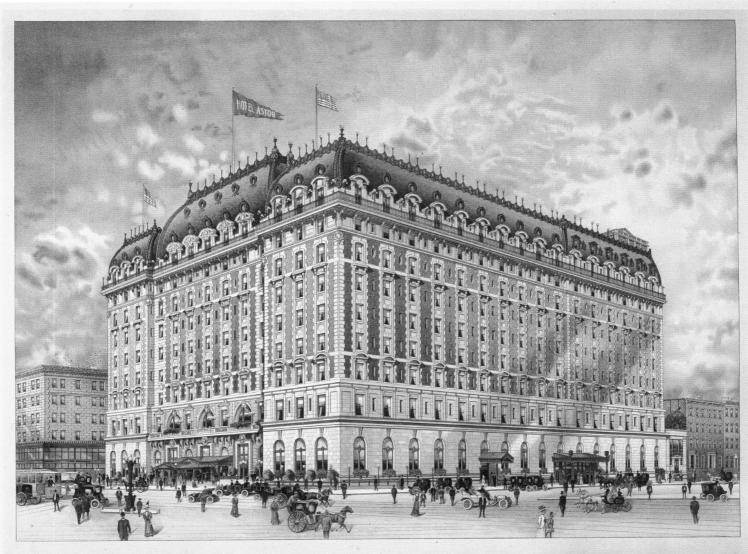

ROOF GARDEN

HOTEL ASTOR
TIMES SQUARE,
NEW YORK
Wm. C. Muschenheim.

ORANGERIE

HOTEL LEGENDS

Opposite: Trio on Central Park. The Sherry-Netherland, the Savoy, and the Plaza hotels, 1930s.
Above: The Hotel Astor on Times Square—headquarters of the hotel dynasty, circa 1910.
Following pages, from left: Social games. The United Nations Day Ball at the Waldorf-Astoria, 1963;
roulette at the Hotel Nacional de Cuba, which was operated by the American mobster Meyer Lansky, 1957.

HOTELLEGENDEN

Links: Trio am Central Park. Das Sherry-Netherland, das Savoy und das Plaza, 1930er-Jahre;
oben: Das Hotel Astor am Times Square – Stammhaus der Hoteldynastie, 1910er-Jahre
Seite 152: Gesellschaftsspiele. Der United Nations Day Ball im Waldorf-Astoria, 1963;
Seite 153: Roulette im Hotel Nacional de Cuba, das vom amerikanischen Mafiosi Meyer Lansky betrieben wurde, 1957

HÔTELS DE LÉGENDE

Ci-contre : le trio de Central Park – le Sherry-Netherland, le Savoy et le Plaza, dans les années 1930 ;
ci-dessus : l'hôtel Astor de Times Square – le premier de toute une dynastie, dans les années 1910
Page 152 : jeux de société. Le bal de la journée des Nations unies au Waldorf-Astoria, 1963
Page 153 : roulette à l'Hotel Nacional de Cuba, dirigé par le mafieux américain Meyer Lansky, 1957

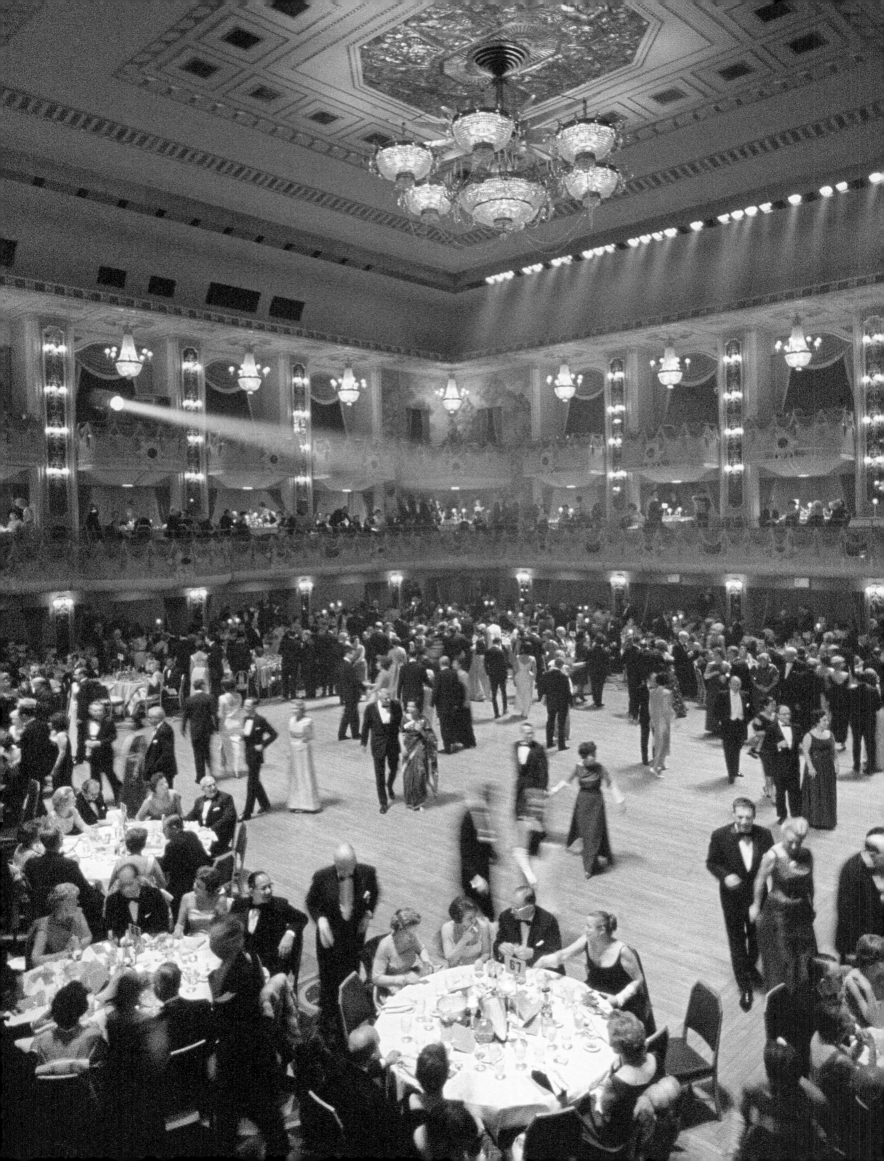

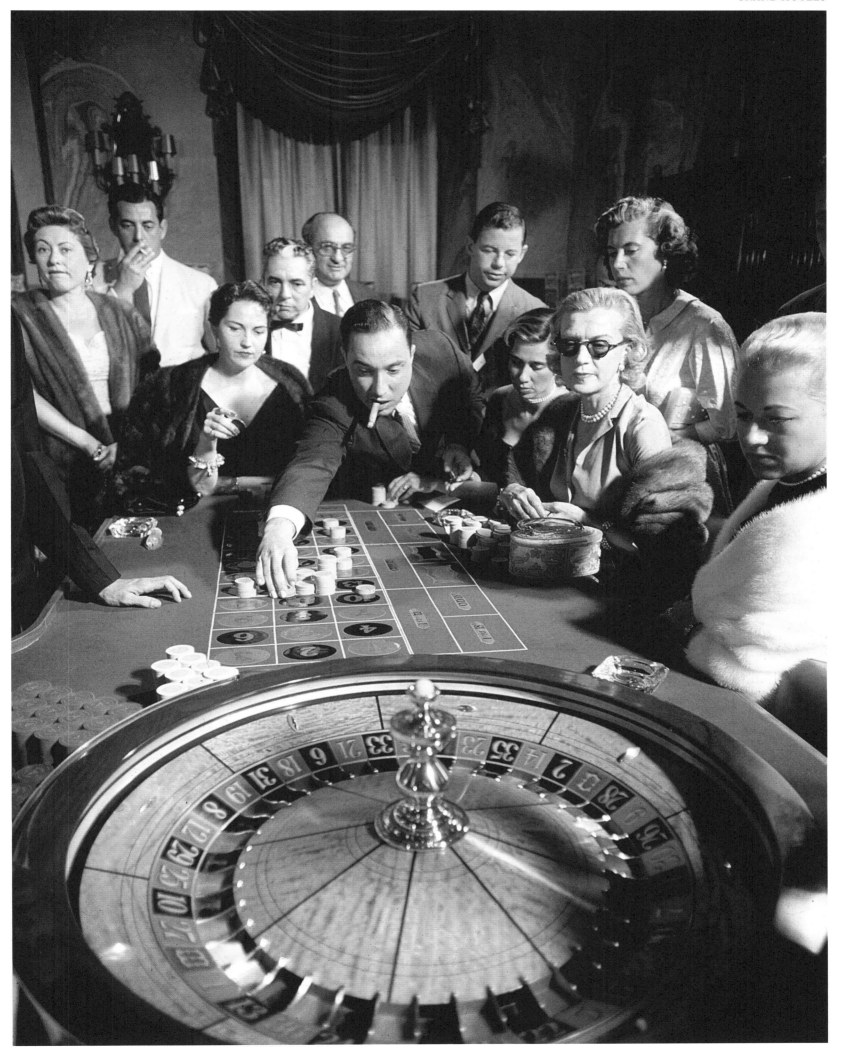

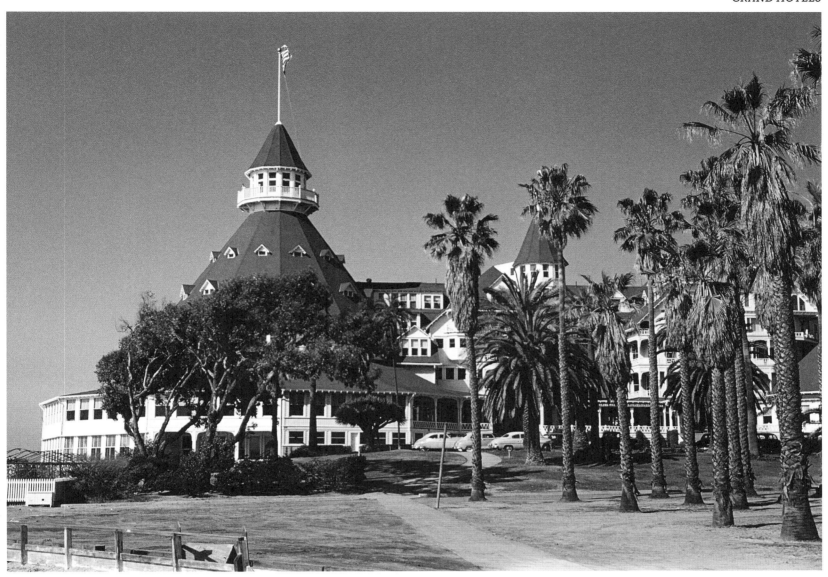

SOME LIKE IT HOT

A party stronghold of Hollywood stars during Prohibition and the setting of the cult comedy by Billy Wilder,
the Hotel del Coronado in San Diego opened in 1888.
Opposite: Scene from *Some Like It Hot* with Marilyn Monroe and Jack Lemmon, 1959. Above: The hotel in 1950.

MANCHE MÖGEN'S HEISS

Partyhochburg der Hollywoodstars in der Prohibitionszeit und Schauplatz der Kultkomödie von Billy Wilder – das
1888 eröffnete Hotel del Coronado in San Diego;
links: Filmszene aus *Manche mögen's heiß* mit Marilyn Monroe und Jack Lemmon, 1959; oben: Das Hotel im Jahre 1950

CERTAINS L'AIMENT CHAUD

Lieu de fête pour les stars hollywoodiennes à l'époque de la prohibition, et théâtre de la comédie culte de Billy Wilder,
l'Hotel del Coronado de San Diego est inauguré en 1888 ; ci-contre : une scène du film *Certains l'aiment chaud*, avec
Marilyn Monroe et Jack Lemmon, 1959 ; ci-dessus : l'hôtel en 1950

6

ON THE HIGH SEAS

AUF HOHER SEE
EN HAUTE MER

GIANT OCEAN LINERS

When the *Clermont*, a steamboat built by the American engineer Robert Fulton, began paddling up the Hudson River toward Albany on August 17, 1807, no one could have imagined what the event would trigger. Fulton's invention was viewed with universal skepticism. During an audience in Paris in 1803, Napoleon purportedly commented to Fulton: "You would make a ship sail against the wind and currents by lighting a bonfire under her decks? I pray you excuse me. I have no time to listen to such nonsense." Although there's no evidence that Napoleon ever actually made this statement, it seems quite likely that the general later regretted his decision to send Fulton away.

Steam-powered ships underwent rapid development: their size steadily increased, and steam engines became increasingly powerful and reliable. Before long, steamers entered regular service, and then it was finally time for them to cross the Atlantic. On May 22, 1819, the *Savannah*, a hybrid sailing ship and side-wheel steamer, set sail from South Carolina and reached Liverpool on June 20. A new era had begun.

Seventy years would pass before ships ventured across the Atlantic Ocean entirely without the benefit of sails. The *Teutonic* was the first in 1889; it made the crossing from Liverpool to New York in less than a week. The ship accommodated 1,490 passengers in three different classes. In an article for the magazine *Ocean*, a writer raved about the elegant facilities and comforts in first class. Shipboard amenities included electric lighting (by no means a given onshore), and its dining room was able to accommodate all

three hundred guests in first class, making it possible for the kitchen to serve everyone at once. Even the second class cabins featured "all the comfort that one would normally find in first-class hotels" with a library, smoker's lounge, and bar.

It goes without saying that first- and second-class passengers had access to separate promenade decks to ensure that members of the upper class didn't have to mingle with middle-class passengers, as well as to guarantee that neither of these groups had to encounter passengers from steerage. Passengers in steerage, usually immigrants who wanted to try their luck in the New World, paid only £3 sterling for a one-way fare.

For wealthy Americans circa 1900, touring Europe was viewed as a status symbol. Sophisticated travelers could look forward to spacious accommodations tauting every amenity on board. In competing for this lucrative business, shipping companies produced ships that continued to grow in size and speed in an effort to win the prestigious Blue Riband, an unofficial award given to the fastest passenger liners crossing the Atlantic Ocean in the westbound direction.

The Cunard Line and the White Star Line were two British shipping companies that were caught up in a particularly fierce rivalry. Owned and operated by the Cunard Line, the *Lusitania* and the *Mauretania* began regular service in 1907. The White Star Line countered four years later with three *Olympic*-class ocean liners, one of which was the ill-fated *Titanic*. During its maiden voyage on April 14, 1912, the *Titanic* sank south of Newfoundland after colliding with an iceberg. Of the 2,200 passengers and crew on board, 1,514 drowned in icy waters. Just three years later, during World War I, a German submarine sank the *Lusitania*, resulting in the death of more than 1,200 passengers and crew.

By no means did British shipping companies have a monopoly on the North Atlantic route. The Hamburg America Line (HAPAG) and Bremen-based North German Lloyd, the sec-

ond-largest shipping company in the world in 1890, had ocean liners operating on the transatlantic route and actively competing for the Blue Riband at the turn of the century. In response to the White Star Line's *Olympic* class, HAPAG commissioned three *Imperator*-class ocean liners in the run-up to World War I. Beginning in the 1920s, the French shipping company Compagnie Générale Transatlantique (CGT) stepped out of the shadows of its European competitors with elegant luxury liners such as the *Île de France* and the *Normandie*.

By contrast, the British Peninsular & Oriental Steam Navigation Company (P&O) dominated regular service between Europe, Africa, Asia and Australia. At first P&O primarily controlled ports on the Iberian Peninsula; later it connected the United Kingdom with overseas possessions and grew into the world's leading shipping company. Thousands of merchants and colonial officials of the British Empire traveled back and forth with their families between the Old World and the colonies in southern Africa and Asia. Most of these passengers belonged to the upper classes and were accustomed to traveling in comfort.

American lines were particularly successful with the Pacific routes to China and Japan. Debuting in 1867, the Pacific Mail Steamship Company offered regular service from San Francisco to Hong Kong and Yokohama. The company was later purchased by the Dollar Steamship Company. During its heyday in the 1920s, it operated the first global passenger and cargo connections that stayed on schedule despite the huge distances involved. San Francisco was also home to the Matson Navigation Company, which opened up Hawaii to tourists from the United States with its luxurious white fleet.

Following World War I, there was a sharp decline in business involving European emigrants to the USA. In response to this development, many shipping lines equipped their ships with affordable cabins for middle-class tourists and business travelers, eliminating

their Spartan third- and fourth-class accommodations. Some shipping companies even began offering dedicated cruises. The elegant *Mauretania*, which upheld its Blue Riband speed record for twenty years, served as a dedicated cruise ship for fifty-four cruises from 1923 to 1934. Passengers on board enjoyed a wide variety of entertainment options, including attending concerts, playing deck tennis, and shooting clay pigeons.

The 1930s saw an upswing in steamer travel. The *Bremen* and its sister ship *Europa*, owned by North German Lloyd, were considered to be the most advanced ocean liners of their day, as they were able to make the crossing

seating for 380, a sauna, and two swimming pools. The ship had a shopping street, a post office with its own telephone switchboard, and a hospital that included a dental clinic for emergencies. Measuring 330 feet in length and featuring seating for seven hundred guests, the dining room was the social hub of life on board. Passengers in search of more exclusive accommodations could book one of the two suites at the end of the sundeck. Each suite boasted four bedrooms, a living room, a dining room, and a private terrace.

The *Normandie* swiftly became a favorite among stars such as Josephine Baker, Marlene Dietrich, and Fred Astaire, although its line operation lasted only four years. While

The *Queen Mary* more than matched the furnishings of the glamourous *Normandie*. Onboard amenities included beauty salons, libraries, and child care for all three classes, as well as a music studio, reading rooms, tennis courts, and even kennels. The luxury ship held the Blue Riband title for sixteen years until she lost it to the *United States* in 1952. The passenger liner that still holds the title to this day, having made the crossing from New York to Southampton in three days, ten hours, and forty minutes.

The writing was on the wall even back then, when it became apparent that regular transatlantic service would not remain feasible for much longer. Ocean liners gave way to the new nonstop intercontinental airplanes, which could transport passengers across the Atlantic in a matter of hours rather than days, drawing continents ever closer together. First-class passengers traveled further and faster. Rather than amusing themselves in the library or the smoker's lounge, they lingered at the onboard bar six miles above ground.

66 ... MORE THAN A VESSEL, IT IS A FLOATING CITY, PART OF THE COUNTRY, DETACHED FROM ENGLISH SOIL, WHICH AFTER HAVING CROSSED THE SEA, UNITES ITSELF TO THE AMERICAN CONTINENT. 99

—JULES VERNE, A FLOATING CITY, 1870
(ABOUT THE TRANSATLANTIC PADDLEWHEEL STEAMSHIP GREAT EASTERN)

to New York in just five days. Both ships were equipped with a small seaplane that was launched via catapult, making it possible to deliver mail to shore several hours before the ocean liner's arrival.

When the French ocean liner *Normandie*, owned by CGT, entered service in 1935, it caused a global sensation because of its art deco interior design. In fact, many considered it to be the "perfect passenger ship." At 1,030 feet in length, it was the largest vessel afloat at that time, even if it was "only" designed for 2,000 passengers, half of whom were in first class. Travelers enjoyed such amenities as restaurants, bars, a theater with

it was later being retrofitted as an American naval vessel in a New York harbor, the luxury liner caught fire and capsized.

The now merged Cunard White Star line had no desire to be left behind in the shipbuilding race by its German and French competitors. In 1936, the *Queen Mary* set out on its maiden voyage and was considered by many to be the epitome of an ocean liner. Like its younger sister ship, the *Queen Elizabeth*, this ocean liner survived World War II and continued regular transatlantic service into the 1960s. It's now permanently moored in the Long Beach, California, port, where it features luxury hotel accommodations.

The sinking of the Italian luxury liner *Andrea Doria* in July 1956 off the coast of Nantucket, Massachusetts, symbolized the end of an era for large passenger ships. Although the large shipping companies ceased regular transatlantic service in the late 1960s, proud ships with illustrious names, such as the *Queen Mary 2*, still traverse the world's oceans today—as cruise ships. Their business and their guests, however, are much different than those of the golden age of ocean liners.

WHEN ANGELS TRAVEL

Page 156: German movie star Marlene Dietrich with a pile of luggage en route to the USA on the ocean liner *Bremen*, 1931.

WENN ENGEL REISEN

Seite 156: Der deutsche Filmstar Marlene Dietrich mit großem Gepäck auf dem Weg in die USA mit dem Dampfer *Bremen*, 1931

UN ANGE PART EN VOYAGE

Page 156 : l'actrice allemande Marlene Dietrich, assise sur ses bagages, en route pour les États-Unis à bord du paquebot *Bremen*, 1931

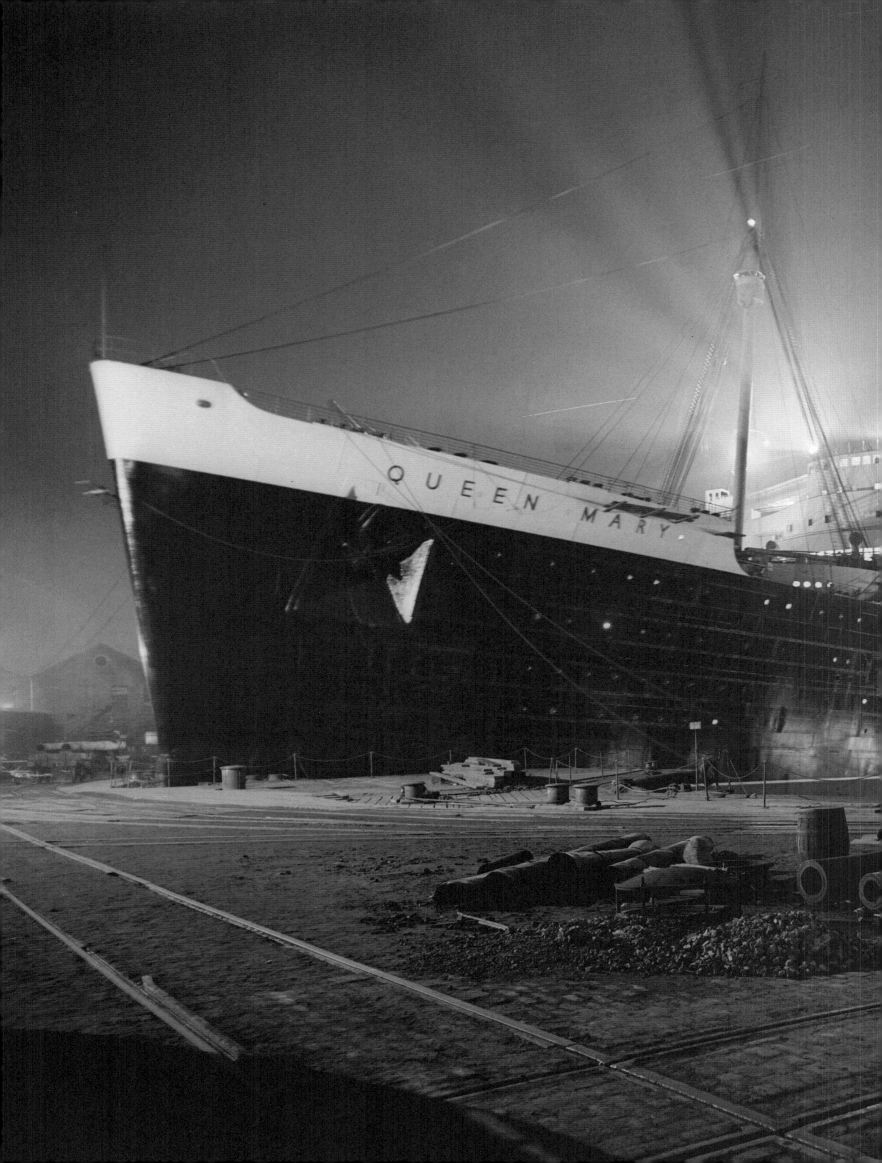

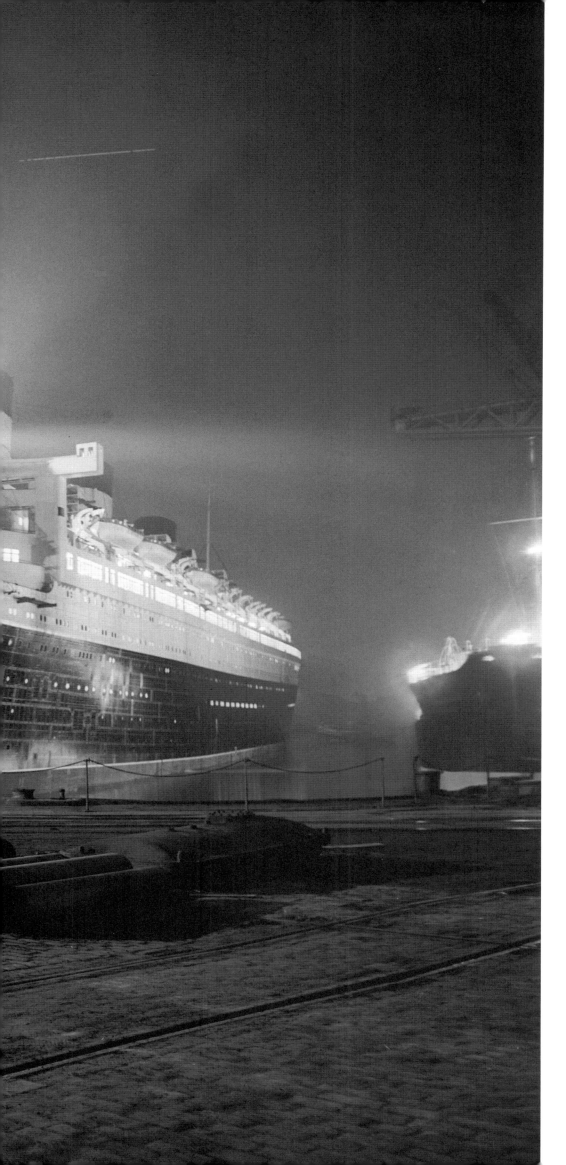

FUTURE QUEEN

Finishing touches being made to the *Queen Mary* at the shipyard in Clydebank, Scotland, before the ship set out on its maiden voyage, 1936. The ocean liner would traverse the oceans for thirty-one years.

KÜNFTIGE KÖNIGIN

Letzte Arbeiten an der *Queen Mary* in der Werft im schottischen Clydebank, bevor das Schiff zu seiner Jungfernfahrt aufbrach, 1936. Der Ozeanriese sollte 31 Jahre lang auf den Weltmeeren kreuzen

REINE EN DEVENIR

Dernières touches pour le *Queen Mary* en rade de Clydebank, en Écosse, avant son voyage inaugural, 1936. Le géant des mers sillonnera les océans pendant trente et un ans

OZEANRIESEN

Als am 17. August 1807 der Raddampfer *Clermont* des amerikanischen Ingenieurs Robert Fulton den Hudson River Richtung Albany hinaufschnaufte, ahnte wohl noch niemand, was Fulton damit auslösen würde. Seine Erfindung wurde allenthalben skeptisch beurteilt. Bei einer Audienz 1803 in Paris soll Napoleon ihn noch gefragt haben: „Mit Zigarrenrauch wollen Sie ein Schiff antreiben?" Das Zitat ist nicht belegt, wohl aber, dass der Feldherr die Entscheidung, Fulton wegzuschicken, später bedauert hat.
Die Entwicklung dampfgetriebener Schiffe folgte Schlag auf Schlag. Sie wurden immer größer, die Dampfmaschinen immer stärker und zuverlässiger. Bald schon konnte man die Dampfer im Liniendienst einsetzen, und schließlich war es an der Zeit, den Atlantik zu überqueren. Am 22. Mai 1819 stach die *Savannah*, ein Segler mit zusätzlichem Dampfantrieb, von South Carolina aus in See und erreichte am 20. Juni Liverpool. Ein neues Zeitalter hatte begonnen.

Völlig ohne Segel traute man sich jedoch erst 70 Jahre später über den Atlantischen Ozean. Den Auftakt machte 1889 die *Teutonic*, die für die Überfahrt von Liverpool nach New York weniger als eine Woche benötigte. 1 490 Passagiere passten in die drei Klassen an Bord. Ein Autor der Zeitschrift *Ocean* schwärmte in seinem Artikel von der eleganten Ausstattung und dem Komfort der ersten Klasse. An Bord gab es elektrisches Licht – auf dem Festland noch lange keine Selbstverständlichkeit. Der Speisesaal konnte 300 Gäste aufnehmen. Mehr fuhren nicht mit in der ersten Klasse, deshalb konnte das Essen aus der Küche für alle auf einmal serviert werden. Selbst die Kabinen zweiter Klasse waren „mit allem Komfort ausgestattet, den man übli-

cherweise in erstklassigen Hotels findet". Es gab eine Bibliothek, einen Rauchersalon und eine Bar.
Für die ersten beiden Klassen standen selbstverständlich separate Promenadendecks zur Verfügung, sodass die gehobene Gesellschaft nicht der nicht ganz so gehobenen Gesellschaft und beide nicht den Passagieren aus dem Zwischendeck begegnen mussten. Letztere hatten für eine Passage ohne Rückfahrt nur 3 Pfund Sterling bezahlt und waren meist Auswanderer, die ihr Glück in der neuen Welt versuchen wollten.

Europareisen waren für reiche Amerikaner um 1900 ein Statussymbol. Entsprechend großzügig waren das Raumangebot und die Ausstattung für diese anspruchsvollen Reisenden an Bord. Die Reedereien wetteiferten um das lukrative Geschäft mit immer größeren und schnelleren Schiffen, um das prestigeträchtige Blaue Band für die schnellste Atlantiküberquerung zu erlangen.

Einen besonders erbitterten Wettstreit lieferten sich die britischen Reedereien Cunard Line und White Star Line. Ab 1907 fuhren die *Lusitania* und die *Mauretania* für die Cunard. White Star konterte vier Jahre später mit drei Schiffen der *Olympic*-Klasse, von denen die *Titanic* traurige Berühmtheit erlangte. Sie sank auf ihrer Jungfernfahrt am 14. April 1912 vor Neufundland, nachdem sie mit einem Eisberg kollidiert war. Von 2 200 Personen an Bord ertranken 1 514 jämmerlich in den kalten Fluten. Nur drei Jahre später, im Ersten Weltkrieg, versenkte ein deutsches U-Boot die *Lusitania* – über 1 200 Menschen fanden dabei den Tod.
Britische Reedereien hatten keineswegs das Monopol auf die Strecke über den Nordatlantik. Die Hamburger HAPAG und Bremens Norddeutscher Lloyd – 1890 die zweitgrößte Reederei der Welt – mischten mit ihren Ozeanriesen im Atlantikverkehr mit und konkurrierten um die Jahrhundertwende ebenfalls um das Blaue Band. Als Antwort auf die *Olympic*-Klasse von White Star ließ die HAPAG am Vorabend des Ersten Weltkrieges drei Schiffe der sogenannten *Imperator*-Klasse bauen.

Die französische Compagnie Générale Transatlantique (CGT) trat ab den 1920er-Jahren mit eleganten Luxuslinern wie der *Île de France* und der *Normandie* aus dem Schatten ihrer europäischen Konkurrenten.

Den Linienverkehr zwischen Europa, Afrika, Asien und Australien dominierte dagegen die britische Peninsular & Oriental Steam Navigation Company (P&O). Sie lief zunächst überwiegend Häfen auf der Iberischen Halbinsel an; später verband sie das Vereinigte Königreich mit den Besitzungen in Übersee und wuchs zur weltweit führenden Reederei heran. Kaufleute und Kolonialbeamte des Britischen Empire reisten mit ihren Familien zu Tausenden zwischen der Alten Welt und den Kolonien im südlichen Afrika oder Asien hin und her. Die meisten dieser Passagiere gehörten zu den oberen Gesellschaftsschichten und waren es gewohnt, entsprechend komfortabel zu reisen.

Amerikanische Linien waren vor allem bei den Pazifikverbindungen nach China und Japan erfolgreich. Schon 1867 fuhr die Pacific Mail Steamship Company regelmäßig von San Francisco nach Hongkong und Yokohama. Sie ging in der Dollar Steamship Company auf. Diese betrieb in ihrer Blütezeit in den 1920er-Jahren die ersten weltumspannenden Passagier- und Frachtschiffsverbindungen, die sich trotz der riesigen Entfernungen sogar an Fahrpläne hielten. San Francisco war außerdem der Heimathafen der Matson Navigation Company, die mit ihrer luxuriösen Weißen Flotte Hawaii für Touristen aus den Vereinigten Staaten erschloss.

Nach dem Ersten Weltkrieg ging das Geschäft mit den europäischen Auswanderern in die USA stark zurück. Viele Linien rüsteten daraufhin ihre Schiffe mit günstigen Kabinen für Mittelklasse-Touristen und Geschäftsreisende um; die spartanische dritte und vierte Klasse entfiel. Einige Reedereien boten auch reine Kreuzfahrten an. So war die elegante *Mauretania*, die das Blaue Band 20 Jahre lang verteidigen konnte, von 1923 bis 1934 auf 54 Kreuzfahrten im Einsatz. An Bord konnten

Passagiere nicht nur Konzerte besuchen, sondern auch Decktennis spielen oder auf Tontauben schießen.

Die 1930er-Jahre sahen nochmals einen Aufschwung der Dampflinien. Die *Bremen* und ihr Schwesterschiff *Europa* des Norddeutschen Lloyds galten als die modernsten Schiffe ihrer Zeit und brauchten nur knapp 5 Tage nach New York. Beide Ozeanriesen verfügten über ein Bordflugzeug, das von einem Katapult gestartet wurde und die Post schon Stunden vor dem Eintreffen des Dampfers an Land brachte.

Bord war der 100 Meter lange Speisesaal, der Platz für 700 Gäste bot. Wer es exklusiver mochte, konnte sich in einer der beiden Suiten am Ende des Sonnendecks einmieten. Jede Suite verfügte über vier Schlafzimmer, ein Wohnzimmer, ein Esszimmer und eine Privatterrasse. Die *Normandie* wurde rasch zum Lieblingsschiff von Showgrößen wie Josephine Baker, Marlene Dietrich oder Fred Astaire. Der Linienbetrieb währte jedoch nur vier Jahre. Beim Umbau zum amerikanischen Kriegsschiff im New Yorker Hafen geriet der Luxusliner dann später in Brand und kenterte.

Klassen, dazu ein Musikstudio, Lesehallen, Tennisplätze und sogar Hundehütten. 16 Jahre lang konnte das Luxusschiff das Blaue Band verteidigen. 1952 nahm es ihr die *United States* ab und hält es bis heute – mit 3 Tagen, 10 Stunden und 40 Minuten von New York nach Southampton.

Schon zu dieser Zeit begann sich abzuzeichnen, dass der Linienbetrieb der großen Dampfer sich bald nicht mehr lohnen würde. An ihre Stelle traten mit den neuen Nonstop-Interkontinentalverbindungen die Flugzeuge, die die Passage über den Atlantik von wenigen Tagen auf wenige Stunden verkürzten und die Kontinente näher zusammenrücken ließen. Erste-Klasse-Passagiere reisten fortan viel schneller und weiter, Kurzweil fanden sie nicht mehr in der Bibliothek oder dem Rauchersalon eines Ozeandampfers, sondern 10 Kilometer über der Erde an der Bordbar. Zum Symbol für das Ende der Ära des Passagierverkehrs wurde der Untergang der italienischen *Andrea Doria* im Juli 1956 vor der Küste von Nantucket. Die großen Reedereien stellten Ende der 1960er-Jahre den Linienbetrieb über den Atlantik ein. Gleichwohl durchpflügen stolze Schiffe mit klangvollen Namen wie die *Queen Mary 2* auch heute noch die Weltmeere – als Kreuzfahrtschiffe. Ihr Geschäft und ihre Gäste sind jedoch andere als in den goldenen Zeiten der Oceanliner.

> ❞ *MAN KANN DIESEN DAMPFER KAUM NOCH EIN SCHIFF NENNEN; ES IST WOHL MEHR EINE SCHWIMMENDE STADT, EIN STÜCK GRAFSCHAFT, DAS SICH VON ENGLISCHEM GRUND UND BODEN LOSLÖST, UM NACH EINER FAHRT ÜBER DAS MEER MIT DEM AMERIKANISCHEN FESTLANDE ZUSAMMENZUWACHSEN.* ❝
>
> *JULES VERNE, EINE SCHWIMMENDE STADT, 1870 (ÜBER DEN TRANSATLANTIK-RADDAMPFER GREAT EASTERN)*

Die 1935 in Dienst gestellte *Normandie* der französischen CGT erregte weltweit Aufsehen durch ihre Art-déco-Innenausstattung und galt als das perfekte Passagierschiff. Mit 314 Metern Länge war sie das bis dahin größte gebaute Schiff, wenn auch „nur" für 2 000 Fahrgäste ausgelegt. Die Hälfte der Passagiere war dafür in der ersten Klasse untergebracht. Den Reisenden standen Restaurants, Bars, ein Theater mit 380 Plätzen, eine Sauna und zwei Schwimmbäder zur Verfügung. Es gab eine Ladenstraße, ein Postamt mit eigener Telefonzentrale und eine Bordklinik mit Zahnstation für Notfälle. Mittelpunkt des gesellschaftlichen Lebens an

Die inzwischen fusionierte Reederei Cunard White Star wollte nicht hinter den deutschen und französischen Superlativen zurückstehen. 1936 lief die *Queen Mary* zu ihrer Jungfernfahrt aus, für viele der Inbegriff des Ozeanriesen. Wie sein jüngeres Schwesterschiff *Queen Elizabeth* überstand dieser Dampfer den Zweiten Weltkrieg, querte noch bis in die 1960er-Jahre als Linienschiff den Atlantik und liegt heute als Luxushotel im kalifornischen Long Beach vor Anker.

Hinter der Ausstattung der glamourösen *Normandie* musste sich die *Queen Mary* nicht verstecken. An Bord gab es Schönheitssalons, Bibliotheken und Kinderbetreuung für alle drei

TRANSATLANTIQUES

Le 17 août 1807, le *Clermont*, un vapeur à roue conçu par l'ingénieur américain Robert Fulton, remonte l'Hudson en direction d'Albany. Nul ne se doute encore de ce qu'augure ce premier voyage. De toutes parts, l'invention du moteur à vapeur est accueillie avec scepticisme. Lors d'une audience que Bonaparte accorde à Fulton en 1803 à Paris, le Premier consul lui aurait demandé : « Vous voulez propulser un bateau avec de la fumée de cigare ? » S'il n'est pas certain qu'il prononçât ces exactes paroles, il est fort probable que le général, par la suite, ait regretté d'avoir éconduit l'ingénieur.

Car la navigation à vapeur ne tarde pas à évoluer à vue d'œil. Les bateaux sont plus en plus grands, à mesure que les machines se font toujours plus fiables et puissantes. En quelques années, les navires à vapeur monopolisent les lignes maritimes régulières. Puis vient le temps des traversées transatlantiques. Le 22 mai 1819, le *Savannah*, un voilier équipé d'un moteur à vapeur, lève l'ancre en Caroline du Sud pour s'élancer à l'assaut de l'océan. Il atteint Liverpool le 20 juin. Une nouvelle ère commence.

Il faudra toutefois attendre encore soixante-dix ans pour que soit tentée la première traversée transatlantique à vapeur sans le soutien de la voile. En 1889, le *Teutonic* donne le coup d'envoi, reliant Liverpool à New York en moins d'une semaine. Il transporte 1 490 passagers, répartis dans les trois classes proposées à bord. Un article publié dans le magazine de navigation *Ocean* décrit avec emphase l'élégance et le confort des premières. Le bateau dispose de l'éclairage électrique, alors que ce luxe ne va pas encore de soi sur la terre ferme à l'époque, loin s'en faut. La salle à manger peut servir 300 couverts, ce qui correspond au nombre de passagers de première classe, de sorte que

les cuisines puissent s'organiser pour que tous prennent leur repas au même service. Les cabines de seconde, elles aussi, sont « équipées de tout le confort digne d'un hôtel haut de gamme ». Pour tuer agréablement le temps, les passagers disposent d'un bar, d'une bibliothèque et d'un salon fumeur. Deux ponts-promenades séparés permettent aux passagers des deux classes supérieures de prendre l'air en toute quiétude : la haute société ne croise pas la moins haute, et ni l'une ni l'autre ne risque de se compromettre avec les passagers de l'entrepont. Ceux-là sont en majorité des migrants qui vont tenter leur chance dans le Nouveau Monde – l'aller simple ne leur a coûté que 3 livres sterling.

Pour les riches Américains des années 1900, un voyage en Europe est une marque de prestige. Et à bord, les espaces et prestations proposés à ces exigeants passagers sont à l'avenant. Le transport transatlantique s'avérant une activité lucrative, les constructeurs rivalisent de vitesse et de démesure afin de rafler et de conserver le prestigieux ruban bleu qui récompense la traversée la plus rapide.

Entre les deux compagnies britanniques, la Cunard Line et la White Star Line, la concurrence est particulièrement âpre. Dès 1907, la Cunard lance le *Lusitania* et le *Mauretania*. Quatre ans plus tard, la White Star contre-attaque avec ses trois fleurons de la classe *Olympique*, dont le *Titanic*, de triste mémoire. Il sombrera lors de son voyage inaugural, le 14 avril 1912, au large de Terre-Neuve, après être entré en collision avec un iceberg. Sur 2 200 passagers à bord, 1 514 périront noyés dans les flots glacés. Trois ans plus tard, en pleine Première Guerre mondiale, un sous-marin allemand va couler le *Lusitania* : plus de 1 200 personnes trouveront la mort dans cette tragédie.

Les compagnies maritimes britanniques n'ont pas le monopole des liaisons transatlantiques. À l'aube du XXᵉ siècle, la HAPAG, à Hambourg, et la Norddeutscher Lloyd de Brème – deuxième constructeur naval du monde en

1890 – lancent leurs paquebots géants dans la course au ruban bleu. En réponse à la classe *Olympique* de la White Star, la HAPAG, à la veille de la Grande Guerre, se lance dans la construction des trois transatlantiques qui composeront sa classe *Impériale*. En France, la Compagnie générale transatlantique (CGT) sort de l'ombre de ses concurrents européens dans les années 1920, mettant à flot de prestigieux transatlantiques, comme l'*Île de France* et le *Normandie*, qui brillent par leur raffinement.

Entre l'Europe et l'Afrique, l'Asie ou l'Australie, en revanche, c'est la Britannique Peninsular & Oriental Steam Navigation Company (P & O) qui règne en maître absolu. Dans un premier temps, elle dessert surtout les ports de la péninsule ibérique, avant d'assurer la liaison avec les colonies de la Couronne. Elle devient alors la deuxième compagnie maritime du monde. À l'époque, des milliers de commerçants et fonctionnaires de l'Empire britannique se déplacent, avec leurs familles, entre l'Ancien Monde et les colonies d'Asie ou d'Afrique méridionale. La plupart de ces passagers appartiennent aux classes aisées, ils s'attendent à certaines normes de confort.

Les compagnies américaines, elles, s'imposent sur les lignes transpacifiques, en direction de la Chine et du Japon. Dès 1867, la Pacific Mail Steamship Company assure régulièrement la liaison entre San Francisco, Hongkong et Yokohama. Puis elle passe sous le contrôle de la Dollar Steamship Company qui, à son apogée, dans les années 1920, exploite les premières lignes de passagers et de marchandises desservant le monde entier – malgré les distances considérables, la compagnie met un point d'honneur à respecter les horaires annoncés. Depuis San Francisco, la Matson Navigation Company achemine les touristes américains à Hawaii à bord d'une luxueuse flotte blanche.

Après la Première Guerre mondiale, le flux de migrants se tarit entre l'Europe et les États-Unis. Nombre de compagnies entreprennent

alors de convertir leurs bâtiments : elles y aménagent des cabines économiques qui s'adressent aux touristes de la classe moyenne et aux passagers en voyages d'affaires, tandis que les très rudimentaires troisième et quatrième classes, elles, disparaissent. Certaines compagnies abandonnent définitivement le transport des passagers au profit des croisières. Entre 1923 et 1934, l'élégant *Mauretania*, qui conserva vingt ans le ruban bleu, fera cinquante-quatre croisières. À bord, les passagers assistent à des concerts, jouent au anno-tennis ou s'essaient au tir au pigeon d'argile.

construit, même s'il accueille « seulement » 2 000 passagers – dont la moitié en première classe. Plusieurs bars et restaurants, un théâtre de 380 places, un sauna et deux piscines sont là pour leur plaisir. Ils ont également à leur disposition des boutiques, une poste avec un central téléphonique et une clinique avec un cabinet dentaire pour les urgences. C'est dans l'immense salle à manger de 100 mètres de long et 700 places que bat le pouls de la vie à bord. Quant aux clients les plus exigeants, ils s'installent dans l'une des deux suites aménagées à l'avant du pont supérieur. Toutes deux se composent

beaucoup, il reste, aujourd'hui encore, le géant des mers par excellence. Comme son « sister-ship » de quatre ans plus jeune, le *Queen Elizabeth*, le *Queen Mary* survivra à la Seconde Guerre mondiale. Il continue même à assurer la traversée transatlantique jusque dans les années 1960. Aujourd'hui converti en hôtel de luxe, il reste amarré à Long Beach, en Californie.

À côté du raffinement du *Normandie*, le *Queen Mary* n'a pas à rougir. Les trois classes disposent de salons de beauté, de bibliothèques et de garderies pour les enfants, auxquels s'ajoutent un studio de musique, des salles de lecture, des courts de tennis et même des niches pour les chiens. Il conserve le ruban bleu pendant seize ans, jusqu'à ce que le *United States* , en 1952, lei lui reprenne avec un record de vitesse qui, aujourd'hui encore, reste inégalé : 3 jours, 10 heures et 40 minutes de New York à Southampton.

« *C'EST PLUS QU'UN VAISSEAU, C'EST UNE VILLE FLOTTANTE, UN MORCEAU DE COMTÉ, DÉTACHÉ DU SOL ANGLAIS, QUI, APRÈS AVOIR TRAVERSÉ LA MER, VA SE SOUDER AU CONTINENT AMÉRICAIN.* »

JULES VERNE, UNE VILLE FLOTTANTE, *1870* (AU SUJET DU TRANSATLANTIQUE À VAPEUR GREAT EASTERN)

Les années 1930 sont celles du renouveau des transatlantiques à vapeur. En leur temps, le *Bremen* et son jumeau, l'*Europa*, tous deux construits par la Norddeutscher Lloyd, sont considérés comme les navires les plus modernes qui soient, ralliant New York en cinq jours à peine. Ils disposent à bord d'un hydravion lancé par une catapulte qui fait gagner quelques heures à la livraison du courrier sur l'arrivée du navire.

Mis en circulation en 1935, le *Normandie*, de la compagnie française CGT, et ses espaces intérieurs Art déco suscitent l'admiration dans le monde entier et atteignent des « sommets de perfection ». Avec ses 314 mètres de long, il est, à l'époque, le plus grand bateau jamais

de quatre chambres à coucher, un salon, une salle à manger et une terrasse privative.

Rien d'étonnant à ce que le *Normandie* devienne le rendez-vous des célébrités du spectacle et du cinéma, comme Joséphine Baker, Marlene Dietrich ou Fred Astaire. Sa brillante carrière ne dure toutefois que quatre ans. Réquisitionné par les États-Unis et converti en bâtiment de guerre, le fier transatlantique, ravagé par un incendie, coulera dans le port de New York.

Les compagnies Cunard et White Star qui, entre-temps, ont fusionné, n'entendent pas rester à la traîne de l'excellence française et allemande. En 1936, le *Queen Mary* lève l'ancre pour son voyage inaugural. Pour

Mais voilà que, déjà, s'annonce la fin du règne du paquebot sur la traversée transatlantique. L'avion le supplantera bientôt, qui réduit le voyage de quelques jours à quelques heures, rapprochant encore davantage les continents. Dorénavant, les passagers de première classe veulent voyager plus vite et plus loin. Ils désertent les bibliothèques et les fumoirs des géants des mers pour tromper leur désœuvrement à dix kilomètres d'altitude, au bar d'un jet.

En juillet 1956, le naufrage du paquebot italien *Andrea Doria* au large de Nantucket met symboliquement un point final à l'ère des transatlantiques. Puis à la fin des années 1960, les grandes compagnies maritimes cessent d'assurer la traversée entre l'Europe et l'Amérique. De la grande époque des géants des mers nous restent de fiers navires qui, sous des noms évoquant le prestige d'antan, comme le *Queen Mary 2*, sillonnent encore les mers du monde entier – en croisière. Leur dimension et leur clientèle, toutefois, n'ont plus rien à voir avec ceux de l'âge d'or des transatlantiques.

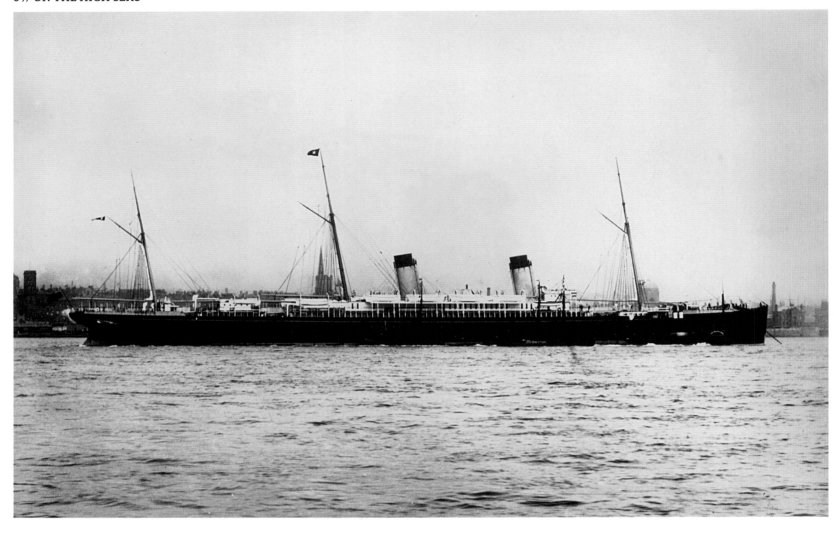

A NEW ERA

Above: When the *Teutonic* was presented at a naval parade, Emperor William II
became so enamored that he immediately demanded similar ships for Germany, 1889.
Opposite: Scenes from a ship voyage, including seasickness, circa 1900.

EIN NEUES ZEITALTER

Oben: Die *Teutonic* versetzte Kaiser Wilhelm II. bei ihrer Vorstellung auf einer Marineparade
in eine solche Begeisterung, dass er Schiffe dieser Art umgehend auch für Deutschland forderte, 1889;
rechts: Szenen einer Schiffspassage, Seekrankheit inbegriffen, um 1900

UNE NOUVELLE ÈRE

Ci-dessus : le *Teutonic* suscite l'enthousiasme de l'empereur Guillaume II qui assiste à sa présentation lors d'un défilé
naval, au point qu'il ordonne sur-le-champ que l'Allemagne se dote des mêmes navires, 1889 ;
ci-contre : scènes de la vie à bord, sans oublier le mal de mer, vers 1900

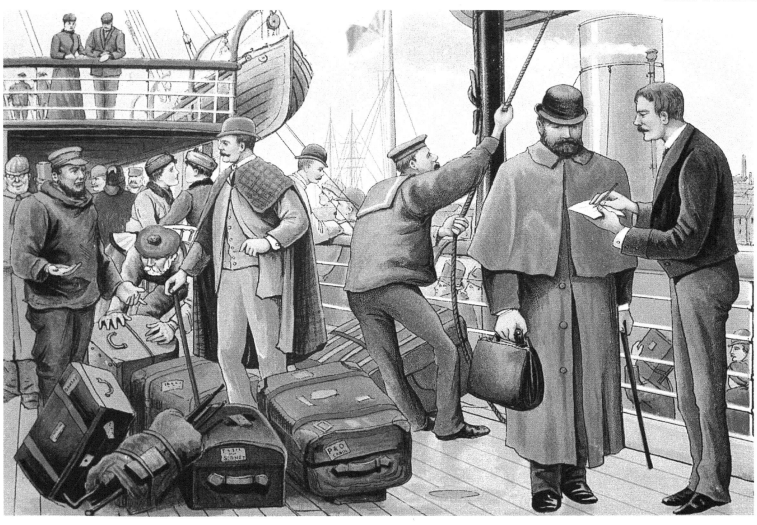

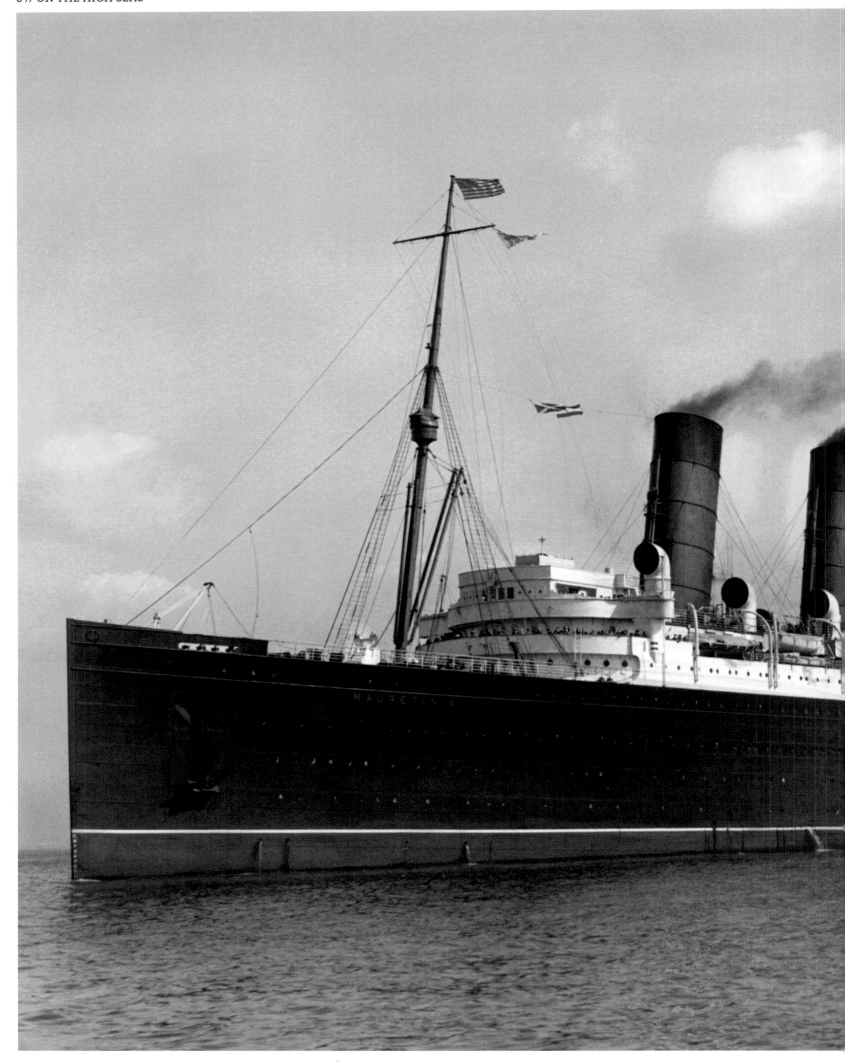

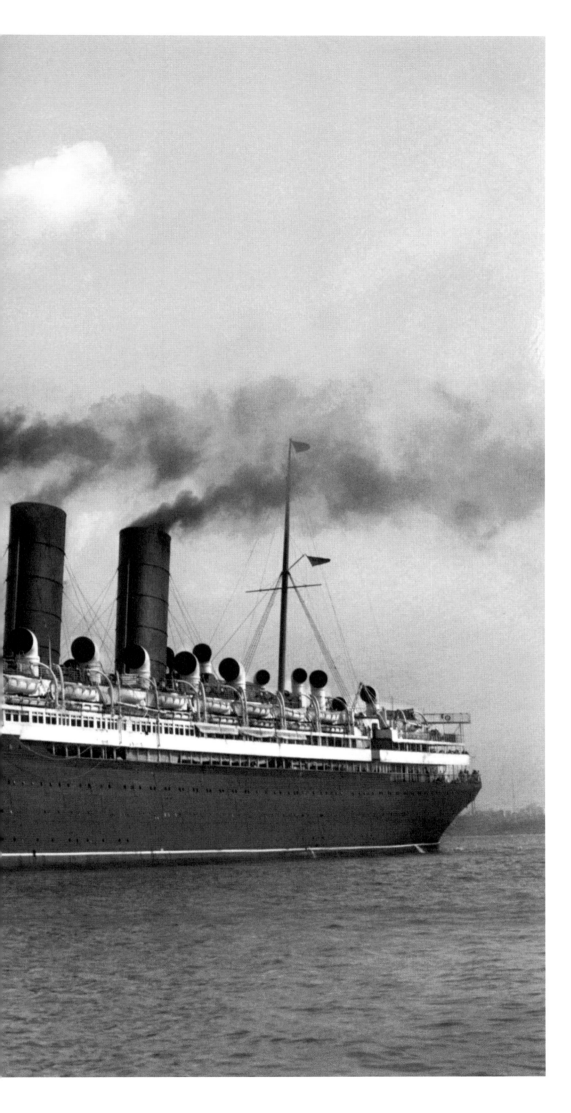

TRUE BEAUTY

Put into service in 1907, the *Mauretania* and its sister ships the *Lusitania* and *Aquitania* set new standards with regard to speed and elegance, 1920s.

WAHRE SCHÖNHEIT

Die 1907 in Dienst gestellte *Mauretania* setzte wie ihre Schwesterschiffe *Lusitania* und *Aquitania* neue Standards in puncto Geschwindigkeit und Eleganz, 1920er-Jahre

PURES SPLENDEURS

Mis en service en 1907, le *Mauretania*, comme ses cousins, le *Lusitania* et l'*Aquitania*, placent la barre toujours plus haut en matière de vitesse et d'élégance, années 1920

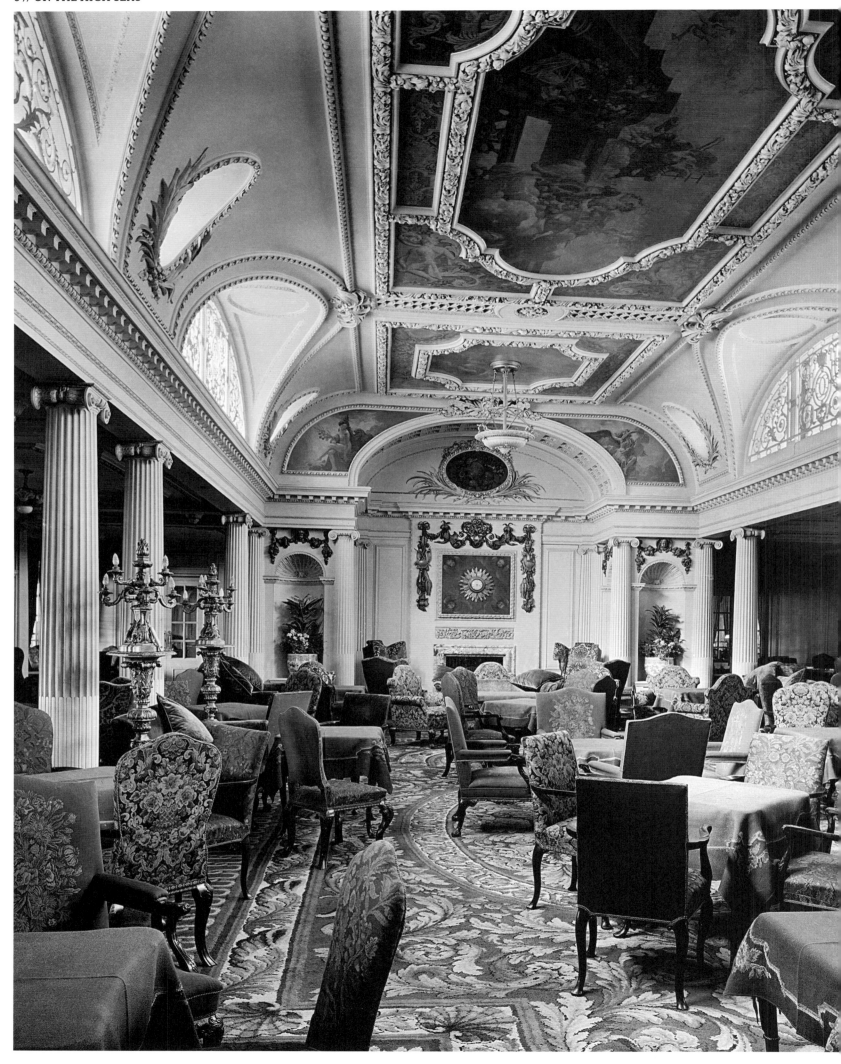

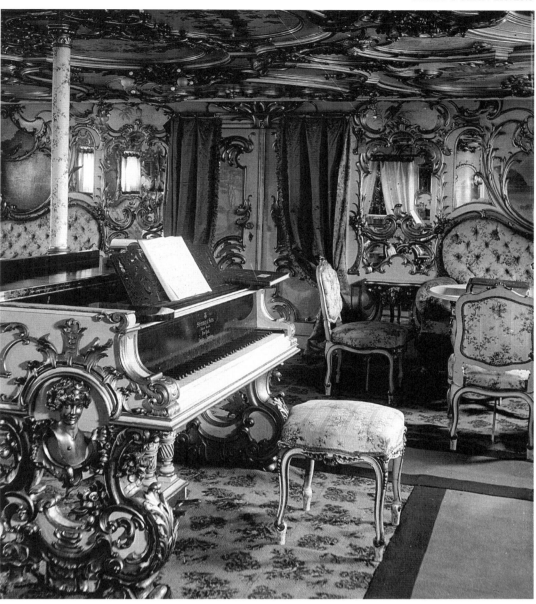

A TASTE OF THE BELLE EPOQUE

Opposite: Palladium Lounge on the *Aquitania*, in service since 1913, photograph from the 1920s.
Above: Music room on the *Columbia*, a ship belonging to the Hamburg America Line (HAPAG), 1891.
Following pages, from left: Class-based society. Cunard Line poster with a cross section of the *Aquitania*, circa 1910;
White Star Line advertising poster for the *Olympic* and the *Titanic*, 1912.

BELLE-ÉPOQUE-GESCHMACK

Links: Palladium Lounge der *Aquitania*, die seit 1913 verkehrte, 1920er-Jahre;
oben: Musikzimmer auf der *Columbia* der deutschen HAPAG, 1891
Seite 174: Klassengesellschaft. Plakat der Cunard Line mit Querschnitt durch die *Aquitania*, 1910er-Jahre;
Seite 175: Werbeplakat der White Star Line für die *Olympic* und die *Titanic*, 1912

AU GOÛT DE LA BELLE ÉPOQUE

Ci-contre : le Palladium lounge de l'*Aquitania*, à flot depuis 1913, dans les années 1920 ;
ci-dessus : le salon de musique du *Columbia* de la compagnie allemande HAPAG, 1891
Page 174 : une société de classes. Affiche de la Cunard Line, avec une coupe de l'*Aquitania*, dans les années 1910 ;
page 175 : affiche publicitaire de la White Star Line pour l'*Olympic* et le *Titanic*, 1912

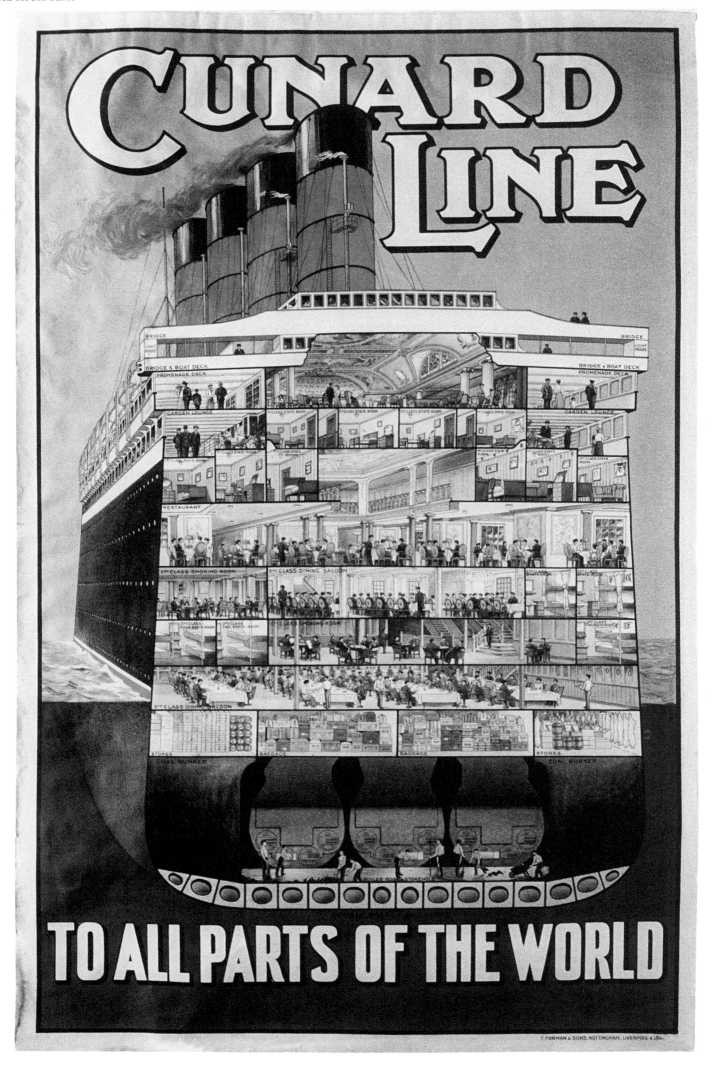

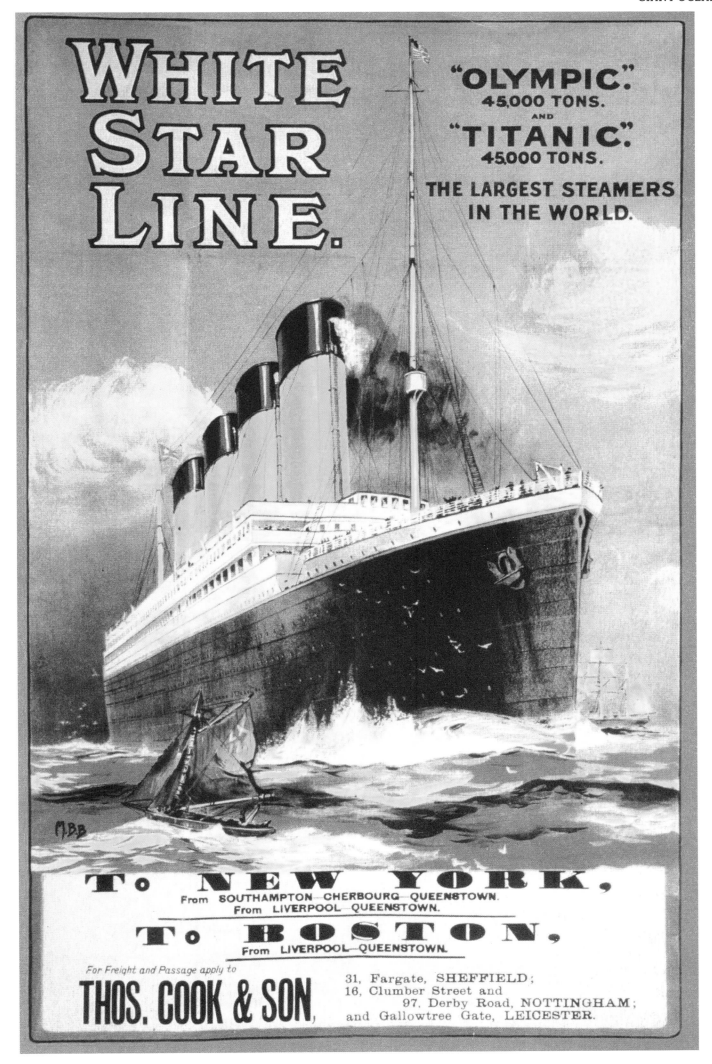

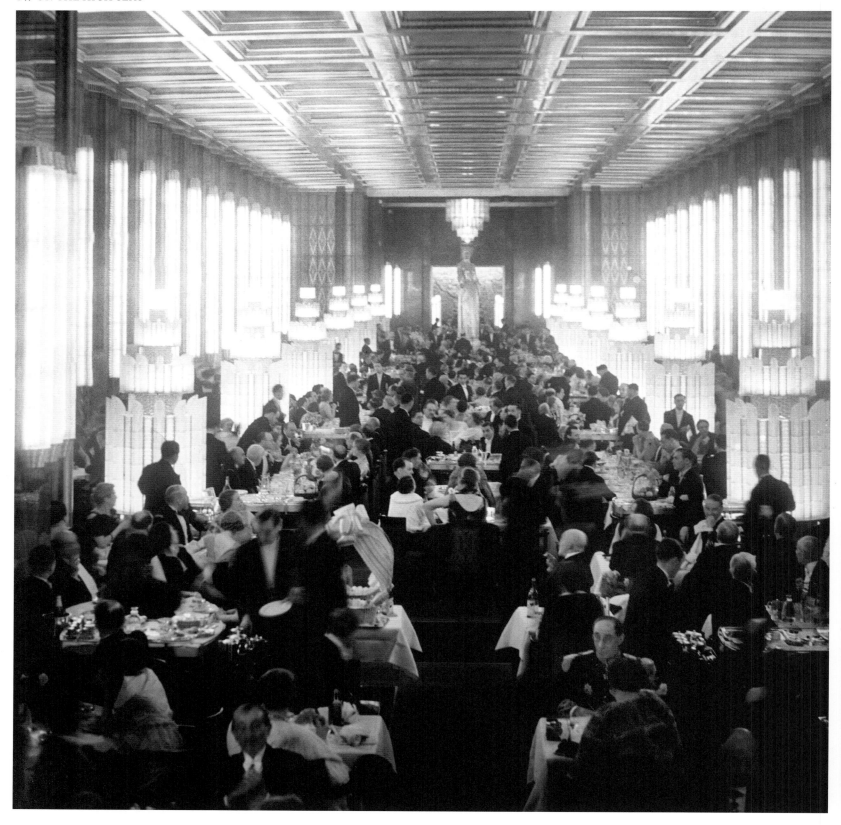

FLOATING ART DECO STAGE

Above: 305 feet in length, the first-class dining hall on the *Normandie* was illuminated by thirty-eight light columns, 1935.
Opposite: Iconic advertising poster by A. M. Cassandre for the CGT's flagship, 1935.

SCHWIMMENDE BÜHNE DES ART DÉCO

Oben: Der fast 100 Meter lange Erste-Klasse-Speisesaal der *Normandie* wurde von 38 Lichtsäulen illuminiert, 1935;
rechts: Ikonisches Werbeplakat von A. M. Cassandre für das Flaggschiff der CGT, 1935

UNE VITRINE ART DÉCO

Ci-dessus : le restaurant des premières classes du *Normandie*, éclairé de 38 colonnes lumineuses,
fait près de 100 mètres de long, 1935 ;
ci-contre : affiche publicitaire signée A. M. Cassandre pour le fleuron de la CGT, 1935

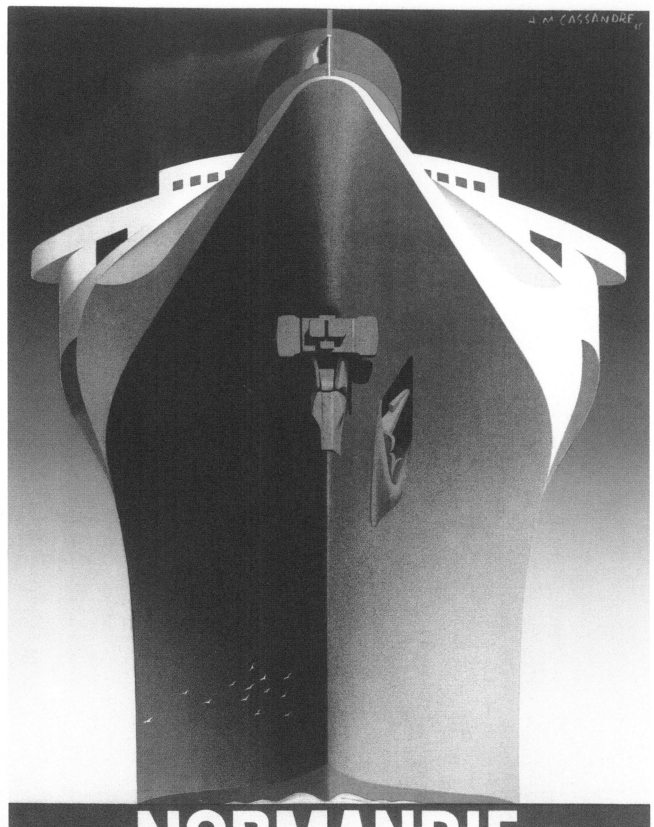

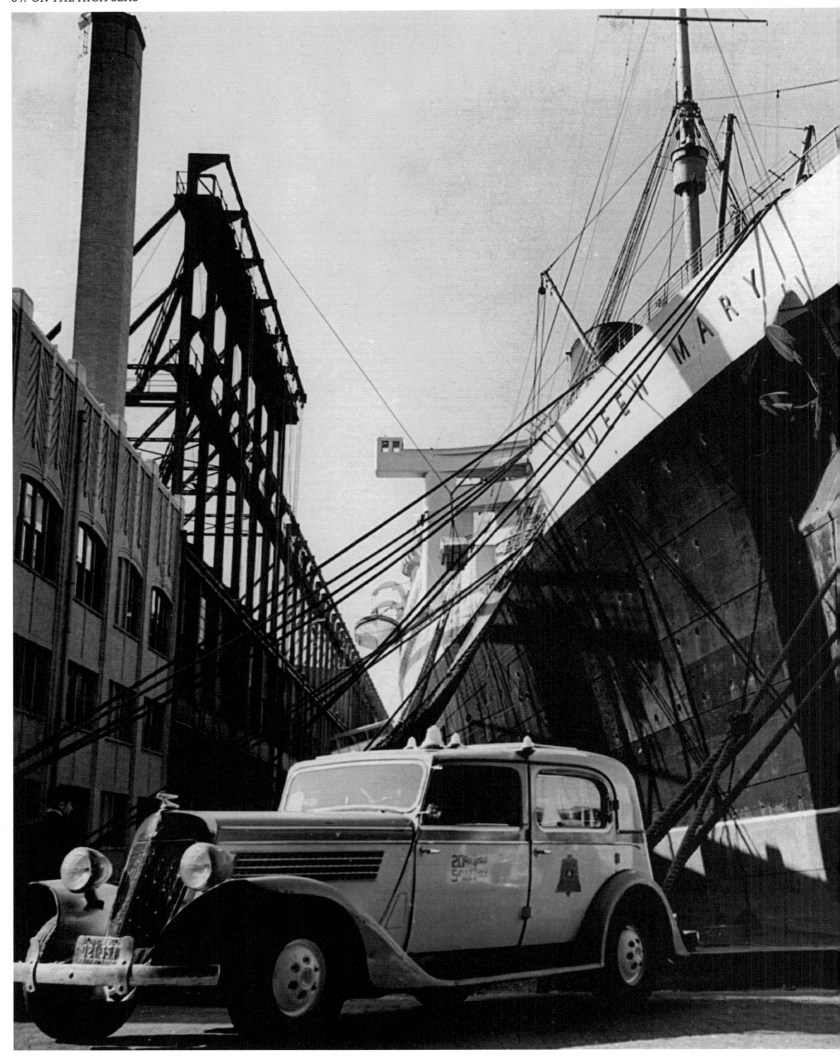

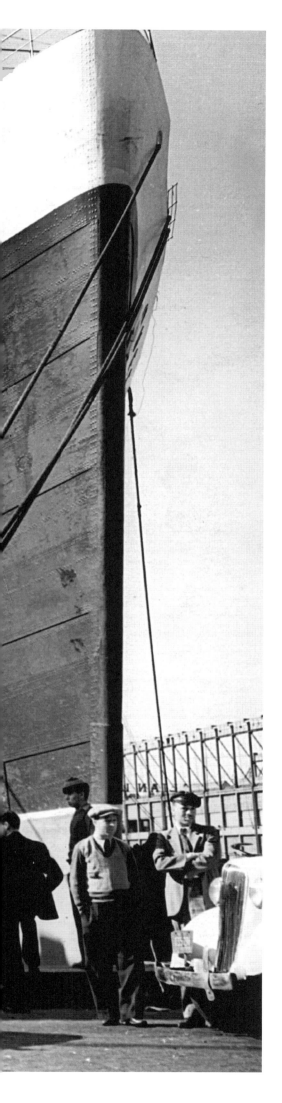

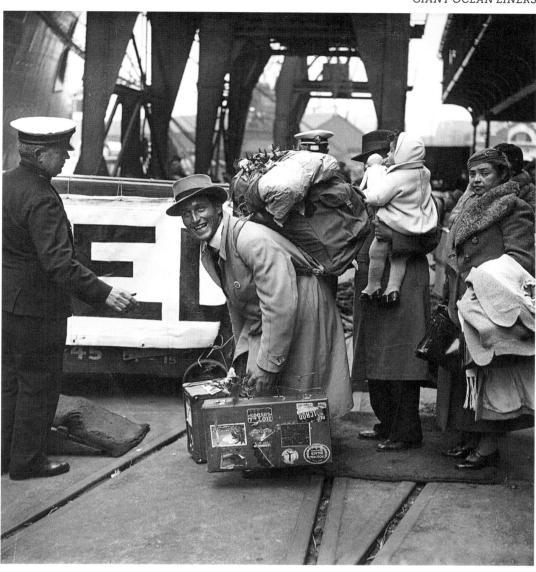

AT THE HABOR

Opposite: Taxi drivers at the harbor in New York wait for arriving ship passengers, 1936.
Above: In anticipation of the maiden voyage of the *Queen Mary*, Southampton, 1936

IM HAFEN

Links: Taxis im New Yorker Hafen warten auf ankommende Schiffspassagiere, 1936;
oben: Vorfreude in Southampton auf die Jungfernfahrt mit der *Queen Mary*, 1936

JOIE DU RETOUR, FIÈVRE DES DÉPARTS

Ci-contre : au port de New York, les taxis attendent le débarquement des passagers, 1936 ;
ci-dessus : à Southampton, la joie des passagers sur le point d'embarquer à bord du *Queen Mary*
pour son voyage inaugural, 1936

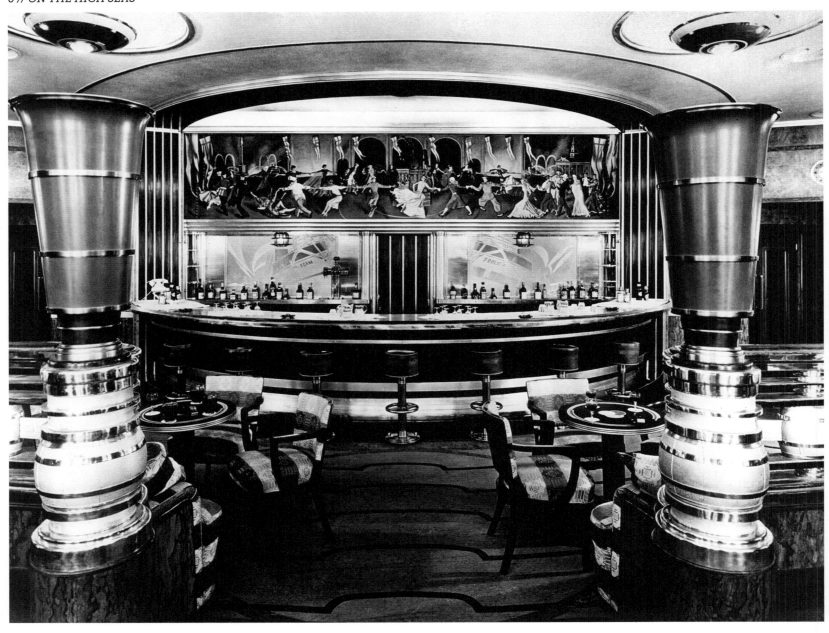

BRITISH GLAMOUR

Interiors of the *Queen Mary*, 1936. Above: The cocktail bar on the observation deck.
Opposite: The restaurant for first class, 1936.
Following pages: Main lounge in second class featuring a grand piano and a stage, 1936.

BRITISCHER GLAMOUR

Interieurs der *Queen Mary*, 1936. Oben: Die Cocktailbar des Observation Decks;
rechts: Das Restaurant der ersten Klasse, 1936
Seite 182/183: Main Lounge der zweiten Klasse mit Flügel und Bühne, 1936

VOYAGE GLAMOUR

À l'intérieur du *Queen Mary*, 1936. Ci-dessus : le bar à cocktail du pont panoramique ;
ci-contre : le restaurant des premières classes, 1936
Pages 182-183 : le grand salon des secondes classes, avec une scène de spectacle et un piano à queue, 1936

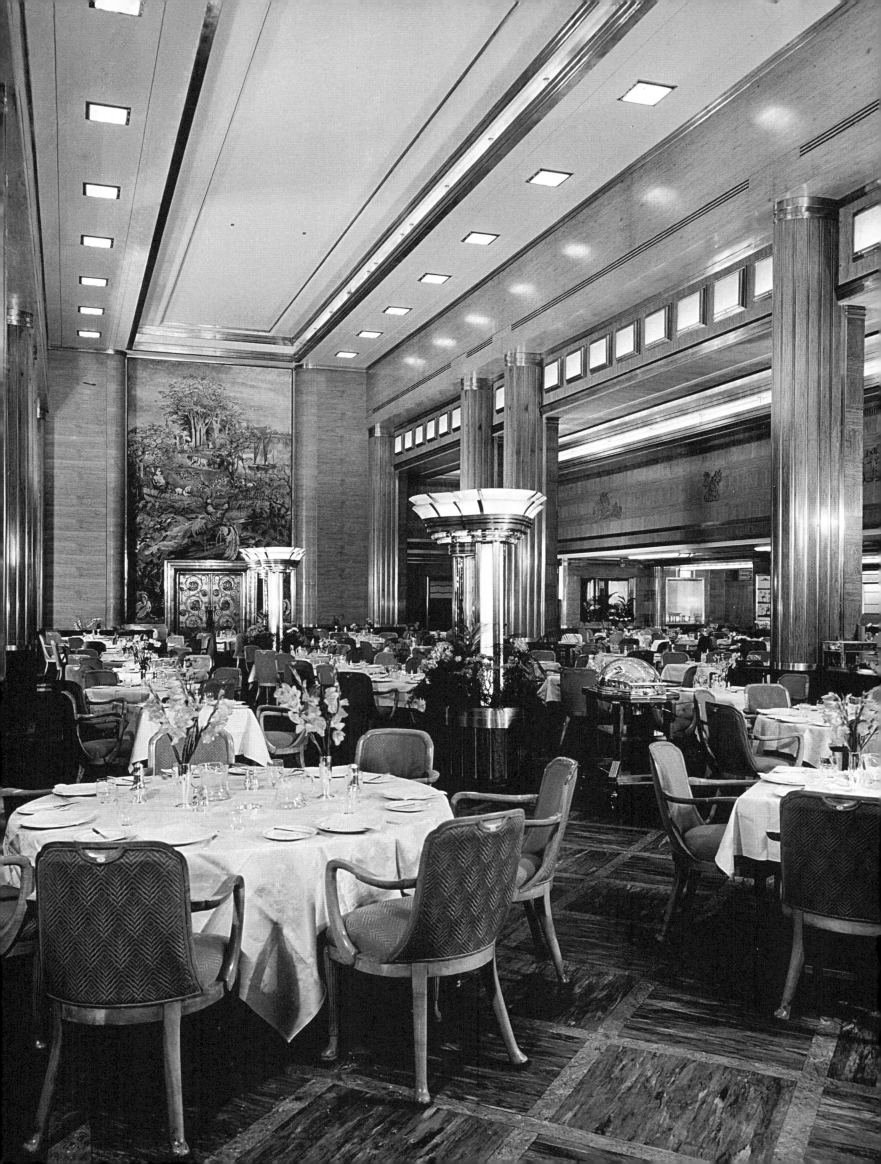

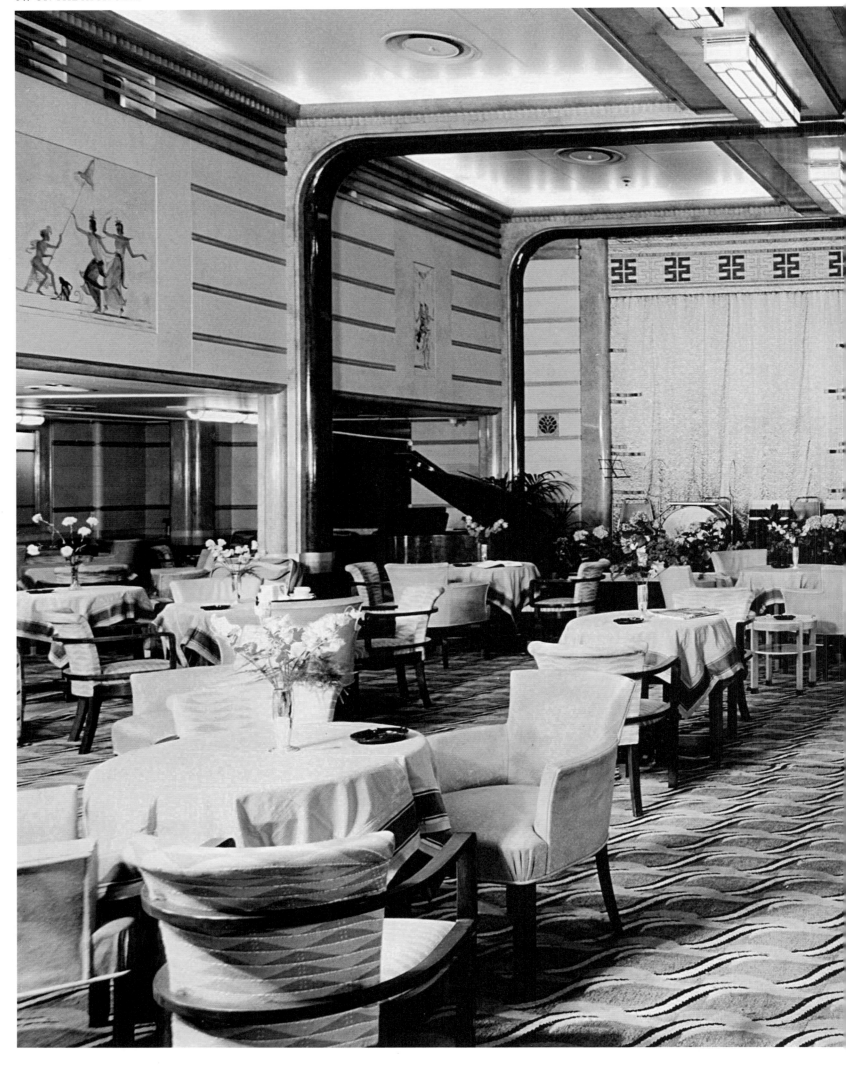

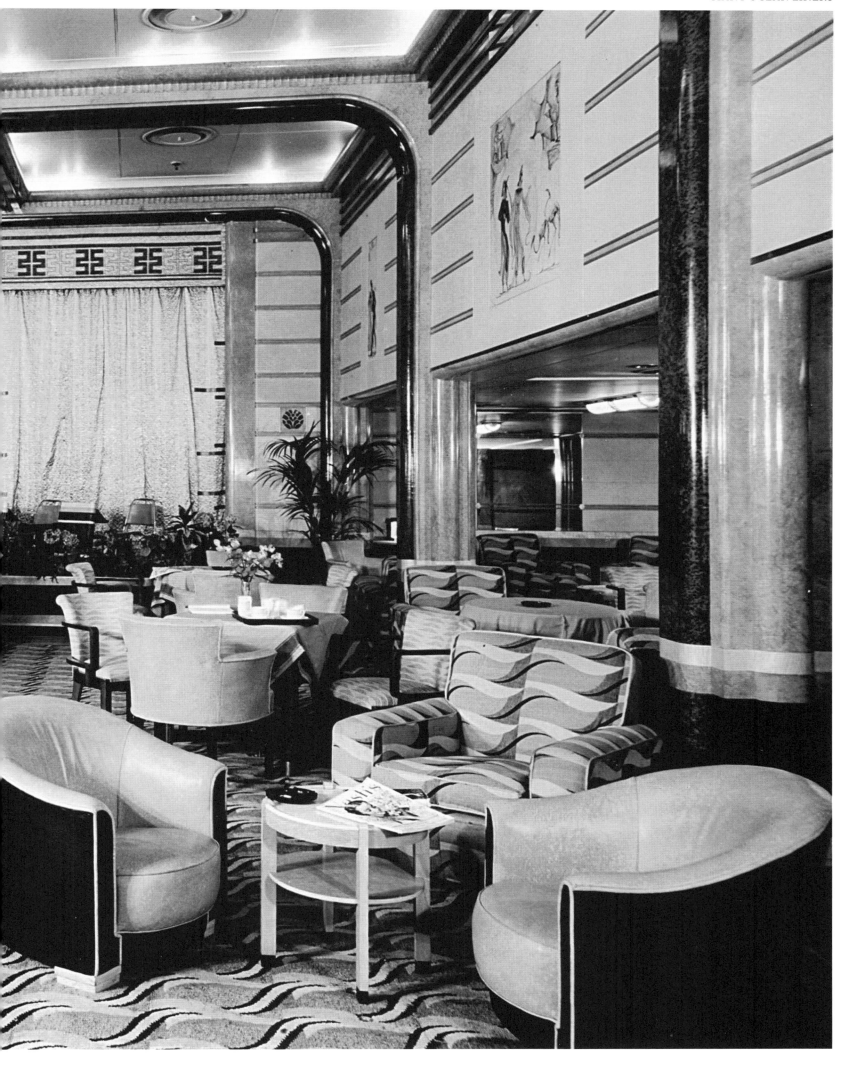

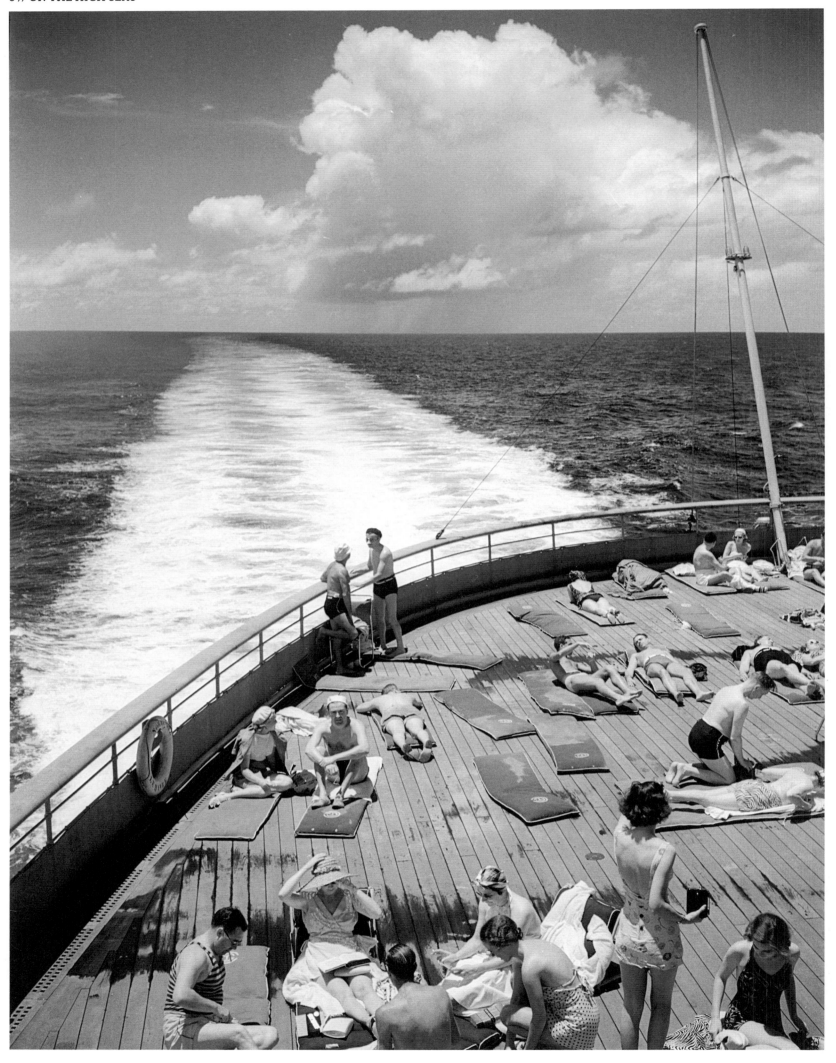

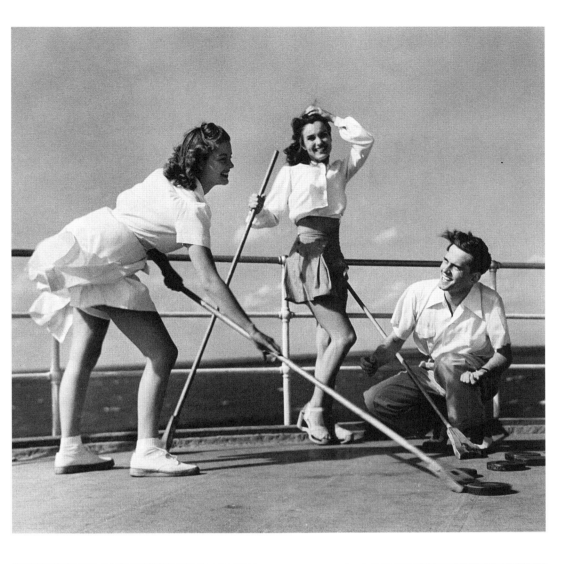

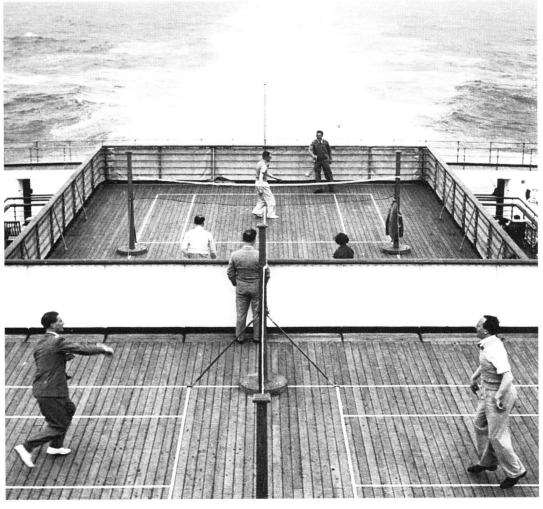

ONBOARD ENTERTAINMENT

Opposite: Sunbathers at the rear of the *Normandie*, 1937.
Above: Shuffleboard players off the coast of Florida, 1940.
Below: Deck tennis on board the *Queen Mary*, 1936.
Following pages, from left: Pacific trips. Advertising
poster for the White Fleet of the Matson Lines, circa 1940;
Charlie Chaplin with Paulette Goddard, whom he had
secretly married in China, on board the *President Coolidge*,
1936. Chaplin used a creative crisis in the early 1930s as
an excuse for extensive travels to Asia.

BORDVERGNÜGUNGEN

Links: Sonnenbadende am Heck der *Normandie*, 1937;
oben: Shuffleboard-Spieler vor Florida, 1940;
unten: Decktennis an Bord der *Queen Mary*, 1936
Seite 186: Pazifikreisen. Werbeplakat für die Weiße Flotte
der Matson Lines, um 1940;
Seite 187: Charlie Chaplin mit Paulette Goddard,
die er heimlich in China geheiratet hatte, auf
der *President Coolidge*, 1936. Chaplin nutzte
eine Schaffenskrise Anfang der 1930er-Jahre
für ausgiebige Reisen nach Asien

LOISIRS DE BORD

Ci-contre : bain de soleil à la poupe
du *Normandie*, 1937 ;
en haut : partie de *shuffleboard* au large
de la Floride, 1940 ;
en bas : partie de anno-tennis à bord du *Queen Mary*, 1936
Page 186 : à l'assaut du Pacifique. Affiche publicitaire
pour la « flotte blanche » de la compagnie Matson Lines,
vers 1940
Page 187 : Charlie Chaplin et Paulette Goddard, épousée
en Chine dans le plus grand secret, à bord du *President
Coolidge*, 1936. Au début des années 1930, Chaplin, en
panne de créativité, en profite pour voyager en Asie

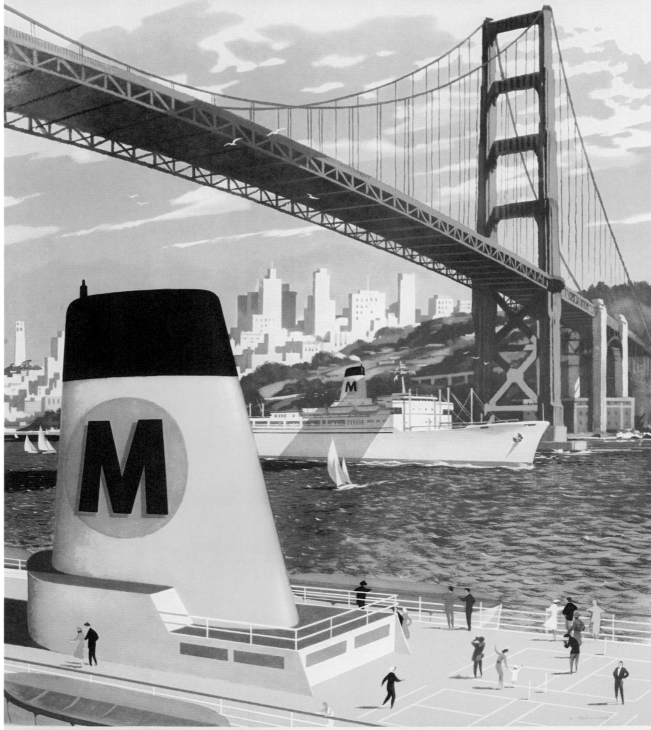

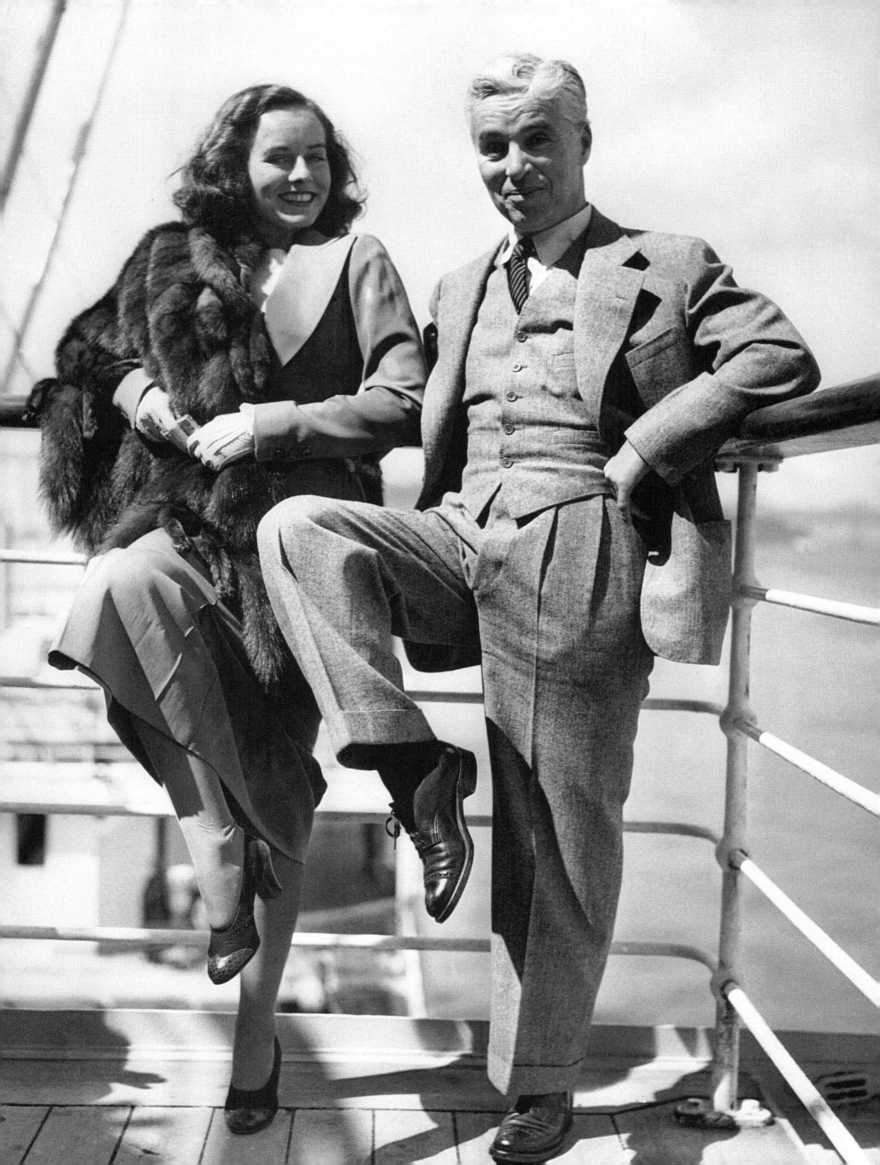

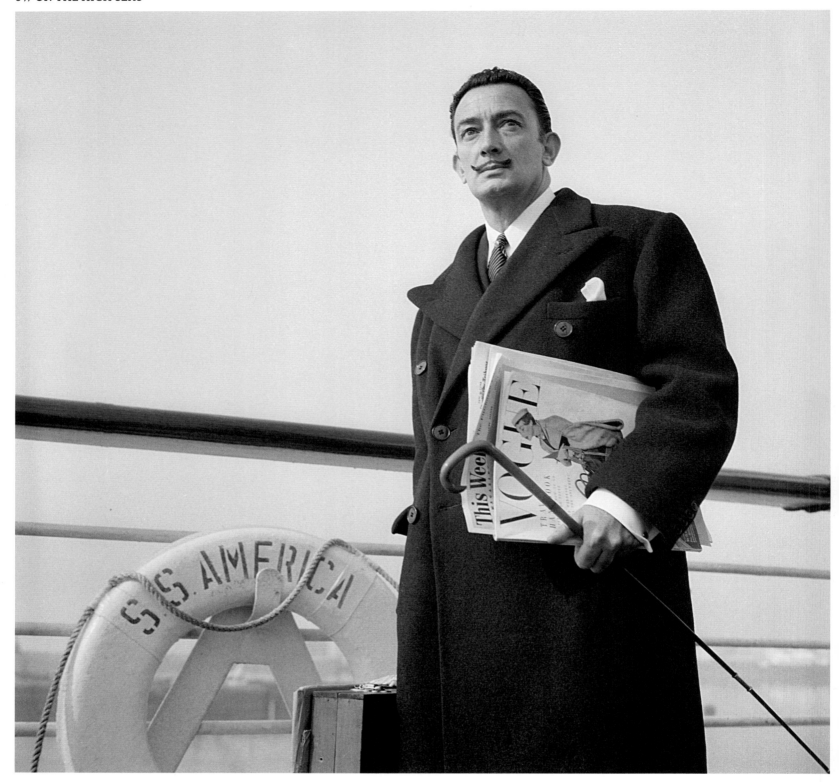

CELEBRITIES ON DECK

Above: With an issue of *Vogue* in hand and a picture of the Virgin Mary in his hand luggage, Salvador Dalí returns to Le Havre from New York on the *America*, 1950.
Opposite: On her way to wedded bliss. Grace Kelly on the *Constitution* en route to Monaco, where she married Prince Rainier shortly thereafter, 1956.
Following pages: The *United States* arriving in New York Harbor on June 23, 1952 right after its commissioning.

PROMINENZ AN DECK

Oben: Salvador Dalí kehrt mit einer Ausgabe der *Vogue* und einem Madonnenbild im Handgepäck mit der *America* aus New York nach Le Havre zurück, 1950;
rechts: In den Hafen der Ehe. Grace Kelly auf der *Constitution* auf dem Weg nach Monaco, wo sie wenige Tage später Fürst Rainier heiratete, 1956
Seite 190/192: Die *United States* beim Eintreffen im New Yorker Hafen anlässlich ihrer Indienststellung am 23. Juni 1952

LES STARS SUR LE PONT

Ci-dessus : un exemplaire de *Vogue* sous le bras, et le portrait d'une Madone dans sa valise, Salvador Dalí quitte New York pour Le Havre à bord de l'*America*, 1950 ;
ci-contre : en route pour la grande aventure du mariage. Grace Kelly à bord du *Constitution*, cap sur Monaco où, quelques jours plus tard, elle doit épouser le prince Rainier, 1956
Pages 190-192 : Le *United States* entre au port de New York pour sa mise en service, le 23 juin 1952

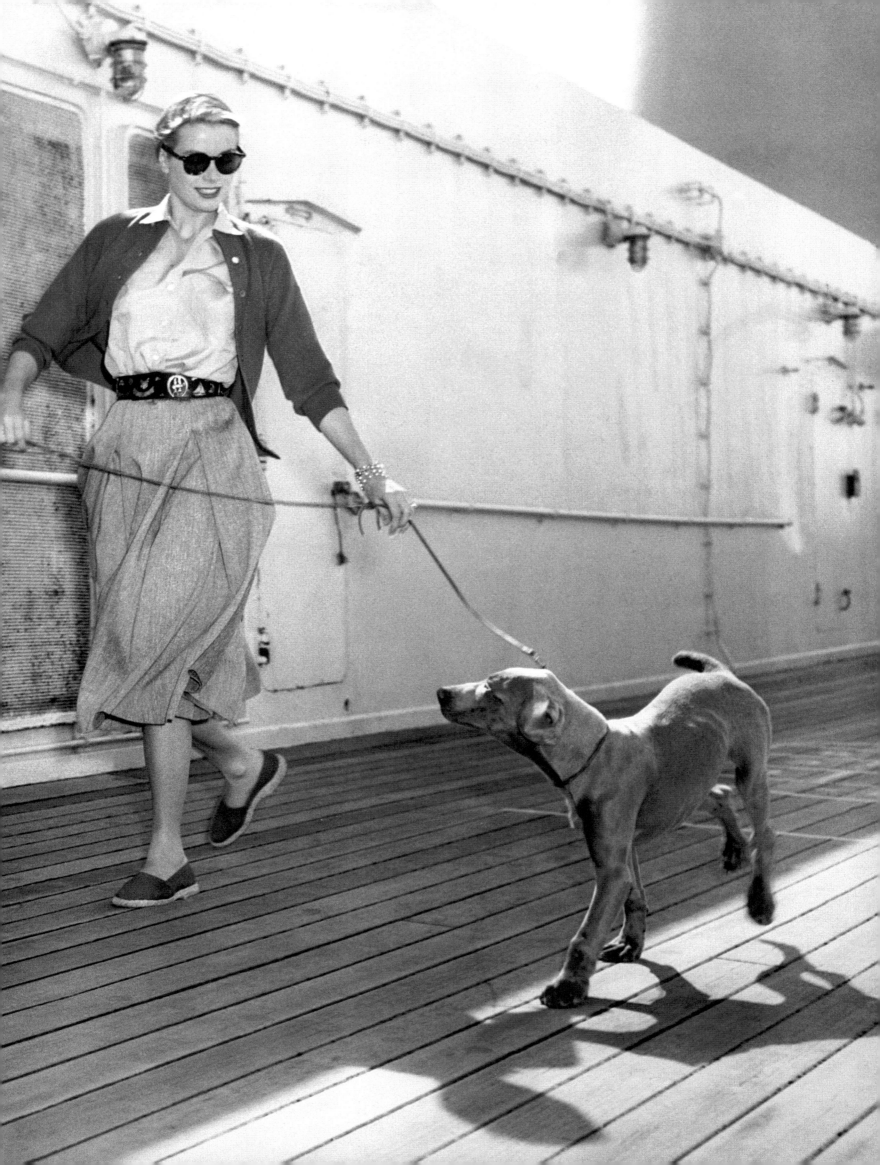

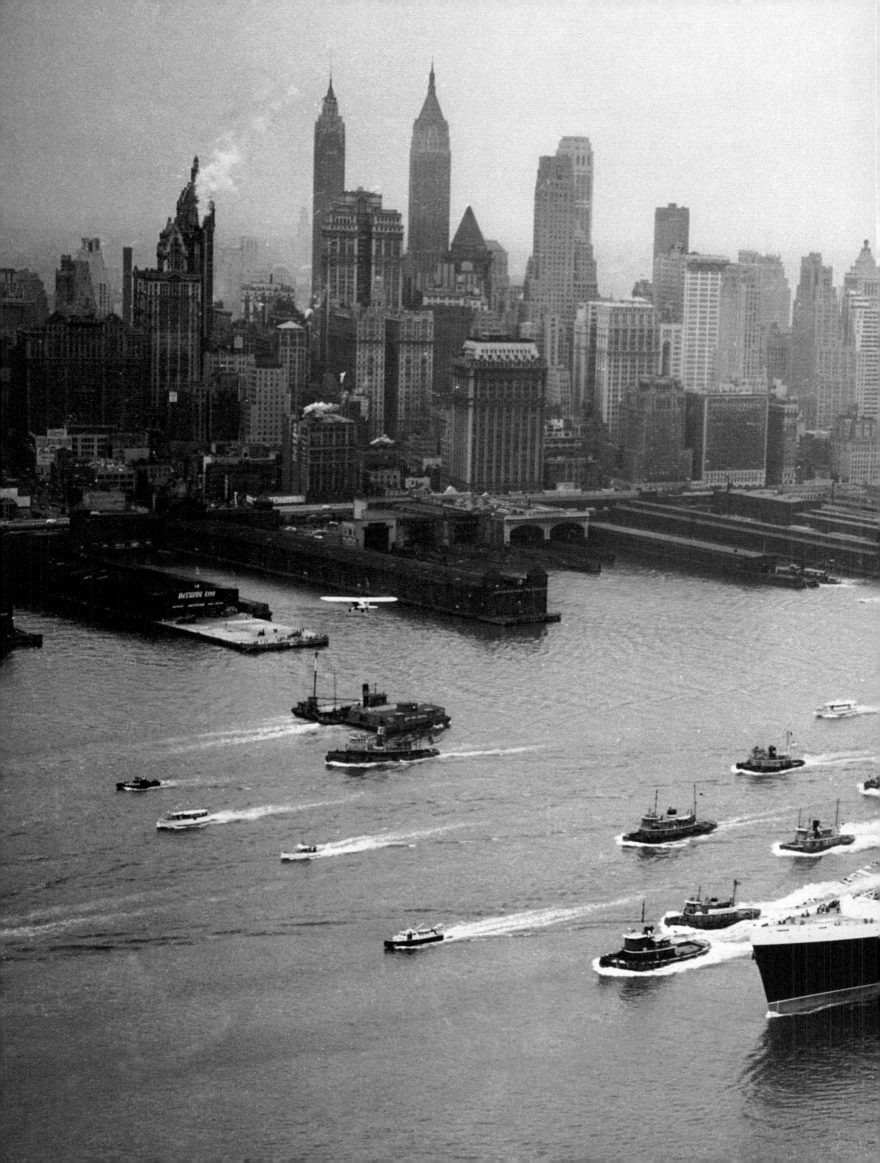

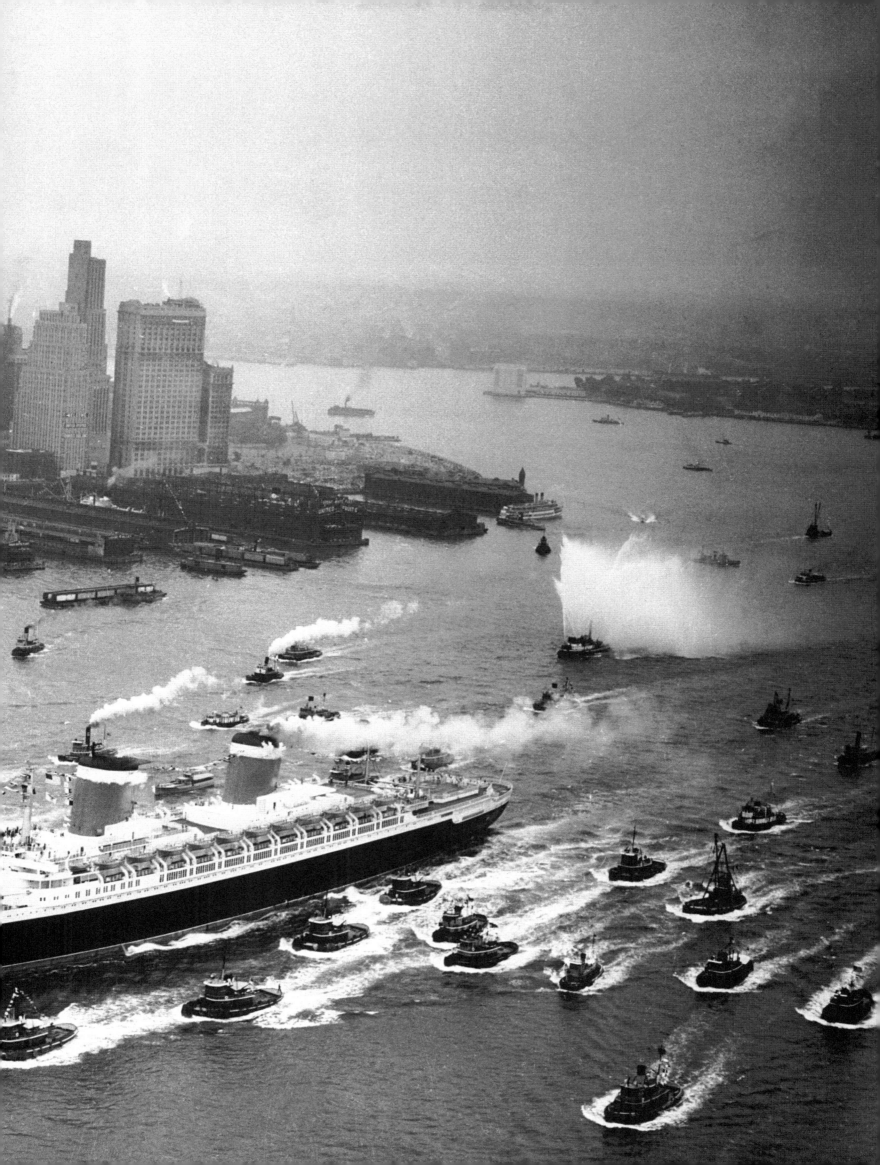

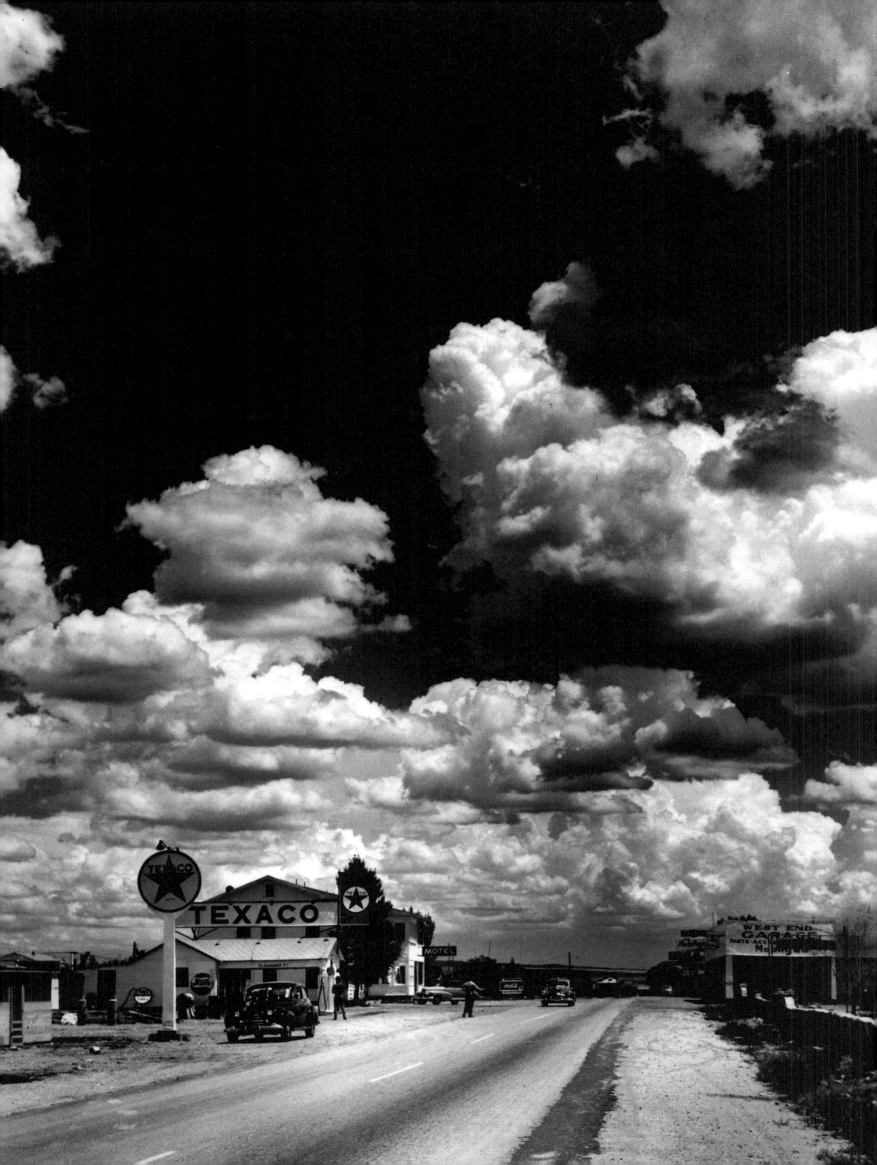

7

ON THE ROAD

AUF ACHSE
ON THE ROAD

AUTO TOURISM

At the turn of the twentieth century, very few people in the United States could afford the luxury of crossing the Big Pond in a steamship and touring the Old World for weeks at a time. Those who could manage a vacation tended to travel within their own country.
Early on, the railroad opened up the American continent and made it possible to transport goods and people by train. But it took another development to transform tourism into a mass phenomenon: the motor car's affordability. Henry Ford's Model T, launched in 1908, fundamentally changed the way people traveled. Although the Model T began as a luxury item, its price dropped dramatically after the assembly line was introduced in 1914, and even middle-class families could gradually afford a car. Also founded in 1908, General Motors offered a wide range of brands aimed at all income levels so that ordinary Americans could finally dream of buying a Chevrolet or a Cadillac.

This new mobility opened up the continent a second time. In 1913, the United States began building the National Auto Trails, a transcontinental system of roads that was later replaced by the highway network, with the even-numbered roads running from east to west and the odd-numbered ones from north to south.
Travelers were soon able to cross the country in just a few days, and they could stop wherever they wanted. As incomes rose and workers gained more vacation time, more and more people were able to get away for a few days, preferring to travel in their own cars. Those who didn't own a car rode the bus. As early as 1914, the Greyhound bus line was carrying passengers all over the United States.

The U.S. highway system, both past and present, has a number of scenic routes that pass through spectacular landscapes. Among them is California State Route 1, some sections of which are called the Pacific Coast Highway. 656 miles in length, this highway runs parallel to California's Pacific coast, all the way to the Mexican border.

An even longer and more legendary road is Route 66. Individual sections were combined to form a 2,451-mile highway linking Chicago with Santa Monica on the Pacific coast. During the Great Depression in the 1930s, Route 66 became the path of migration for impoverished Midwestern farmers seeking their fortune in California. Photographers such as Walker Evans and Dorothea Lange documented the arduous journey to the west with iconic images, and John Steinbeck fictionalized the experience in his novel *The Grapes of Wrath*. Barely thirty years after the two-lane "Mother Road" opened, the construction of a modern interstate highway system rendered it obsolete, and Route 66 became the stuff of legend.
However, the largest American motorway by far was the Pan-American Highway. The idea to build this intercontinental road system emerged at the Fifth International Conference of American States in 1923. Measuring more than 19,000 miles in length, today it is the longest north-south route, connecting the two American continents from Alaska to Tierra del Fuego.

Where did these road trips lead to? Nature was one popular destination. As early as the mid-nineteenth century the writers Ralph Waldo Emerson and Henry David Thoreau called for greater efforts to protect the environment. The polymath John Muir lived in California's Yosemite National Park for several years. Infuriated by the way Californians treated nature, in 1871 he declared, "God has cared for these trees, saved them from drought, disease, avalanches, and a thousand straining, leveling tempests and floods, but he cannot save them from fools—only Uncle Sam can do that."
One year later, Yellowstone National Park in Wyoming became the first national park in the United states and is now the oldest in the world. East-Coast nature lovers were drawn to the Appalachians and explored Niagara Falls on the border between New York State and the Canadian province of Ontario.
In places where the landscape lacked sufficient natural beauty to attract tourists, explosives did the job. In 1927, the sculptor Gutzon Borglum and his son Lincoln began carving fifty-nine foot likenesses of four American presidents out of Mount Rushmore, in South Dakota. Their work was completed in 1941 and now allures three million visitors each year.

Casinos and amusement parks were already drawing crowds to nineteenth-century beach resorts, and the following century saw gambling establishments cropping up in the desert. Nevada legalized gambling in 1931 and shortened the minimum residency requirement to six weeks for couples seeking a divorce. After the Hoover Dam was built, Las Vegas casinos entered their boom years in the 1940s. Lovers visiting the gambling mecca could tie the knot spontaneously—and then head to Reno for a divorce.
If the marriage lasted, parents could drive their children to Anaheim, near Los Angeles, where the film producer Walt Disney opened Disneyland in 1955. He brought the characters and sets of his animated films to life in this amusement park, which served as a model for all the others to come. Visitors had the choice of traveling to the future or the past—to "Tomorrowland" or to the Main Street of an idealized small town at the turn of the twentieth century.

While hotels once offered accommodations at railroad junctions, the auto tourist now needed a new kind of place to spend the night, and preferably one with only a short walk from the car to the room: the motel, a portmanteau blend of "motor" and "hotel." The first such establishment was the Motel Inn, which opened on December 12, 1925, in San Luis Obispo, California.
Early motels were individual, rustic cottages constructed of wood or stone; some were even concrete tepees. In the 1950s, they turned into fully fledged hotels with bars and swimming pools, having long since left their

traditional forebears behind. The diners and drive-ins that shape highways today underwent a similar evolution. On May 15, 1940, the brothers Richard and Maurice McDonald opened their first fast-food restaurant in San Bernardino, California—right on Route 66.

To avoid motel stays, some travelers brought along their own tent, a travel trailer, or a pop-up camper. Travel trailers had been touring American roads since the early 1920s and culminated with the elegant, streamlined models built by Airstream. Manufactured in the 1930s, these trailers featured gleaming chrome bodywork and an aeronautical design. Pop-up campers were precursors to today's big RVs. A normal set of wheels by day, these campers had a roof that popped up at night

66 GET YOUR KICKS ON ROUTE 66 99

—BOBBY TROUP, 1946

and provided space for two beds, while inside the vehicle they had room for a small cooktop and sink.

In the 1960s, the inexpensive and reliable Volkswagen Bus, whose robust body could be easily converted into a home workshop, served as a typical camping vehicle. The van and similar vehicles were particularly popular among hippies. America's counterculture crowd viewed driving down apparently endless highways as an expression of personal freedom. Jack Kerouac's 1957 novel *On the Road* bore witness to this phenomenon, as did Dennis Hopper's 1969 film *Easy Rider*. Whether they drove a van or hitchhiked with a knapsack on their backs, counterculture tourists headed for rock festivals, Califor-

nia beaches, and other such destinations. Europe's flower children, in particular, set out on the "hippie trail" for southern Asia. This Grand Tour led them on a journey of self-discovery through Turkey, Iran, Afghanistan, and Pakistan, ending up in Katmandu, Goa, or Bangkok.

Unlike in the United States, very few Europeans were able to take a road trip for their vacation in the first half of the twentieth century. France led the way in the years between the two world wars after building a national highway network with Paris as the natural destination point. In 1919, André Citroën followed Ford's example and became the first European automaker to build cars on an assembly line. Auto tourists throughout

Europe armed themselves with travel guides and maps published by the tire manufacturer Michelin. The very first *Michelin Guide* appeared in 1900, offering tips on the best restaurants—and not only for drivers of the new motorcar.

However, mass motorization—and therefore mass tourism—didn't develop in Europe until after World War II. In the 1950s, after Western Europeans had cleared away the worst of wartime rubble and the economic recovery had begun, travelers were again able to look farther afield. In 1957, France, the Benelux states, Italy, and the Federal Republic of Germany signed the Treaties of Rome aimed at easing restrictions on trade and travel, paving the way for today's European Union.

The European highway system grew steadily as more nations joined the European Economic Community, and small cars named after animals, such as "Beetle" and "Topolino" (little mouse) soon populated the roads.

West Germans began to visit Italy again, just as the German author Goethe had once done. However, instead of following Goethe's example and touring the remains of classic antiquity, they headed for Lake Garda, the Adriatic Coast, and the Riviera. The Brenner Pass offered a route through the Alps at the lowest altitude, although it also created bottlenecks. VW Beetles packed full of sun-starved Germans drove from Kufstein and Innsbruck, snaked their way along the narrow road through the pass up to an altitude of 4,500 feet, and down the other side. They moved along at what felt like a snail's pace—to the great irritation of local villagers. But the journey through the Alps was a necessary evil that had to be tolerated in order to find a place in the sun.

When the Brenner Motorway was finally completed in the mid-1970s, other destinations, such as Spain, become more popular. Once again the United Kingdom set the trend. As early as the 1950s, British airlines began offering vacation packages to Spanish destinations. Instead of visiting seaside resorts at home, English tourists headed for the beaches of Costa Blanca and the Balearic Islands.

THE MOTHER ROAD

Page 192: Dramatic cumulus clouds above a gas station—*Texaco Station on Route 66*, photograph by Andreas Feininger, 1947.

DIE MOTHER ROAD

Seite 192: Dramatische Kumuluswolken über einer Tankstelle – Fotografie *Texaco Station on Route 66* von Andreas Feininger, 1947

MOTHER ROAD

Page 192 : spectaculaire amas nuageux au-dessus d'une station-service – *Texaco Station on Route 66*, une photo signée Andreas Feininger, 1947

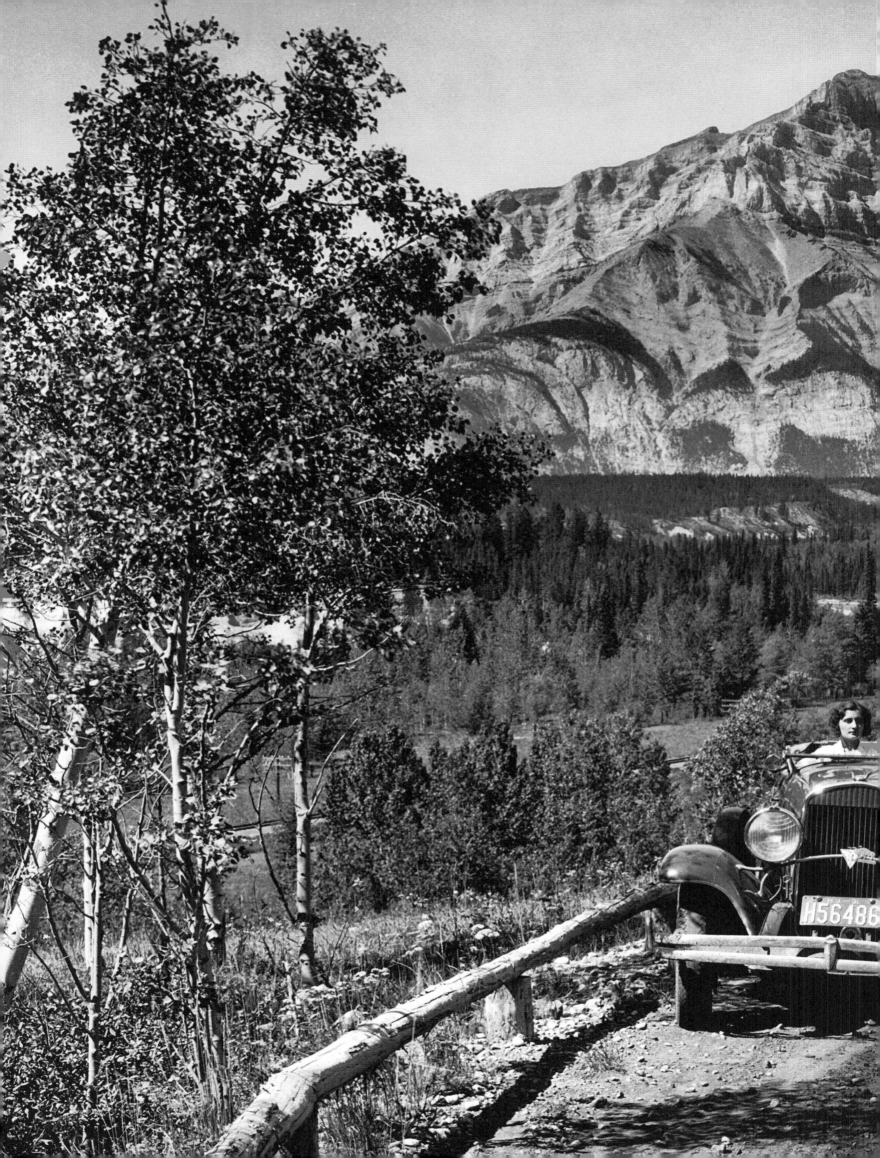

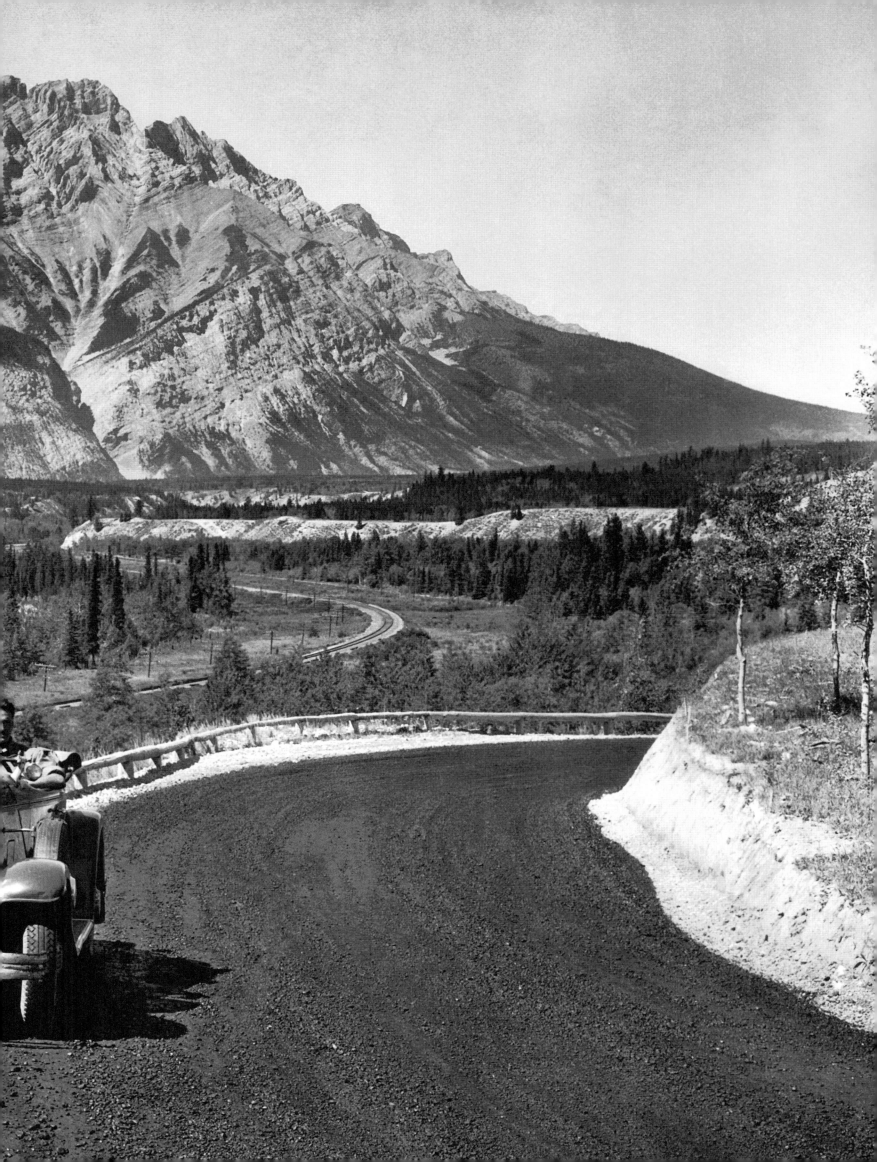

AUTOTOURISMUS

Zu Beginn des 20. Jahrhunderts konnte sich nur eine Minderheit in den Vereinigten Staaten den Luxus leisten, den Großen Teich mit einem Dampfer zu überqueren und wochenlang durch die Alte Welt zu reisen. Wenn man sich überhaupt eine Tour erlauben konnte, dann innerhalb des eigenen Landes.

Hatten die Eisenbahnen schon früh den amerikanischen Kontinent auf Schienen erschlossen und so die Möglichkeit geschaffen, Güter und Personen zu transportieren, so trug ein weiterer Faktor dazu bei, dass der Tourismus zum Massenphänomen wurde: die Motorisierung der amerikanischen Bevölkerung. Henry Fords Model T, das 1908 auf den Markt kam, veränderte die mobile Welt grundlegend. Tatsächlich war auch das T-Modell anfangs ein Luxusgut, doch als der Verkaufspreis durch die Fließbandproduktion ab 1914 deutlich sank, konnten sich allmählich auch Menschen mit Durchschnittseinkommen einen Wagen leisten. 1908 war zudem das Geburtsjahr von General Motors. Mit seiner Markenvielfalt sprach das Unternehmen alle Amerikaner an und ließ sie vom eigenen Chevrolet oder Cadillac träumen.

Was damals stattfand, war eine zweite Erschließung des Kontinents. Nach 1913 entstand in den USA ein transkontinentales Straßensystem, der National Auto Trail, der später durch die Highways abgelöst wurde. Die Straßen mit geraden Zahlen führten von Ost nach West, die mit ungeraden von Nord nach Süd. Bald war es möglich, das Land in wenigen Tagen zu durchqueren und dabei anzuhalten, wo man wollte. Da die Einkommen stiegen und die Arbeitnehmer mehr Urlaub bekamen, konnten immer mehr Menschen ein paar Tage verreisen. Am liebsten taten sie das im eigenen Auto. Wer keines besaß, setzte sich in den Bus: Bereits 1914 beförderte die Greyhound-Linie Passagiere kreuz und quer durch die USA.

Unter den US-Fernstraßen gab und gibt es einige außergewöhnliche Routen, die durch spektakuläre Landschaften führen. Dazu gehörte die State Route 1 in Kalifornien, die in einigen Abschnitten den Namen Pacific Coast Highway trug. Die Straße verlief über eine Länge von 1 000 Kilometern durch Kalifornien an der Pazifikküste entlang bis zur mexikanischen Grenze.

Noch berühmter und länger ist die Route 66. 1926 wurden ihre Teilstücke zu einem 3 945 Kilometer langen Highway zusammengefügt, der Chicago mit Santa Monica an der Pazifikküste verband. Während der Großen Depression in den 1930er-Jahren wurde die Route 66 zur Schicksalsstraße für verarmte Farmer aus dem Mittleren Westen, die ihr Glück in Kalifornien suchten. Den mühsamen Treck nach Westen haben Fotografen wie Walker Evans und Dorothea Lange eindrücklich dokumentiert und John Steinbeck in *Früchte des Zorns* literarisch verarbeitet. Gerade einmal 30 Jahre nach ihrer Eröffnung war die zweispurige „Mother Road" durch den Bau moderner Interstate Highways bereits überflüssig und wurde unmittelbar mythisch verklärt.

Die ganz große amerikanische Autoroute war aber die Panamericana. 1923 entstand auf der Fünften Internationalen Konferenz der Amerikanischen Staaten die Idee, ein Fernstraßensystem zu bauen, das von Alaska bis Feuerland beide amerikanische Teilkontinente durchquert und in der längsten Nord-Südverbindung heute über 30 000 Kilometer lang ist.

Wo ging die Reise hin? Gerne hinaus in die Natur. Schon Mitte des 19. Jahrhunderts forderten die Schriftsteller Ralph Waldo Emerson und Henry David Thoreau, die Umwelt besser zu schützen. Der Universalgelehrte John Muir lebte mehrere Jahre im kalifornischen Naturschutzreservat Yosemite. Er war entsetzt über den Umgang der Menschen Ostkaliforniens mit der Natur und erkannte 1871: „Gott hat für diese Bäume gesorgt, sie vor Sturm und Flut bewahrt, aber er kann sie nicht vor Verrückten bewahren. Nur Uncle Sam kann das."

Ein Jahr später entstand der Yellowstone-Nationalpark in Wyoming, erster Nationalpark

der Vereinigten Staaten und ältester Nationalpark der Welt. An der Ostküste zog es Naturliebhaber in die Appalachen oder zu den Niagara-Wasserfällen an der Grenze zwischen dem US-Bundesstaat New York und der kanadischen Provinz Ontario.

Wo die Schönheit der Landschaft nicht reichte, um Touristen anzuziehen, wurde schon mal mit Sprengstoff nachgeholfen. Ab 1927 modellierten der Bildhauer Gutzon Borglum und sein Sohn Lincoln 18 Meter hohe Porträts von vier amerikanischen Präsidenten in den Mount Rushmore in South Dakota. 1941 war das Werk vollbracht, das mittlerweile jährlich drei Millionen Besucher anzieht.

Casinos und Vergnügungsparks waren bereits in den Badeorten des 19. Jahrhunderts gerne besuchte Etablissements. Im folgenden Jahrhundert eröffneten Spielbanken auch in der Wüste. 1931 legalisierte der Staat Nevada Glücksspiele und verringerte die vorgeschriebene Residenzpflicht für Scheidungswillige auf sechs Wochen. Nach dem Bau des Hoover-Staudammes in der Nähe begann in Las Vegas ab 1941 der Boom der Spielcasinos. Frischverliebte konnten in der Spielermetropole kurz entschlossen heiraten – und in Reno konnte man sich wieder scheiden lassen.

Wenn die Ehe hielt, ging es mit den Kindern vielleicht nach Anaheim bei Los Angeles, wo der Filmproduzent Walt Disney 1955 Disneyland eröffnete, das zum Vorbild aller kommenden Vergnügungsparks werden sollte. Hier erweckte Disney die Figuren und Kulissen aus seinen Zeichentrickfilmen zum Leben. Die Besucher konnten wahlweise in die Zukunft oder in die Vergangenheit reisen: ins „Tomorrowland" oder auf die Main Street einer idealisierten Kleinstadt der Jahrhundertwende.

Standen früher an den Eisenbahnknotenpunkten Hotels für Übernachtungen bereit, so brauchte der Autotourist eine neue Art der Unterkunft. Am besten eine, bei der man den fahrbaren Untersatz buchstäblich mit aufs Zimmer nehmen konnte: ein Motel. Die Bezeichnung ist ein Kunstwort aus „Motor" und „Hotel". Das erste war das Motel

Inn im kalifornischen San Luis Obispo, es eröffnete am 12. Dezember 1925.

Anfangs waren die Motels einzelne rustikale Hütten aus Holz oder Bruchstein, manchmal auch Wigwams aus Beton. In den 1950er-Jahren mauserten sie sich zu richtiggehenden Hotels mit Bar und Swimmingpool. Von ihren traditionellen Vorbildern hatten sich die Motels längst gelöst. Bei Restaurants galt das Gleiche für die Diner und Drive-Inns, die die Highways prägten. Am 15. Mai 1940 öffneten die Brüder Richard und Maurice McDonald im kalifornischen San Bernadino ihr erstes Schnellrestaurant – an der Route 66.

Unabhängig von den Motels war man, wenn man mit dem eigenen Zelt, einem Travel Trailer oder einem Pop-up Camper reiste. Travel Trailer waren seit den frühen 1920er-Jahren

Fahren auf scheinbar endlosen Highways ein Ausdruck individueller Freiheit: Jack Kerouacs Roman *On the Road* von 1957 legt davon ebenso Zeugnis ab wie Dennis Hoppers Film *Easy Rider* von 1969. Ob im eigenen VW-Bus oder per Anhalter als Rucksacktourist – Ziele waren nicht nur Rockfestivals oder die Strände Kaliforniens. Besonders europäische Blumenkinder zogen auf dem „Hippie-Trail" ins südliche Asien: eine Grand Tour als Selbsterfahrungstrip, die über die Türkei, den Iran, Afghanistan und Pakistan bis nach Katmandu, Goa oder Bangkok führte.

Anders als in den USA waren in Europa in der ersten Hälfte des 20. Jahrhunderts nur wenige in der Lage, mit dem eigenen Auto in den Urlaub zu fahren. Vorreiter war in den Zwischenkriegsjahren Frankreich mit seinem

Ferne schweifen lassen. 1957 legten Frankreich, die Benelux-Staaten, Italien und die Bundesrepublik Deutschland in den Römischen Verträgen eine Reihe von Erleichterungen für Handel und Verkehr fest, die den Kern der heutigen EU bildeten. Wie die Zahl der Staaten der Europäischen Wirtschaftsgemeinschaft wuchs auch das europäische Fernstraßennetz stetig, bevölkert von Kleinwagen, die auf Tiernamen wie „Ente", „Käfer" oder „Topolino" (Mäuschen) hörten.

Wie einst Goethe zog es die Westdeutschen wieder nach Italien. Allerdings weniger zu den Stätten der Antike, sondern an den Gardasee, an die Küsten der Adria und der Riviera. Der niedrigste Pass über die Alpen und zugleich Flaschenhals auf dem Weg war der Brenner. Bis oben hin bepackte VW-Käfer der sonnenhungrigen Teutonen kamen von Kufstein und Innsbruck, schlängelten sich über die schmale Passstraße auf 1 370 Meter hinauf und auf der anderen Seite wieder hinunter, bei gefühlter Schrittgeschwindigkeit und zum Leidwesen der Anwohner in den Gebirgsdörfern. Die Alpenquerung war das notwendige Übel, um an den Platz an der Sonne zu gelangen.

Als die Brennerautobahn dann Mitte der 1970er-Jahre endlich fertig war, standen andere Reiseziele, wie beispielsweise Spanien, bereits höher im Kurs. Trendsetter war wieder einmal Großbritannien. Schon in den 1950er-Jahren wurden dort die ersten Pauschalflugreisen mit spanischen Zielen angeboten. Statt in die heimischen Seebäder ging es nun an die Sandstrände der Costa Blanca oder der Balearen.

> ## ,, GET YOUR KICKS ON ROUTE 66 ،،
> ### BOBBY TROUP, 1946

auf amerikanischen Straßen unterwegs und gipfelten in den eleganten, chromblitzenden, stromlinienförmigen Modellen von Airstream, deren Form aus dem Flugzeugbau abgeleitet war. Hergestellt wurden sie ab den 1930er-Jahren. Der Pop-up Camper war ein Vorläufer der großen Wohnmobile. Tagsüber fahrbarer Untersatz ließ sich abends das Dach auffalten und bot Raum für zwei Betten, während im Wageninneren Platz für ein kleines Kochfeld und eine Spüle war.

Das typische Camper-Gefährt der 1960er-Jahre war der preiswerte und zuverlässige VW-Bus, dessen Karosserie robust war und der sich auch von Heimwerkern einfach umrüsten ließ. Besonders bei Hippies standen der „Bulli" und ähnliche Fahrzeuge hoch im Kurs. Für die amerikanische Gegenkultur war das

nationalen Fernstraßensystem, natürlich mit Paris als Fluchtpunkt. André Citroën nahm sich Ford als Vorbild und produzierte seit 1919 als erster europäischer Hersteller Autos am Fließband. Autoreisende in ganz Europa wappneten sich mit Reiseführern und Karten des Reifenherstellers Michelin. Der erste *Guide Michelin* war bereits im Jahre 1900 auf den Markt gekommen und wies nicht nur Wagenlenkern den Weg zu den besten Restaurants.

Die Massenmotorisierung und damit auch der Massentourismus in Europa entwickelten sich jedoch erst nach dem Zweiten Weltkrieg. Als in den 1950er-Jahren in Westeuropa die gröbsten Kriegsschäden beseitigt waren und der wirtschaftliche Aufschwung begann, konnte man den Blick wieder in die

WITH THE ROADSTER TO THE ROCKIES
Previous pages: Taking a Chrysler for a spin in the Canadian Rocky Mountains between Banff and Jasper, 1931.

MIT DEM ROADSTER IN DIE ROCKIES
Seite 196/197: Ausfahrt im Chrysler in den kanadischen Rocky Mountains zwischen Banff und Jasper, 1931

EN VOITURE DANS LES ROCHEUSES
Pages 196-197 : évasion en Chrysler dans les Rocheuses canadiennes, entre Banff et Jasper, 1931

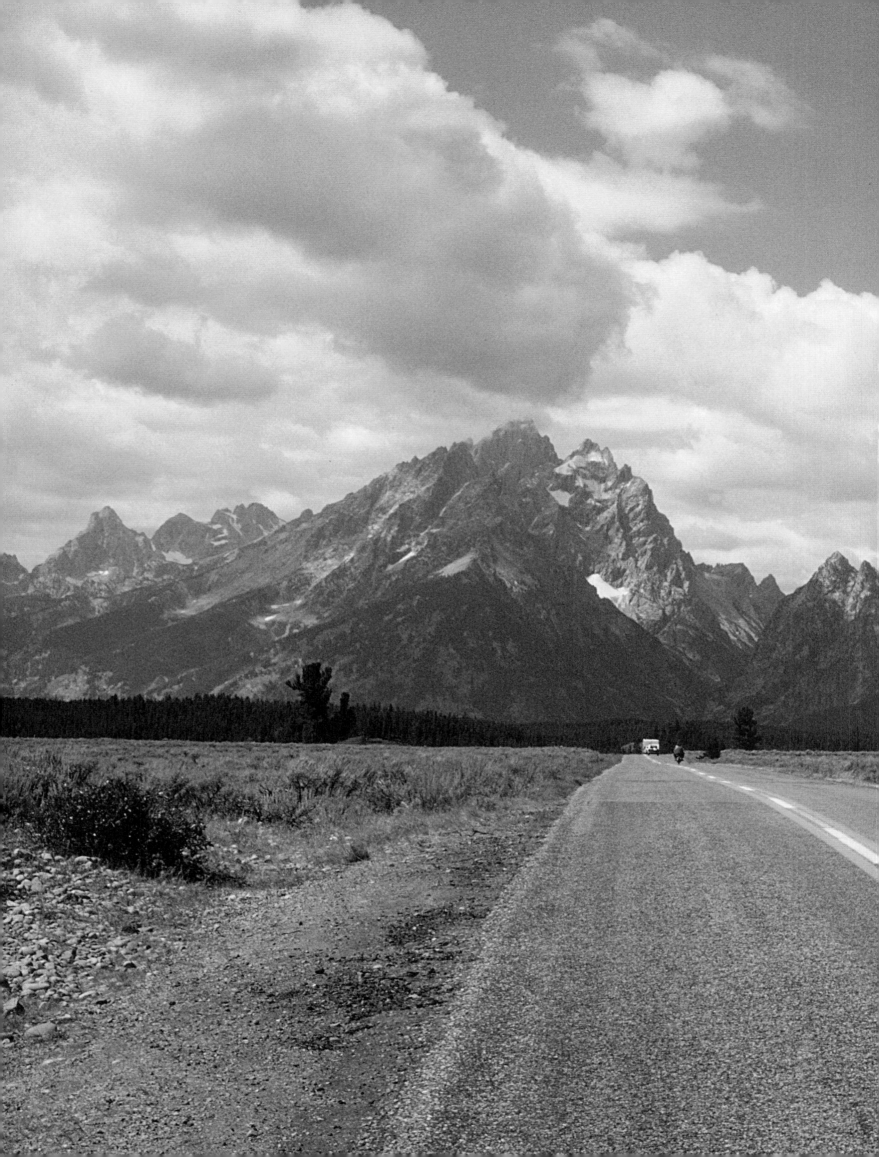

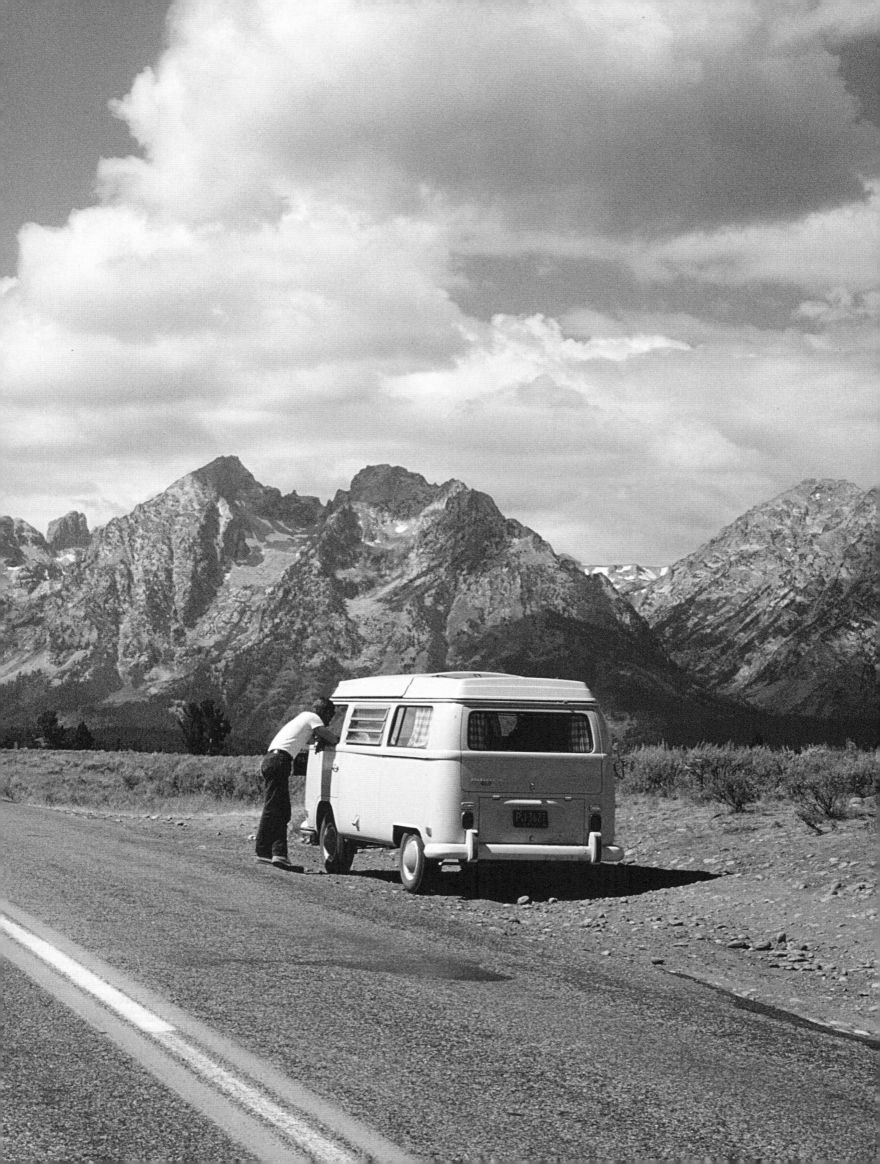

LE TOURISME AUTOMOBILE

Au début du XXᵉ siècle, seule une minorité d'Américains peut s'offrir le luxe de franchir l'Atlantique en paquebot, pour ensuite sillonner l'Ancien Continent pendant plusieurs semaines. Car parmi les privilégiés qui ont les moyens de partir en vacances, la plupart ne se hasardent pas au-delà de leurs frontières. Grâce au chemin de fer, les vastes espaces du continent américain s'ouvrent rapidement aux voyageurs et aux marchandises. Mais apparaît bientôt, aux États-Unis, un autre vecteur de développement qui contribue à faire du tourisme un phénomène de masse : la motorisation des particuliers. Commercialisé en 1908, le modèle T de Henry Ford bouleverse profondément la culture du voyage. Dans un premier temps, pourtant, la Ford T reste un produit de luxe. Puis, en 1913, la mise en service des chaînes de fabrication fait dégringoler son prix de vente. Dès lors, l'automobile devient peu à peu accessible aux revenus moyens. General Motors voit le jour en 1908, qui propose plusieurs marques s'adressant à tous les Américains. Et chacun de se prendre à rêver de conduire sa Chevrolet ou d'acheter sa Cadillac.

C'est alors une deuxième révolution des transports qui transfigure l'Amérique. À partir de 1913, les États-Unis développent le National Auto Trail, un réseau de routes transcontinentales qui préfigurent les futures *highways*. Les routes nationales qui portent des numéros pairs vont d'est en ouest ; celles qui sont désignées par des numéros impairs sont orientées nord-sud.

Il est désormais possible de traverser le pays en quelques jours et de choisir ses étapes. À mesure qu'augmentent les revenus et les congés des Américains, ils se font toujours plus nombreux à s'offrir quelques jours d'escapade. Et c'est en voiture qu'ils aiment partir. Ceux qui n'en ont pas les moyens prennent le bus : dès 1914, les lignes de la compagnie Greyhound acheminent les passagers aux quatre coins du pays.

Parmi les grands axes des États-Unis, quelques routes sont entrées dans la légende, qui traversaient – et traversent encore – des paysages extraordinaires. Ainsi la State Route Number 1, en Californie, alias Pacific Coast Highway sur certains tronçons, qui se déroule sur mille kilomètres le long de la côte Pacifique jusqu'à la frontière mexicaine, au sud de la Californie.

Plus connue, et encore plus longue, la Route 66 est née en 1926 de la jonction de plusieurs segments en une seule *highway* de 3 945 kilomètres, qui relie Chicago à Santa Monica, sur la côte pacifique. Pendant la grande dépression, dans les années 1930, c'est par la Route 66 que les fermiers du Midwest, laissés sans ressources, partent tenter leur chance en Californie. Des photographes comme Walker Evans et Dorothea Lange ont immortalisé par de poignantes images leur pénible marche vers l'ouest. Cet épisode de l'histoire moderne est entré en littérature sous la plume de John Steinbeck dans *Les Raisins de la colère*. Mais trente ans seulement après son inauguration, la « mother Road » à deux voies est déjà dépassée par la construction des *interstate highways*, plus modernes. La Route 66 devient un mythe.

La Panaméricaine, elle, est *la* grande autoroute d'Amérique. C'est en 1923, lors de la cinquième conférence internationale des États d'Amérique, que naît le projet d'un réseau autoroutier reliant les deux parties du continent américain, de l'Alaska jusqu'à la Terre de feu. Du nord au sud, elle ferait 30 000 kilomètres de long.

Que cherchent tous ceux qui prennent la route ? Le retour à la nature, souvent. Dès le milieu du XIXᵉ siècle, les écrivains Ralph Waldo Emerson et Henry David Thoreau plaident pour la protection de l'environnement. Le savant universel John Muir s'immerge pendant plusieurs années au cœur de la réserve naturelle de Yosemite, en Californie. Choqué par le comportement des hommes à l'égard de la nature dans l'est de l'État, il déclare, en 1871 : « Dieu a créé ces arbres et il les a gardés de la tempête et du déluge, mais il ne peut pas les protéger de la folie des hommes. Cela, seul l'Oncle Sam le peut. »
Un an plus tard, le parc national de Yellowstone, le premier des États-Unis, ouvre dans le

Wyoming ; il reste aujourd'hui le plus vieux parc national au monde. Sur la côte est, les amoureux de la nature qui se lancent à la découverte des Appalaches poussent jusqu'aux chutes du Niagara, à la frontière entre l'État de New York et la province canadienne de l'Ontario.
Quand les beautés naturelles du paysage ne suffisent pas, l'homme intervient à coups de dynamite. Ainsi les sculpteurs Gutzon Borglum et son fils Lincoln s'attaquent-ils, dès 1927, au mont Rushmore, dans le Dakota du Sud. À même la roche, ils taillent les portraits géants de 18 mètres de haut de quatre présidents américains. Achevée en 1941, leur œuvre attire, aujourd'hui encore, plus de trois million de touristes par an.

Dans les stations balnéaires du XIXᵉ siècle, casinos et parcs d'attractions connaissent déjà un succès fou. Au siècle suivant, l'industrie des loisirs investit le désert. En 1931, l'État du Nevada légalise les jeux de hasard et réduit à six semaines le délai légal pour les candidats au divorce. Puis dans les années 1940, la construction du barrage Hoover donne le coup d'envoi de l'explosion des casinos à Las Vegas. Les amoureux peuvent désormais se marier à l'improviste dans la capitale du jeu – pour divorcer aussi facilement à Reno, à l'autre bout du Nevada.
Mais quand le mariage dure, le couple, avec ses enfants, peut mettre le cap plein sud, vers la petite ville d'Anaheim, près de Los Angeles. C'est là qu'en 1955, le producteur de cinéma Walt Disney inaugure Disneyland, qui restera un modèle pour tous les parcs d'attractions à venir. Les visiteurs viennent y rencontrer les personnages des dessins animés de Disney qui évoluent dans leur décor reconstitué. Ils voyagent à leur guise dans le passé ou le futur, partant *À la poursuite de demain* ou flânant dans la rue principale d'une petite ville de la fin du XIXᵉ siècle idéalisée.
Les passagers des trains trouvaient naguère des hôtels pour se loger aux carrefours ferroviaires. Le touriste automobile, lui, a besoin d'un nouveau type d'hébergement – une formule qui, de préférence, lui permettrait de passer de sa voiture à son lit par le plus court chemin. Ainsi est né le « motel », un mot-valise issu de *motor* et *hotel*. Le premier du genre, le Motel Inn de San Luis Obispo, en Californie, ouvre le 12 décembre 1925.

Dans un premier temps, les motels se réduisent à une poignée de cabanes en bois rustiques, de bâtisses en maçonnerie ou de tipis en béton. Puis dans les années 1950, ils s'apparenteront de plus en plus à des hôtels à part entière, avec bar et piscine, depuis longtemps affranchis de leurs modèles européens. *Idem* pour les *diners* et les *drive-ins*, qui permettent de se restaurer sans quitter la route. Le 15 mai 1940, les frères Richard et Maurice McDonald inaugurent un premier établissement de restauration rapide à San Bernadino, en Californie – sur la Route 66.

Pour éviter le motel, il faut voyager avec sa tente sur le dos, ou encore une caravane fixe ou pliante en remorque. Les caravanes qui, depuis le début des années 1920, sillonnent les routes américaines, atteignent des sommets de raffinement avec les élégants modèles

est une forme d'expression de liberté individuelle : le roman de Jack Kerouac *Sur la route*, publié en 1957, en témoigne, tout comme le film de Dennis Hopper *Easy Rider*, en 1969. En VW Combi ou le pouce levé au bord de la route, sac au dos, le but du voyage n'est pas forcément un festival de rock ou une plage de Californie. En Europe, les soixante-huitards se retrouvent sur la *hippie-trail*, la route de l'Asie du Sud : un grand tour pour aller à la recherche de soi-même en passant par la Turquie, l'Iran, l'Afghanistan et le Pakistan, cap sur Katmandou, Goa ou Bangkok.

Contrairement aux Américains, rares sont les Européens qui, dans la première moitié du XXᵉ siècle, ont leur propre voiture pour partir en vacances. Dans l'entre-deux-guerres, c'est la France qui donne le coup d'envoi du tourisme automobile en s'équipant d'un réseau de

rieuses, l'Europe se reprend à faire des projets. En 1957, la France, les pays du Benelux, l'Italie et la République fédérale d'Allemagne énoncent, dans le traité de Rome, une série de règles destinées à faciliter la circulation des hommes et des marchandises. Des pays qui, aujourd'hui, restent le noyau de l'actuelle Union européenne. À mesure que s'élargit la Communauté européenne, son réseau de routes se ramifie et se peuple de petites voitures aux noms d'animaux, comme « Coccinelle » ou *topolino* (la « petite souris », alias Fiat 500).

Comme Goethe autrefois, les Allemands de l'Ouest partent à la découverte de l'Italie, même s'ils délaissent désormais les sites antiques au profit du lac de Garde et des rivages de l'Adriatique ou de la Méditerranée. Mais le col du Brenner, le plus accessible pour franchir les Alpes, reste un goulet d'étranglement sur la route du sud. Des flots de Coccinelles chargées à bloc, jusque sur le toit, et bondées de gens du nord en mal de soleil déferlent de Kufstein et d'Innsbruck ; elles se faufilent par la petite route qui serpente jusqu'à 1 370 mètres d'altitude, puis redescendent de l'autre côté, au pas, et au grand dam des montagnards. Franchir les Alpes est un mal nécessaire pour « se faire une place au soleil ».

« *GET YOUR KICKS ON ROUTE 66* »
BOBBY TROUP, 1946

chromés et aérodynamiques d'Airstream construits dans les années 1930, dont les lignes s'inspirent de l'aéronautique. La caravane pliante, elle, préfigure le camping-car. Elle se compose d'un socle sur roues qui, le soir, se recouvre d'un toit que l'on déplie au-dessus de deux couchages, tandis que l'intérieur recèle une cuisine miniature et un évier.

Dans les années 1960, le Volkswagen Combi devient l'indispensable compagnon du campeur. Abordable et fiable, avec sa robuste carrosserie, il est facile à convertir pour quiconque est un peu bricoleur. Comme tous les véhicules du même acabit, celui que l'on surnomme le Combi a particulièrement la cote auprès des hippies. Pour la contre-culture américaine, avaler des kilomètres sur des routes qui semblent se dérouler à l'infini

routes nationales qui rayonnent depuis Paris. S'inspirant de Ford, André Citroën est, dès 1919, le premier constructeur du continent à fabriquer à la chaîne. Dès lors, les automobilistes de toute l'Europe s'arment des cartes et des guides de voyage proposés par le fabricant de pneumatiques Michelin. Dès 1900, le premier *Guide Michelin* indique les itinéraires menant aux meilleurs restaurants – et les automobilistes ne sont pas les seuls à suivre ses conseils.

Il faut toutefois attendre la fin de la Seconde Guerre mondiale pour que la motorisation de masse, et par conséquent le tourisme de masse, se développe dans le vieux monde. Dans les années 1950, alors que les principaux stigmates de la guerre s'effacent et que s'amorce l'essor économique des trente glo-

Au milieu des années 1970, alors que l'autoroute du Brenner entre enfin en service, d'autres destinations, comme l'Espagne, ont déjà le vent en poupe. Une fois de plus, c'est la Grande-Bretagne qui a pris les devants. Dès les années 1950, les agences anglaises proposent des formules de vacances en Espagne, vol inclus. Dès lors, les Britanniques privilégient les plages de la Costa Blanca et des Baléares aux bains dans la mer du Nord.

CAMPER VACATION
Previous pages: Traveling in a Volkswagen Bus on the way to the Teton Range in the Rocky Mountains, Wyoming, 1965.

URLAUB IM CARAVAN
Seite 200/201: Mit dem VW-Bulli auf dem Weg zur Teton-Range-Bergkette in den Rocky Mountains, Wyoming, 1965

CAMPING SAUVAGE
Pages 200-201 : en Volkswagen Combi, cap sur la chaîne Teton, dans les Rocheuses, Wyoming, 1965

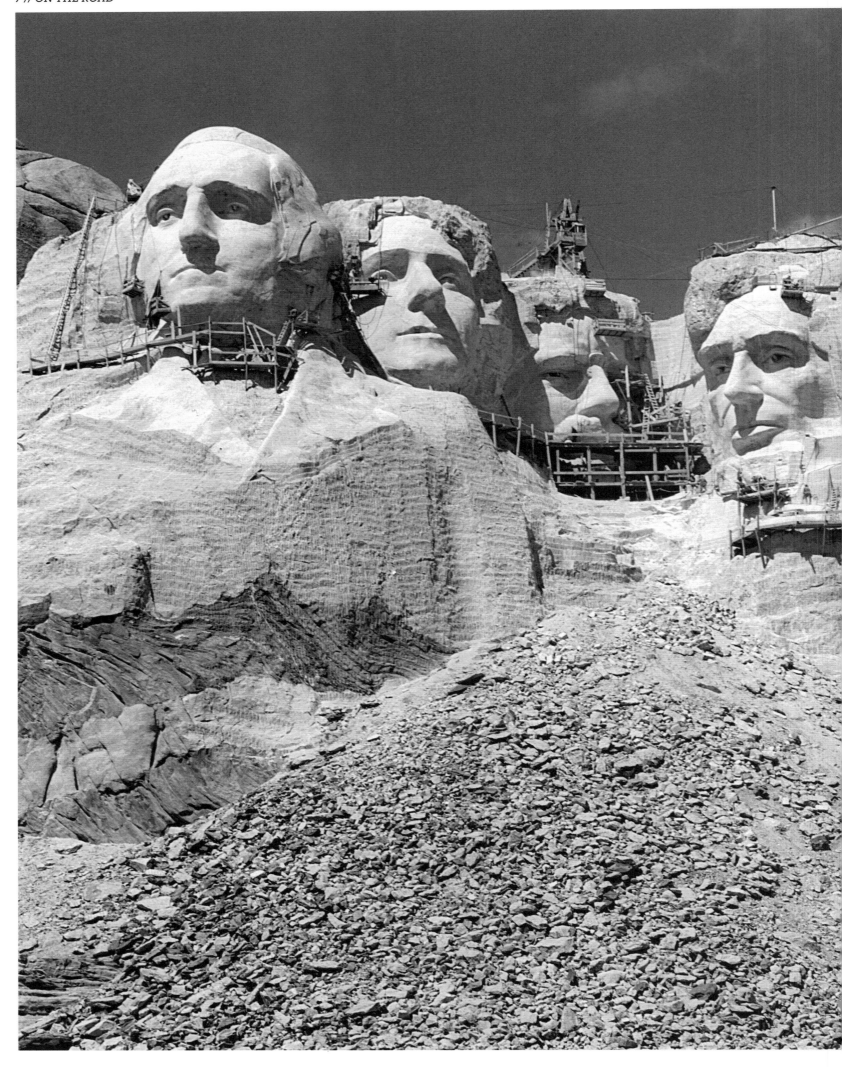

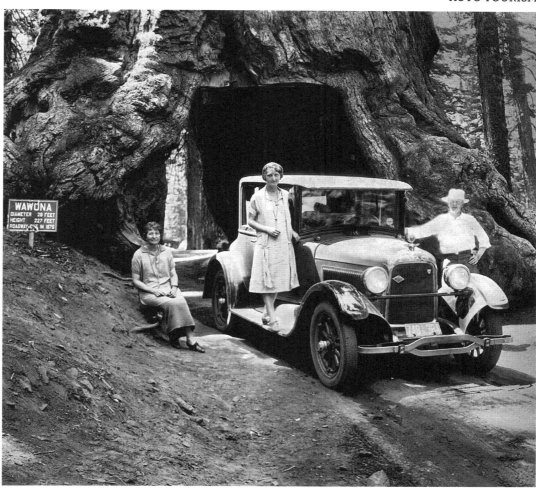

DOMINION OVER NATURE

Opposite: The Mount Rushmore National Memorial in the Black Hills, South Dakota, 1930s. The heads of the four U.S. Presidents George Washington Thomas Jefferson, Theodore Roosevelt, and Abraham Lincoln start to take shape. Above: Day trippers in Mariposa Grove at Yosemite National Park in California, 1920s. A road tunneling through the 2,300-year-old mammoth tree was build in 1876.

NATURBEHERRSCHUNG

Links: Das Mount Rushmore National Memorial in den Black Hills, South Dakota, 1930er-Jahre. Die vier Köpfe der US-Präsidenten George Washington Thomas Jefferson, Theodore Roosevelt und Abraham Lincoln nehmen Gestalt an; oben: Ausflügler im Mariposa Grove am Yosemite Nationalpark in Kalifornien, 1920er-Jahre. Durch den 2300 Jahre alten Mammutbaum wurde 1876 ein Straßentunnel gegraben

DOMPTER LA NATURE

Ci-contre : le mémorial national du mont Rushmore, dans les Black Hills du Dakota du Sud, dans les années 1930. Les visages de quatre présidents des États-Unis émergent de la roche : George Washington, Thomas Jefferson, Theodore Roosevelt et Abraham Lincoln ;
ci-dessus : excursion à Mariposa Grove, dans le parc national de Yosemite, en Californie, dans les années 1920. Depuis 1876, un tunnel traverse le tronc du séquoia géant séculaire

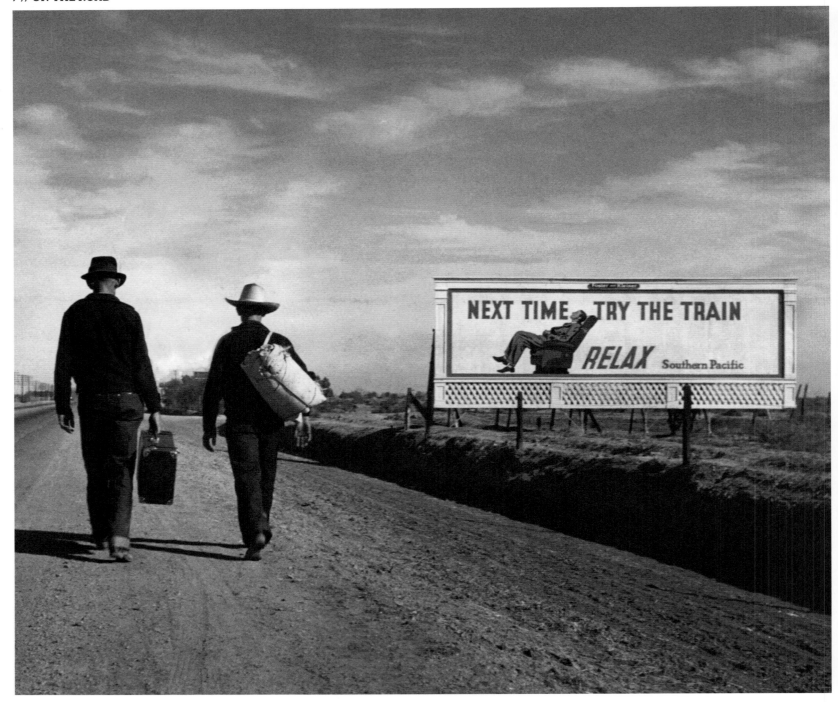

GO WEST

Above: Farmers from the Dust Bowl regions laid waste by drought follow Route 66 on their way to California—photo
titled *Toward Los Angeles* by Dorothea Lange, 1937.
Opposite. The prospect of finding work in California's munitions industry drew many jobless migrant workers to the
West Coast, 1945.

GO WEST

Oben: Farmer aus den durch Dürren verödeten Landstrichen der „Dust Bowl", unterwegs auf der Route 66
nach Kalifornien – Fotografie *Toward Los Angeles* von Dorothea Lange, 1937;
rechts: Viele arbeitslose Wanderarbeiter wurden von der Aussicht auf Arbeit in der kalifornischen Rüstungsindustrie
an die Westküste gelockt, 1945

À L'OUEST, TOUT EST NOUVEAU

Ci-dessus : ruinés par les sécheresses, les fermiers quittent les immensités désolées du Dust Bowl,
cap sur la Californie par la route 66 – *Toward Los Angeles*, une photo signée Dorothea Lange, 1937 ;
ci-contre : les perspectives d'emploi dans l'armement en Californie poussent de nombreux ouvriers
itinérants à tenter leur chance sur la côte Ouest, 1945

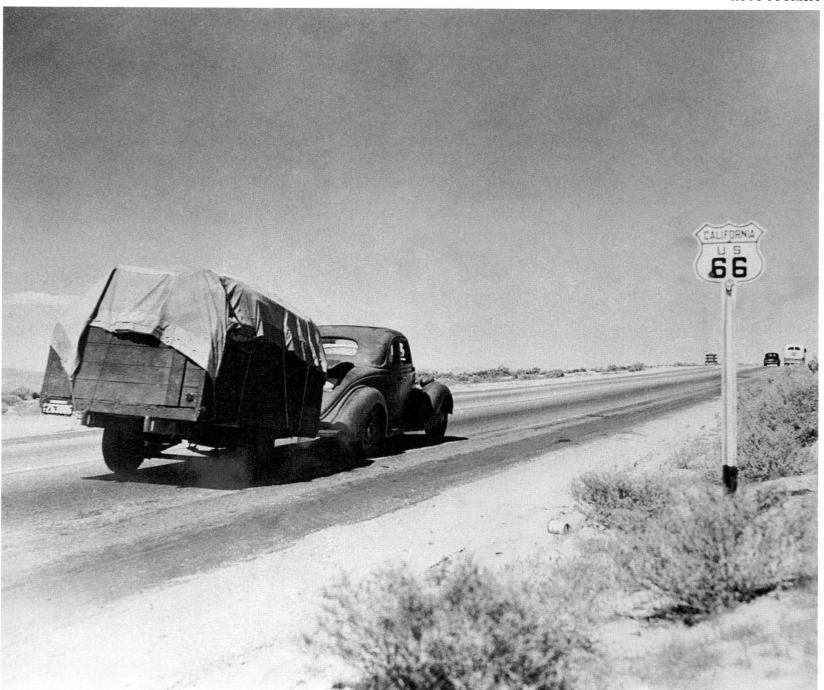

GIANTS

Following pages, from left: A Greyhound bus on Route 13 in Delaware. For many travelers, long-distance busses were a popular and lower-cost alternative to trains, 1950s; teen idol James Dean beside a travel trailer during the filming of his movie *Giant*, 1955. The actor didn't live to see the premiere—he died in a car crash after work on the film wrapped.

GIGANTEN

Seite 208: Ein Greyhound-Bus auf der Route 13 in Delaware. Die Fernbusse waren für viele Reisende eine beliebte und günstigere Alternative zur Eisenbahn, 1950er-Jahre;
Seite 209: Jugendidol James Dean vor einem Travel Trailer während der Filmaufnahmen zu *Giganten*. Die Premiere erlebte der Schauspieler nicht mehr – er starb nach Abschluss der Dreharbeiten bei einem Autounfall, 1955

GÉANT DES ROUTES

Page 208 : un bus Greyhound sur la Route 13, dans le Delaware. Pour de nombreux voyageurs, l'autocar longue distance est une alternative agréable et bon marché au chemin de fer dans les années 1950
Page 209 : James Dean, l'idole des jeunes, adossé à une caravane pendant le tournage de *Géant*. L'acteur n'assistera jamais à la première, victime d'un accident de voiture à la fin du tournage, 1955

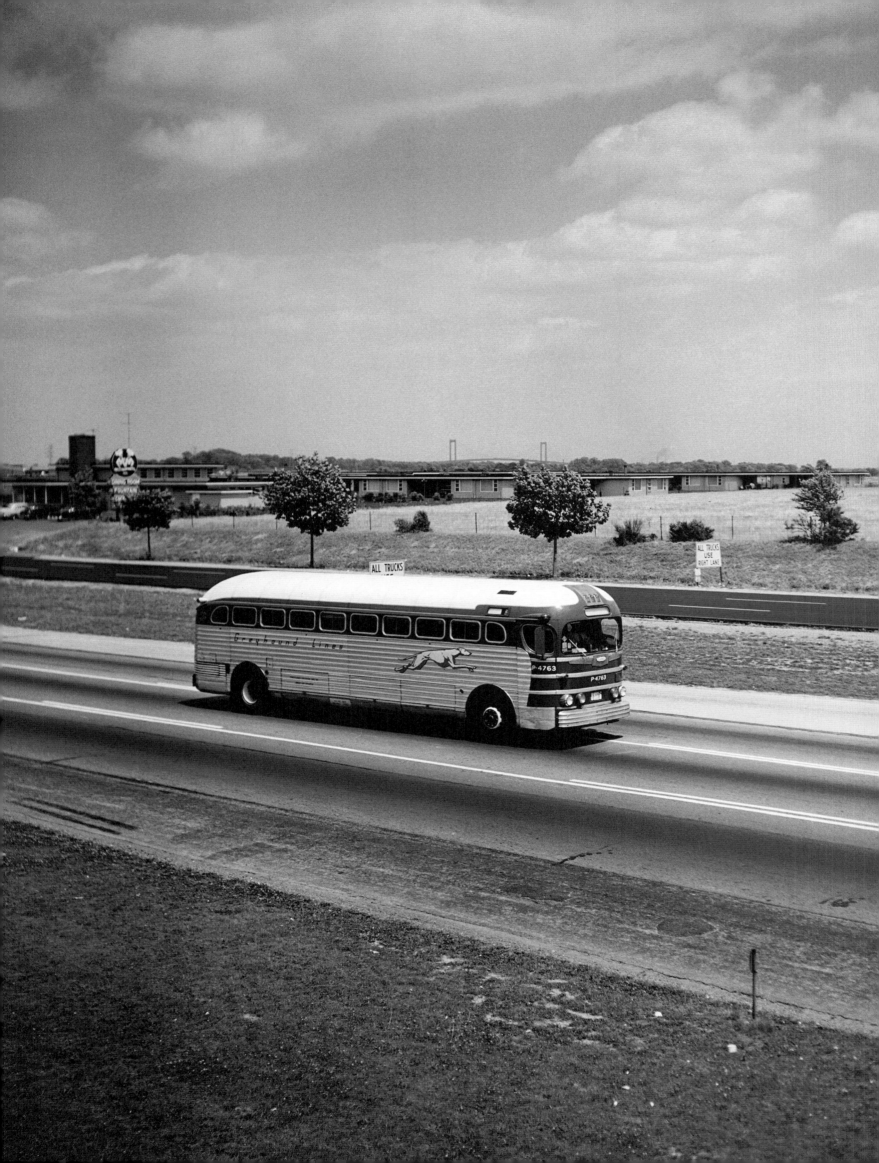

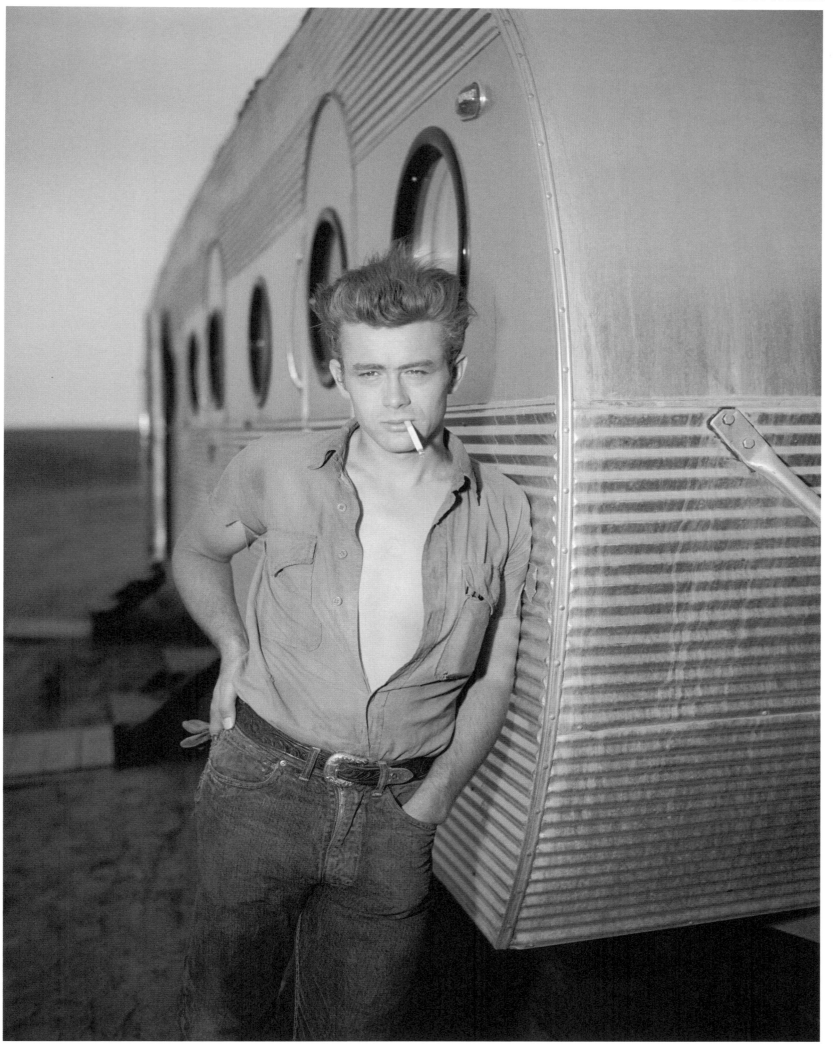

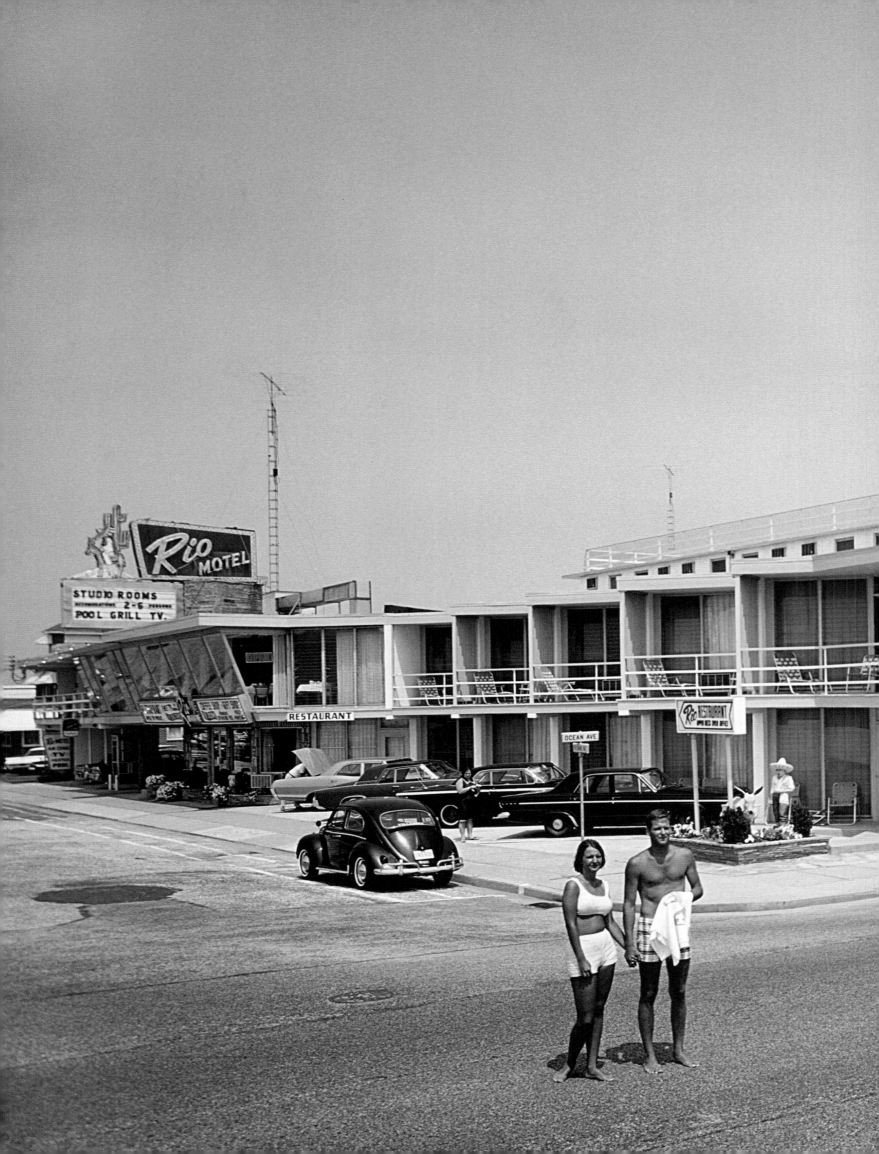

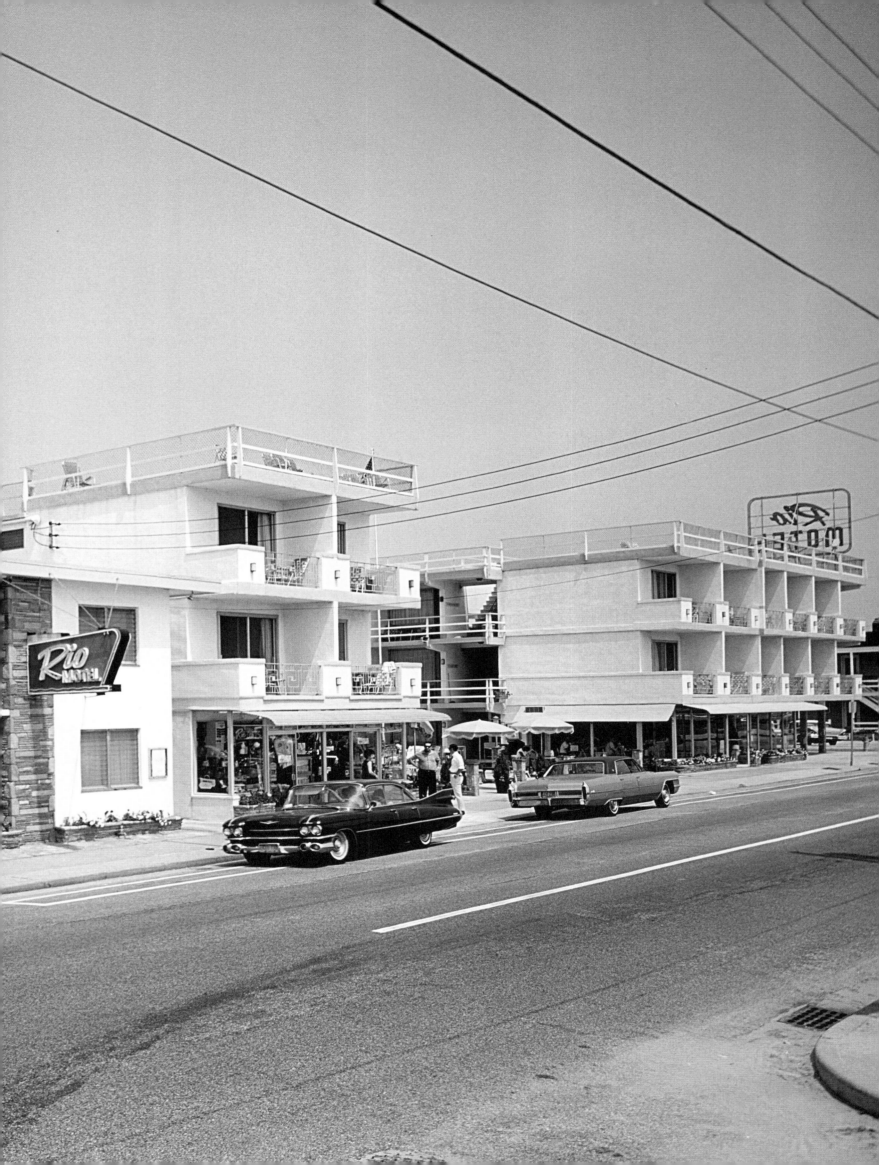

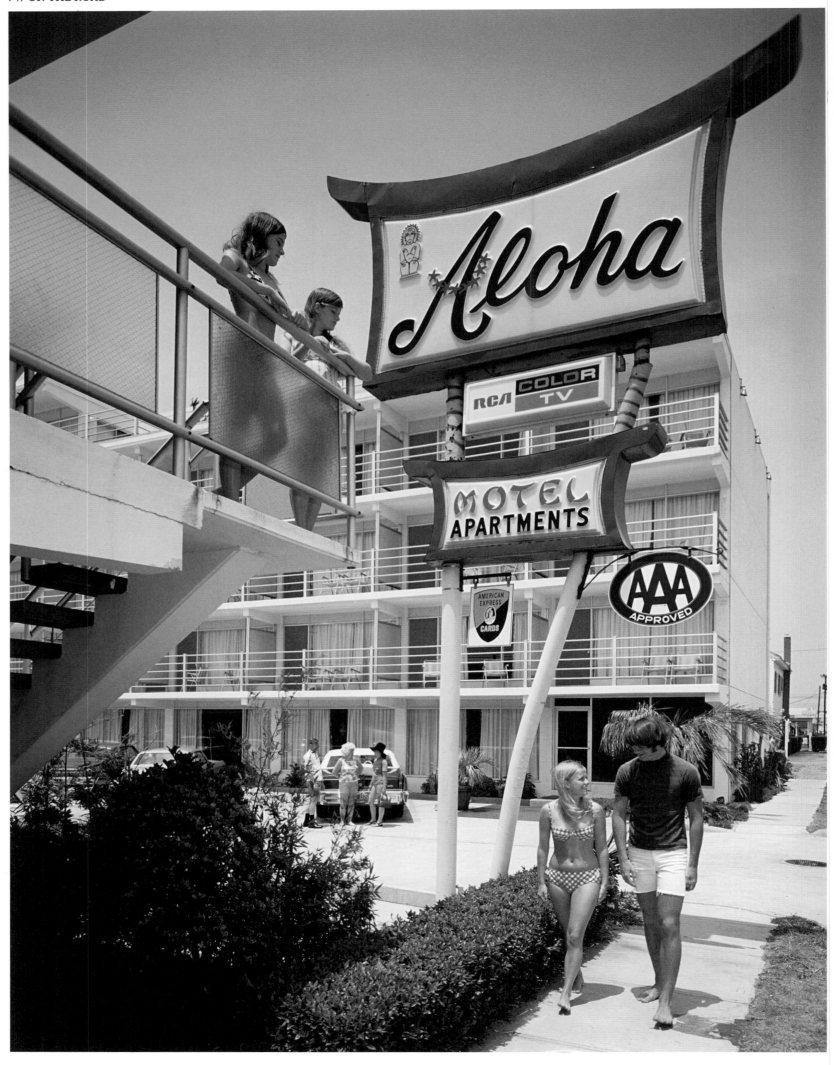

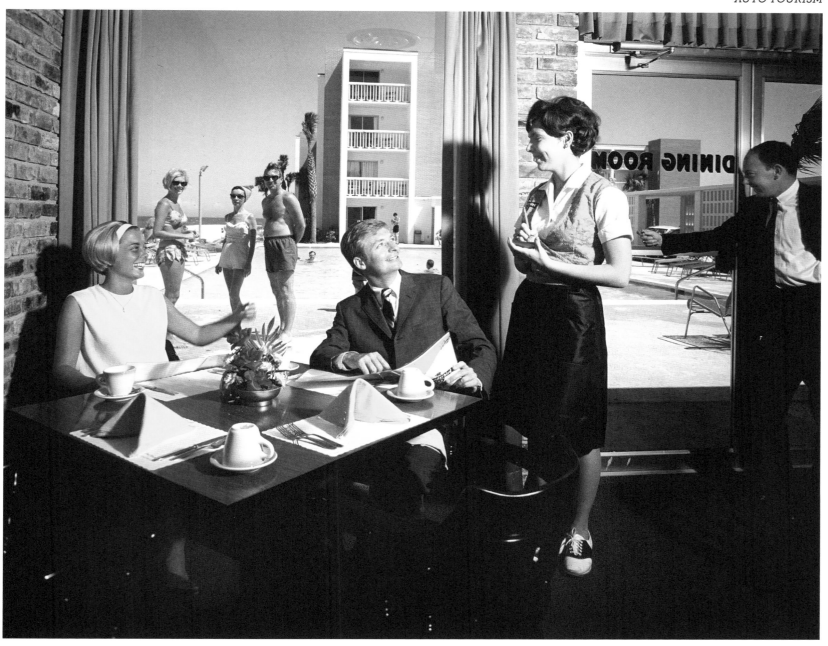

ROOM WITH A VIEW OF THE CAR

Previous pages: From the highway to the beach. The Rio Motel in Wildwood, New Jersey, 1963.
Opposite: The Aloha Motel on the Atlantic coast, North Wildwood, New Jersey, 1960s.
Above: Coffee shop at the Thunderbird Motel in Myrtle Beach, South Carolina, 1965.

ZIMMER MIT AUSSICHT AUFS AUTO

Seite 210/211: Vom Highway an den Strand. Das Rio Motel in Wildwood, New Jersey, 1963
Links: Das Aloha Motel an der Atlantikküste in North Wildwood, New Jersey, 1960er-Jahre
Oben: Coffee Shop des Thunderbird Motels in Myrtle Beach, South Carolina, 1965

CHAMBRES AVEC VUE SUR LE PARKING

Pages 210-211 : la route des plages. Le motel Rio, à Wildwood dans le New Jersey, 1963
Ci-contre : le motel Aloha, sur la côte Atlantique, à North Wildwood dans le New Jersey, dans les années 1960 ;
ci-dessus : le café du motel Thunderbird à Myrtle Beach, en Caroline du Sud, 1965

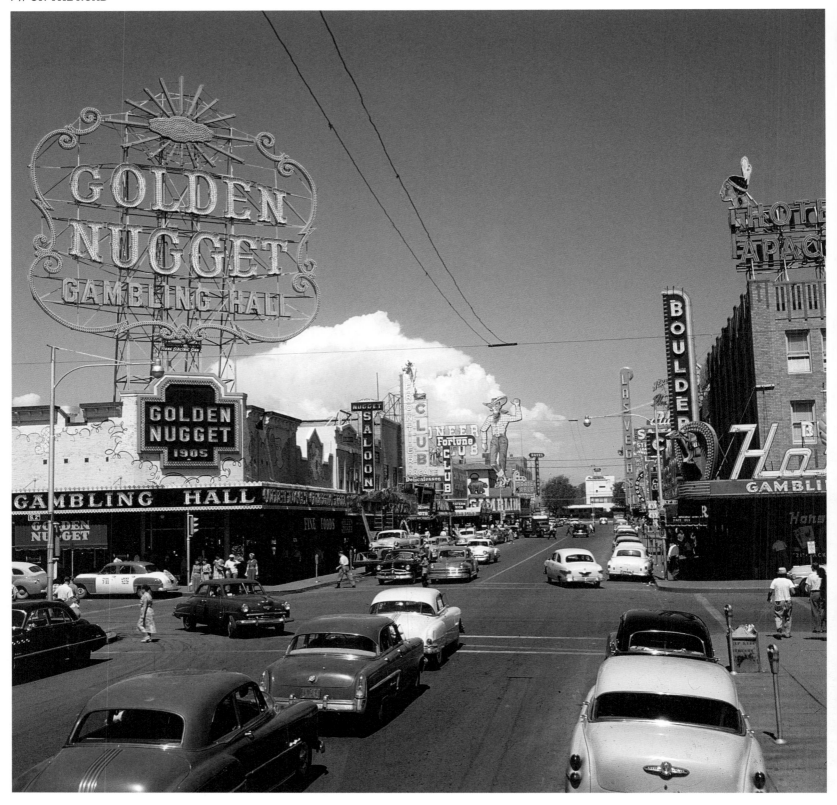

THEME PARKS

Above: Fremont Street in Las Vegas, Nevada, 1953. Seven years earlier,
the Golden Nugget became the first casino hotel.
Opposite: Disneyland in Anaheim, California, opened in 1955. Walt and
Lillian Disney drive an antique car through the amusement park, 1966.

THEMENPARKS

Oben: Fremont Street in Las Vegas, Nevada, 1953. Sieben Jahre zuvor wurde das
Golden Nugget als erstes Kasinohotel eröffnet;
rechts: Seit 1955 gibt es das Disneyland im kalifornischen Anaheim. Walt und
Lillian Disney steuern ein altertümliches Auto durch den Vergnügungspark, 1966

PARCS À THÈME

Ci-dessus : Fremont Street à Las Vegas, dans le Nevada, 1953. Sept ans
auparavant ouvrait le Golden Nugget, le premier hôtel-casino ;
ci-contre : le Disneyland d'Anaheim, en Californie, existe depuis 1955.
Walt et Lillian Disney au volant d'une voiturette rétro, 1966

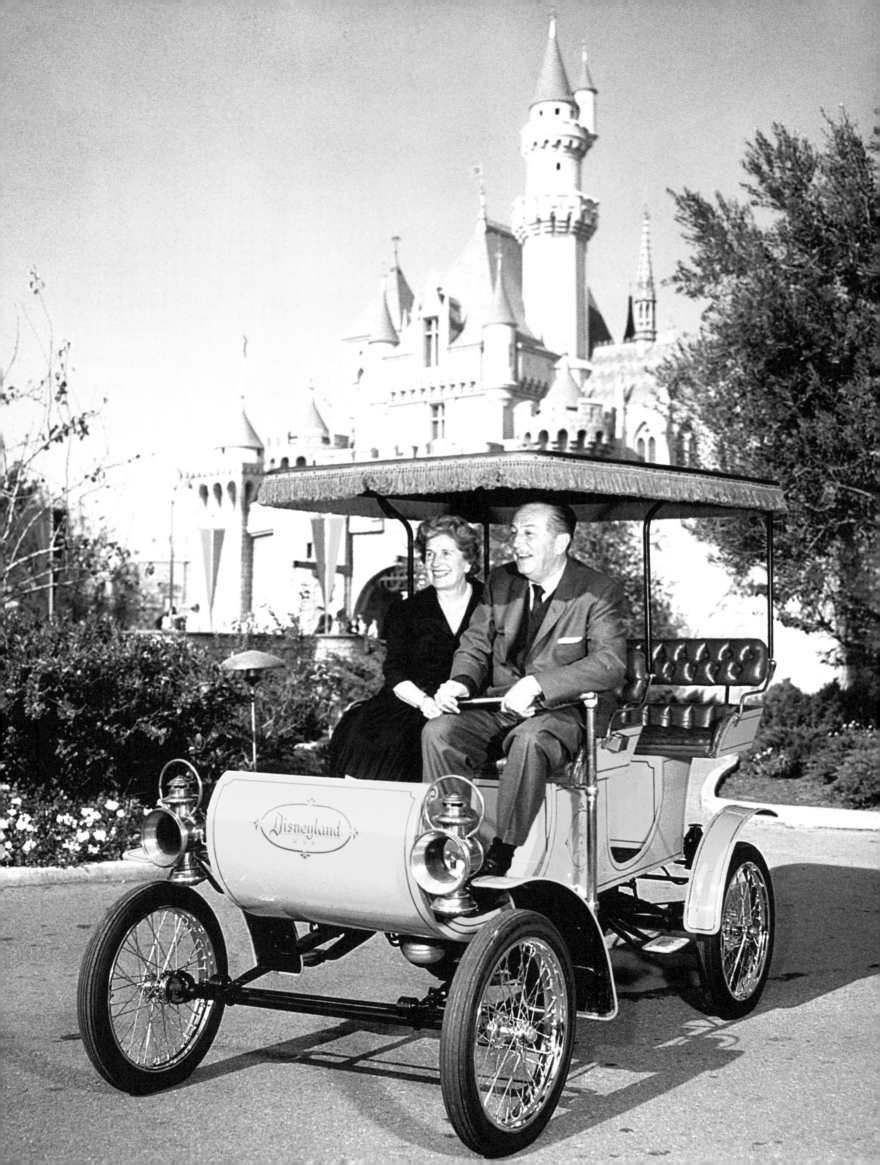

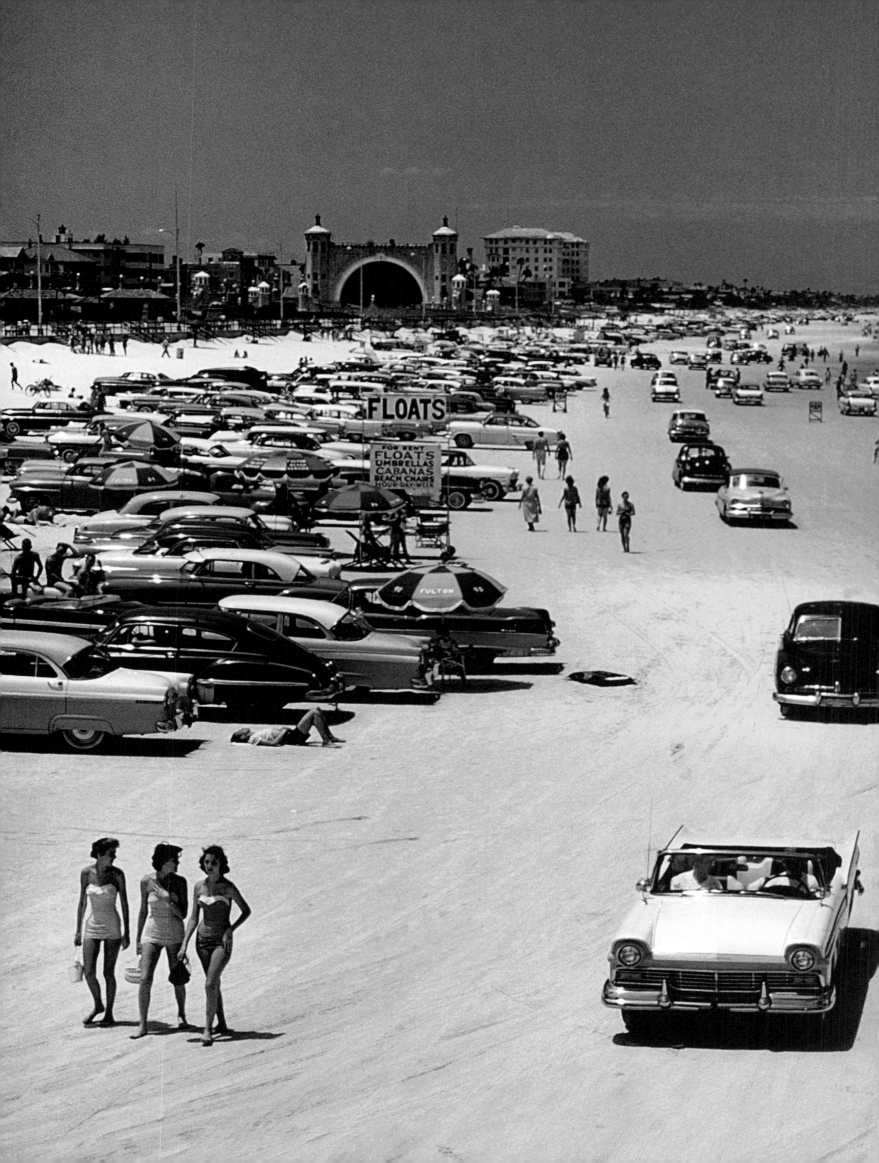

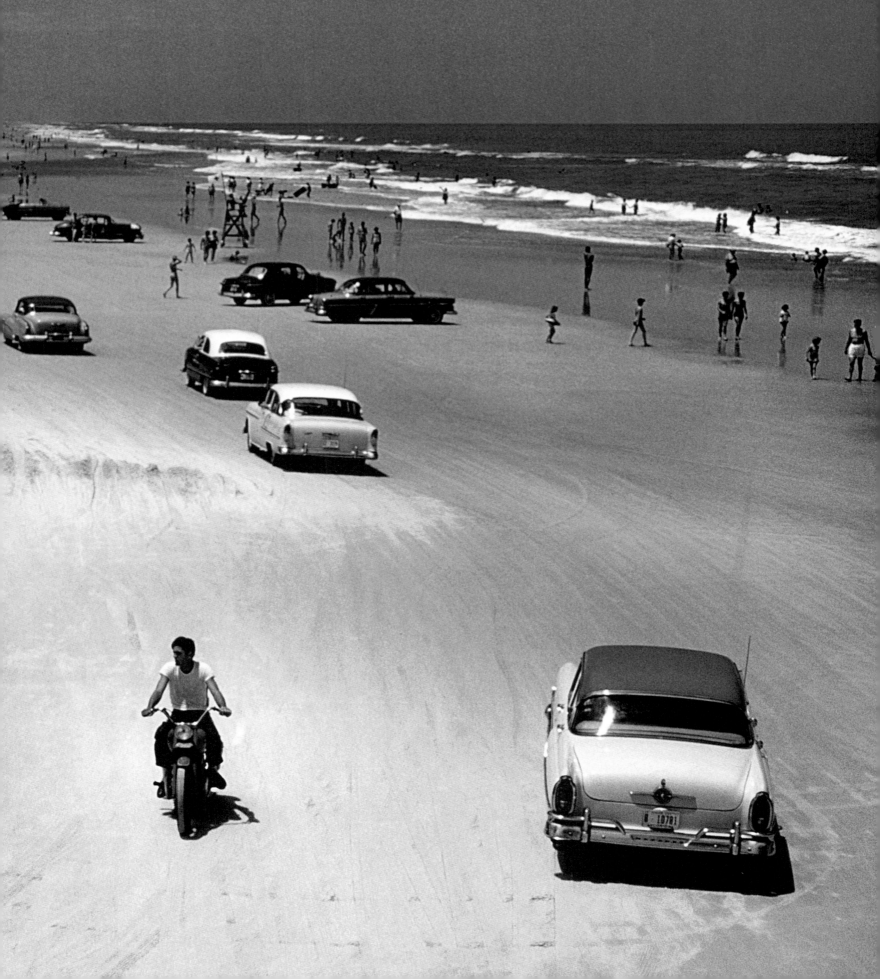

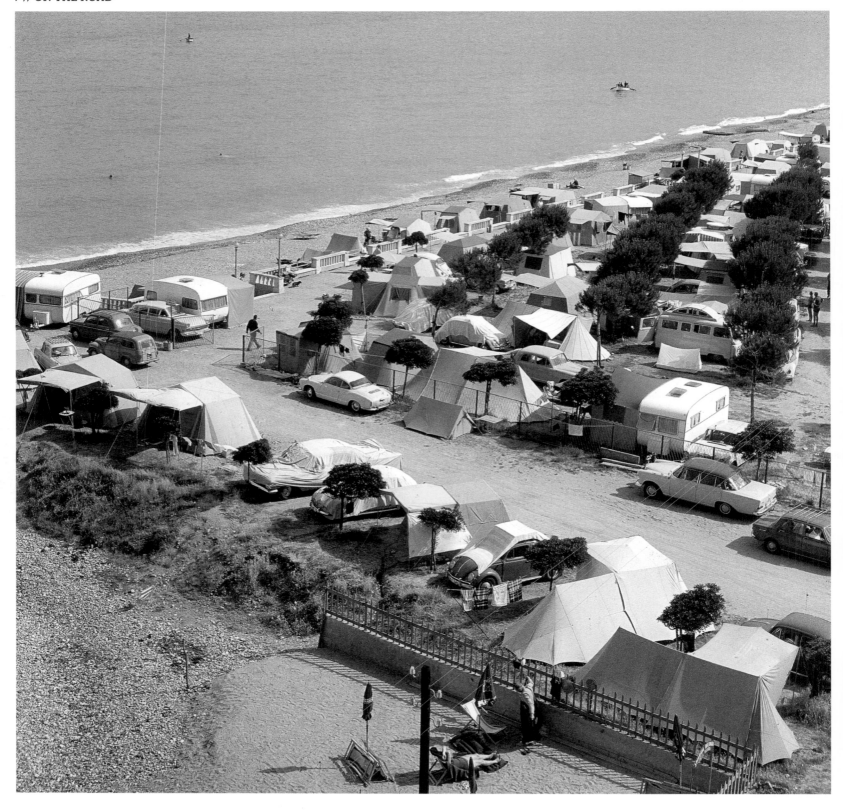

DRIVING TO THE BEACH

Previous pages: Traffic congestion on Daytona Beach, Florida, 1957.
Volkswagen Beetles on the Riviera. Above: A campground in Ceriale, Italy 1963.
Opposite: A narrow strip of sand along the esplanade in Juan-les-Pins, France, 1963.

AUTOSTRAND

Seite 216/217: Viel Verkehr in Daytona Beach, Florida, 1957
Mit dem VW Käfer an die Riviera. Oben: Ein Campingplatz im italienischen Ceriale, 1963;
rechts: Ein schmaler Sandstreifen an der Promenade des französischen Juan-les-Pins, 1963

LA PLAGE EN VOITURE

Pages 216-217 : jour d'affluence à Daytona Beach, en Floride, 1957
En VW Coccinelle, cap sur la Côte d'Azur. Ci-dessus : camping à Ceriale, en Italie, 1963 ;
ci-contre : une étroite bande de sable le long de la promenade du front de mer à Juan-les-Pins, 1963

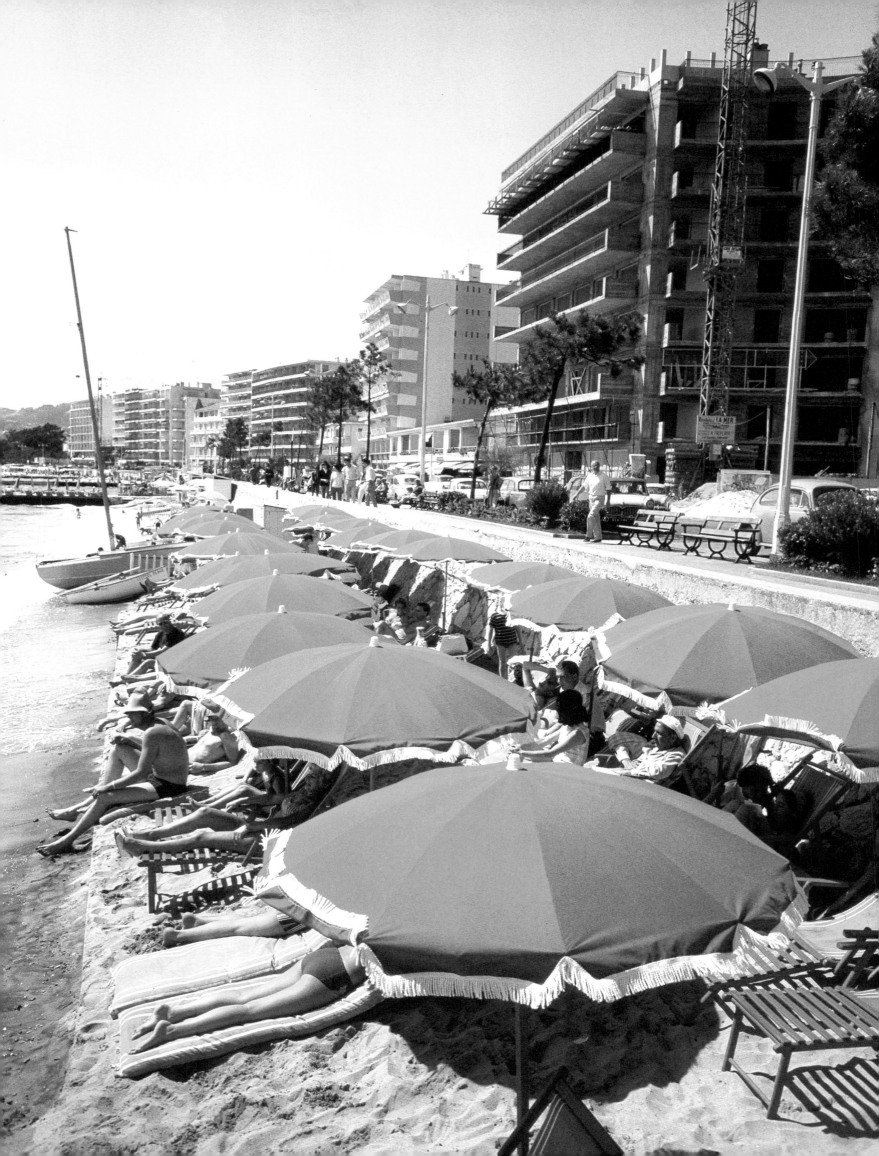

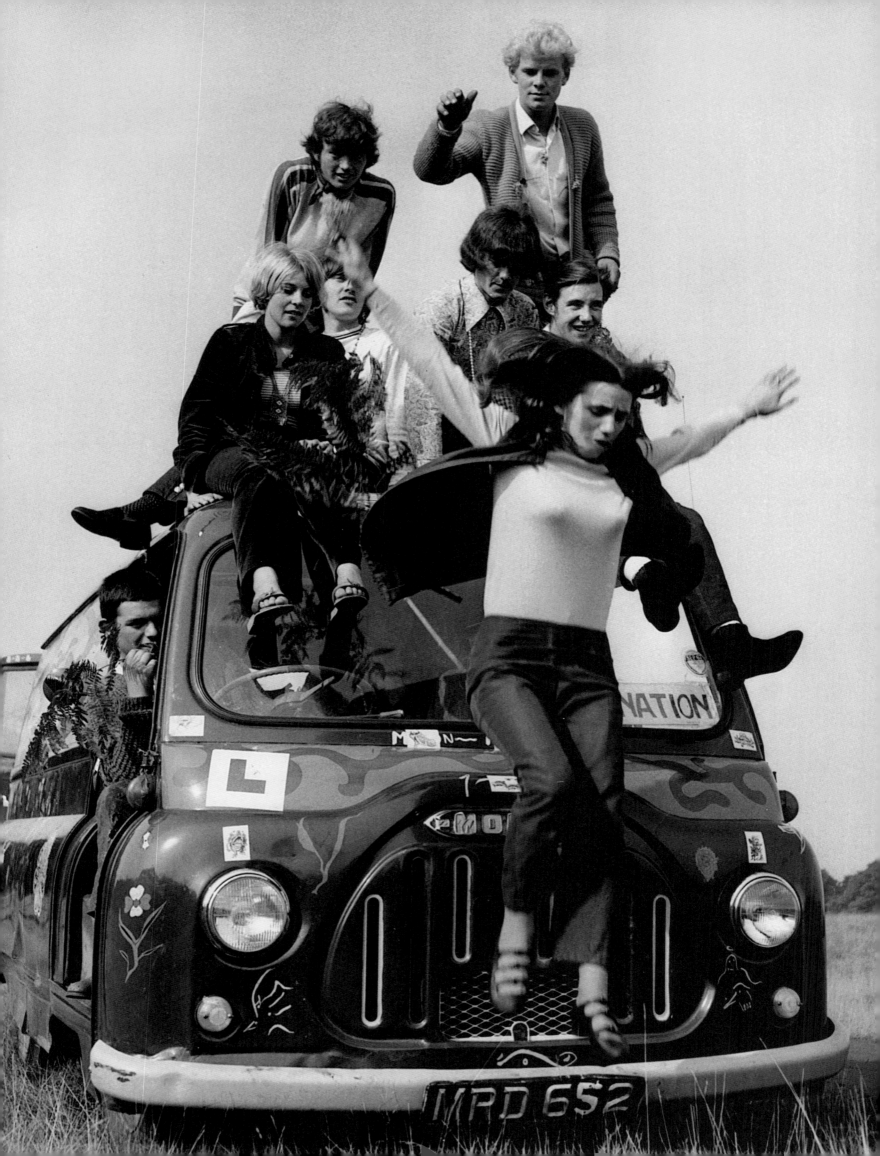

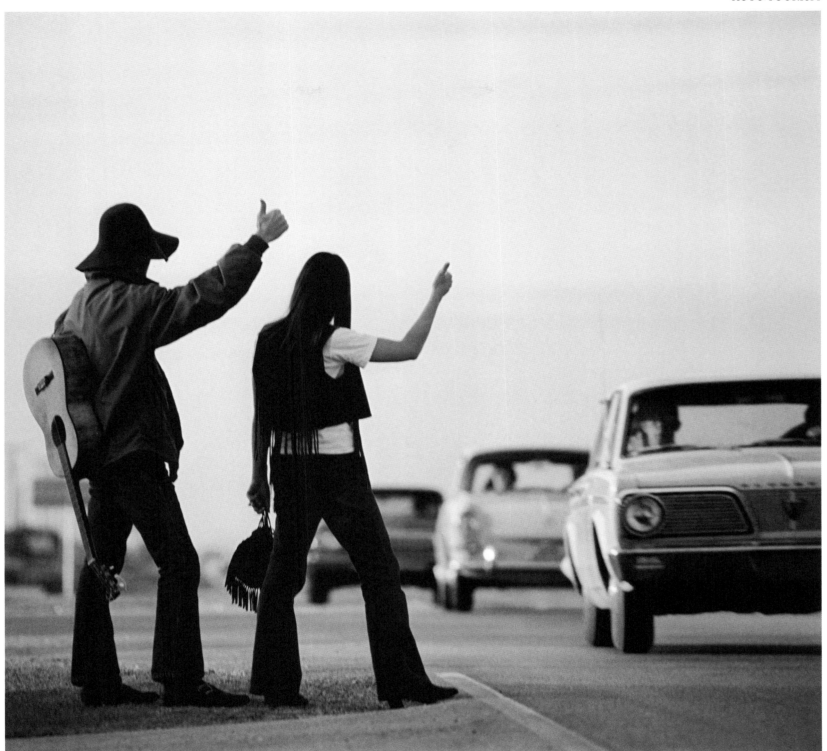

MAGIC BUS

Opposite: British hippies in and on a Morris J2 van, 1967.
Above: a couple hitchhiking on a highway, 1960s.

MAGIC BUS

Links: Britische Hippies in und auf einem Morris J2 Van, 1967;
oben: Ein Pärchen versucht, an einem Highway per Anhalter vorwärtszukommen, 1960er-Jahre

MAGIC BUS

Ci-contre : des hippies britanniques investissent un minibus Morris J2, 1967 ;
ci-dessus : au bord de la route, un jeune couple tente sa chance en stop, dans les années 1960

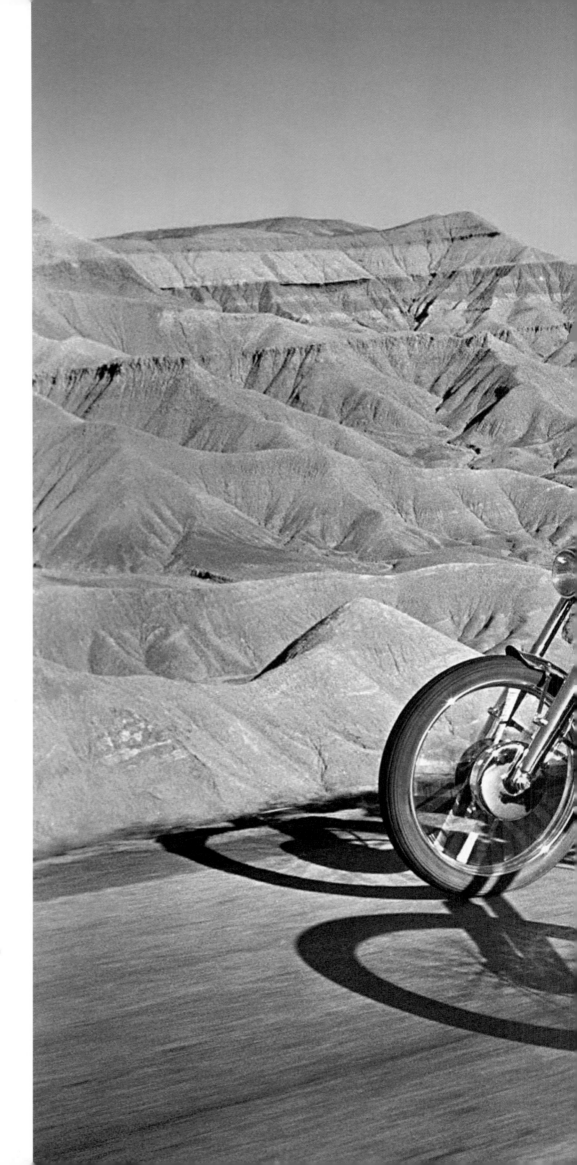

BORN TO BE WILD

The cult film for an entire generation. Dennis Hopper, Peter Fonda, and Luke Askew on their Harley Davidson choppers in *Easy Rider*, 1969.

BORN TO BE WILD

Kultfilm einer ganzen Generation. Dennis Hopper, Peter Fonda und Luke Askew auf ihren Harley-Davidson-Choppern in *Easy Rider*, 1969

BORN TO BE WILD

Un film culte pour toute une génération. Dennis Hopper, Peter Fonda et Luke Askew en choppers Harley Davidson dans *Easy Rider*, 1969

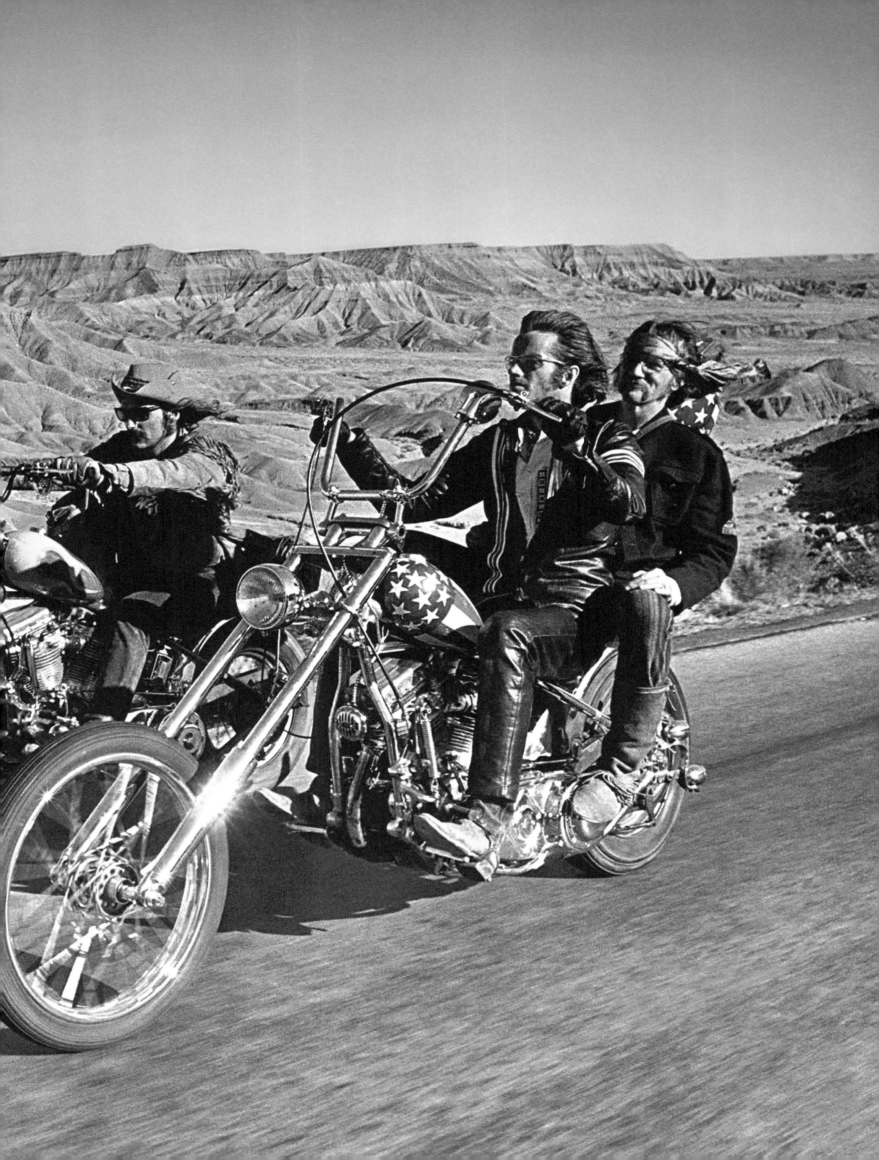

JUDGE

JANUARY 25, 1930 — PRICE 15 CENTS

THE RISING GENERATION

8

ABOVE THE CLOUDS

ÜBER DEN WOLKEN
PAR-DELÀ LES NUAGES

AIRLINES

The single-engine Junkers F 13 took flight for the first time in Dessau, Germany, on June 25, 1919. The first cantilever all-metal airliner in the world was also the ancestor of all passenger airplanes. Its creator, the visionary engineer and entrepreneur Hugo Junkers, wanted to peacefully unite the world's nations in the wake of the horrors of World War I—and he intended to do so by air.

The first nonstop transatlantic flight took place that same year. Eight years later, Charles Lindbergh became a star when he completed the first solo transatlantic flight. On May 20, 1927, the young U.S. Air Mail pilot set out from New York to Paris in the *Spirit of St. Louis*, inspiring commercial interest in air travel with his flight. Within just twenty-five years, aviation had transformed from the playground of a few eccentric adventurers into an industry of profit-oriented airline managers and aircraft manufacturers.

Numerous airlines were founded. Before long, passenger numbers shot up in Europe as well as in Asia, but particularly in North and South America. It didn't take long for aircraft manufacturers to realize that they needed to offer a certain level of comfort if they wanted to attract wealthy passengers. Airplanes became larger and more spacious, and passengers soon learned that airplanes offered comfortable seats and beds similar to those in luxury railway cars—along with the associated service. British Imperial Airways began flying with flight attendants in 1927, followed by Deutsche Lufthansa the year after. Similar to concierges and conductors, flight attendants were male in air travel's early days, but the first stewardess stepped on board in 1930. Her name was Ellen Church, an American pilot and nurse. In the bumpy early days of passenger flights, it was believed that female flight attendants would have a calming influence on passengers, and before long they became brand ambassadors for airlines and their uniforms emerged as fashion statements.

A decade after the first single-engine commercial aircraft had made their appearance, the elegant silver birds achieved hitherto unheard-of dimensions with regard to power, size, and comfort. Conceived by the German designer Claudius Dornier, the twelve-engine Do X accommodated sixty-six passengers. Guests relaxed in elegant chairs situated on fine Persian carpets, and while countries and oceans drifted past down below they dined on china that had been made specially for Do X. In the late 1920s, airlines also served warm meals that were heated in cramped galleys on board—yet not always with the most convincing results.

Hugo Junkers's four-engine G 38 even featured beds. However, it was the Ju 52 that achieved cult status. Possibly the most famous European passenger aircraft, nearly five thousand of these models were manufactured by 1952. Passengers loved "Iron Annie" for her high level of comfort, while operators valued its reliability and versatility.

During that same time period in the United States, aircraft manufacturers such as Donald Wills Douglas and William Edward Boeing were setting new standards. It was as if the huge continent had been created for aviation as the future's mode of transportation. The Douglas DC-3 first entered regular service in 1936; more than fifteen thousand models were manufactured. With its smooth and elegant streamlined body, it shaped the design of modern passenger aircraft—an aesthetic that carries over to this day.

The Boeing 314 was even bigger: a four-engine flying boat that was able to transport up to seventy-four passengers. As the Pan Am Clipper, the aircraft took twenty-four hours to travel from Southampton to New York. Overnight, the seats were converted into berths, and there were separate dressing rooms for men and women. Chefs from four-star restaurants were in charge of meals. Of course, this kind of trip came at a price to match: a ticket from New York to Southampton cost a hefty $675 in 1939—around $11,500 in today's currency. Passengers on the Boeing 314 Clipper included the Prime Minister of Great Britain, Winston Churchill, and the U.S. President Franklin D. Roosevelt.

Early aircraft manufacturers initially had to compete not only with railroads and shipping companies, but with an entirely different means of air travel: the zeppelin. In the mid-1930s, the two sister airships *Graf Zeppelin* and *Hindenburg* operated regular transatlantic flights from Germany to New York and Rio de Janeiro. A trip took about two-and-a-half days.

On the *Hindenburg*, seventy-two passengers could enjoy the journey on two decks, while a Blüthner grand piano featuring an aluminum frame adorned the lounge. The Empire State Building's spire was originally designed to serve as a mooring mast allowing passengers to exit the airship in the middle of New York City, but it was never actually used in that manner. The loss of the *Hindenburg* on May 6, 1937, at the landing site in Lakehurst, New Jersey, was the last in a series of airship crashes and brought the era of zeppelins to an early close.

Numerous airlines around the world, mostly small operations, began to consolidate early on until the large ones remained. The oldest airline still flying is the Dutch airline KLM, founded in 1919. Trans World Airlines (TWA) became the largest airline in the world, after the film producer and aviation pioneer Howard Hughes purchased it in 1939. After World War II, the airline entered the transatlantic business with a passenger airplane from the California manufacturer Lockheed; it was initially outfitted with forty seats. With a range of 3,400 miles on the North-Atlantic route, the Constellation and its Super Constellation and Starliner variants were able to fly at high altitudes above the weather and without refueling.

Pan American World Airways, Pan Am for short, became TWA's biggest rival in long-distance travel, as Pan Am was the first airline to operate a global network. The airline's logo shaped the image of aviation during the golden era of airlines. Pan Am was making its mark on the ground as well: opened in 1963, the Pan Am skyscraper situated on Fifth Avenue in New York eclipsed Grand Central Station.

The demand for airports that were both functional and attractive grew hand-in-hand

with the rising volume of passengers. The first airports were frequently a collection of wooden barracks and hangars surrounding a runway that was often not even paved. The construction of Berlin's Tempelhof Airport in 1936 resulted in the largest building complex in the world. After entering through huge neoclassical halls and checking in, passengers could board without even getting wet thanks to a canopy-style roof that sheltered airplanes that were parked.

The optimistic postwar years are best represented by one of the most beautiful passenger terminals in the world, the TWA Flight Center in New York. Opened in 1962, Terminal 5 at the current John F. Kennedy Airport was designed by the Finnish architect Eero Saarinen. Two elegantly curved arches support a reinforced concrete ceiling, and together with large, angled glass walls, they are reminiscent of a bird's wings.

than 1,500 Boeing 747s have been built over the course of nearly fifty years. In the early Jumbo Jets, first-class passengers reached the upper deck via a spiral staircase, where they could visit the onboard bar and enjoy a drink while traveling at nearly the speed of sound over the North Atlantic before retiring to their beds.

There was only one further advance left to be made in commercial aviation: supersonic passenger flights. The Soviet Tupolev Tu-144 took off for the first time in 1968, followed by the Anglo-French Concorde in March 1969. Both aircraft flew at over twice the speed of sound, and only a small number of each was ever built. They were incredibly noisy and consumed absurdly high volumes of jet fuel. And although their flight operation was never cost effective, these supersonic aircraft were an important object of prestige in the

for very long: in 1996, the Concorde crossed the Atlantic from London to New York in less than three hours. That record still stands to this day.

Luxury air travel is still alive and well. The lounges, first-class amenities, and top-notch service on board are still a fixed part of the portfolio for every frequent flyer program. Flying ceased to be a privilege a long time ago; for a growing number of people, it's become as much a part of their daily routine as driving a car or taking the train.

Since commercial tourism first took root around two hundred years ago, the world has experienced a plethora of revolutionary developments. The global population has grown sevenfold since 1800. Where it once took months to travel to certain destinations, today we can reach those same places in just a few hours. In Europe, traveling to a neighboring country often represented a leap into the unknown. Yet today, we already know what to expect before we even embark on a trip.

Travel offerings are now as diverse as the requirements of tourists themselves, whether they want to spend a lot of money or very little, or are interested in all-inclusive trips or customized tours. Despite all that, the actual experience of traveling remains a personal one. And the force that drives us to set out to distant destinations remains the same: it's the desire to gather new impressions, to expand our personal horizons and experiences. Perhaps Goethe said it best: "For natures like mine [. . .] a journey is invaluable; it animates, instructs, and cultivates."

> **66 TO DESIGN A FLYING MACHINE IS NOTHING. TO BUILD ONE IS SOMETHING. BUT TO FLY ONE IS EVERYTHING 99**
> —FERDINAND FERBER, 1898

1958 marked the beginning of the age of passenger jets with the Boeing 707, which was designed to carry around one hundred passengers, and the nearly identical Douglas DC-8. Flying became increasingly routine—fast, comfortable, usually unaffected by weather, and increasingly safe. Commercial airlines finally gained the upper hand over ocean liners for transatlantic routes.

The wide-body Boeing 747, justifiably nicknamed "Jumbo Jet," opened up an entirely new dimension in 1969. The four hundred–ton airliner accommodated up to more than five hundred passengers. It remained the largest passenger aircraft in the world until the advent of the Airbus A380 super airliner with seating for eight hundred fifty in 2005. More

race between political systems. Both models entered commercial service in the mid-1970s. "Breakfast in London, Lunch in New York—Baggage in Rio" was a parody of the slogan used by British Airways to advertise its supersonic service.

Those who flew on the Concorde definitely belonged to an elite class of travelers. Before the Concorde ceased operation in 2003, a round-trip London–New York ticket cost around £4,000, and a Paris–New York ticket was just under €9,000. The cabin interior for roughly one hundred passengers was relatively Spartan, featuring a center aisle with rows of two seats on either side. On the other hand, passengers didn't need to stay seated

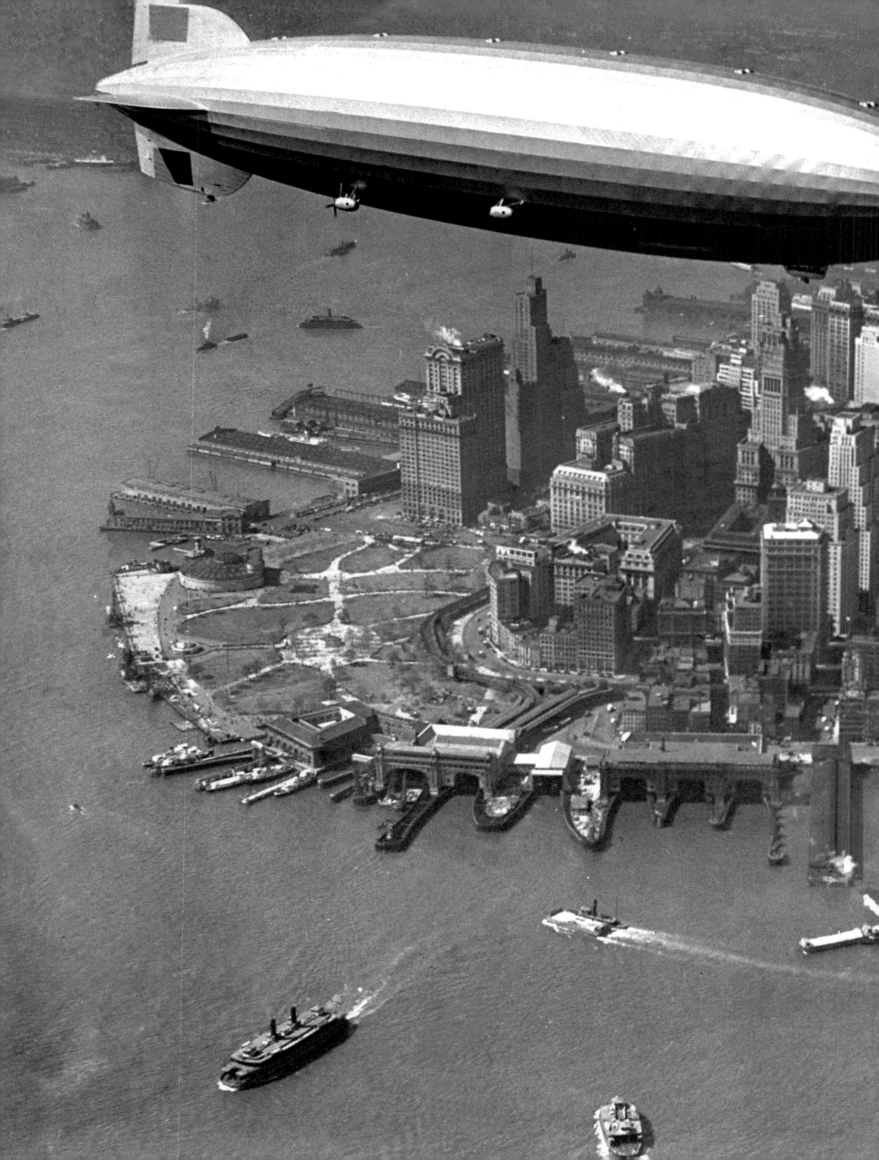

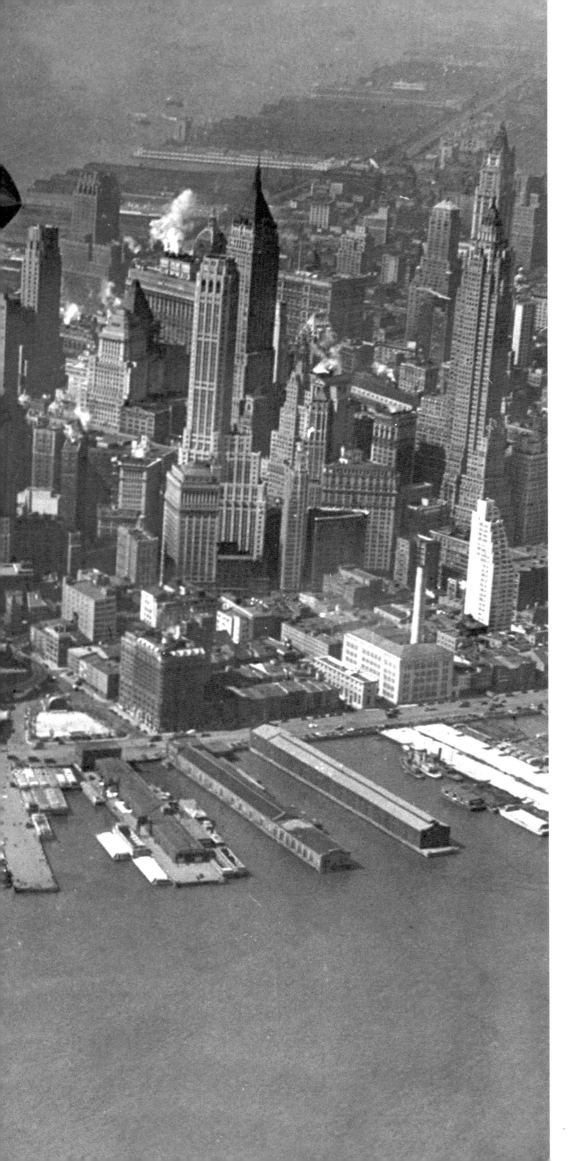

GIANT OF THE SKIES

The *Hindenburg* crossing the southern tip of Manhattan en route from Frankfurt am Main to New Jersey, 1936. The airship managed to complete ten trips on this route before crashing in May 1937.

GIGANT AM HIMMEL

Auf dem Weg von Frankfurt am Main nach New Jersey überquert die *Hindenburg* die Südspitze Manhattans, 1936. Zehn Fahrten auf dieser Strecke konnte das Luftschiff absolvieren, bis es im Mai 1937 verunglückte

GÉANTS DES AIRS

Au bout de son voyage entre Francfort-sur-le-Main et le New Jersey, le *Hindenburg* survole la pointe sud de Manhattan, 1936. Le dirigeable effectuera ce voyage à dix reprises avant de s'écraser en flammes, en mai 1937

FLUGLINIEN

Am 25. Juni 1919 hob die einmotorige Junkers F 13 erstmals in Dessau ab. Der erste selbsttragende Ganzmetall-Airliner der Welt war der Urahn aller Passagiermaschinen. Ihr Schöpfer, der visionäre Ingenieur und Unternehmer Hugo Junkers, wollte nach den schrecklichen Erfahrungen des Ersten Weltkriegs die Nationen der Welt friedlich miteinander verbinden – auf dem Luftweg.

Im gleichen Jahr gelang der erste Nonstop-Atlantikflug und acht Jahre später wurde Charles Lindbergh zum Star, als er die Strecke als Erster allein bewältigte. Am 20. Mai 1927 brach der junge Postflieger mit der *Spirit of St. Louis* von New York nach Paris auf und beflügelte auch das kommerzielle Interesse an Luftreisen. Innerhalb eines Vierteljahrhunderts war die Fliegerei vom Tummelplatz einiger exzentrischer Abenteurer zum Geschäftsfeld gewinnorientierter Linienmanager und Flugzeugbauer geworden.

Zahlreiche Luftfahrtgesellschaften wurden gegründet. Schon bald schossen die Passagierzahlen nicht nur in Europa, sondern auch in Asien, vor allem aber in Nord- und Südamerika in die Höhe. Die Flugzeughersteller hatten schnell erkannt, dass sie zahlungskräftige Passagiere mit einem gewissen Komfort an Bord locken mussten. Die Flugzeuge wurden größer und geräumiger, und Passagiere fanden darin bald ähnlich bequeme Sitze und Betten vor wie in den Luxuswaggons der Eisenbahn, einschließlich dazugehörigem Service. Ab 1927 flog die britische Imperial Airways, im Jahr darauf die Lufthansa mit Flugbegleitern. Wie Portiers und Schaffner waren Flugbegleiter zuerst männlich, aber bereits 1930 war mit der amerikanischen Pilotin und Krankenschwester Ellen Church die erste Stewardess mit an Bord. Weibliche Flugbegleiter sollten in den holprigen Anfangstagen der Luftpassagierfahrt einen beruhigenden Einfluss auf die Fluggäste ausüben. Sie wurden zu Markenbotschafterinnen der Airlines und ihre Uniformen zu Mode-Statements.

Ein Jahrzehnt nach den ersten einmotorigen Verkehrsflugzeugen erreichten die eleganten Silbervögel bisher ungeahnte Dimensionen in puncto Leistung, Größe und Komfort. In der zwölfmotorigen Do X des deutschen Konstrukteurs Claudius Dornier konnten 66 Passagiere in eleganten Sesseln auf edlen Perserteppichen von eigens gefertigtem Do-X-Porzellan speisen, während Länder und Meere unter ihnen dahinglitten. Ab dem Ende der 1920er-Jahre servierten die Fluglinien auch warme Mahlzeiten, die in beengten Bordküchen aufgewärmt wurden – nicht immer mit überzeugenden Ergebnissen.

Hugo Junkers' viermotorige G 38 hatte bereits Betten an Bord. Kultstatus erreichte dann die Ju 52: Das vermutlich bekannteste europäische Verkehrsflugzeug wurde bis 1952 fast 5000-mal gefertigt. Bei den Passagieren war die „Tante Ju" wegen ihres hohen Komforts, bei den Betreibern wegen ihrer Zuverlässigkeit und Vielseitigkeit beliebt.

In den USA setzten in der gleichen Zeit Flugzeugbauer wie Donald Wills Douglas oder William Edward Boeing neue Standards. Der Riesenkontinent war wie geschaffen für den Luftverkehr als Fortbewegungsart der Zukunft. Die 1936 erstmals regulär eingesetzte und über 15 000-mal gebaute DC-3 prägte mit ihrer glatten, eleganten Stromlinienform das auch heute noch gültige Design moderner Verkehrsflugzeuge.

Noch größer war die Boeing 314, ein viermotoriges Flugboot, das bis zu 74 Passagiere transportieren konnte. Als Pan Am Clipper brauchte die Maschine 24 Stunden von Southampton nach New York. Über Nacht wurden die Sitze in Kojen umgebaut, für Männer und Frauen gab es getrennte Umkleiden. Köche aus Vier-Sterne-Hotels sorgten für das Essen an Bord. Eine solche Reise war entsprechend teuer: Das Ticket New York–Southampton kostete 1939 üppige 675 US-Dollar, nach heutigem Wert etwa 11 500 US-Dollar. Zu den Passagieren der Boeing 314 Clipper gehörten Großbritanniens Premier Winston Churchill und der amerikanische Präsident Franklin D. Roosevelt.

Die frühen Flugzeugbauer standen anfangs nicht nur in Konkurrenz zu Eisenbahn und Schifffahrt, sondern auch zu einem anderen Luftverkehrsmittel: dem Zeppelin. Mitte der 1930er-Jahre bedienten die beiden Schwesterschiffe *Graf Zeppelin* und *Hindenburg* die Atlantikrouten zwischen Deutschland und New York oder Rio de Janeiro im Linienbetrieb. Eine einfache Fahrt dauerte etwa zweieinhalb Tage.

Auf der *Hindenburg* konnten 72 Passagiere die Fahrt auf zwei Decks genießen, im Gesellschaftsraum gab es sogar einen Blüthner-Flügel mit Aluminiumrahmen. Die Spitze des Empire State Buildings wurde sogar mit einem Ankermast versehen, damit die Passagiere das Luftschiff mitten in der Stadt verlassen konnten. Benutzt wurde er allerdings nie. Der Verlust der *Hindenburg* am 6. Mai 1937 am Landeplatz Lakehurst in New Jersey war der letzte in einer ganzen Reihe von Luftschiffabstürzen und setzte dem Zeitalter der Zeppeline frühzeitig ein Ende.

Die vielen, meist kleinen Fluggesellschaften der Welt begannen sich schon früh zu konsolidieren, übrig blieben nur die großen. Die älteste Luftfahrtgesellschaft, die seit ihrer Gründung 1919 noch fliegt, ist die niederländische KLM. Zur größten Fluggesellschaft der Welt wurde die Trans World Airlines. 1939 kaufte der Filmproduzent und Luftfahrtpionier Howard Hughes die TWA; nach dem Zweiten Weltkrieg stieg die Fluglinie dann mit einem zunächst vierzigsitzigen Passagierflugzeug des kalifornischen Herstellers Lockheed in den Transatlantikverkehr ein. Die Constellation, mit ihren Varianten Super Constellation und Starliner, konnte mit einer Reichweite von 5 500 Kilometern auf der Nordatlantikroute in großer Höhe über dem Wetter fliegen, ohne zwischendurch tanken zu müssen.

Größter Konkurrent der TWA im Fernverkehr wurde die Pan American World Airways, kurz Pan Am, die als erste Fluggesellschaft ein weltumspannendes Streckennetz betrieb. Das Logo der Fluggesellschaft prägte das Bild des Fliegens im goldenen Zeitalter der Airlines. Und auch auf dem Boden setzte Pan Am Zeichen: Ihr 1963 eingeweihter Wolkenkratzer an der Fifth Avenue in New York stellt die Grand Central Station buchstäblich in den Schatten.

Durch die steigenden Passagierzahlen stieg auch die Nachfrage nach funktionalen und repräsentativen Flughäfen. Die ersten Flugplätze waren häufig eine Ansammlung von Holzbaracken und Flugzeughallen um eine Piste herum, die oft nicht einmal betoniert war. Mit dem Hauptstadtflughafen Tempelhof in Berlin entstand 1936 der größte Gebäudekomplex der Welt. Passagiere bestiegen hier nach der Abfertigung in riesigen, neoklassizistisch anmutenden Hallen trockenen Fußes ihre Flugzeuge, die auf dem Vorfeld unter Schleppdächern bereitstanden.

Für die optimistischen Nachkriegsjahre steht eines der schönsten Abfertigungsgebäude der Welt, das TWA Flight Center in New York. Das 1962 eingeweihte Terminal 5 auf dem heutigen Flughafen John F. Kennedy stammt von dem finnischen Architekten Eero Saarinen. Zwei elegant geschwungene Bögen tragen die

des Superairliners A380 von Airbus mit seinen bis zu 800 Sitzplätzen im Jahr 2005 das größte Passagierflugzeug der Welt. In bald 50 Jahren wurden über 1500 Exemplare der Boeing 747 gebaut. Die frühen „Jumbos" boten den Erste-Klasse-Passagieren im Oberdeck, das man über eine Wendeltreppe erreichen konnte, eine Bordbar, wo die Gäste bei nahezu Schallgeschwindigkeit einen Drink über dem Nordatlantik einnehmen konnten, bevor sie sich in ihre Betten legten.

Nun gab es nur noch eine weitere Steigerung in der Verkehrsluftfahrt: Passagierflüge mit Überschallgeschwindigkeit. Binnen weniger Wochen hoben erstmals Ende 1968 die sowjetische Tupolew Tu-144 und Anfang 1969 die französisch-britische Concorde ab. Beide Flugzeuge flogen bei zweifacher Schallgeschwindigkeit, wurden aber nur in geringen

in einer Reihe mit Mittelgang vergleichsweise spartanisch. Aber man musste ja auch nicht lange sitzen: Den Atlantik überquerte die Concorde 1996 von London nach New York in weniger als drei Stunden. Der Rekord wurde bis heute nicht eingestellt.

Luxusreisen in der Luft gibt es immer noch. Die Lounges, First-Class-Services und Komfort, Eleganz und Spitzenservice an Bord für Meilen-Millionäre sind immer noch fester Bestandteil im Portfolio jedes Vielfliegerprogramms. Fliegen selbst ist jedoch schon lange kein Privileg mehr, es gehört für immer mehr Menschen zum Alltag wie das Fahren mit der Bahn und dem Auto.

Seit der kommerzielle Tourismus vor etwa zweihundert Jahren seinen Anfang nahm, hat die Welt eine Fülle revolutionärer Entwicklungen durchlaufen. Die Weltbevölkerung hat sich gegenüber 1800 versiebenfacht. Orte, die früher viele Reisemonate entfernt waren, erreichen wir heute in wenigen Stunden. War eine Reise in europäische Nachbarländer ehemals oft ein Aufbruch ins Ungewisse, so wissen wir heute schon vor Reisebeginn, was auf uns zukommen wird.

> ## „ EIN FLUGZEUG ZU ERFINDEN, IST NICHTS. ES ZU BAUEN, EIN ANFANG. FLIEGEN, DAS IST ALLES "
>
> FERDINAND FERBER, 1898

Die Angebote sind heute so vielfältig wie die Ansprüche der Touristen: für wenig Geld oder viel, Pauschalreise oder individuell geplante Tour. Das eigentliche Erlebnis des Reisens jedoch ist und bleibt ein persönliches. Auch die Triebfeder, warum wir uns heute noch in die Ferne aufmachen, ist geblieben: Es ist die Lust auf neue Eindrücke, die Erweiterung des persönlichen Horizonts und der Erfahrung, oder aber, wie schon Goethe sagte: „Für Naturen wie die meine [...] ist eine Reise unschätzbar: sie belebt, berichtigt, belehrt und bildet."

Decke aus Spannbeton und erinnern zusammen mit den großen, geneigten Glasfronten an die Schwingen eines Vogels.

Mit der für etwa 100 Passagiere ausgelegten Boeing 707 und der fast baugleichen Douglas DC-8 begann 1958 das Zeitalter der Düsenpassagierflugzeuge. Fliegen wurde immer mehr zur Routine – schnell, bequem, überwiegend wetterunabhängig und zunehmend sicher. Nun übernahmen die Linienflugzeuge endgültig die Vorherrschaft über die Transatlantikrouten von den Ozeandampfern.

In eine neue Dimension stieß 1969 das Großraumflugzeug Boeing 747 vor, das nicht zu Unrecht den Namen „Jumbo-Jet" trägt. Je nach Ausstattung passen über 500 Passagiere in den 400-Tonnen-Flieger. Er war bis zum Start

Stückzahlen gebaut, machten einen Höllenlärm und brauchten aberwitzige Mengen von Kerosin. Wirtschaftlich war der Flugbetrieb jedenfalls nie, aber ein wichtiges Prestigeobjekt im Wettlauf der politischen Systeme. Den Linienflugbetrieb nahmen beide Flugzeuge Mitte der 1970er-Jahre auf. „Breakfast in London, Lunch in New York – Baggage in Rio" war eine Verballhornung des British-Airways-Slogans, mit dem die Gesellschaft ihre Überschallverbindungen bewarb.

Wer mit der Concorde flog, gehörte als Reisender definitiv zur Elite. Ein Hin- und Retourticket London–New York kostete vor dem Ende des Flugbetriebs 2003 etwa 4000 britische Pfund, Paris–New York knapp 9000 Euro. Dabei war die Kabinenausstattung für die etwa 100 Passagiere mit je zwei Sitzen

TRANSCONTINENTAL
Following pages: A Lockheed Constellation, the most advanced airplane of its age, en route from California to Washington, D.C., 1945.

TRANSCONTINENTAL
Seite 232/233: Eine Lockheed Constellation, das modernste Flugzeug seiner Zeit, auf dem Weg von Kalifornien nach Washington, D.C., 1945

TRANSCONTINENTAL
Pages 232-233 : le Constellation de Lockheed, l'avion le plus moderne de son temps, quelque part entre la Californie et Washington DC. 1945

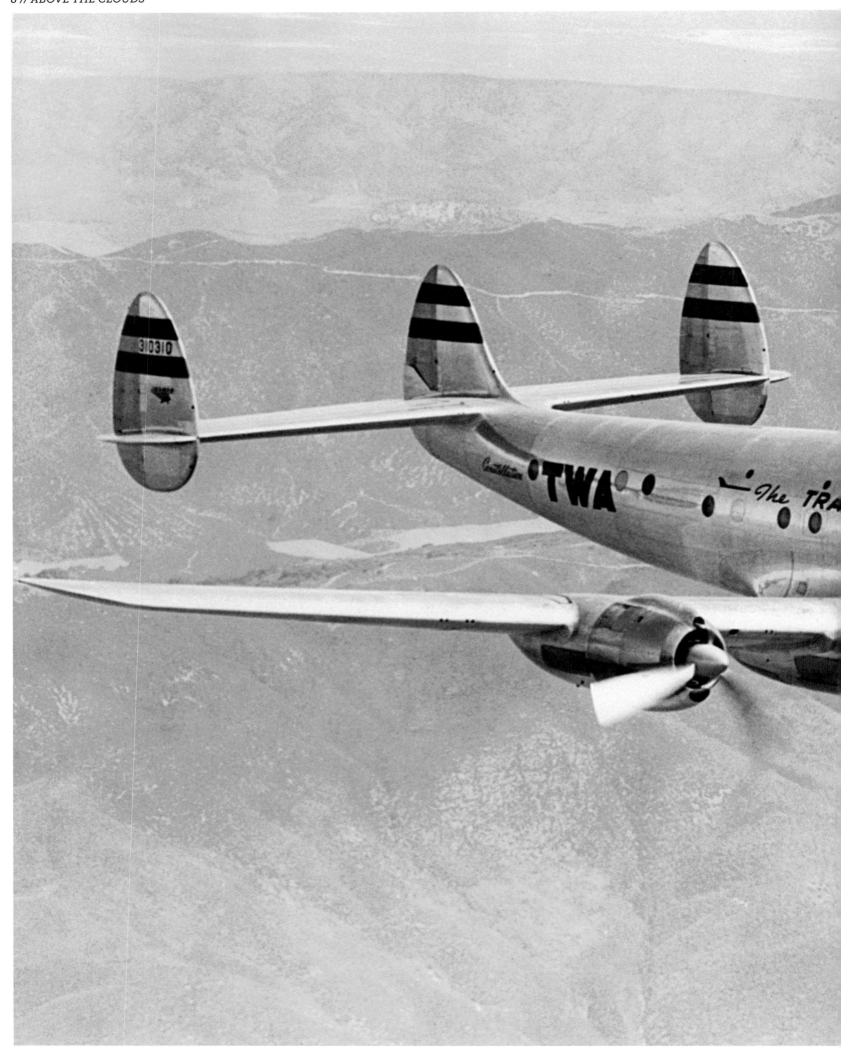

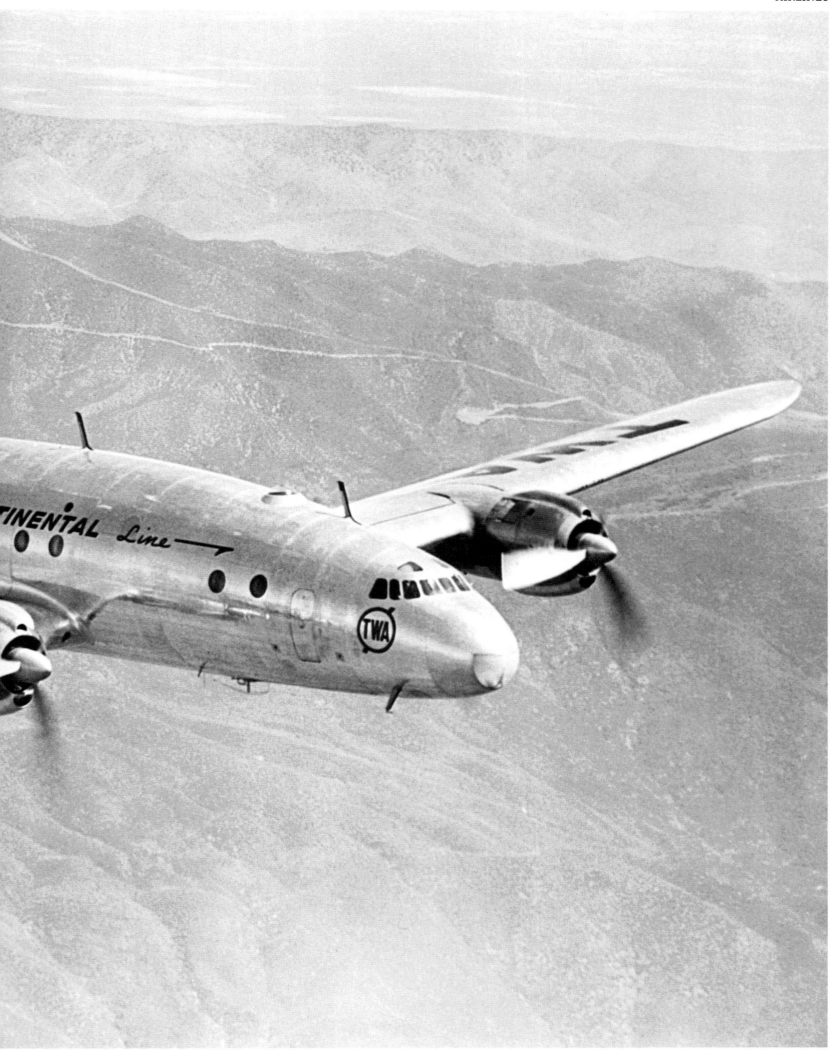

L'AVIATION DE LIGNE

Le 25 juin 1919, le monomoteur Junkers F 13 prend son envol à Dessau, en Allemagne. Cet appareil autoportant entièrement métallique, le premier au monde, est l'ancêtre de tous les avions de passagers. Après les horreurs de la Première Guerre mondiale, son créateur, l'ingénieur et visionnaire allemand Hugo Junkers, rêve de rapprocher les nations dans la paix – et en traversant les airs.

Cette année-là est aussi celle du premier vol transatlantique sans escale. Huit ans plus tard, Charles Lindbergh réalise cette même traversée en solitaire – il entre dans la légende. Le 20 mai 1927, le jeune pilote de l'aéronavale relie New York à Paris à bord du *Spirit of St. Louis*. Dès lors, l'exploitation commerciale du transport aérien devient une perspective prometteuse. En un quart de siècle, ce qui n'était que le terrain de jeu d'une poignée d'aventuriers excentriques deviendra un secteur d'activités juteux pour les exploitants de lignes commerciales et les constructeurs d'avions.

Une myriade de compagnies aériennes éclosent. Le nombre des passagers explose en Europe, mais aussi en Asie, et surtout en Amérique du Nord et du Sud. Très vite, les constructeurs comprennent qu'un certain standing à bord s'impose pour s'adapter aux passagers à la bourse bien garnie. Les avions se font plus grands, plus spacieux, et se dotent bientôt des mêmes couchettes et sièges moelleux que les trains de luxe, assortis d'un service à l'avenant. Dès 1927, l'Imperial Airways britannique engage du personnel de bord, suivie, un an plus tard, par la Deutsche Lufthansa. Comme les concierges d'hôtel et les contrôleurs de train, les premiers navigants sont des hommes. Puis en 1930, l'infirmière et pilote américaine Ellen Church s'impose comme hôtesse de l'air. Le personnel féminin, dit-on alors, a un effet plus apaisant sur les passagers en cas de vol un peu agité, ce qui est fréquent aux débuts de l'aviation commerciale. Les hôtesses deviennent les ambassadrices de leur compagnie, et leur uniforme crée la tendance.

Dix ans après les premiers monomoteurs dédiés au transport de passagers, d'élégants aéroplanes au fuselage argenté atteignent des sommets en matière de confort, de taille et de performance. Propulsé par 12 moteurs, le Do X du constructeur allemand Claudius Dornier emporte par-delà les mers et les continents 66 passagers confortablement installés dans d'élégants fauteuils, parmi les tapis persans, qui dégustent un dîner servi dans de la porcelaine de fabrication spéciale. Dès la fin des années 1920, les compagnies aériennes équipent leurs appareils de mini-cuisines de bord afin de proposer des repas chauds – avec un succès parfois mitigé.

Pour son quadrimoteur G 38, l'Allemand Hugo Junkers a déjà prévu des couchettes à bord. Puis vient le mythique Ju 52, probablement le plus connu des avions de transport européens. Entre 1932 et 1952, celui que l'on surnomme « Tante Ju » est construit à près de 5 000 exemplaires. Les passagers apprécient son confort, tandis que les exploitants se reposent sur sa fiabilité et sa polyvalence.

Dans le même temps, les constructeurs aéronautiques américains, comme Donald Wills Douglas ou William Edward Boeing, placent la barre encore plus haut. L'immense continent semble taillé pour que l'avion y devienne le mode de transport de l'avenir. Mis en service sur les lignes régulières dès 1936, le Douglas DC-3 sera construit à plus de 15 000 exemplaires. Son élégante silhouette, épurée et aérodynamique, inaugure un design qui reste, aujourd'hui encore, celui des avions modernes.

Encore plus grand, le Boeing 314 est un quadrimoteur de 74 places. Devenu le *Clipper* de la Pan Am, il relie Southampton à New York en vingt-quatre heures. Les sièges se convertissent en couchettes, et hommes et femmes peuvent se préparer à la nuit dans des vestiaires séparés. Les repas servis à bord sont concoctés par des cuisiniers recrutés dans les hôtels quatre étoiles. Le prix du voyage est à la hauteur des prestations : en 1939, un New York-Southampton coûte la somme rondelette de 675 dollars, soit quelque 11 500 dollars actuels. Le Premier ministre britannique Winston Churchill et le président américain Franklin D. Roosevelt comptent parmi les habitués du clipper de Boeing.

Les premiers constructeurs aéronautiques se posent en concurrents du chemin de fer et des paquebots transatlantiques, mais ils doivent aussi compter avec un autre moyen de transport aérien : le dirigeable, ou zeppelin, d'après le nom de son inventeur allemand. Au milieu des années 1930, les deux dirigeables *Graf Zeppelin* et *Hindenburg* relient Allemagne à New York et Río de Janeiro en deux jours et demi environ.

À bord du *Hindenburg*, les 72 passagers disposent de deux ponts superposés et, entre autres, d'un salon équipé d'un piano à queue à cadre en aluminium conçu par Blüthner. La flèche de l'Empire State Building est même équipée d'un mât d'amarrage, afin que les passagers puissent débarquer en plein cœur de New York, mais il ne servira jamais. La perte du *Hindenburg*, le 6 mai 1937, lors de son atterrissage à Lakehurst, dans le New Jersey, sera le dernier d'une longue série d'accidents et mettra un terme à la courte épopée du dirigeable.

Les nombreuses sociétés aériennes, souvent modestes, qui ont éclos un peu partout commencent à voir plus grand – seules les plus solides resteront. Fondée en 1919, la néerlandaise KLM deviendra la plus ancienne de toutes ; elle est encore en exploitation aujourd'hui. La Trans World Airlines, elle, sera la plus grande compagnie du monde. Rachetée en 1939 par le producteur de cinéma et pionnier de l'aviation Howard Hughes, TWA se lance dans le transport transatlantique après la Seconde Guerre mondiale avec, dans un premier temps, un avion de quarante places du constructeur californien Lockheed. Disposant d'une portée de 5 500 kilomètres, le Constellation, puis ses variantes Super Constellation et Starliner, peuvent prendre la route de l'Atlantique Nord à haute altitude, au-dessus des intempéries, sans devoir faire escale pour reconstituer leurs réserves de carburant.

Principal concurrent de la TWA sur les long-courriers, la Pan American World Airways, ou Pan Am, est la première compagnie à couvrir le monde entier. Son logo reste à jamais gravé dans les esprits et appartient à l'imagerie de l'aéronautique civile à l'âge d'or des grandes compagnies. Au sol aussi,

elle laisse une marque indélébile : inauguré en 1963, le gratte-ciel de la Pan Am, sur la 5ᵉ avenue, fait encore de l'ombre à la Grand Central Station de New York.

Pour accueillir la foule croissante des passagers, il faut désormais des aéroports fonctionnels et de standing. Les premiers aérodromes se réduisent à une poignée de baraques en bois et de hangars autour d'une piste qui, souvent, n'est même pas bétonnée. En 1936, l'aéroport de Tempelhof, à Berlin, devient le plus grand complexe de bâtiments du monde. Les passagers y enregistrent dans d'immenses halls accueillants de style néoclassique, pour embarquer directement dans les avions positionnés sur les aires de stationnement abritées sous une avancée du toit.
Emblématique de l'optimisme de l'après-

En 1969, le Boeing 747, surnommé à juste titre « Jumbo Jet », projette l'aviation civile dans une nouvelle dimension. Ce gros-porteur de 400 tonnes peut embarquer plus de 500 passagers. Il restera le plus grand avion du monde jusqu'en 2005 et la mise en service de l'A380 d'Airbus, avec ses 800 places. En près de cinquante ans, plus de 1 500 « jumbos » ont été mis en circulation. Dans les premiers 747, les passagers de première classe disposent d'un bar sur le pont supérieur, desservi par un escalier en colimaçon. Là, les privilégiés vont siroter un verre en survolant l'Atlantique Nord à la vitesse du son, ou presque, avant d'aller s'allonger sur leurs couchettes.
Et pourtant, le transport aérien civil a encore un pas à franchir, celui du vol supersonique. En l'espace de quelques semaines vont décoller pour la première fois le Tupolev soviétique Tu-144, fin 1968, et le Concorde

en 2003, il faut débourser environ 4 000 livres pour un aller-retour Londres-New York, alors qu'un aller-retour Paris-New York coûte presque 9 000 euros… Et pourtant, l'aménagement intérieur est relativement spartiate : il se réduit à deux rangées de deux sièges de part et d'autre d'un couloir central pour 100 passagers. Heureusement, ils n'y sont pas immobilisés pour très longtemps : en 1996, le Concorde franchit l'Atlantique, entre Londres et New York, en moins de trois heures. Un record qui, aujourd'hui encore, reste inégalé.
Et le voyage aérien de luxe n'a pas dit son dernier mot. Les salons VIP, les prestations de première classe, ainsi que le confort, l'élégance et les services haut de gamme réservés aux *frequent flyers* millionnaires s'inscrivent encore dans les programmes de fidélité de toutes les compagnies. Mais l'avion en soi n'est plus un privilège depuis longtemps, qui fait désormais partie de notre quotidien, au même titre que la voiture.

« CONCEVOIR UNE MACHINE VOLANTE N'EST RIEN. LA CONSTRUIRE EST PEU. L'ESSAYER EST TOUT. »

FERDINAND FERBER, 1898

guerre, le TWA Flight Center, à New York, reste l'un des plus belles aérogares du monde. Inauguré en 1962, le terminal 5 de l'actuel aéroport John F. Kennedy est une réalisation de l'architecte finlandais Eero Saarinen. Son toit de béton précontraint décrit deux arcs à la courbe gracieuse ponctués de grandes façades de verre inclinées pour évoquer l'envol d'un oiseau.

En 1958, le Boeing 707, prévu pour une centaine de passagers, et son pendant chez Douglas, le DC-8, inaugurent l'ère des appareils de ligne à réaction. Le transport aérien entre dans les mœurs – rapide, confortable, le plus souvent indépendant des intempéries, et de plus en plus sûr. Dès lors, le bateau est définitivement évincé sur les itinéraires transatlantiques.

franco-britannique, début 1969. De l'un et l'autre, il n'existera jamais que quelques rares exemplaires. Pour atteindre une vitesse de croisière de deux fois la vitesse du son, ils font un bruit d'enfer et consomment une quantité astronomique de kérosène. Si leur exploitation commerciale ne sera jamais rentable, ils demeurent toutefois de forts symboles de prestige dans un contexte de concurrence entre systèmes politiques. Tous deux effectuent des vols réguliers à partir du milieu des années 1970. « Petit déjeuner à Londres, déjeuner à New York… et bagages à Río », dit-on pour se moquer du slogan publicitaire choisi par la British Airways pour vanter ses vols supersoniques.
Les passagers du Concorde font partie de l'élite des voyageurs. Avant que les supersoniques soient définitivement mis au rencard,

Depuis les premiers frémissements du tourisme commercial, voici environ deux siècles de cela, une succession de révolutions ont changé la face du monde. La population de la planète est aujourd'hui sept fois plus importante qu'en 1800. Les régions qui, naguère, n'étaient accessibles qu'au prix de longs mois de voyage, sont maintenant à notre portée en quelques heures. Hier encore, partir à la découverte d'un pays voisin, en Europe, était une véritable aventure en *terra incognita* ; aujourd'hui, avant même de partir, nous savons déjà ce que nous allons trouver au bout du chemin.
Les offres de voyages sont aussi variées que les exigences des touristes : forfait ou sur mesure, de luxe ou économique. Mais le regard de chacun sur son voyage est, et restera, une expérience très personnelle. Car les ressorts qui nous poussent vers d'autres horizons restent les mêmes : la recherche de nouvelles sensations, l'envie d'élargir nos perspectives et d'étoffer notre expérience, ou encore, comme le disait Goethe : « Pour des tempéraments comme le mien, un voyage est d'un prix incalculable […] : il anime, il redresse, il instruit et il forme. »

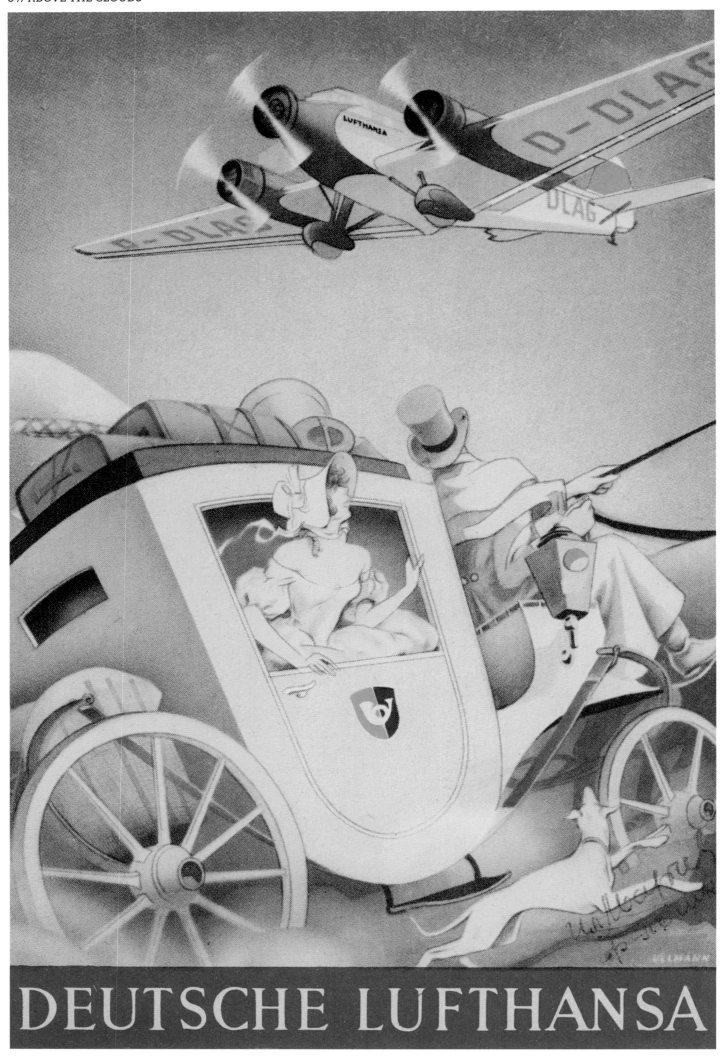

DEUTSCHE LUFTHANSA

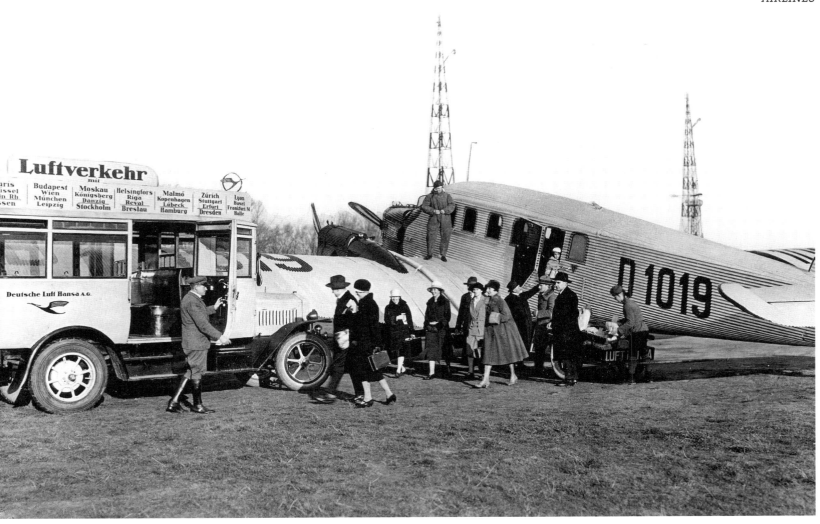

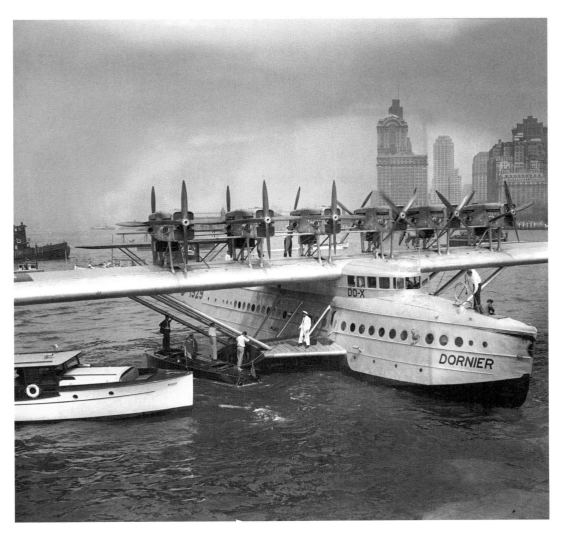

ON LAND, ON WATER, AND IN THE AIR

Opposite: Lufthansa poster depicting a
Junkers Ju 52, 1936.
Above: The passengers of a Junkers G 24 board
a bus heading downtown from Berlin's Tempelhof
Airport, 1928.
Below: The passengers of a Dornier Do X take
a boat shuttle in New York, 1931.

ZU LANDE, ZU WASSER UND IN DER LUFT

Links: Plakat der Deutschen Lufthansa mit einer
Junkers Ju 52, 1936;
Oben: Bustransfer vom Berliner Flughafen
Tempelhof in die Stadtmitte für die Passagiere
einer Junkers G 24, 1928; unten: Einen Boot-Shuttle
benötigten die Fluggäste einer Dornier Do X
in New York, 1931

SUR TERRE, SUR MER ET DANS LES AIRS

Ci-contre : affiche de la Lufthansa représentant
un Junkers Ju 52, 1936 ;
en haut : les passagers d'un Junkers G 24 sont
transférés en bus de l'aéroport berlinois de
Tempelhof jusqu'au centre-ville, 1928 ;
en bas : une navette maritime vient chercher
les passagers d'un Dornier Do X à New York, 1931

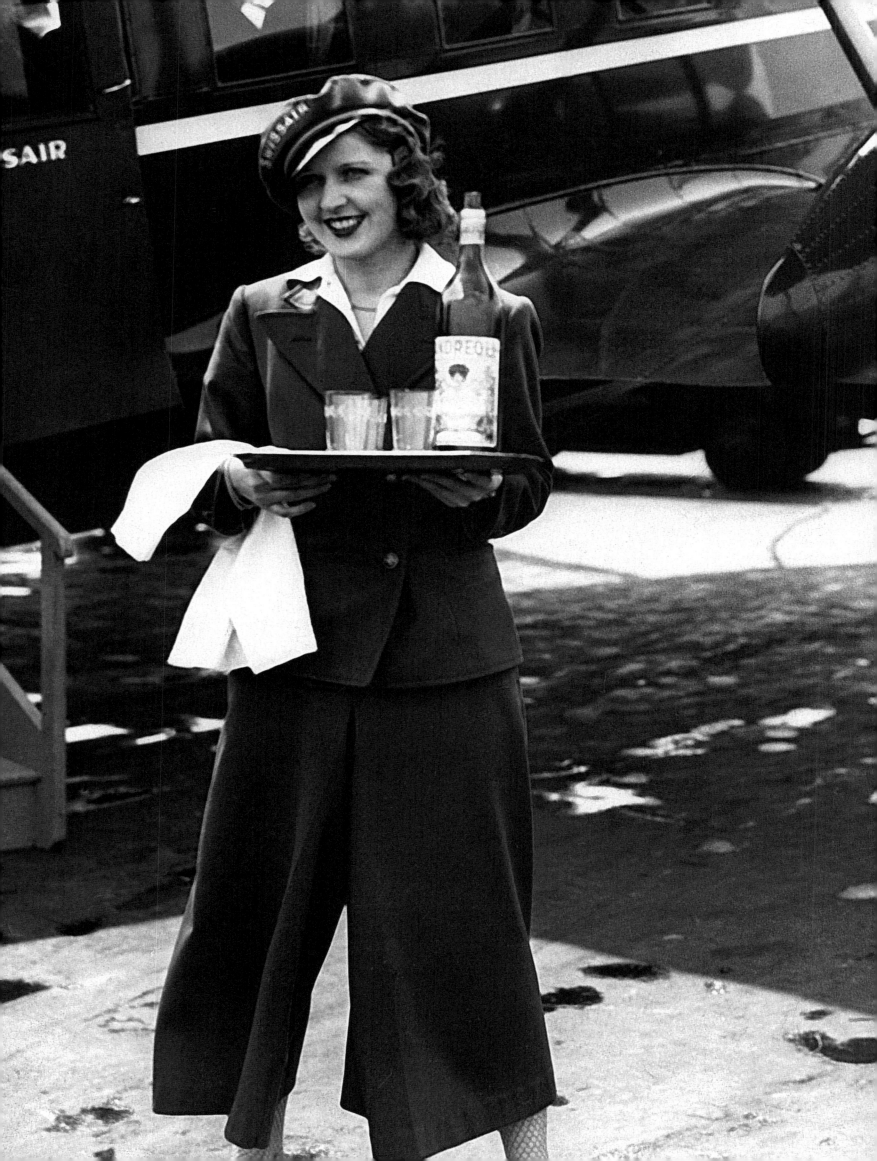

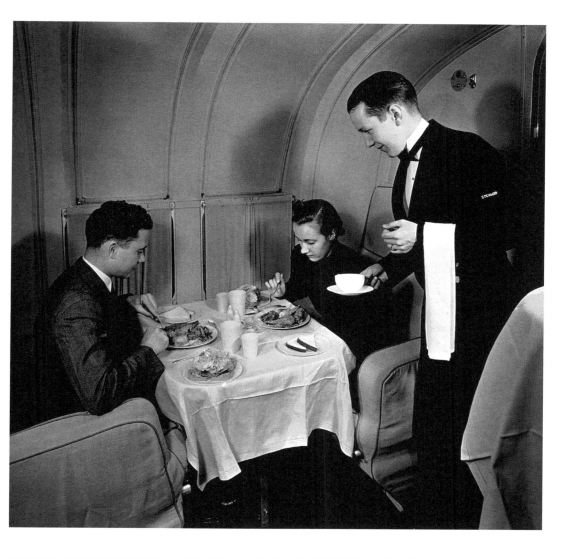

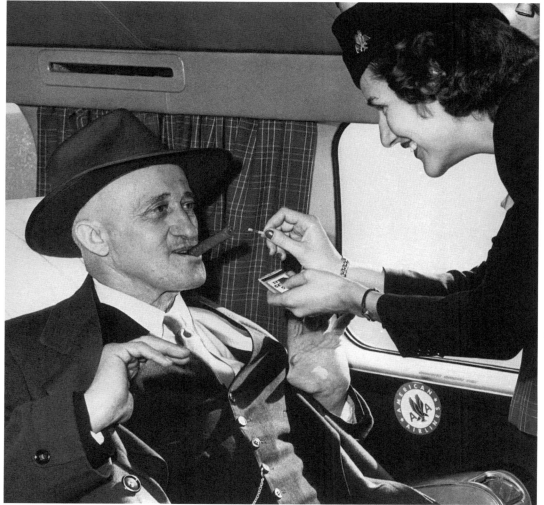

WINE, COFFEE, OR A CIGAR?

Opposite: Stewardess beside a Curtiss T-32 Condor
at the Tempelhof Airport in Berlin, 1934.
Swissair was the first European airline to hire
female flight attendants.
Above: Coffee with dinner in a Boeing 314
Pan American Clipper, circa 1936.
Below: A passenger has a stewardess light
his cigar on an American Airlines flight, 1949.

WEIN, KAFFEE ODER ZIGARRE?

Links: Stewardess vor einer Curtiss T-32 Condor
am Flughafen Tempelhof in Berlin, 1934.
Die Swissair setzte als erste europäische
Fluggesellschaft weibliche Flugbegleiter ein;
oben: Kaffee zum Dinner in einer Boeing 314
Pan American Clipper, um 1936;
unten: Ein Fluggast erhält Feuer von einer Stewardess
auf einem American-Airlines-Flug, 1949

VIN, CAFÉ OU CIGARE ?

Ci-contre : une hôtesse de l'air devant un T-32 Condor
de Curtiss à l'aéroport berlinois de Tempelhof, 1934.
La Swissair est la première compagnie européenne à
engager du personnel navigant féminin ;
en haut : un petit café après le repas à bord d'un
Boeing 314, le clipper de la Pan American, vers 1936 ;
en bas : une hôtesse allume le cigare d'un passager
sur un vol American Airlines, 1949

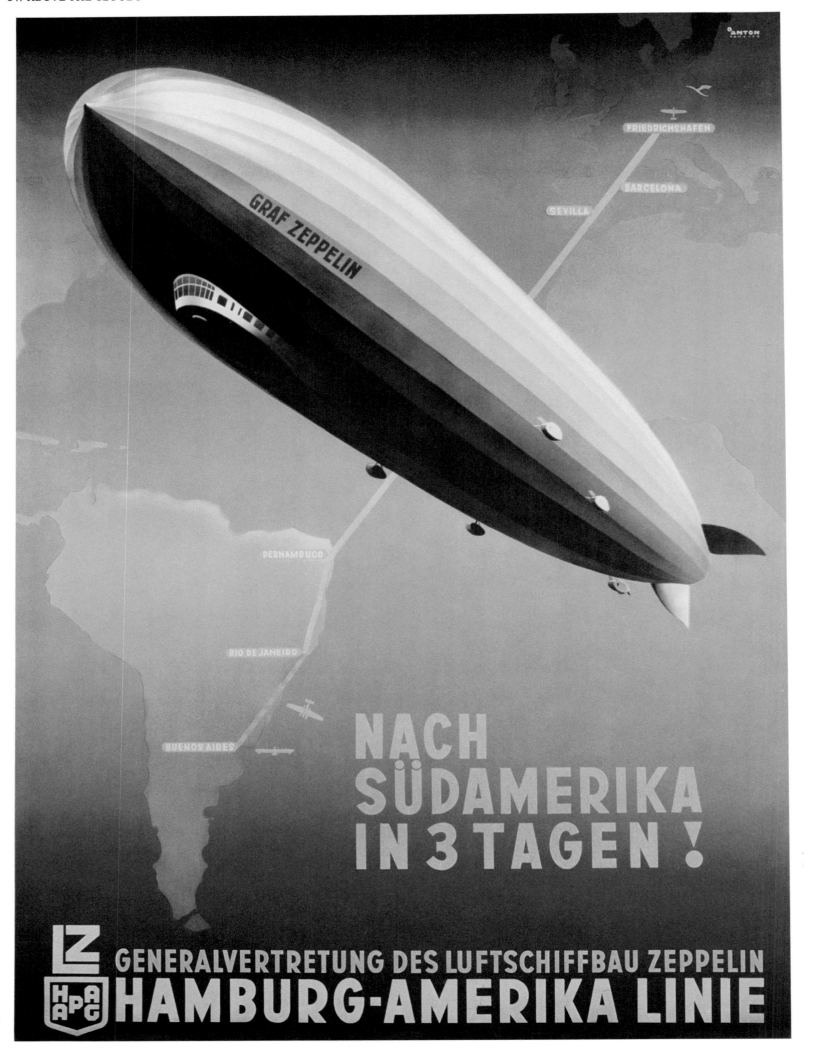

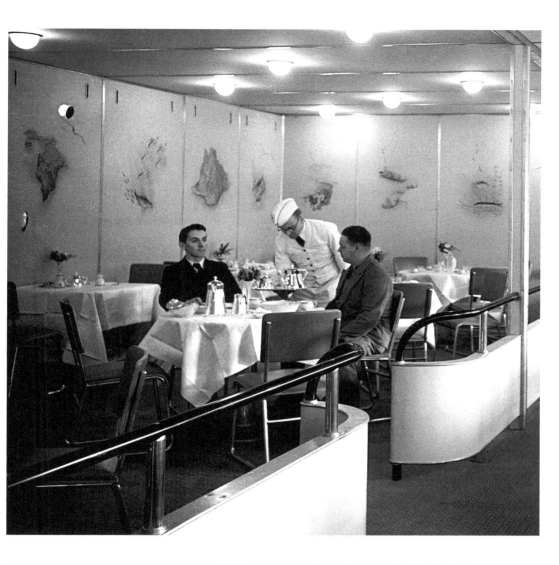

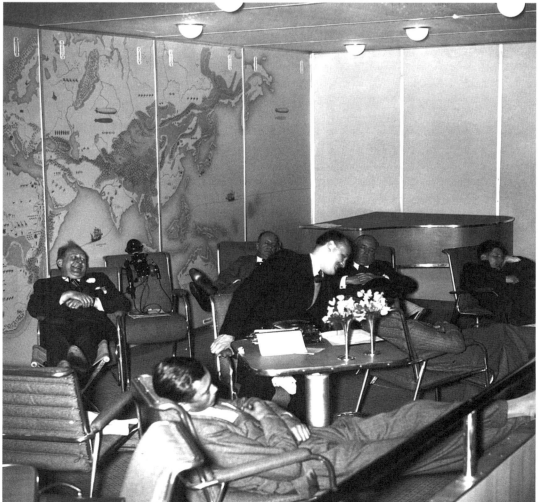

FLYING ON A ZEPPELIN

Opposite: A poster for the *Graf Zeppelin* advertises
a three-day flight from Friedrichshafen, Germany,
to Rio Janeiro, 1930s.
Above and below: Lunch and an afternoon nap
on board the *Hindenburg*, 1936.

UNTERWEGS MIT DEM ZEPPELIN

Links: Eine Reise in drei Tagen von Friedrichshafen
nach Rio de Janeiro verspricht ein Werbeplakat
für die *Graf Zeppelin*, 1930er-Jahre;
oben/unten: Mittagessen und Mittagsschlaf an Bord
der *Hindenburg*, 1936

À BORD D'UN DIRIGEABLE

Ci-contre : trois jours de voyage entre Friedrichshafen
et Rio de Janeiro – c'est ce que promet cette affiche
publicitaire pour le *Graf Zeppelin* dans les années 1930 ;
en haut, en bas : déjeuner et sieste à bord du
Hindenburg, 1936

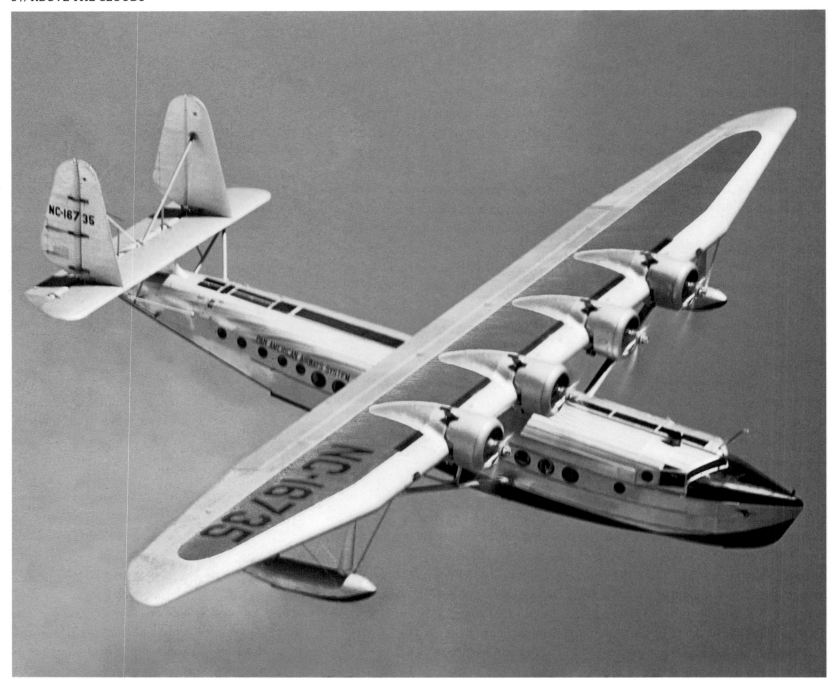

AMERICAN AIRCRAFT INGENUITY

Above: A Sikorsky S-42 Pan Am Bermuda Clipper, 1938.
Opposite: Two Douglas DC-3s at LaGuardia Airport in New York, 1941.
The DC-3 is still the most popular commercial airplane ever built,
with more than fifteen thousand models manufactured.

AMERIKANISCHE FLUGZEUGBAUKUNST

Oben: Eine Sikorsky S-42 Pan Am Bermuda Clipper, 1938;
rechts: Zwei Douglas DC-3 am New Yorker LaGuardia-Flughafen, 1941.
Die DC-3 ist bis heute mit über 15 000 gefertigten Exemplaren das
meistgebaute Verkehrsflugzeug

L'ART DE L'AÉRONAUTIQUE À L'AMÉRICAINE

Ci-dessus : le Sikorsky S-42 Pan Am Bermuda Clipper, 1938 ;
ci-contre : deux DC-3 de Douglas à l'aéroport de LaGuardia, à New York, 1941.
Construit à 15 000 exemplaires, le DC-3 reste l'avion de passagers le plus
fabriqué de tous les temps

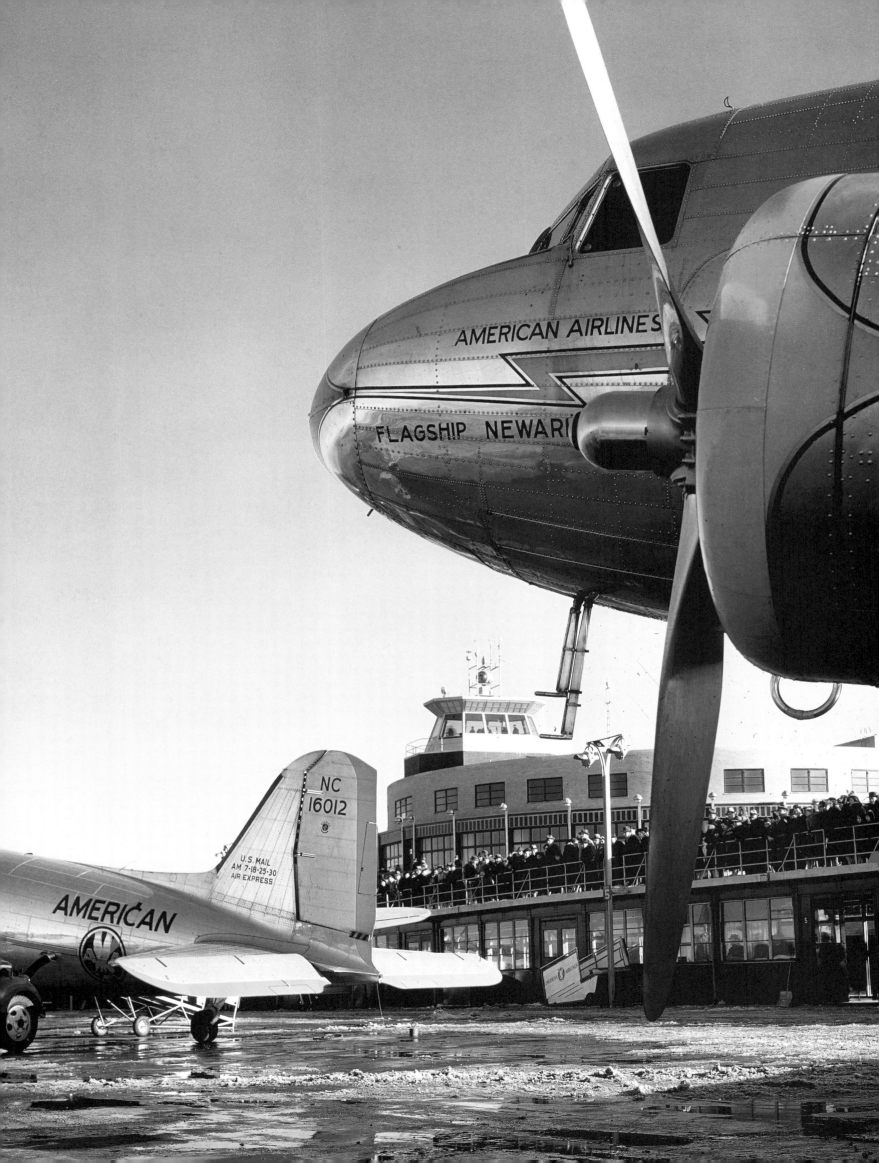

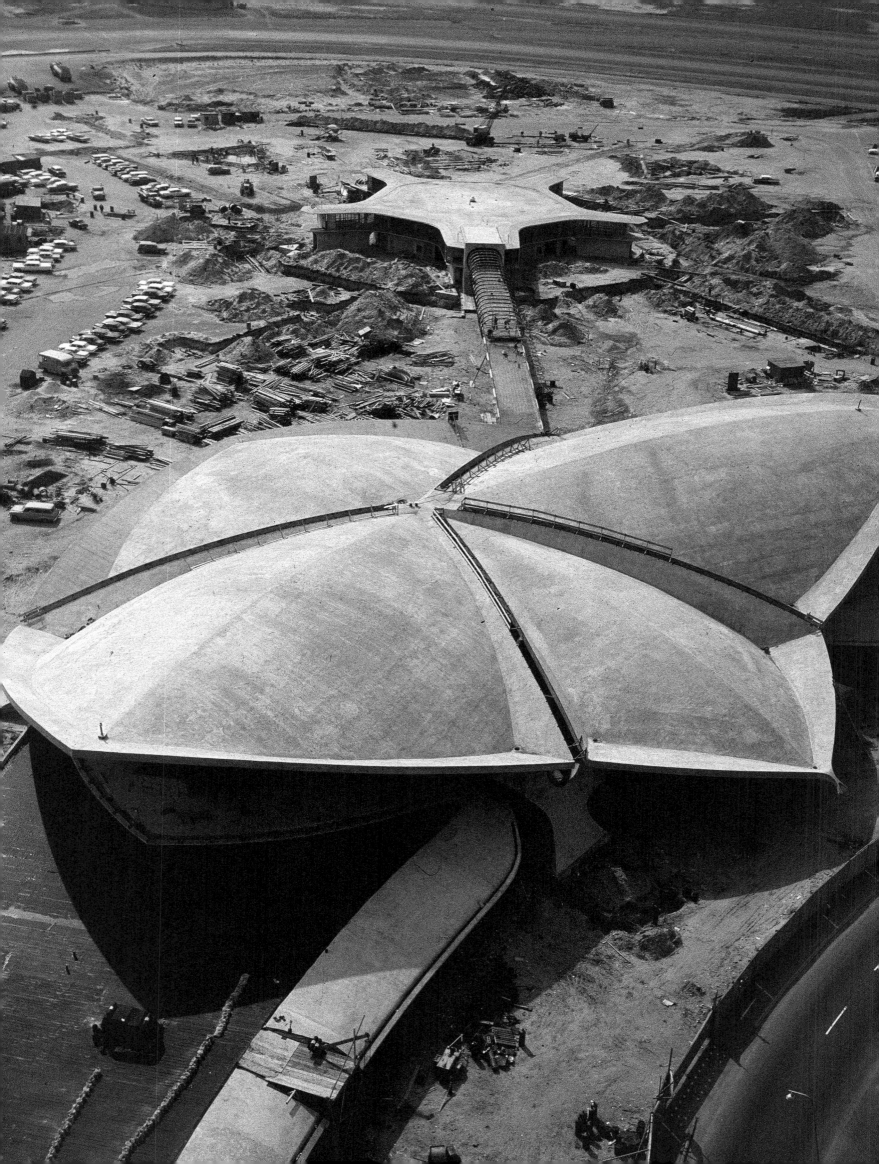

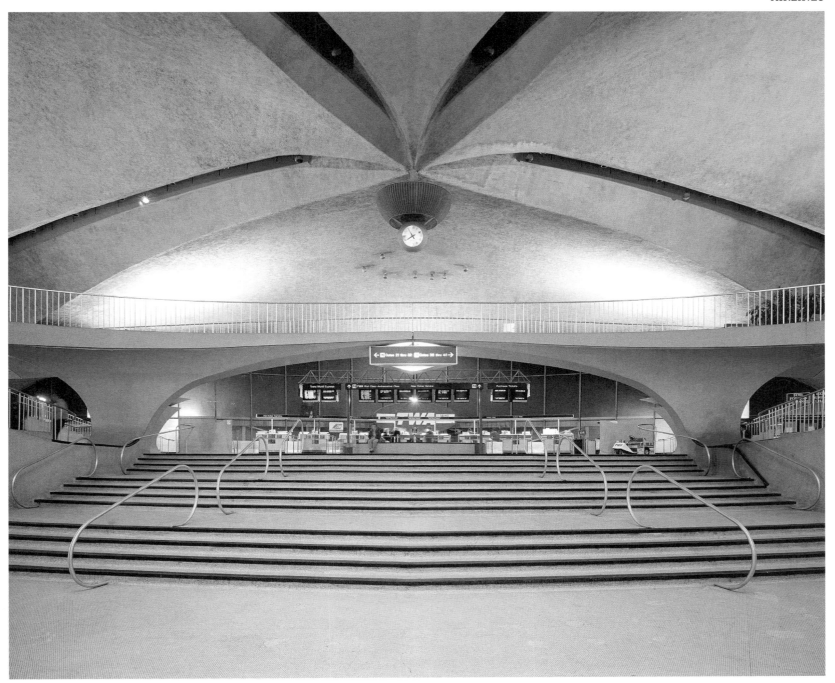

EUROPEAN IMPORTS

Opposite: Under construction. The TWA Flight Center designed by the Finnish architect Eero Saarinen; 1961.
Above: TWA ticket counters inside the terminal, 1962.
Following pages, from left: Poster for the Pan Am Building in New York, co-designed by Walter Gropius, 1960;
British invasion. The Beatles arrive in New York on their first American tour in a Pan Am airplane, 1964.
George Harrison shows his nonconformist side by carrying a bag with the British European Airways logo.

EUROPÄISCHE IMPORTE

Links: Das TWA Flight Center des finnischen Architekten Eero Saarinen im Bau, 1961;
oben: Halle mit TWA-Schaltern, 1962
Seite 246: Plakat für das New Yorker Pan Am Building, das von Walter Gropius mitentworfen wurde, 1960er-Jahre;
Seite 247: British Invasion. Mit einer Pan-Am-Maschine treffen die Beatles zu ihrer ersten Amerikatour in New York
ein, 1964. George Harrison tanzt mit seiner Tasche der British European Airways aus der Reihe

INFLUENCES EUROPÉENNES

Ci-contre : le Flight Center de la TWA conçu par l'architecte finlandais Eero Saarinen encore en chantier, 1961 ;
ci-dessus : le hall avec les comptoirs TWA, 1962
Page 246 : affiche représentant le gratte-ciel de la Pan Am à New York, un édifice signé, entre autres,
Walter Gropius, dans les années 1960
Page 247 : les Anglais débarquent. C'est à bord d'un appareil de la Pan Am que les Beatles entament leur première
tournée américaine à New York, 1964. George Harrison dénote avec son sac siglé de la British European Airways

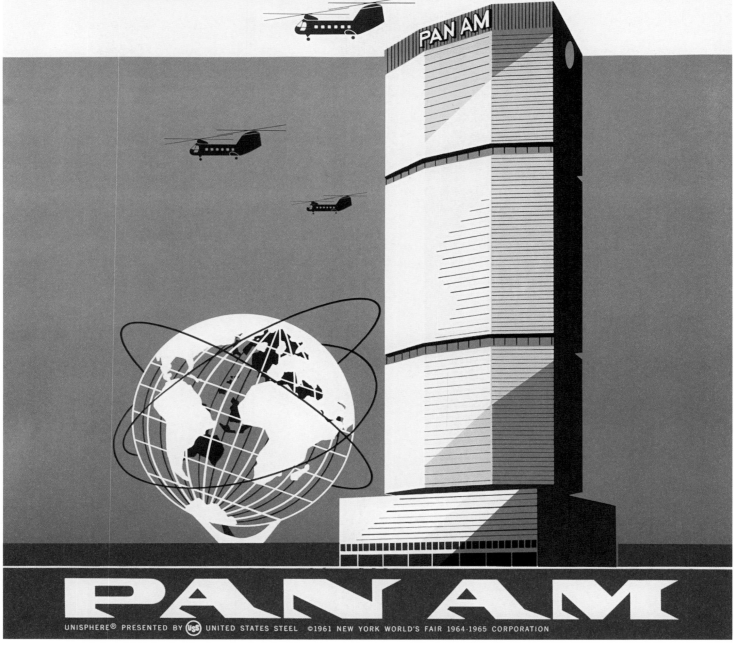

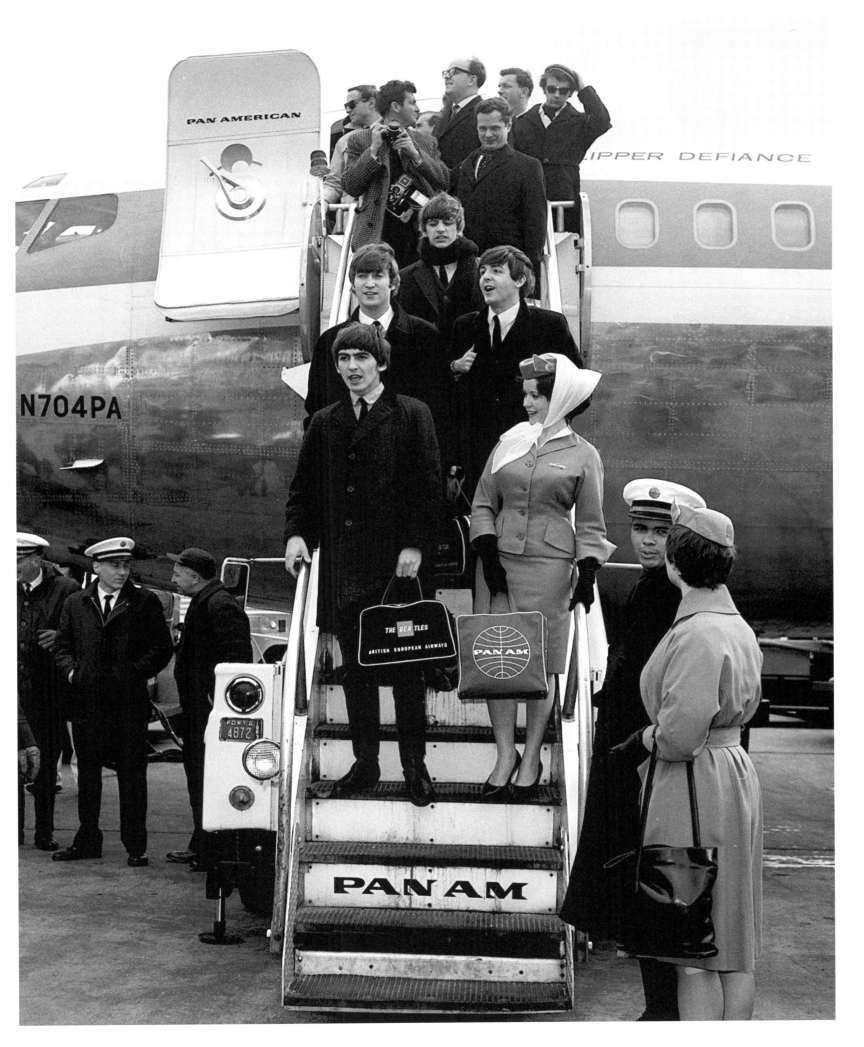

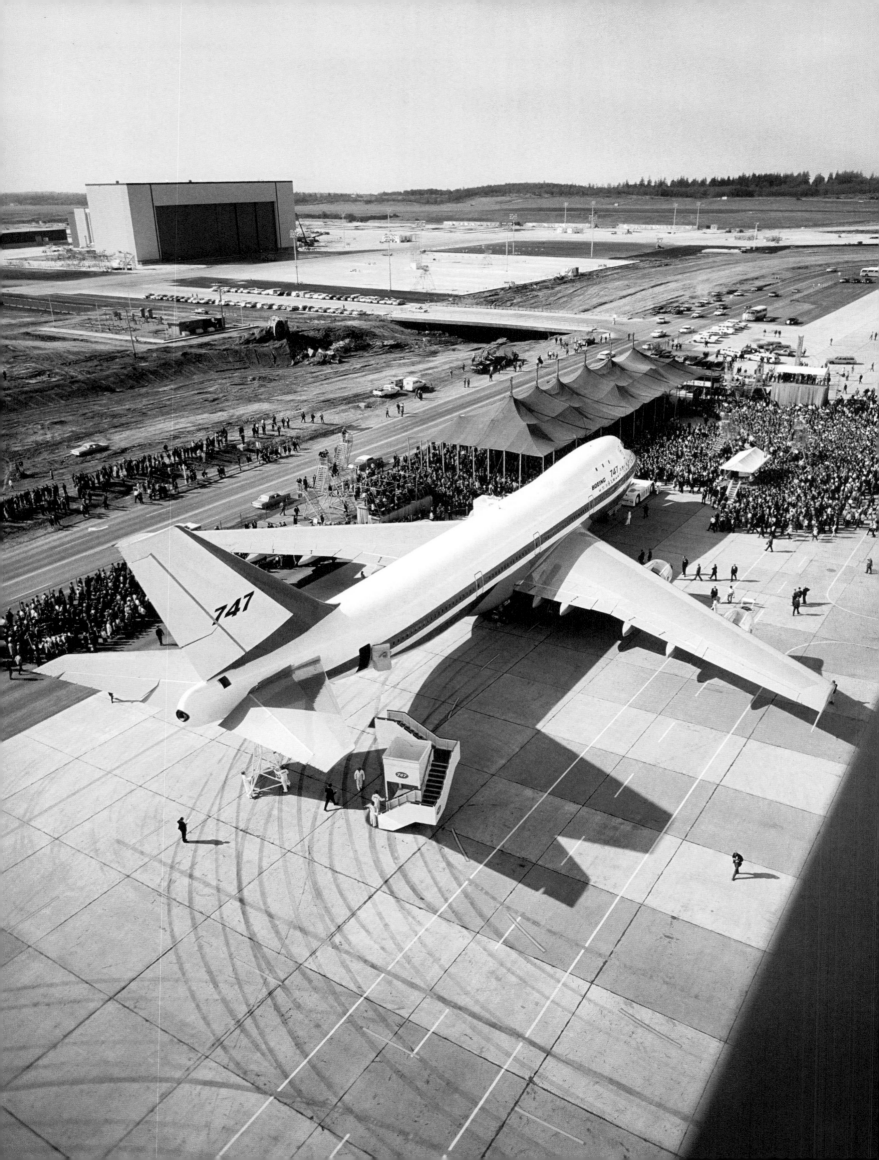

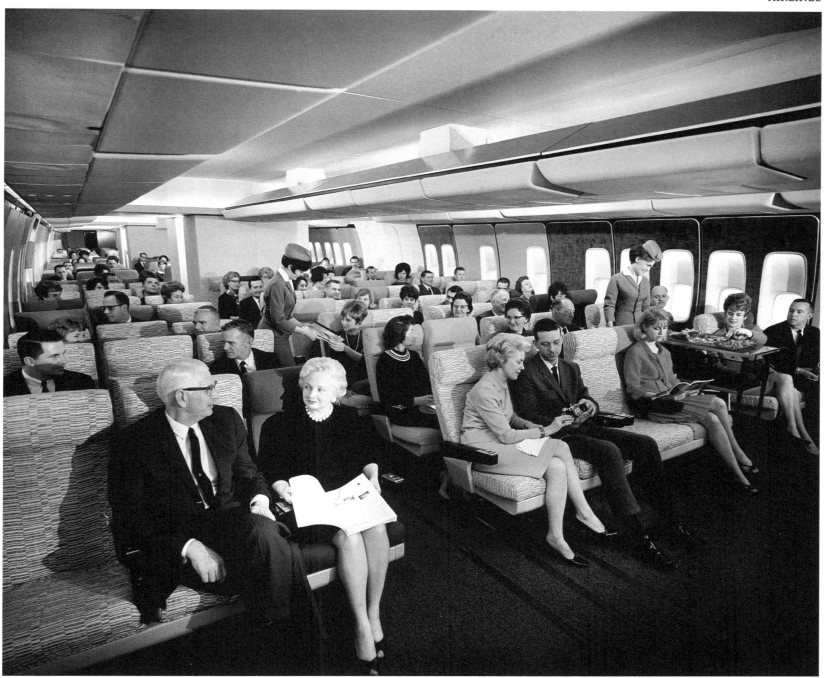

SIZE DOES MATTER

Opposite: Introducing the Boeing 747 in Everett, Washington, 1969. With its five hundred seats, the jumbo jet remained the world's biggest passenger airplane until 2005.
Above: Trying out the seats in the jumbo jet at the Paris Aerosalon, 1969.
Following pages: The cabin of a Lockheed L-1011 TriStar prototype, 1968. The wide-body aircraft, which could seat four hundred passengers, was the aircraft manufacturer's last attempt to gain a foothold in civil aviation.

SIZE DOES MATTER

Links: Vorstellung der Boeing 747 in Everett, Washington, 1969. Der Jumbo-Jet blieb mit seinen 500 Sitzen bis 2005 das größte Passagierflugzeug der Welt;
oben: Probesitzen im Jumbo-Jet beim Pariser Aerosalon, 1969
Seite 250/251: Die Kabine des Prototyps einer Lockheed L-1011 TriStar, 1968. Das Großraumflugzeug für bis zu 400 Passagiere war der bisher letzte Versuch des Flugzeugherstellers im zivilen Luftverkehr Fuß zu fassen

PLUS GRAND, TOUJOURS PLUS GRAND

Ci-contre : présentation du Boeing 747 à Everett, État de Washington, 1969. Avec ses 500 places,
le Jumbo Jet restera le plus grand appareil de passagers au monde jusqu'en 2005 ;
ci-dessus : cabine témoin du Jumbo Jet au salon du Bourget, 1969
Pages 250-251 : cabine d'un prototype de L-1011 TriStar de Lockheed, 1968. Prévu pour 400 passagers,
le gros-porteur est l'ultime tentative du constructeur aéronautique pour se convertir à l'aviation civile

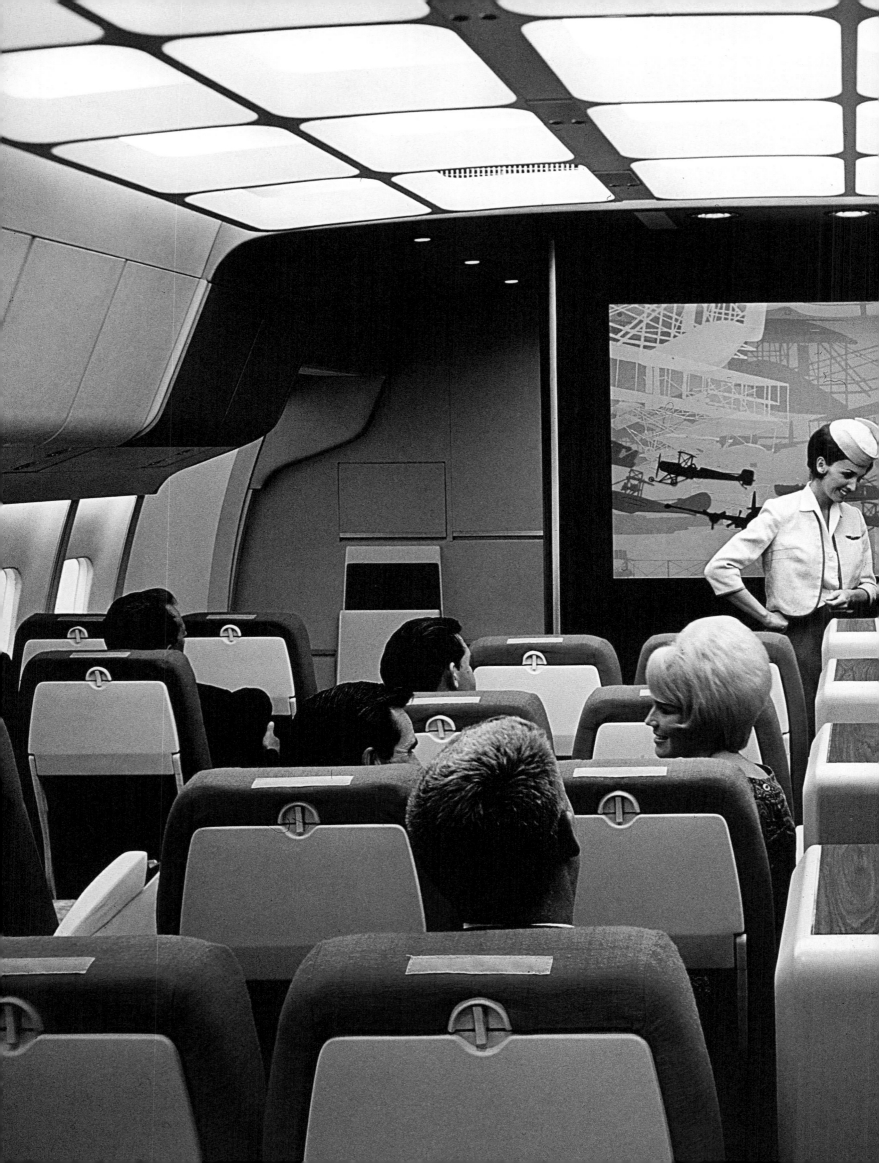

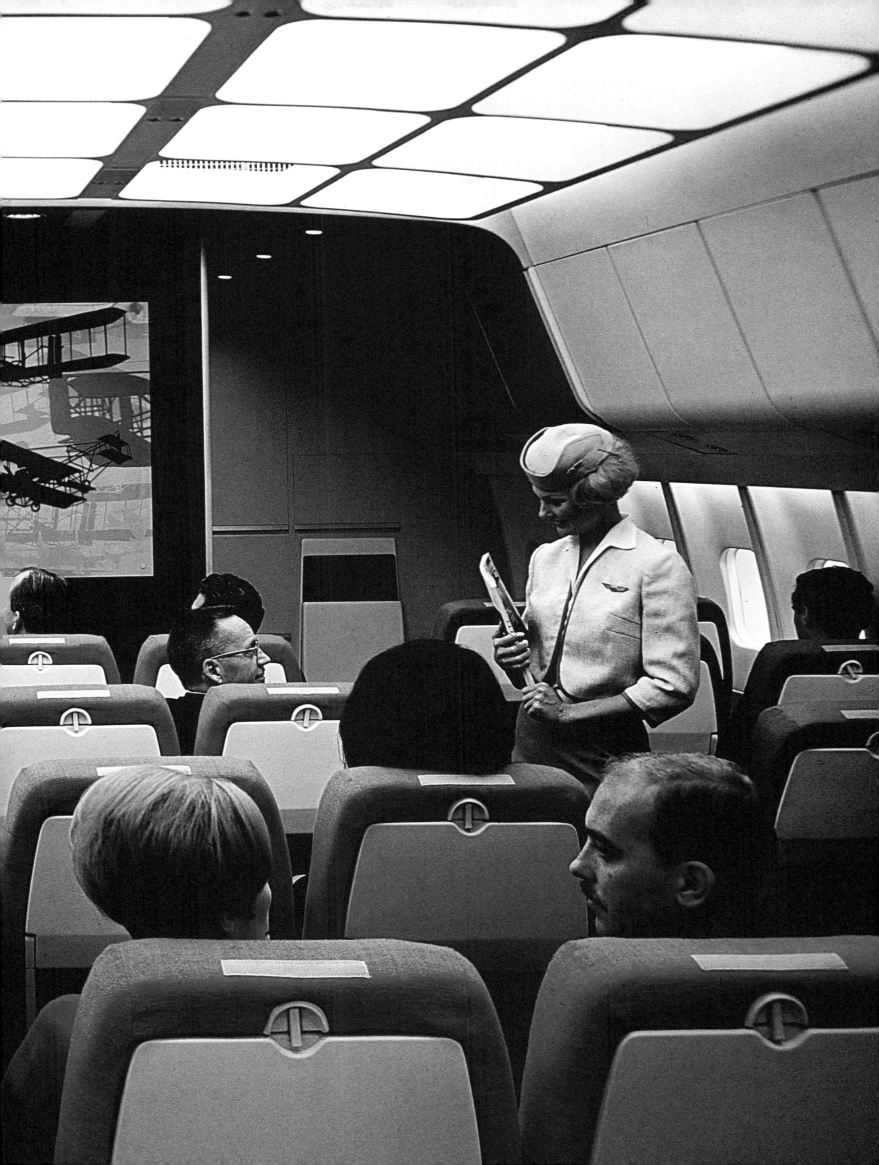

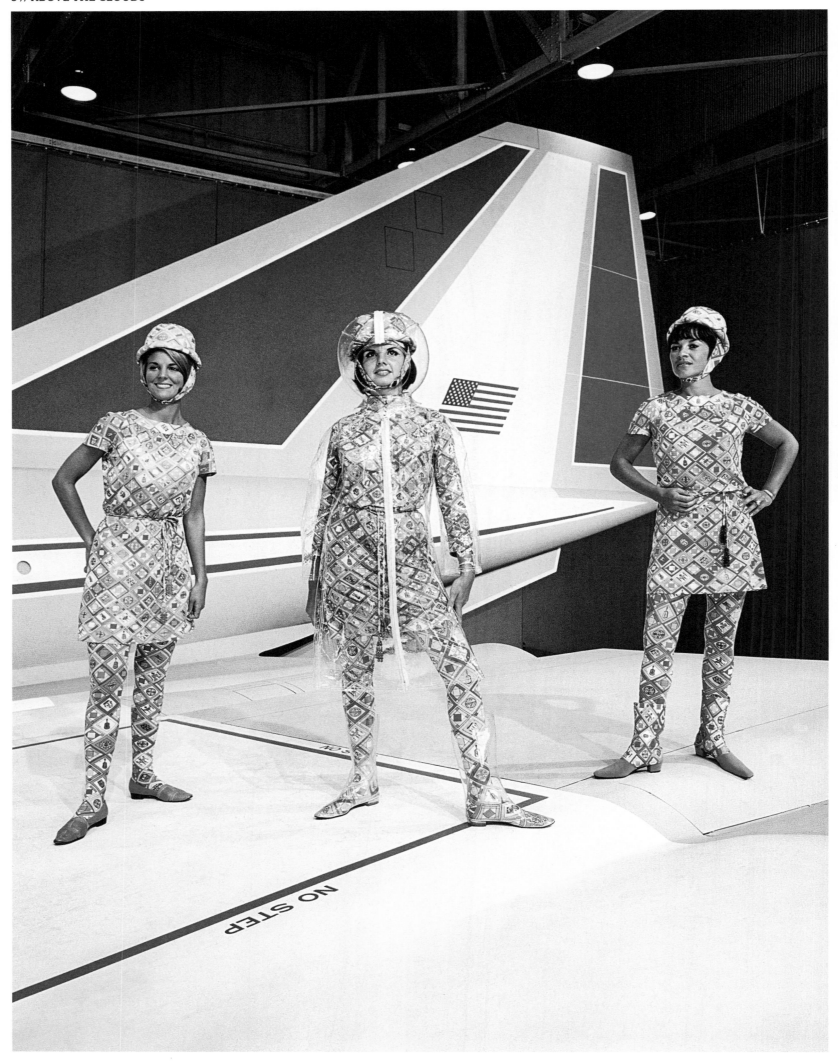

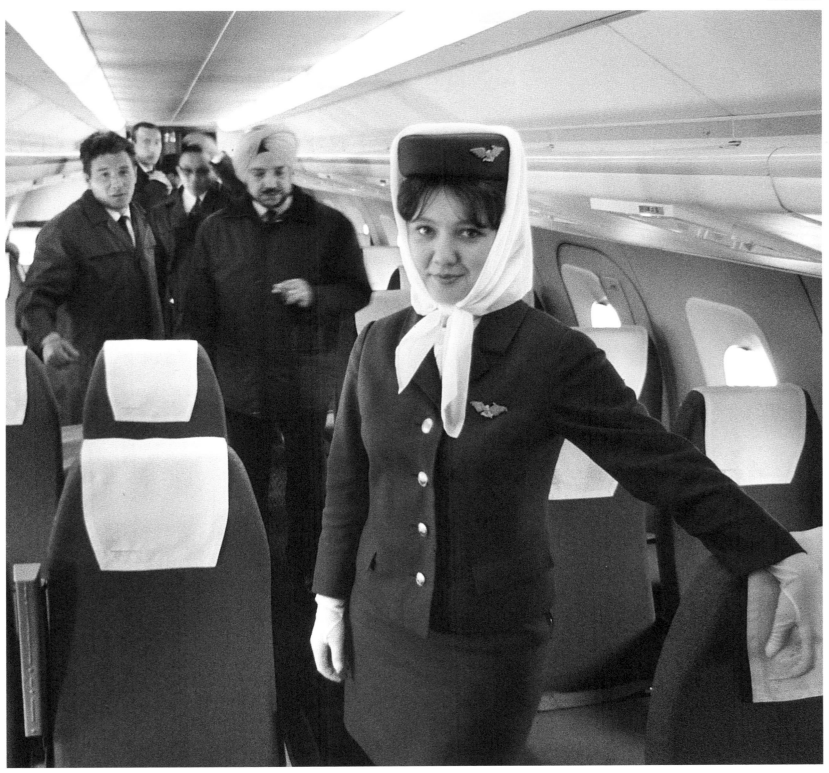

A COLD WAR IN SUPERSONIC AIRCRAFT

Opposite: Colorful stewardess uniforms designed by Emilio Pucci being modeled on the wing of a Concorde, 1970.
Above: Flight attendant and first passengers on board of the Soviet Tupolev Tu-144, 1969.
Following pages: An Air France Concorde in flight, 1975.

KALTER KRIEG MIT ÜBERSCHALLFLUGZEUGEN

Links: Präsentation farbenfroher Stewardess-Uniformen vom Emilio Pucci auf dem Flügel einer Concorde, 1970;
oben: Erste Gäste an Bord der sowjetischen Tupolew Tu-144, 1969;
Seite 254/255: Eine Concorde der Air France im Flug, 1975

LA GUERRE FROIDE DES SUPERSONIQUES

À gauche : uniformes bariolés dessinés par Emilio Pucci, présentés par des hôtesses sur une aile de Concorde, 1970 ;
ci-dessus : une hôtesse de l'air accueille les premiers passagers à bord d'un Tupolev Tu-144 soviétique, 1969 ;
Pages 254-255 : un Concorde d'Air France en vol, 1975

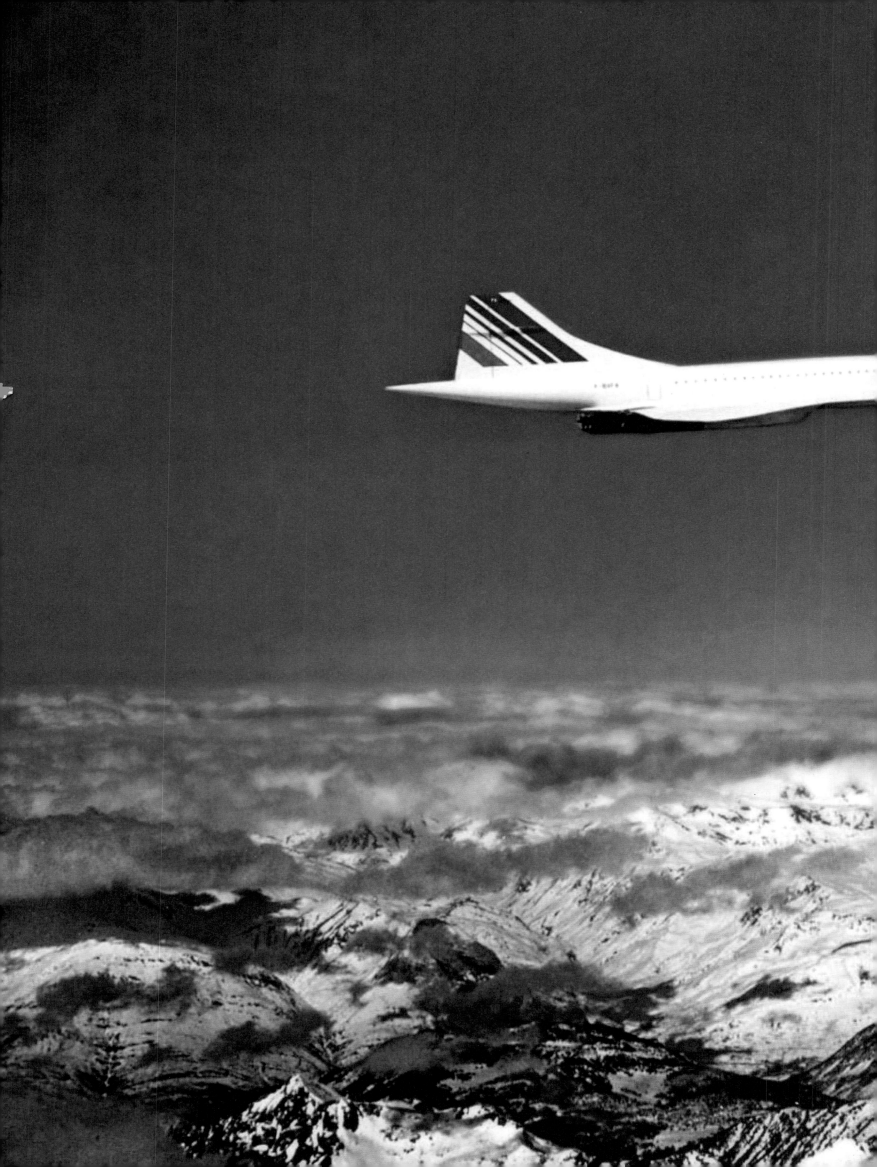